THE LAST PICTURE SHOW

Douglas Fogle

THE LAST PICTURE SHOW: ARTISTS USING PHOTOGRAPHY 1960–1982

Walker Art Center, Minneapolis

Published on the occasion of the exhibition **The Last Picture Show: Artists Using Photography, 1960–1982**, curated by Douglas Fogle for the Walker Art Center.

Walker Art Center
Minneapolis, Minnesota
October 11, 2003–
January 4, 2004
UCLA Hammer Museum
Los Angeles, California
February 8–May 11, 2004
Museo de Arte Contemporánea de Vigo (MARCO)
Vigo, Spain
May 28–September 19, 2004
Fotomuseum Winterthur
Winterthur, Switzerland
November 27, 2004–
February 20, 2005
Miami Art Central
Miami, Florida
March–June, 2005

The Last Picture Show: Artists Using Photography, 1960–1982 is made possible by generous support from Karen and Ken Heithoff, La Colección Jumex, Carol and Judson Bemis Jr., and Harry M. Drake.

The exhibition catalogue is made possible in part by a grant from the Andrew W. Mellon Foundation in support of Walker Art Center publications.

Major support for Walker Art Center programs is provided by the Minnesota State Arts Board through an appropriation by the Minnesota State Legislature, The Wallace Foundation, the Doris Duke Charitable Foundation through the Doris Duke Fund for Jazz and Dance and the Doris Duke Performing Arts Endowment Fund, The Bush Foundation, Target Stores, Marshall Field's, and Mervyn's with support from the Target Foundation, The McKnight Foundation, General Mills Foundation, Coldwell Banker Burnet, the Institute of Museum and Library Services, the National Endowment for the Arts, American Express Philanthropic Program, The Regis Foundation, The Cargill Foundation, 3M, U.S. Bank, and the members of the Walker Art Center.

Library of Congress
Cataloging-in-Publication Data

Fogle, Douglas, 1964–
 The last picture show : artists using photography, 1960-1982 / Douglas Fogle.— 1st ed.
 p. cm.
Catalogue of an exhibition held at the Walker Art Center Minneapolis, Minn., Oct. 2003–Jan. 2004; UCLA Hammer Museum Los Angeles, Calif., Feb.–May, 2004.
 ISBN 0-935640-76-2
(alk. paper)
 1. Photography, Artistic—History—20th century—Exhibitions. 2. Art and photography—History—20th century—Exhibitions.
I. Walker Art Center. II. UCLA Hammer Museum of Art and Cultural Center. III. Title.
 TR645.M542W354 2003
 770—dc22

 2003017642

First Edition

Available through D.A.P./Distributed Art Publishers 155 Sixth Avenue New York, NY 10013

Every reasonable attempt has been made to identify owners of copyright. Errors or omissions will be corrected in subsequent editions.

Designers
Andrew Blauvelt and Chad Kloepfer
Editor
Karen Jacobson
Publications Manager
Lisa Middag
Curatorial Assistant
Alisa Eimen

Printed and bound in the United Kingdom by Butler & Tanner Ltd.

Contents

Foreword

We are exposed daily to literally thousands of pictures. While increasing numbers of these images are digital, crafted out of zeros and ones before being sent electronically across the Internet with a few clicks of the mouse, their lineage can be traced to the time-based and chemical magic of the photographic process, invented in the early part of the nineteenth century. The relationship of artists to this supple technology has been a fruitful one, predating the moment in 1850 when Paul Delaroche first glimpsed a daguerreotype and was said to have hyperbolically noted, "From today, painting is dead." The intimate connection between the artist and the camera is even more evident today, as earlier distinctions between the practices of painting and photography blur. As more and more artists have incorporated photographic images and processes into their practices, the ways in which we look at, understand, and value the medium and its history have clearly changed as well.

The Last Picture Show: Artists Using Photography, 1960–1982 seeks to tell one part of this evolving story as it brings together the works of fifty-seven artists, each of whom has exploited the conceptual and formal properties of the medium with great self-awareness. In doing so, these artists defied the traditional hierarchy that valued painting and sculpture above other media, introduced the performative as well as the vernacular into their imagery, and advanced the chimerical qualities of the medium rather than its alleged capacity to capture objective truth. While the tradition of modernist fine art photography found a home within established networks of galleries and museums, another kind of photographic practice was emerging among artists who identified themselves primarily as sculptors or painters. In the early 1960s artists working within the context of contemporaneous artistic trends such as Conceptual Art, Process Art, and Arte Povera began to use the medium in a rigorously experimental manner, eschewing the technical mastery of the fine art print. They instead favored a more radically utilitarian stance that put photography in the service of the world of ideas rather than that of images or their physical realization. As Sol LeWitt wrote in 1969 in "Sentences on Conceptual Art": "Conceptual artists are mystics rather than rationalists. They leap to conclusions that logic cannot reach. . . . When words such as painting and sculpture are used, they connote a whole tradition and imply a consequent acceptance of this tradition, thus placing limitations on the artist who would be reluctant to make art that goes beyond the limitations. . . . Since no form is intrinsically superior to another, the artist may use any form, from an expression of words, (written or spoken) to physical reality, equally."

Spanning a twenty-year period, this exhibition explores for the first time the development of conceptual trends in postwar photographic practice from their first glimmerings in the 1960s in the work of Bernd and Hilla Becher, Edward Ruscha, Bruce Nauman, and others to their culmination in the late 1970s and early 1980s in the photo-based work of artists such as Sherrie Levine, Richard Prince, and Cindy Sherman. Each of these artists has used the camera to frame critical investigations of issues surrounding self-portraiture, the body, landscape, the architecture of the built environment, anonymous images, and the impact of advertising and mass media.

The Last Picture Show follows in the wake of a number of recent exhibitions at the Walker Art Center that delved into the conceptual uses of photography, including *Photography in Contemporary German Art: 1960 to the Present* (1992), *Bruce Nauman* (1993), *In the Spirit of Fluxus* (1993), *The Photomontages of Hannah Höch* (1996), *Peter Fischli and David Weiss: In a Restless World* (1996), *2000 B.C. The Bruce Conner Story, Part II* (1999), and *Zero to Infinity: Arte Povera, 1962–1972* (2001). The Walker has also hosted solo photo-based exhibitions by artists such as Carrie Mae Weems (1994), Dawoud Bey (1995), Lorna Simpson (1999), and Catherine Opie (2002). In many ways, *The Last Picture Show* can be seen as providing a genealogical backdrop for an entire generation of young artists who took up photography in the 1990s. A number of these then-emerging artists were presented in a 1997 exhibition at the Walker Art Center entitled *Stills: Emerging Photography in the 1990s*, curated by Douglas Fogle, who organized this exhibition as well. Douglas' curatorial talents and interests are wide-ranging; his commitment to examining the critical and social context surrounding art makes for an unusually rich and perceptive frame of reference. Similarly, his devotion to both artists and young scholars creates a safe environment for them to express themselves freely and to take the risks necessary to be genuinely inventive. He has organized this exhibition and catalogue with a thoroughness and intelligence that are hallmarks of important new scholarship. I also appreciate Douglas' constant concern for what serves this institution best. This exhibition, which gives concrete form to one focus of our collection as well as to our global mission, is but one example of the public rewards of such devotion.

Indeed, the Walker Art Center's own history is closely linked to that of the artists who sought to develop photography in more conceptual directions. In the last decade the Walker has acquired works for its permanent collection by a number of these artists, including Peter Fischli and David Weiss, Andreas Gursky, Sherrie Levine, Adrian Piper, Sigmar Polke, Cindy Sherman, Thomas Struth, Jeff Wall, and Andy Warhol. Happily, many of these works are on view in this exhibition.

Like any project of this magnitude and complexity, *The Last Picture Show* would not be possible without the very generous contributions of those who share the Walker Art Center's commitment to investigating the work of artists who help us make sense of the world around us. The Walker Art Center is deeply grateful for the financial support of Karen and Ken Heithoff; La Colección Jumex, Mexico City; Carol and Judson Bemis Jr.; and Harry M. Drake.

Finally, we all are grateful for the cooperation of the artists in this exhibition, for the courage with which they approached their own efforts, and for their support of our endeavors.

Kathy Halbreich
Director

Acknowledgments

I would like to extend my deep appreciation to all those who have helped in the conception and realization of this exhibition and publication. First and foremost, I want to thank the artists represented in this exhibition, who have taken the medium of photography into new and extraordinary realms of experimentation and imagination.

I am also deeply grateful to the authors represented in this publication. Their contributions to this volume—whether newly commissioned or reprinted—constitute an equally important part of this project, as their creative questioning has brought to the fore the complexities of the various parallel histories of photography.

The Last Picture Show: Artists Using Photography, 1960–1982 would not have been possible without the generosity and commitment of the many lenders to this exhibition who agreed to share important works from their collections. Their names may be found on page 333. We are deeply grateful for their willingness to make such remarkable work available to a larger viewing public.

After its showing at the Walker, *The Last Picture Show* will travel to the UCLA Hammer Museum in Los Angeles. I would like to thank our colleagues at this venue, Director Ann Philbin and Chief Curator Russell Ferguson, whose commitment has ensured a broader audience for this project.

Among the many individuals and organizations that helped to facilitate this project, special thanks go to Mike Bellon at Acconci Studio, New York; Janelle Patrick at Brooke Alexander Editions; Michelle Andrews; Tim Hardacre and Ben Portis at the Art Gallery of Ontario, Toronto; Emma Robertson at The Approach, London; Gabriel Catone at Art Advisory Services, New York; Charles Guarino and Nicole Rudick at *Artforum*, New York; Angelo Baldassarre; Brienne Arrington, Jen Liu, and Kim Schoenstadt at John Baldessari Studio, Los Angeles; Amada Cruz at Bard Center for Curatorial Studies; Evelyn Bertram-Neunzig; Tim Blum and Jeff Poe at Blum and Poe, Los Angeles; Marilena Bonomo at Galeria Bonomo, Bari, Italy; Ron Warren at Mary Boone Gallery, New York; Jeanne Bickley at The Brant Foundation, Greenwich, Connecticut; Julianna Hanner and Joanne Heyler at the Broad Art Foundation, Santa Monica; Christine Burgin and Catherine Ecclestone at Christine Burgin Gallery, New York; Chana Budgazad at Casey Kaplan, New York; Aimee Chang; James Cohan, Elyse Goldberg, and Hannah Israel at James Cohan Gallery, New York; Pippa Cohen; Steve Henry and Maki Nanamori at Paula Cooper Gallery, New York; Tommaso Corvi-Mora at Corvi-Mora, London; Adrienne Parks and Laura Raicovich at Dia Art Foundation, New York; James Elliott and Laura Ricketts at Anthony d'Offay Ltd.; Michel Durand-Dessert; Thomas Erben and Louky Keijsers at Thomas Erben Gallery, New York; Filippo Fossati at Esso Gallery, New York; Sarah H. Paulson at Ronald Feldman Fine Arts, New York; Ulla Wiegand at Konrad Fischer Galerie, Munich; Robert McKeever and Hanako Williams at Gagosian Gallery, New York and Los Angeles; Tal Trost at Galerie Bob van Orsouw, Zurich; Michael Hughes at Galerie Lelong, New York; Sarah Gavlak;

Catherine Belloy, Marian Goodman, and Andrew Richards at Marian Goodman Gallery, New York; Rosalie Benitez, Ivy Crewdson, Barbara Gladstone, and Kelly Kyst at Barbara Gladstone Gallery, New York; Jay Gorney and Sheri L. Pasquarella at Gorney, Bravin + Lee, New York; Cornelia Grassi and Holly Walsh at Greengrassi, London; Kim Bush and Nancy Spector at the Solomon R. Guggenheim Museum, New York; Rhona Hoffman at Rhona Hoffman Gallery, Chicago; Beatrice Merz and Elisabetta Salzotti at Hopefulmonster, Turin; Darcy Huebler and Luciano Perna; Geeta Kapur; Thomas Kellein; Robert Gurbo at the Estate of André Kertész; Carmen Knoebel; Sabine Knust at Galerie Sabine Knust, Munich; Frank and Patti Kolodny; Dr. Dieter Schwarz at Kunstmuseum Winterthur; Michel Blanscubé, Eugenio Lopez, and Patricia Martin at La Colección Jumex; Wendy Brandow and Margo Leavin at Margo Leavin Gallery, Los Angeles; James Lingwood at Artangel, London; Victoria Cuthbert and Sonny Fitzsimonds at Matthew Marks Gallery, New York; Allison Card, Travis W. Choat, and Tom Heman at Metro Pictures, New York; Lisa Mark at the Museum of Contemporary Art, Los Angeles; Amy Plumb at Dennis Oppenheim Studio; Kim Jones at Pace/MacGill Gallery, New York; Élia Pijollet; Beth Taylor at Rachofsky House, Dallas; Julie Chiofolo, Lisa Overduin, and Shaun Caley Regen at Regen Projects, Los Angeles; Wendy Chang, Liz Harris, Sachiyo Yoshimoto, and Patrick Painter at Patrick Painter Editions; Scott Rothkopf; Mary Dean at Ruscha Studio, Los Angeles; Antonio Tucci Russo at Galleria Tucci Russo, Torre Pellice, Italy; Alan Schwartzman; Shirana Shahbazi; Susanna Singer; Leslie Fritz and Per Skarstedt at Skarstedt Fine Art, New York; Wendy Hurlock and Richard Sorensen at the Smithsonian Institution, Washington, D.C.; Laura Bloom, Antonio Homem, Xan Price, and Jason Ysenberg at Sonnabend Gallery, New York; Pierpaolo Falone, Michael Short, and Gian Enzo Sperone at Sperone Westwater, New York and Turin; Kurt Brondo, Lisa Spellman, and Mari Spirito at 303 Gallery, New York; Deepak Talwar at Talwar Gallery, New York; Helaina Blume at the Tang Teaching Museum and Art Gallery at Skidmore College, Saratoga Springs, New York; Elizabeth Thomas; Leslie Tonkonow at Leslie Tonkonow Artworks + Projects, New York; Ticiana Corteletti and Marcia Fortes at Galerie Fortes Villaça, São Paulo; Greg Burchard at the Andy Warhol Museum, Pittsburgh; Sara Seagull at Robert Watts Studio Archive, New York; Jason Duval and Kelly Sturhahn at Michael Werner, New York; Iain Boyd Whyte; Ellen Mahoney at Stephen Wirtz Gallery, San Francisco; Tanja Elstgeest at Witte de With, Rotterdam; Angela Choon, Matt Siegle, and David Zwirner at David Zwirner Gallery, New York.

Among the many people with whom I shared productive discussions about this material over the past two years, I am particularly indebted to Francesco Bonami, Manilow Senior Curator at the Museum of Contemporary Art, Chicago, for his early encouragement of this project and his important intellectual insights, and to Geoffrey Batchen, professor of art history at the Graduate Center of the City University of New York, for the ongoing critical dialogue about the history of photography that we have been having for more than fifteen years.

At the Walker Art Center I would like to thank Director Kathy Halbreich for creating an institutional environment that both values the experimental and gives a new meaning to the notion

of a team; Chief Curator Richard Flood, whose door has been open to me since the day I arrived in Minneapolis and whose ideas and critical eye have played a crucial role in shaping this project; Curator Philippe Vergne for his critical support, for his gift of a title, and for providing a necessary (and oftentimes hilarious) sounding board; Curator Joan Rothfuss for her timely advice; Summer Curatorial Intern Natilee Harren for giving up her summer; and Curatorial Intern Alisa Eimen, whose incredible dedication, intellectual curiosity, and attention to detail inform every aspect of this exhibition and publication.

In the Visual Arts Department, I would like to acknowledge Administrative Assistants Lynn Dierks and Kate Dowling, who deftly handled the many administrative details of the exhibition, publication, and exhibition tour. In the Registration Department, Registrar Gwen Bitz expertly oversaw the care and safe handling of more than two hundred objects and heroically organized an extremely complicated shipping schedule. For their extraordinary installation of the works, I am indebted to Cameron Zebrun and his entire Program Services staff, especially Phil Docken. Their dedication to artists makes this a truly special place to work. In the Development Department, I would like to thank Director Christopher Stevens and his colleagues Kathryn Ross and Aaron Mack for their unflagging efforts in making this exhibition finan-cially possible. Thanks also go the Walker's fiscal caretakers, Administrative Director Ann Bitter and Finance Director Mary Polta. In addition, I would like to express my appreciation to Director of Education Sarah Schultz and her talented public programs staff, including Meredith Walters and Sarah Peters, who organized the exhibition-related educational programs.

I am extremely grateful to the staff of the Walker's Design Department, including Design Director Andrew Blauvelt and Senior Designer Chad Kloepfer, who were responsible for the beautiful design of this publication. Independent editor Karen Jacobson thoughtfully and painstakingly shaped the many texts in this volume, while Publications Manager Lisa Middag deftly shepherded the production of this book from its inception to its delivery. Additional invaluable support was provided by Photographer Cameron Wittig, who shot many of the works reproduced in this publication, and Librarian Rosemary Furtak.

Douglas Fogle

Douglas Fogle

The Last Picture Show

Douglas Fogle is associate curator of visual arts at the Walker Art Center and organizer of the exhibition *The Last Picture Show: Artists Using Photography, 1960–1982*. During his tenure at the Walker he has initiated a number of other exhibitions, including *Stills: Emerging Photography in the 1990s* (1997), *Painting at the Edge of the World* (2001), *Catherine Opie: Skyways and Icehouses* (2002), and *Julie Mehretu: Drawing into Painting* (2003).

There is something abominable about cameras, because they possess the power to invent many worlds. As an artist who has been lost in this wilderness of mechanical reproduction for many years, I do not know which world to start with. I have seen fellow artists driven to the point of frenzy by photography.

Robert Smithson, "Art through the Camera's Eye"

In 1960 Yves Klein stood on the edge of a precipice. More specifically, he stood on the roof ledge of a building in the suburbs of Paris waiting to perform a miraculous feat. On the street below were the photographers Harry Shunk and John Kender, who had been employed by Klein to document this event. Shunk and his friend Kender collaborated with Klein in order to create what might arguably and paradoxically be considered to be one of the painter's most important works. With the photograph *Leap into the Void* (1960), they produced a fictionalized photographic document that showed Klein making a superhuman leap onto the street below. In a starkly existential act that spoke at once to the mystical powers of the artist as well as to his hyperbolic attitude toward his own artistic production, this "painter of space," who was best known for his blue monochromes and for using the body as a paintbrush, was able to construct a dramatic visual metaphor for his work. The end product of this "documentary" photo shoot was Klein's self-published newspaper edition *Dimanche*, which illustrated the artist's writings on his Theater of the Void with this now-legendary photograph. Disseminated in Parisian newsstands next to copies of the real *Dimanche*, this image would come to

play an important role in the creation of the mythic aspects of Klein's career and would be a crucial intellectual reference for the Viennese Actionists in the late 1960s and other performance-based artists of the 1970s. Of course, what was not visible in this photograph were the dozen or so students from the nearby judo academy who held an outstretched tarpaulin to break the artist's fall. Removing these individuals from the image through the technique of photomontage, Klein and his colleagues employed the evidentiary power of photography to abet a hoax. At the same time, however, they launched a powerful iconic marker into the network of artistic images circulating at the time. The impact of this particular image rested in its photographic nature and the way in which it played with the assumed verisimilitude of the medium.

If the status of this object was questionable, however, it was only partly due to the fact that the image was doctored in the service of producing a dramatic effect. Its problematic character grew out of its ambiguous status as an object of art or, more precisely, as a piece of photographic art. What exactly was this photographic entity? A documentation of a performance? A work of art in its own right? How could this object possibly be read within the context of the history of art and, more to the point, the history of art photography as it existed in 1960?

Leap into the Void (1960): A conceptual event principally embodied in a photograph by Harry Shunk of Yves Klein leaping from a roof ledge in the Paris suburb of Fontenay-aux-Roses

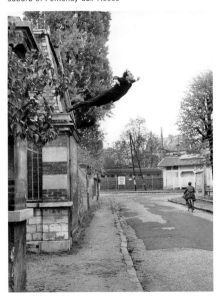

Klein's "leap" might be seen in contrast to another well-known photographic leap, captured by the lens of Henri Cartier-Bresson in 1932. In his now-classic image of a man jumping across a puddle behind the Gare Saint-Lazare in Paris, Cartier-Bresson provided us with a clear example of what he called photography's "decisive moment." As he explained:

To me, photography is the simultaneous recognition, in a fraction of a second, of the significance of an event as well as of a precise organization of forms which give that event its proper expression. I believe that, through the act of living, the discovery of oneself is made concurrently with the discovery of the world around us which can mold us, but which can also be affected by us. A balance must be established between these two worlds—the one inside us and the one outside us. As the result of a constant reciprocal process, both these worlds come to form a single one. And it is this world that we must communicate.[1]

Cartier-Bresson's statement appeared in the 1952 edition of his large-format publication *The Decisive Moment*, which collected his best-known pictures.

In many ways, the concept of the "decisive moment" would come to stand in for a wide array of photographic practices that were

Henri Cartier-Bresson; *Behind the Gare Saint-Lazare, Paris*, 1932; gelatin silver print; 22¹¹⁄₁₆ x 15⅜ in. (57.6 x 39.1 cm); The Minneapolis Institute of Arts, The Alfred and Ingrid Lenz Harrison Fund

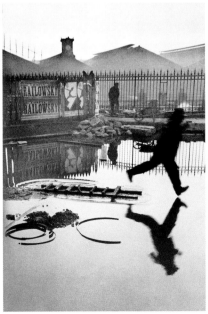

championed by those who took a modernist view of the medium's aesthetic autonomy, including John Szarkowski, curator of photography at the Museum of Modern Art in New York. In fact, Cartier-Bresson's photographs would be prominently featured in Szarkowski's exhibition *The Photographer's Eye*, held at MoMA in 1964, which posed the possibility of writing a "history of the medium in terms of photographers' progressive awareness of characteristics and problems inherent in the medium"[2] by juxtaposing works by well-known artist-photographers with so-called functional works by anonymous photographers culled from archives around the world. This vision was, however, predicated on constructing a history of photography that established both its consciously artistic and naive manifestations as aspects of an autonomous and coherent art form.

Here we are confronted by two very different leaps, resulting in two extremely divergent photographic worlds with equally disparate histories. On the one hand, we have the aesthetic mediation of the split between subject and object in an elaboration of the artist's channeling of photography's "decisive moment." On the other, we have a hybrid, collaborative photographic "event," staged by an artist hoping to create an altogether different kind of moment, one that perhaps signaled the emergence of a very different kind of artistic world that was beginning to take form at that time. It is the gap between these two photographic worlds—the modernist aesthetic transmission of an authentic immediacy through the capturing of a photographic essence and the conceptual construction of a staged event that took up photography as a means to an end—that interests us here. It is in the context of this gap that Klein's questionable "leap" and Shunk and Kender's equally problematic "documentation" of that event in 1960 might be seen as a useful starting point for a discussion of the proliferation of the uses of photography outside the then-dominant configurations of art photography in a decade that saw the slow erosion of the boundaries between artistic media.

If Cartier-Bresson's image might be thought of as a traditional photographic "picture," then what exactly was Klein's? It could hardly be seen as a "decisive moment." It is, rather, a hybrid object that might be thought of in terms of what Lucy Lippard and John Chandler first identified

in 1967 as the "dematerialization of the object of art," an approach they saw as crucial to a wide range of emerging art practices in the 1960s that rejected traditional forms of painting and sculpture in favor of an "ultraconceptual art that emphasizes the thinking process almost exclusively."[3] Encompassing a range of practices—from the elevation of the idea to the status of the object to performance-based work that addressed the phenomenology of the body—these alternative strategies would help to create what Rosalind Krauss called an "expanded field" in which the camera became another tool among many available for the execution of a project.[4] Klein's photographic leap embodied just such an approach. Neither simply performance nor document and far from an aesthetic embodiment of modernist photography's hermetic concern with its own limits and conditions of possibility, this work disrupted the standard circuits of the reception of both photography as art and the traditional object of sculpture by surreptitiously inserting itself into the flow of consumer print culture.

It is in this questionable photographic object—or rather this confluence of photographic and performative activity—that we begin to see something of what Robert Smithson described, in the quotation that serves as an epigraph to this essay, as the "abominable" power of the camera. In the last forty years, we have seen the emergence of a plethora of photographic worlds as the use value and the status of this medium has shifted many times over. Following Smithson, then, we could point to a moment in the 1960s when it became clear that there was a new kind of "frenzy" around the medium of photography within the art world and the culture at large. This was a historical moment that witnessed a global explosion of media and the ability to disseminate images. The proliferation of television broadcasting, satellite transmissions, and the exponential spread of photographic print culture gave a new intensity to the power of the photographic image and prompted its expanded use within artistic practices that sought to question the conventional status of the art object. The artists in this exhibition, including Smithson himself, were all, as he put it, "insane enough" to imagine that they could "tame this wilderness created by the camera." It is precisely the multiple photographic worlds created by artists in their attempts to

conquer this "wilderness" that are the subject of *The Last Picture Show: Artists Using Photography, 1960–1982*.

Focusing on a roughly twenty-year period, *The Last Picture Show* brings together photographic works by fifty-seven artists who had little interest in finding photography's true essence as an art or in capturing decisive moments. The artists represented in the exhibition looked at photography instrumentally, as a means to an end, taking up the camera as a tool as they pursued a wide range of experimental agendas, be they sculptural, performative, or even painterly. The scope of the photographic practices and the subjects that they explore is diverse, moving from revisionist investigations of the legacy of the traditional artistic genre of the landscape to visual explorations of nonsequiturs and the absurd to equally challenging explorations of ethnic and gender identity through the use of the masquerade in self-portraiture. Whether or not these artists saw themselves primarily as photographers (some did, and many did not), their wide-ranging practices are linked by what at times might seem like an extraphotographic impulse to launch themselves into the world—or, more correctly, into a multiplicity of photographic worlds of their own making.

But how, precisely, do these photographic worlds come together to create the "last picture show"? The exhibition's title, of course, has been appropriated from the 1966 Larry McMurtry novel and its 1971 film adaptation by Peter Bogdanovich, which tells the coming-of-age story of a group of adolescents in a small Texas town that is dying a quiet death. This is a tale of lost innocence that is symbolized by the closing of the town's last movie house, which marks a turning point in the lives of the protagonists. Perhaps our last picture show is no different. Historically, we too might be seen as having suffered our own cultural loss of innocence. Was our last picture show the moment when we could no longer see photographic images as autonomous aesthetic objects? Following this line of thought, was Szarkowski's 1964 exhibition *The Photographer's Eye*—with its attempt to encompass the whole of photographic practice, both vernacular and artistic, within the purview of a categorical imperative of photography as an art form—the last picture show? Or was our last picture show the progressive loss of our visual

innocence as a result of the explosion and global dissemination of images in the print and electronic media in the 1960s, producing what the Situationist critic Guy Debord referred to in 1967 as the "society of the spectacle," a process that would be accelerated by the proliferation of images being transmitted from the war in Vietnam?

The notion of the "last picture" has been endlessly resurrected in art historical circles for the better part of the last century, from Aleksandr Rodchenko's 1921 completion of three monochromes that he declared the "last paintings" to Daniel Buren's "refusal" of painting in the late 1960s. The picture, or the "Western Concept of the Picture," as Jeff Wall points out in his 1995 essay reprinted in this volume, is "that *tableau*, that independently beautiful depiction and composition that derives from the institutionalization of perspective and dramatic figuration at the origins of modern Western art." This conceptualization of the picture was an organizing principle for painting for hundreds of years but was of course also highly influential as it was adopted by art photography in the late nineteenth and early twentieth centuries under the rubric of Pictorialism. A number of the contributors included in this volume in some way or other make reference to the transformation of this received definition of the picture through the practices of artists associated with Conceptual Art and its aftermath. Wall, for example, suggests that a new model of the picture emerged in the wake of Conceptual Art's incorporation of the techniques of photographic reportage into its artistic strategies. Stefan Gronert, by contrast, focusing on the history of photography in Europe, argues that the adoption of photoconceptualist practices by artists in the 1970s paradoxically resulted in the reemergence of the picture form in contemporary photography. Jean-François Chevrier, in a newly translated essay of 1989, traces the circuitous development of the picture form as employed by photographers over a century and a half, writing: "The picture's adventures in the history of photography and of its artistic uses, whatever the period, have now led us to the point where it has again, and more strongly so than ever, been embraced by the majority of contemporary photographers as a necessary, or at least sufficient, form of (or model for) artistic production and experience."

The Last Picture Show is in a sense an attempt to write a provisional account of some of these "adventures" of the (photographic) picture form and, in so doing, construct what Michel Foucault called a "history of the present."[5] The artists represented in this exhibition challenge us to reassess our commonly held assumptions of what constitutes a picture and help us acquire a deeper understanding of the extraordinarily diverse and widespread uses of photography in the art world today. In light of this, we might take our lead from a question posed in a 1981 photograph by Louise Lawler and ask ourselves, "Why pictures now?" In some ways this is the underlying mantra of this exhibition. Of course, we might add an important corollary to that question and ask, "What kind of pictures?" In the end, these two questions are inseparable.

As even a cursory review of the diversity of practices reflected in this exhibition would suggest, the history of photography is itself, like any history, necessarily plural. As Geoffrey Batchen points out in his essay in this volume, "American art photography was in fact continually being ruptured from within [and] conceptual practices of various kinds have always been rife within the photography community." The same holds true for European art photography. Numerous radical photographic practices by artists

involved in Surrealism, Dada, and the other avant-gardes pointed this medium outside the realm of its own disciplinary boundaries into a conceptual terra incognita that would not be easily recoupable into a strictly modernist narrative. One need only point to Brassaï's photograph *Involuntary Sculptures*, published in the Surrealist journal *Minotaure* in 1933, which documented Salvador Dalí's "sculptures" found in everyday life (twisted bus tickets, strangely shaped loafs of bread, and so on) or Man Ray's *Dust Breeding* (1920), a photographic experiment conducted with Marcel Duchamp on the latter's *Large Glass* (1915–1923), to understand that neither the category of photographic Pictorialism nor that of straight photography could contain the radical aesthetic questioning to which photography was being put to use.

Dust Breeding in particular presents an interesting precursor of the use of photography by artists in the 1960s. Duchamp allowed the lower back panel of the *Large Glass* to accumulate a thick layer of dust over a period of three months. Man Ray then photographed this work, producing an image of an alien landscape that was neither a documentation of Duchamp's "sculpture" nor a formalist photographic exercise, but rather a hybrid object caught somewhere between the realms of photography and sculpture, dramatically embodying

Man Ray; *Dust Breeding*, 1920; gelatin silver print; 9⁷/₁₆ x 12 in. (24 x 30.5 cm); Musée Nationale d'Art Moderne, Centre Georges Pompidou, Paris

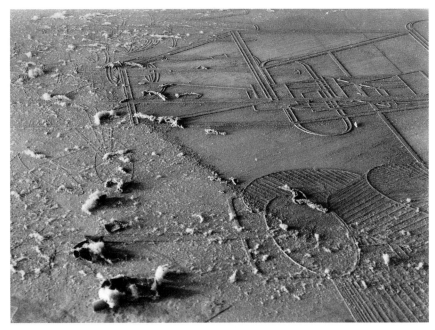

Man Ray's contention that "photography is not art."[6] Already in 1920 then, Man Ray's work was prompting questions whose conceptual origins could be traced to the radical influence of Duchamp's Readymades and their destabilizing effects on the status of the art object.[7]

The work of Man Ray and his cohort would be the harbinger of a host of new photographic possibilities that began to emerge in the 1960s. The first of these new photographic worlds emerged from the shadow of the appropriation of media images in Pop Art and the focus on what Donald Judd termed the "specific objects" of Minimalism, as artists turned increasingly to the camera in order to investigate the realm of conceptual and process-based forms of practice. In 1976, in an article reprinted in this volume, Nancy Foote would give a name to this increasingly widespread impulse, using the term "anti-photographers" to describe the work of a number of artists (including many represented in this exhibition) who were dependent on a utilitarian attitude toward photography but displayed "little *photographic* self-consciousness." This new attitude toward photography's expanded field would come to be exemplified by artists such as Edward Ruscha, who just two years

after Klein's leap would publish the first of his photographic books, *Twentysix Gasoline Stations* (1962), a work that would rigorously eschew the sanctified aesthetic nature of the modernist "decisive moment" in favor of the industrial, low-fi photographic aesthetic of magazine and book culture. Appropriately, Ruscha would comment on his instrumental use of the medium in a 1972 *New York Times* interview with A. D. Coleman (reprinted in this volume), suggesting that photography was for him "strictly a medium to use or not use, and I use it only when I have to. I use it to do a job, which is to make a book." Published in large, affordable editions, his books relied not on the modernist fetish of the master photographic print but on their functionality and conceptual strength, suggesting that what was important was not so much the artistic qualities of the picture but its content and the context in which it was viewed.

Other artists working at the same historical moment would bring the camera into their studios in order to explore the limits of contemporary sculptural practice. Ironically, it would be a 1966 visit to a retrospective of the work of Man Ray held at the Los Angeles County Museum of Art that would prompt Bruce Nauman to begin experimenting with the camera.[8] Drawn

to Man Ray's conscious lack of a consistent style and his use of staged settings in his photographs, Nauman would turn to the camera to create a series of works at the end of 1966 and into 1967 that were as much performative sculptural acts as they were photographs.[9]

Like much of Nauman's other work of that time in sculpture and film and video, these works were the products of a series of experiments that investigated the space of the artist's studio in relation to the conceptual and phenomenological limits that it imposed on sculptural practice. While in *Flour Arrangements* (1966) Nauman mapped the material limits of studio practice and the physical activity of the artist by continually shaping and reshaping a pile of flour on his studio floor and photographing it over the course of a month (one is reminded here of Man Ray's *Dust Breeding*), a work such as *Self-Portrait as a Fountain* from Eleven Color Photographs (1966–1967/1970) suggested a more performative bodily investigation. As in all of the works in this series, Nauman used theatrical lighting and employed a professional photographer to construct a set of situations that physically and linguistically turned "things inside out to see what they look like."[10] The camera would in essence help Nauman construct a photographic strategy that would enable him to turn the world inside out, whether he was looking at the plastic properties of his sculptural materials (including his own body) or the structure of language itself.

At the same time that Nauman was moving a radicalized notion of sculpture into the realm of photography, thereby blurring the established boundaries of these media, Giulio Paolini was experimenting in Italy with photosensitive emulsions on stretched canvas. As early as 1965 Paolini produced a series of works that both physically and intellectually took on the legacy of the traditional history of painting in terms of both its physical materiality and its organization of perspectival space. Rather than simply being a commentary on this structural history of painting, the picture plane would, in Paolini's work, itself become a photograph. In works such as *Delfo* (Delphi, 1965), for example, he used an alternative photographic process to transfer to a rectangular canvas an image of himself hidden behind the wooden stretcher bars of a painting. Calling into question both the material

Bruce Nauman, *Self-Portrait as a Fountain*, 1966–1967/70 (under cat. no. 106)

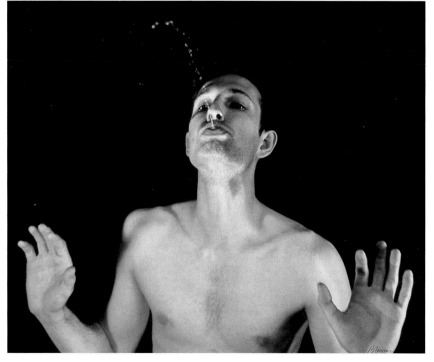

support of painting and the status of the painter, *Delfo* puts Walter Benjamin's discussion of "the work of art in the age of mechanical reproduction" into a different light.[11] In this case photography calls into question the nearly five-hundred-year legacy of European easel painting not by reproducing and disseminating images of great works and thereby destroying their "aura," as suggested by Benjamin, but by transforming the surface of a canvas itself into a photosensitive emulsion that foregrounded the material support of painting. The veritable "body" of painting was replaced by the new flesh of photography.

If Paolini would begin to use photography in the mid-1960s to call into question the legacy of easel painting, at the same time in Germany the painter Sigmar Polke would begin what would become a lifelong obsession with the camera that would lead to photographic experiments with sculptural forms and the alchemy of the developing and printing processes. In fact, Polke would turn to photography almost exclusively as a medium of choice for a good part of the 1970s. One of his earliest endeavors with the camera resulted in a hilarious self-portrait photograph cum sculptural object that goes by the title *Polkes Peitsche* (Polke's whip, 1968). Composed of five small photographic images of the artist contorting his face, attached with string to a wooden whip handle, this self-flagellating photographic object replaces the self-abuse of medieval penitents with satirical, self-deprecating commentary on the role of the artist. In *Bamboostange liebt Zollstockstern* (Bamboo pole loves folding ruler star, 1968–1969), Polke presents the viewer with a series of sixteen black-and-white prints depicting a set of inexplicable and unexpected scenarios constructed from everyday household objects that seem to invoke the strange, illogically elaborate contraptions of Rube Goldberg. The playfulness, humor, and experimental freedom demonstrated by works such as these would become a crucial reference point for artists such as Peter Fischli and David Weiss later in the 1970s.

From the very beginning Polke often incorporated photographic elements into his painting as a result of his fascination with the dots that compose the screens used to reproduce images in commercial printing processes. More importantly, he became interested in the powerful effect of the printing error, that elusive blot disrupting

the uniformity of industrial printing procedures. Polke was able to transfer his interest in the mistake into his photographic practice by playing with the technical "disasters" of the developing and printing process. In 1995 he would elaborate on the liberating effect of photography's malleability: "A negative is never finished. You can handle a negative. You can do what you want. I can play with it. I can make with it. I can mix with it. I can choose with it."[12] Later works pushed the boundaries of photographic clarity and cleanliness to the edge of visual intelligibility by asserting the privileged position of the unstable and the incorrect. Experimenting with the alchemy of the developing process (as well as with his own personal alchemy, by developing and printing work while under the effects of hallucinogens), Polke treated photography as a transformative medium that was almost mystical in its ability to channel the cosmos.

By the end of the 1960s it was becoming clear that these numerous experimental and conceptual uses of photography were gaining both momentum and credence within the international art world. A critical historical marker of the proliferation of photographic practices among artists can be found in an exhibition and editioned multiple entitled *Artists and Photographs*, organized by Multiples Gallery in New York in 1970. This boxed publication included work by nineteen artists, among them Mel Bochner, Jan Dibbets, Dan Graham, Douglas Huebler, Sol LeWitt, Richard Long, Bruce Nauman, Dennis Oppenheim, Edward Ruscha, Robert Smithson, and Andy Warhol. As Lawrence Alloway suggested in his introductory essay for this project (reprinted in this volume), while photography had been in the hands of artists since the nineteenth century, the exhibition and publication were trying to clarify "with a new intensity the uses of photography," which were becoming more and more diverse and ubiquitous at that time.

While Alloway would struggle to deal with the implications of the opposition that he was describing between an instrumental use of photography as documentation and a kind of photography that was to be considered an object of art in and of itself, he would never quite escape it. This problem would be dramatized by a number of works included in the *Artists and Photographs* multiple, such as Mel Bochner's aptly named photographic text piece

Misunderstandings: A Theory of Photography (1967–1970), reproduced in this volume. Bochner, who, like Nauman, began experimenting with photography in 1966, had originally compiled a list of quotations about photography as part of an article that he submitted to *Artforum* in 1969 under the title "Dead Ends and Vicious Circles." When the article was rejected for publication, Bochner brought together a number of these quotations to form his "theory of photography." Presented on note cards in a manila envelope, the nine photographs of handwritten quotes that constitute this work were derived from purported sources as wide-ranging as Marcel Duchamp, Mao Tse-tung, and the *Encyclopaedia Britannica*. The problem was, however, that three of these citations were fabrications by the artist (it is still unclear which ones) slipped like a virus into the discussion of the truth function of photographic representation. Was one of these false "misunderstandings" the assertion that "photography cannot record abstract ideas," which Bochner credited to the *Encyclopaedia Britannica*? Or perhaps the statement, attributed to Marcel

Giulio Paolini; *Delfo* (Delphi), 1965; photographic screenprint on canvas; 70⅞ x 35¹³⁄₁₆ in. (180 x 91 cm); collection Rosangela Cochran, Antigua, Guatemala

Proust, that "photography is the product of complete alienation"? One would like to think that the declaration ascribed to Marcel Duchamp might be true—"I would like to see photography make people despise painting until something else will make photography unbearable"— as that would make a fine contribution to our discussion of the last picture, but Bochner casts doubt on this statement just as he casts doubt on the medium of photography itself by presenting these photographs of possibly spurious statements as his theory of the medium.

Of course Bochner, Klein, Ruscha, Nauman, Paolini, and Polke were far from the only ones who picked up a camera at this point in time. The other artists included in *The Last Picture Show* continued to "misunderstand" this medium across a number of different categories of artistic endeavor, ranging from genres traditionally found in painting and photography, such as landscape and self-portraiture, to extremely contemporary investigations of the body and the world of media images.

A number of artists in the 1960s and 1970s, for example, employed photography in projects that sought to radically rework our understanding of the landscape. Jan Dibbets, Richard Long, and Giovanni Anselmo explored the cultural legacy of the landscape but adopted approaches that were far different from those found in the landscape photography of Ansel Adams or Edward Weston, with their invocation of a photographic sublime. Dibbets' understanding of the landscape, for example, was heavily informed by the history of Dutch painting, and all of his photographic works in one way or another explore the conventions of that genre. In *Horizon 1°–10° Land* (1973), he presented ten thin, vertical photographs of an abstracted horizon line of the notoriously flat Dutch landscape. Progressively tilting the image to an eventual pitch of ten degrees, Dibbets confounds our visual expectations and, in so doing, destabilizes our vision and undermines the fabricated and historically loaded conventions of our cultural depictions of the landscape. Richard Long, by contrast, produced photographic documents of ephemeral sculptural and performative acts that the artist enacted in and on the landscape. His impermanent interventions— which included cutting an X-shaped swath through a field of daisies and walking back

and forth across a field in a straight line until a visible path was worn in works such as *A Line Made By Walking, England* (1967)—gave a new meaning to William Henry Fox Talbot's description of photography as the "pencil of nature," as these actions themselves could be seen to be "writing" on the surface of the English countryside. Working concurrently in Italy, Anselmo would produce *Entrare nell'opera* (Entering the work, 1971), a photographic emulsion on canvas that depicts the artist taking another kind of walk through the landscape. In this case we are presented with a long-range view of the artist himself walking down the slopes of a volcanic mountainside in rural Italy. Anselmo's photograph is at once an existentialist statement about the isolation of the individual and an invocation of the geological forces of gravity and volcanism, as well as the physical energy that is continuously present in the natural world. As he suggested, "energy exists beneath the most varied of appearances and situations."[13]

Photography also became a tool in the 1960s and 1970s for a number of artists who began to make investigations and interventions into the built environment. If Anselmo was concerned with the natural forces of gravity, Robert Smithson would attempt in his sculptures and photographic works to capture the movement of another kind of energy—the transformative geological decay associated with "what the physicist calls 'entropy' or 'energy drain.'"[14] Whether turning his camera on the crumbling "monumental" industrial structures of suburban New Jersey in *Monuments of Passaic* (1967) or on the ongoing simultaneous disintegration and reconstruction of a small Mexican hotel in his slide lecture presentation *Hotel Palenque* (1969), Smithson would record the "ghostly photographic remains" of the slow movement of entropy in the man-made environment.[15] His friend and contemporary Gordon Matta-Clark would also engage the camera as an aesthetic accomplice in looking at another kind of ghostly remains. In his case, he would use photography to at once document and complete his "cutting" interventions into abandoned vernacular architectural forms in the urban environment. Described by Dan Graham as a "form of urban ecology," Matta-Clark's projects, such as *Splitting* (1974), provided a sculptural attempt at a critical social analysis of vernacular architectural forms as kinds of

"anti-monuments." His photographs of these ephemeral works were later recomposed into collages that took on a sculptural presence in and of themselves.

Architecture was an important critical concern at this time, as can be seen in Pamela Lee's essay in this volume, which addresses the dialectical relationship between the camera and architecture since the invention of photography. It was taken up in the 1960s as a subject by Bernd and Hilla Becher and Dan Graham, each of whom undertook photographic analyses of ubiquitous and banal architectural forms. While the Bechers focused on the disappearing vernacular architecture of the industrial landscape, photographing structures such as water towers, gas holders, grain elevators, and cooling towers, which they referred to as "anonymous sculptures," Dan Graham would point a somewhat more critical eye at the serial repetition of forms in American postwar suburban tract housing in *Homes for America* (1966–1967). Employing an amateur snapshot aesthetic, as opposed to the Bechers' more professional approach, Graham used his camera to call into question the repetitive nature of the architectural forms of American suburban housing, critically likening them to the serial nature of the "primary structures" of Minimalist sculpture. For Graham, both the New Jersey tract homes that he documented and Minimalist sculpture were products of a standardization that generated a particular kind of alienating effect in its disconnection from a grounding in the social. His photographic intervention tries to make these connections explicit.

While the Bechers and Graham focused on the formal and social analysis of the built environment, another group of artists working concurrently took another approach to the Minimalist aesthetics of the period by either constructing or documenting abstracted photographic geometries. In 1966 Mel Bochner took up photography to begin a series of Post-Minimalist investigations into the formal nature of the system of perspective. His abstracted photographic distortions of the grid—the central tool of Renaissance perspective—would refocus our attention on the system of perspective itself rather than employing perspective as a tool to represent the world. Sol LeWitt would similarly take on the legacy of the grid in his photo books, such as the aptly

named *Photogrids* (1978), in which he brought together hundreds of snapshots of readymade grids and gridlike structures in the everyday environment. The serial nature of these works belies their ability to tell a story through the narrative juxtaposition of abstracted forms taken from a variety of sources, including window screens, air vents, manhole covers, and mosaic treatments in Islamic architecture. A similar but more phenomenological analysis of Minimalist geometries in the built environment can be seen in the work of the Indian artist Nasreen Mohamedi, whose mid-1970s photographs of abstracted architectural forms around New Delhi trace the index of a peripatetic subject attempting to comprehend the formal complexity of urban space. As Geeta Kapur has suggested, Mohamedi's photographs instantiate a vision in which "the mobile body seeks to comprehend the urban environment."[16]

A number of artists in the 1960s and 1970s became increasingly interested in the profusion and growing power of photographic images in both our personal lives and the mass media. The influence of our cultural photographic archive can be seen in the work of Christian Boltanski and Hans-Peter Feldmann. In works such as *Les 62 membres du Club Mickey en 1955* (The 62 members of the Mickey Mouse Club in 1955) of 1972, which consists of arrangements of found snapshots of anonymous people, Boltanski took a less analytical approach to the archive by attributing a poetic melancholy of lost memory to the forgotten faces in family portraits and snapshots. Feldmann, by contrast—in his series of modest book editions begun in 1968, simply titled *Bild* or *Bilder* (Picture or Pictures) or in his collection of 1970s commercial posters *Sonntagsbilder* (Sunday pictures; 1976–1977)—brought together banal images found in the media—airplanes, shoes, chairs, women's knees, clothing, soccer players, landscapes—organizing them without commentary in a systematic format. His idiosyncratic archive drew on the wealth of everyday images that surround us. By culling photographs from the media environment and reorganizing them according to the logic of his own taxonomy, Feldmann reinvested them with a new kind of visual narrativity that allows viewers to read them in light of their personal histories.

Among the primary forces behind the profusion of multiple uses for photography in

this period were the strategies of conceptually inspired artists such as Victor Burgin, Douglas Huebler, Martha Rosler, and Allen Ruppersberg. In works such as Huebler's Variable Pieces, Burgin's *Performative/Narrative* (1971), Ruppersberg's *Seeing and Believing* (1972), and Rosler's *The Bowery in Two Inadequate Descriptive Systems* (1974), the artists explore the gap between the intelligibility of language and the certainty of visual perception. Ruppersberg's *Seeing and Believing*, for example, presents us with a paradox. Six snapshots of the exteriors of houses are mounted under a text that reads "seeing," while another six snapshots of the artist in a series of living rooms that may or may not be from those homes sit beneath a text that reads "believing." Are we to believe what we see? How adequate (or inadequate, as Rosler's title suggests) is the system of linguistic and visual representation? Each of these works, in its own way, casts doubt on the transparency of this confluence of language and images.

Staged photography—what the critic A. D. Coleman referred to in 1976 as photography's "directorial mode"—became an important tool for a number of artists who sought to compose their very own theaters of the absurd.[17] In the photographic work of Bas Jan Ader, Peter Fischli and David Weiss, Ger Van Elk, and William Wegman, photography was used to construct humor-laden scenarios that are at once fantastic and illogical. Ader's comedic attempt to use his prone body to compose a Mondrian painting in his work *On the Road to Neo Plasticism, Westkapelle, Holland* (1971) and Van Elk's equally strange "documentation" of the emergence of a school of sardines from the cracks in the pavement of a highway in *The Discovery of the Sardines, Placerita Canyon, Newhall, California* (1971) both point to an increasingly common use of set-up or staged photography for theatrical ends. Wegman's early photographic scenarios included similar investigations of perceptual nonsequiturs that were often as intellectually challenging as they were humorous. In *Crow* (1970), a taxidermic parrot casts a strangely inappropriate shadow, while another photograph depicts a piece of heavy steel leaning against the wall with the appended caption "to hide his deformity he wore special clothing." Later in the decade, this technique would find its way into the work of the Swiss duo Fischli and Weiss, whose first

collaborative work, Wurstserie (Sausage series, 1979), would present ten "dramatic" tableaux enacted by sausages and lunch-meats. Engaging a childlike sense of play and wonder, these scenarios often turn dark, as in the depiction of the collision of two "sausagemobiles" in *Der Unfall* (The accident). As in Nauman's Eleven Color Photographs, the humor that suffuses these works, while undermining the self-importance of much contemporary art of the time, belies a critical engagement with issues of language and visual perception.

The body has been a primary subject for photography since its invention in the early nineteenth century. As we have already seen in the work of Klein and Nauman, the 1960s and 1970s saw the emergence of a wide variety of artistic practices that reasserted the primacy of embodiment in performative works that were often done solely in front of the camera. Vito Acconci, one of the primary innovators in this field, completed an important series of photographic works between 1969 and 1970 that explored a series of perceptual and phenomenological tasks that the artist assigned himself as a way of physically embodying vision and exploring the world around him. Setting himself tasks such as "jumping, holding camera: 5 broad jumps along country path—at the end of each jump, snap shutter as I hit ground," Acconci would literally throw himself into his environment and record the physical perception of that movement with a photograph. As he suggested, "They were photos not of an activity but through an activity; the activity . . . could produce a picture."[18]

Other artists working at the time—such as Charles Ray, Valie Export, and Bruce Conner—also used their own bodies to undertake photographic experiments in their studios or the environment. In Ray's *Plank Piece I–II* (1973), Export's Körperkonfiguration (Body configuration) series, or Conner's ANGEL (1975), the artist's body takes center stage in an arena normally reserved for more traditional materials. This expanded sense of sculptural practice, with the body at its center, is also articulated in the earliest photographic works of Gilbert & George. In the series Any Port in a Storm, for example, the artists turned the camera on themselves to construct sculptural photographic documents of distorted states of being, as in their works *Staggering*, *Smashed*, or *Falling*, all of 1972,

each of which was related to an altered perceptual or physical state.

At the same time that Gilbert & George declared all of their work to be sculpture—including their performances, which they called "living sculptures"—the physical substance of the body, as a subject and an artistic material, would also become a favored topic of a wide range of artists who interrogated both aesthetic and social issues regarding the status of gender. Eleanor Antin's *Carving: A Traditional Sculpture* (1972), for example, can be read as an early entry into this discussion. The 148 black-and-white photographs that make up this work document the artist's weight loss over a thirty-six-day period. Installed in a grid format with multiple views of the artist's naked body from the front, back, and sides, Antin's work questions not only the objectified status of women in a patriarchal culture but also the conventional notion of sculpture itself.

The use of the artist's body in the photographic practice of the time was closely related to another use of self-portraiture in the service of the interrogation of identity. Works such as Hannah Wilke's *S.O.S.—Starification Object Series* (1974–1982), Ana Mendieta's *Untitled (Facial Cosmetic Variations)* (1972), and Adrian Piper's *Mythic Being: I/You (Her)* (1974) would also use the camera to explore issues of gender and racial identity. In Piper's case, for example, the artist hand-altered a series of black-and-white photographic self-portraits of herself with a white woman, transforming her image through drawing into that of an African American man with exaggerated features. Piper would also add a continuous written monologue onto the surface of the photographic image that details the deterioration of the relationship between these two figures, raising questions about our perceptions of the politics of ethnic difference.

Piper's "mythic being" was one among many personas that artists at this moment would adopt in order to pose a wide-ranging set of questions about identity. This strategy of self-portraiture was referred to by many critics as masquerade. David Lamelas' *Rock Star (Character Appropriation)* (1974) presented an early example of this approach. In this series of ten photographs Lamelas transformed himself into a cultural icon in a kind of photographic elaboration of boyhood air guitar fantasies. Cindy Sherman is perhaps the best known of the artists who have turned to this device in their work. She would follow Lamelas and Piper with her Untitled Film Stills (1977–1980), which ambivalently depicted the artist in a series of stereotypical female roles, ranging from the femme fatale to the ingenue, derived from the history of Hollywood cinema. The act of personal transformation, as the artist moves from one fragmented narrative scenario to the next, can also be seen at work in the Polaroid self-portraits of Andy Warhol dressed in drag, from around 1981. These images descend in a direct line from the early Man Ray portrait of Marcel Duchamp dressed as his alter ego Rrose Sélavy. In each of these cases, the camera becomes a transformational apparatus that allows the artist to respond to the various mediated images of identity that bombard us in contemporary consumer culture.

In 1976, even as Nancy Foote's provocative elaboration of "anti-photography" was giving a name to fifteen years of wide-ranging alternative uses of photography, the argument had shifted once again as a new generation of artists began building on the ground cleared by the photographic practices of Nauman, Ruscha, and others. In 1977 this shift would become visible in an exhibition entitled *Pictures*, which was organized by the art historian and critic Douglas Crimp for Artists Space in New York. Including the work of Troy Brauntauch, Jack Goldstein, Sherrie Levine, Robert Longo, and Phillip Smith, *Pictures* would signal the recognition of the influence of a virulent media culture not just on photographic practice but on painting and sculpture as well. Crimp's curatorial statement for this exhibition offered a telling assessment of the shifting cultural sands of the late 1970s:

> To an ever greater extent our experience is governed by pictures, pictures in newspapers and magazines, on television and in the cinema. Next to these pictures firsthand experience begins to retreat, to seem more and more trivial. While it once seemed that pictures had the function of interpreting reality, it now seems that they have usurped it. It therefore becomes imperative to understand the picture itself, not in order to uncover a lost reality, but to determine how a picture becomes a signifying structure of its own accord.[19]

The image world to which Crimp alluded was foreshadowed in the writings of Walter Benjamin and Siegfried Kracauer in the 1920s and 1930s and later those of Marshall McLuhan in the 1960s. It was at the very moment that Crimp was writing, however, that intellectuals such as Jean Baudrillard began theorizing in publications such as *Simulations* (1983) what he would term the

Cindy Sherman, *Untitled Film Still #56*, 1980 (cat. no. 157)

world of the "simulacrum," where the image no longer corresponds to reality but becomes a kind of reality in and of itself.[20] The generation of artists that Crimp was pointing to was interested in unpacking the structural mechanics of this world of simulation and of the picture itself. How was it possible to operate in a world where the image had lost its truth function and reality had morphed into illusion without the minimal courtesy of an acknowledgment? This question was hardly a new one, as even a cursory reading of Plato's *Republic*, with its skeptical attitude toward the shadows of representation, might suggest, but it nonetheless presented itself in a newly intensified manner in the late 1970s.

Crimp was one of a number of authors, including Abigail Solomon-Godeau and Hal Foster, who would become leading critical voices in the attempt to elaborate what would come to be called "postmodern culture." In his 1984 essay "The Photographic Activity of Postmodernism," (reprinted in this volume) Crimp would argue that our new relationship to pictures challenges "photography's claims to originality, showing those claims for the fiction that they are, showing photography to be always a representation, always-already-seen." He then went on to point out that the artists that he was discussing—Sherrie Levine, Cindy Sherman, and Richard Prince—practiced a kind of image theft in their work which would come to be known as appropriation.

"Their images are purloined, *stolen*. In their work, the original cannot be located, it is always deferred; even the self which might have generated an original is shown to be itself a copy." While the debates around the question of postmodernism raged throughout the 1980s and into the early 1990s—raising doubts about its significance, desirability, and character—it became clear that a new cultural situation had emerged, to which artists were clearly responding with new aesthetic strategies.

Theoretical debates aside, this newly defined world of pictures would become the focal point for a wide range of artists, including Sarah Charlesworth, Barbara Kruger, Sherrie Levine, Richard Prince, Cindy Sherman, Laurie Simmons, and James Welling. What bound many of these artists together (albeit loosely) was the strategy of appropriation—the "purloined" or "stolen" images that Crimp identified as the defining characteristic of postmodern photographic activity. The choice of borrowing images from the media in the late 1970s was, however, hardly a revolutionary aesthetic technique, owing an enormous debt to avant-garde practitioners of the 1920s and 1930s, including John Heartfield and even Marcel Duchamp. It was also impossible to overlook the impact of the work of Robert Rauschenberg and particu-

larly Andy Warhol or even the graphic provocateurs of the Situationist movement of the 1960s. These younger artists practicing what might be loosely called appropriation owed a more direct debt to the influential photographic work of John Baldessari, who even in the late 1960s began to presage the coming of the so-called Pictures artists in the mid-1970s. In works such as *A Movie: Directional Piece Where People Are Looking* (1972–1973), Baldessari borrowed images from the history of film, rearranging them and re-presenting them in order to disrupt and challenge our received notions of the syntax of narrative cinema.

Baldessari's use of appropriation would set the stage for a number of younger artists in the 1970s and 1980s who would come to develop these strategies for other ends. Sherrie Levine would make a head-on assault on the male-dominated canon of art history by provocatively rephotographing the works of famous male artists such as Edward Weston, Egon Schiele, and Aleksandr Rodchenko and presenting these images as her own. In the fall of 1981, for example, Levine would mount an exhibition at Metro Pictures in New York in which she would display After Walker Evans (1981), a suite of twenty-two rephotographed images of some of the most famous works of the

Sherrie Levine; *After Walker Evans: 17*, 1981 (under cat. no. 85)

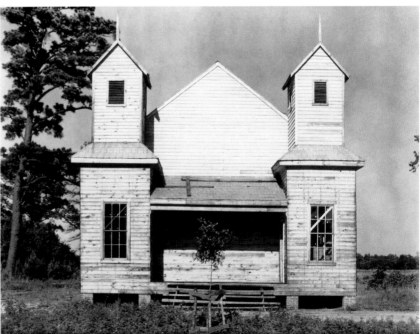

Man Ray; *Marcel Duchamp as Rrose Sélavy*, c. 1920–1921; gelatin silver print; 8½ x 6¹³/₁₆ in. (21.6 x 17.3 cm); Philadelphia Museum of Art: The Samuel S. White 3rd and Vera White Collection, 1957

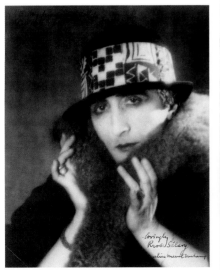

American photographer. Levine took this portfolio of photographs from Evans' contribution to his 1939 book with the writer James Agee, *Let Us Now Praise Famous Men*, a classic example of the social documentary journalism commissioned by the Farm Security Administration during the Great Depression. On one level, Levine's simple Duchampian gesture of appropriation presented an ardent attempt to disrupt the liturgical flow of the modernist story of art history, with its focus on the heroic achievements of male artists, by raising questions of authorship, originality, and attribution. On another level, her act of appropriation was not so much a negation as a strange kind of homage to her subjects. Her rephotographed works were, as she explained, "in some sense two photographs—a photograph on top of a photograph," which helped her "create a metaphor by layering two images, instead of putting them side by side."[21] It is the doubling effect produced in these works, their creation of doppelgangers of well-known images, that has given them the power to disturb our sense of order while also opening them up for another kind of interpretive cathexis.

Even before Sherrie Levine turned her attention to the world of art history for source material, Richard Prince had trained his camera on images from the realm of advertising. In 1977 he rephotographed a series of four commercial images of luxuri-

ant living room ensembles that had originally been published in the *New York Times Magazine* and presented them as his own, without their accompanying texts. Other images would soon come into his field of vision, including highly polished commercial depictions of luxury products such as watches and pens or the consumerist fantasy scenarios inhabited by male and female models. In works such as *Untitled (three men looking in the same direction)* (1978), Prince's repeated acts of serial appropriation produced a destabilizing effect on the content of the images—what he referred to as a kind of "social science fiction"—and offered a somewhat ambivalent commentary on the circulatory system of the media, with its inundating flow of fictional images. Who were these people? What were these worlds that they inhabited? These are the questions that present themselves when looking at Prince's images.

Through its appropriative procedures, Prince's work, like that of Levine, would similarly produce a doubling of the representation and the real that was seen as a crucial aspect of so-called postmodern photographic practice. He would comment on this aspect of his work, suggesting that these photographs might be more real than real, a corollary to the slogan "more human than human," proffered by the "replicant" manufacturer Tyrel Corporation in Ridley Scott's 1982 film *Blade Runner*:

By generating what appears to be a double, it might be possible to represent what the original photograph or picture *imagined*. . . . More technological than mechanical, more a simulation than an expression, the result is a photograph that's *the closest thing to the real thing*. And since I feel a bit more comfortable, perhaps more reassured around a picture that appears to be truer than it really is, I find the best way for me to make it real is to make it again, and making it again is enough for me and certainly, personally speaking, almost me.[22]

Perhaps then we are the Marlboro men of Prince's untitled series of cowboys from the early 1980s, liberated from our captivity in the world of consumer images. The "almost me" of Prince's practice suggests a different kind of vision of America than that proffered by Walker Evans, as it is on one level resolutely in denial of the humanist intentions of that earlier body of documentary photography. Nonetheless, Prince's doubling of the real world evokes another vision of photography—that of Bochner's "misunderstandings," with their implicit distrust of the truth function of the medium. This was the landscape that photography inhabited in 1982.

We began this story in 1960 in France, the purported site of photography's invention, with a literally incredible leap into the void. We end it a continent away, in America, with the confluence of two pirated pictures of the American dream: Levine's vision of Walker Evans' America, on the one hand, and Prince's overwrought images of consumption brought to us by the likes of Philip Morris, on the other. One might think from looking at their works that these artists are the ultimate purveyors of the last picture, as they offer us the photographic spoils of a world saturated with images. Looking at Levine's version of Evans' photograph of Annie Mae Gudger or Prince's rephotographed "gang" of fashion models, it is not hard to imagine precisely why Smithson suggested that the power of the camera was "abominable" or even why he would go on to contend that a camera shop would make a good setting for a horror movie. Presumably, photography's boundless ability to replicate the world was at the center of his anxiety.

But perhaps Smithson's discomfort was misplaced. In the end, are Prince and Levine any more "guilty" of appropriation than, say, Walker Evans? Isn't appropriat-

Richard Prince; *Untitled (Cowboy)*, 1980–1984; Ektacolor print; 50 x 70 in. (127 x 177.8 cm); courtesy Barbara Gladstone Gallery

ing the world what the camera does best? In effect, each of these artists has presented a portrait of America—Evans, a group of sharecroppers; Levine, a series of "still-life" photographs of the book plate reproductions of Evans' images; Prince, a fictional landscape composed of our collective dreams of the consumer image world. The conceptual gap separating these snapshots of America seems much smaller today than it might have in 1960. Evans himself "rephotographed" commercial signage and roadside billboards throughout his career and is often credited with inspiring the development of Pop Art in the 1960s. This convergence makes one start to think that the last picture might not have come yet, let alone the last picture show, which today seems like a distant dream.

By the early 1980s this so-called abominable power of the camera had come full circle to critically engage in a provocative cultural image cannibalism that was far removed from the canonical "decisive moments" of twentieth-century art photography in its modernist incarnation. The irony, however, is that Levine and Prince might be seen to be practicing a straighter kind of photography than modernist "straight photography" itself. Of course, the subject of Levine's and Prince's straight photography is the world of pictures.

It is here then that the last picture comes back into the frame of the first picture and Nancy Foote's "anti-photographers" simply become artists using the camera. *The Last Picture Show* traces this movement through two decades of artistic practice that encouraged provocative experimentation with and through the medium of photography, providing something of an answer to Smithson's anxiety. Far from offering us a photographic apocalypse, the artists represented in this exhibition instead reinvigorated photography, clearing ground for subsequent artists who would explore the medium. In the twenty years that have passed since the last work in this exhibition was produced, two or three generations have profited from these conceptual engagements with the medium. Taking up the camera as one tool among others, these younger artists have attempted to respond to Louise Lawler's question "Why pictures now?" The legacy of the artists whose work appears in *The Last Picture Show* has enabled them to proffer a simple answer: "Why not?"

Notes

1. Henri Cartier-Bresson, *The Decisive Moment* (New York: Simon & Schuster, 1952), unpaginated.
2. John Szarkowski, *The Photographer's Eye* (New York: Museum of Modern Art, 1966), 4.
3. Lucy Lippard and John Chandler, "The Dematerialization of Art," in *Conceptual Art: A Critical Anthology*, ed. Alexander Alberro and Blake Stimson (Cambridge: MIT Press, 1999), 46. Originally published in *Art International* 12 (February 1968): 31–36.
4. Rosalind Krauss, "Sculpture in the Expanded Field," in *The Anti-Aesthetic: Essays on Postmodern Culture*, ed. Hal Foster (Seattle: Bay Press, 1983), 31–42.
5. See Michel Foucault, *Discipline and Punish: The Birth of the Prison*, trans. Alan Sheridan (New York: Vintage, 1977).
6. In 1937 Man Ray published a portfolio of twelve of his photographs with an introduction by André Breton under the title *Photography Is Not Art*. See Arturo Schwarz, *Man Ray: The Rigour of Imagination* (New York: Rizzoli, 1977), 14.
7. Cited ibid., 12.
8. See Neal Benezra, "Surveying Nauman," in *Bruce Nauman* (Minneapolis: Walker Art Center, 1994), 24.
9. Coosje van Bruggen, *Bruce Nauman* (New York: Rizzoli, 1988), 14.
10. Willoughby Sharp, "Nauman Interview," *Arts Magazine* 44 (March 1970): 2.
11. Walter Benjamin, "The Work of Art in the Age of Mechanical Reproduction," in *Illuminations*, ed. Hannah Arendt, trans. Harry Zohn (New York: Schocken, 1968), 217–251.
12. Paul Schimmel, "Polkography," in *Sigmar Polke Photoworks: When Pictures Vanish*, exh. cat. (Los Angeles: Museum of Contemporary Art, 1995), 61.
13. Giovanni Anselmo, "I, The World, Things, Life," in Germano Celant, *Art Povera* (New York: Praeger, 1969), 109.
14. Robert Smithson, "Entropy and the New Monuments," *Artforum* 4 (June 1966); reprinted in Jack Flam, ed., *Robert Smithson: The Collected Writings* (Berkeley: University of California Press, 1996), 10–11.
15. Robert Smithson, "Incidents of Mirror-Travel in the Yucatan," *Artforum* 8 (September 1969): 31.
16. Geeta Kapur, *When Was Modernism?* (New Delhi: Tulika Books, 2000), 78.
17. A. D. Coleman, "The Directorial Mode: Notes toward a Definition," *Artforum* 15 (September 1976): 55–61.
18. Vito Acconci, "Notes on My Photographs, 1969–1970," in *Vito Acconci: Photographic Works, 1969–1970*, exh. cat. (New York: Brooke Alexander, 1988), unpaginated.
19. Douglas Crimp, "Pictures," in *Pictures*, exh. cat. (New York: Artists Space, 1977), 3, as cited in Anne Rorimer, "Photography/Language/Context: Prelude to the 1980s," in *A Forest of Signs*, exh. cat. (Los Angeles: Museum of Contemporary Art, 1989), 151.
20. See Jean Baudrillard, *Simulations* (New York: Semiotexte, 1983).
21. Sherrie Levine, in Jeanne Siegel, "The Anxiety of Influence—Head On: A Conversation between Sherrie Levine and Jeanne Siegel," in *Sherrie Levine*, exh. cat. (Zurich: Kunsthalle Zürich, 1991), 15.
22. Richard Prince, "The Closest Thing to the Real Thing" (1982), cited in Lisa Phillips, *Richard Prince*, exh. cat. (New York: Whitney Museum of American Art, 1992), 28.

Louise Lawler, *Why Pictures Now*, 1981 (cat. no. 78)

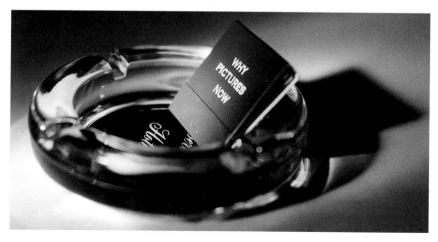

Lawrence Alloway

Artists and Photographs (1970)

Originally published in *Artists and Photographs* (New York: Multiples Inc., 1970); reprinted in *Studio International* 179 (April 1970): 162–164. *Artists and Photographs* contains an exhibition catalogue with text by Lawrence Alloway and nineteen works by different artists.

At least since Delacroix, when the camera provided a modern technique for getting direct images of the world (*Journal*, May 21, 1853), photographs have been in the hands of artists. They were, as Delacroix saw, images of the world unmediated by the conventions of painting; these were followed, later in the 19th century, by the wide distribution of works of art by photographic reproductions. This was defined by Walter Benjamin in Marxist terms in the 20s and celebrated later by Andre Malraux in terms of the camera's autonomous pictorial values. In the 20s, collages and photomontage, new works of art produced by photography, were abundant.

The present exhibition/catalogue clarifies with a new intensity the uses of photography, in a spectrum that ranges from documentation to newly-minted works. Some photographs are the evidence of absent works of art, other photographs constitute themselves works of art, and still others serve as documents of documents. This last area was the subject of an exhibition at the Kunsthalle, Bern, last year, *Plans and projects as art*, a survey of diagrams, proposals, propositions, programs, and signs of signs. Bernar Venet's book which is a profile of his "exploited" documents since 1966 demonstrates this possibility. The different usages are immense: for example, Douglas Huebler documents place not duration, whereas Dennis Oppenheim's piece is sequential, a chart of time-changes. One thing everybody has in common should be noted: there is an anti-expertise, anti-glamorous quality about all the photographs here. Their factual appearance is maintained through even the most problematic relationships.

One of the uses of photography is to provide the coordinates of absent works of art.

Earthworks, for example, such as Robert Smithson's, can sometimes be experienced on the spot, but not for long and not by many people. Documentation distributes and makes consultable the work of art that is inaccessible, in a desert, say, or ephemeral, made of flowers. The photographic record is evidential, but it is not a reproduction in the sense that a compact painting or a solid object can be reproduced as a legible unit. The documentary photograph is grounds for believing that something happened.

Photographs used as coordinates, or as echoes, soundings that enable us to deduce distant or past events and objects, are not the same as works of art in their operation. Max Bense has divided art and photography like this: "the esthetic process in painting is directed towards creation: the esthetic process of photography has to do with transmission." "Painting reveals itself more strongly as a 'source' art, and photography more strongly as a 'channel' art."[1] Dennis Oppenheim classifies photographic documentation as a "secondary statement . . . after the fact,"[2] the fact being, of course, the work out in the field. He feels restricted because "the photograph gives constant reference to the rectangle. This forces any idea into the confines of pictorial illusionism." However, the distinction between source art and channel art enables us to disregard the four edges as a design factor; the area of the photograph is simply the size of the sample of information transmitted, a glimpse. Common to both the absent original and to the photographic record is phototopic or day vision, with light as the medium of perception on the site and in the record. The works are, after all, photographable.

There is the possibility that documents, as accumulating at present, may acquire the preciousness that we associate with, say, limited edition graphics. The development of Earthwork or Street Events is resistant to the possession of art as usually understood and photography resists becoming personal property by its potentially endless reproduction. The fact that photographs are multiple originals, not unique originals, as well as one's sense of them as evidence rather than as source objects, should protect their authenticity ultimately. In the present instance, in *Artists & Photographs*, the contents of the catalogue are variants of the items in the exhibition, not repro-

ductions. Both the exhibited "object" and the catalogue "entry" are permutations made possible by the repeatability of the photographic process.

Michael Heizer has discussed the role of photography in relation to his own work. Of a work in Nevada he writes: "it is being photographed throughout its disintegration."[3] The run of photographs records the return of probability to his initial interruption of the landscape. He points out that photographs are like drawings, as the basic graphic form of his big works in the landscape is recovered in aerial photography which shows the earth's surface as an inscribed plane. Related to the concise graphism of photographs is the camera's effectiveness as an image-maker. Heizer's own bleak landscapes, like excavation sites, Smithson's photographing of mirrors in a pattern in landscapes to make a compound play of reference levels, and Richard Long's walks in the country with regular stops for documentation with a camera (of the view, not of the walker) presuppose a photographic step in the work process. As Oppenheim has said: "communication outside the system of the work will take the form of photographic documentation. . . . "[4]

Other artists in this exhibition/catalogue use the camera as a tool with which to initiate ideas rather than to amplify or record them. Edward Ruscha is represented by *Baby Cakes*, one of the factual series of photographs which began as early as 1962 with his book *Twentysix Gasoline Stations*. This book like his later ones, is neither sociological (the sample of subjects is arbitrary) nor formalistic (the imagery is casual), but it is a concordance of decisions, unmistakably esthetic, for all their deadpan candour, in the absence of other purposes. Similarly Bruce Nauman's photographs of the air (sky?) over Los Angeles solidifies the channel functions of photography into a source art. In such works the photographs are themselves an object, an original structure projected by the artist. The information that Nauman's photographs carry cannot be decoded as news of weather or pollution or as a lack of unidentified flying objects. (The information that Nauman's *LAAIR* does not carry, though it looks as if it might, is different from Marcel Duchamp's *Air de Paris*, 1919. That sample of the atmosphere is contained in a sealed glass ampule, of which one would

have to say, this is *not* a piece of laboratory equipment, etc. The artists in both cases work against the reduction of the photograph or the object to a channel function.)

Michael Kirby takes "clarity as the only conscious standard" in both shooting and developing his photographs, but the result is not record but source. In *Pont Neuf* he uses six photographs, taken from one point, to provide views of the surrounding space: the work can, as it were, be inferred backwards to the converging point. Jan Dibbets' work is inconceivable without monocular vision (that is, a camera); his "perspective corrections," whether constructions built in a field or areas ploughed on a beach, demand one absolute viewpoint to be effective. Only from that one point can his inversion of distance give the appearance of flat squares and posts of identical size. "Misunderstandings," an anthology of quotations found by Mel Bochner (his contribution to the catalogue), includes this: "Photography cannot record abstract ideas," but his piece in the exhibition ironically and defiantly is concerned with measurement (i.e. a form of abstraction).

The artistic ideas and operations that need photographic documentation are especially those that are modified in time. Time, in fact, is central to photography. In the case of Christo there is data on the wrapping of a tower, some of it prospective (dia-grammatic or simulated) and some of it memorial; the work process is arrested at different points in time. Sol LeWitt's *Muybridge III* takes a classic image of motion (successive views of a walking nude) and encloses it to be viewed directionally. Dan Graham's work alludes to Muybridge's measured walking images, but here it is the walkers who take relational photographs of one another. The slides are then projected quickly on two screens, compressing the original time sequence. Robert Morris' piece is a record of a "continuous project (altered daily)." Only by photography can the temporal route of a work of art be recorded in terms homologous to the original events. It should be stressed that it is not a question of memorializing a favorite state, catching the work's best profile, but of following the process.

These artists occupy various points in a zone that includes Conceptual art, Earthworks, Happenings. Conceptual art, to the extent that it is to be thought about, or repeated, or enacted by others, insists on documentation systems *originated by the artist himself*. This is no less true of performance arts, such as Happenings or Events, which survive verbally as scenarios or schedules and visually as photographs. The record of one of Allan Kaprow's Happenings is a form of completion. It is necessary to differentiate these uses of photographs by artists from other approaches. The present title *Artists & Photographs* has a verbal echo of, for instance, *The Painter and the Photograph* (University of New Mexico, 1964) which is a study of photography as a transmitter of information for the use of figurative painters.[5] *The Photographic Image* (Solomon R. Guggenheim Museum, 1966) was divided between artists who imprinted photographs in paintings or who copied photographs, less as an aid to illusion than as a play with the channel characteristics of the medium. (In the work of Richard Artschwager, Malcolm Morley, and Joseph Raffael the subject is frequently the photograph itself rather than what the photograph depicts.) *Paintings from the Photo* (Riverside Museum, 1969–70) combined both realist and post-Pop usages.

A Note on Process Abbreviation

Abstract painting has many ways of achieving the 20th century dream of an instant, unrevised, all-at-once art form. There has been a steady sequence of process-abbreviation, compressing and reducing in number the stages that go to make up a work of art. Staining and high-speed calligraphy, for instance, have a directness to which figurative art has little access. One of the few ways is in the use of photographic images printed on silkscreens; not only is there an immediate delivery of a grainy, convincing image to the canvas, as the screen is pressed down and painted on the back, but the screen can be used again. Both technique and image are immediate. If "a print is the widow of the stone," to quote Robert Rauschenberg,[6] then a photograph is the twin of an event. Andy Warhol's method is the repetition of the single image within each work, varying it by nonchalant registering and impatient inking; Rauschenberg's way is to cluster different screens in each work, repeating them only in other works.

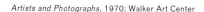

Artists and Photographs, 1970; Walker Art Center

Notes
1. *Camera*, 4, 1958.
2. Letter to Multiples, 1969.
3. *Artforum*, December, 1969.
4. *Land Art*, Fernsehgalerie, Berlin, 1969.
5. The catalogue includes a history of artists using photos by Van Deren Coke.
6. *Studio International*, December, 1969. Rauschenberg is referring to lithography, but in terms of assimilating photographic impressions the medium resembles silkscreen printing.

A. D. Coleman

"I'm Not Really a Photographer" (1972)

Originally published in the New York Times, *September 10, 1972.*

"It's a playground, is all it is," says Ed Ruscha. "Photography's just a playground for me. I'm not a photographer at all."

Despite this disclaimer, Ruscha's fourteen small books of photographs have found much of their audience among people interested in contemporary photography. They were among the first of the new wave of privately published photography books; they also pioneered in the use of photography as a basic tool of conceptual art. Quite aside from their historical signif- icance, these books have a consistency and a charmingly mystifying ambiguity which results from their very literalness. They seem—at this admittedly early stage— to be remarkably durable works, Ruscha's fear of their eventual "quaintness" notwithstanding.

Ruscha indicates that he began working with photographs out of "a combination of desires." One was to, first of all, make a book. "I wanted to make a book of some kind. And at the same time, I—my whole attitude about everything came out in this one phrase that I made up for myself, which was 'twenty-six gasoline stations.' I worked on that in my mind for a long time and I knew that title before the book had even come about. And then, paradox- ically, the idea of the photographs of the gas stations came around, so it's an idea first—and then I kind of worked it down. It went hand in hand with what I felt about traveling. . . .

"I just barely got my feet wet with gas sta- tions," he continues. "Then I just had a lot of other things come out. Fires have been a part of my work before too, I've painted pictures of fire, and there've been little things about fire in my life—not an experi- ence, not in a negative way, there's been no catastrophe as far as fire goes, but the image of fire has always been strong in my

work and so it just culminated in this little book here [*Various Small Fires*, which contains sixteen images—burning pipes, cigars, cigarettes, a flare, a cigarette lighter aflame]. It's probably one of the strangest books—it kind of stands apart, a lot of peo- ple have even mentioned to me about how it stands apart from the others because it's more introverted, I guess; introverted, less appealing, probably more *meaningless* than any of the other books, if you know what I mean."

I mention finding, in a Fourth Avenue used-book store, a copy of a catalog from one of his exhibitions, the cover of which

was charred by fire. "Charred by fire?" Ruscha laughs. "Everything gets its due, right? Bruce Nauman took a copy of *Various Small Fires* and burned it cere- moniously, took a picture of each page, and made a big book out of it, which is an extension of that. I think he liked *Various Small Fires*.

"Some of them look like *capers*," Ruscha adds. "Like *Business Cards* looks like a caper, which it is . . ." Or *Crackers*?

"*Crackers* is a caper; *Sunset Strip* is a *visual* caper; *Royal Road Test*, yeah . . . " This is a significant distinction, especially in light

Edward Ruscha with his books, c. 1969; courtesy Gagosian Gallery, Los Angeles

of the slight note of dissatisfaction which Ruscha applies to the term "caper." All four of these books hinge on something other than the images themselves, being thus more specific and conceptually limited (though also, perhaps, more accessible) than the rest. *Sunset Strip* depends on its accordion-fold format and the inclusion of every building on the Strip; the other three are tied to staged events.

Royal Road Test documents the results of heaving a Royal typewriter out the window of a 1963 Buick Le Sabre traveling at ninety miles per hour; it stars Ruscha himself as Driver and singer-songwriter-humorist Mason Williams as Thrower. Williams wrote the story on which *Crackers*—an improbable and somewhat misogynistic narrative in stills—is based. (Ruscha, working on a Guggenheim Fellowship, recently turned this into a movie titled *Premium*.) And *Business Cards* records a business card exchange between Ruscha and Billy Al Bengston and a presentation dinner in celebration thereof.

The latter book is also one of the two signed editions Ruscha has published, a practice from which he has since veered away. "I decided I don't want anything like that. I just want to get the book out. And the books will compete with any other books on the paperback market; they'll just be my style of books, you know? . . . Most of my books should be of unlimited quantity. I don't want people to come up to me and say, 'Boy, I'm going to save this because some day it's going to be a work of art.' That's not it—you missed it . . . "

Ruscha, who feels that he's "just scratching the surface" with his books so far, indicates that "It's not only photography that interests me, it's the whole production of the books . . . I just use that thing [the camera—he works with a Yashica, by the way], I just pick it up like an axe when I've got to chop down a tree, I pick up a camera and go out and shoot the pictures that I have to shoot. I never take pictures just for the taking of pictures; I'm not interested in that at all. I'm not intrigued *that* much with the medium . . . I want the end product; that's what I'm really interested in. It's strictly a medium to use or to not use, and I use it only when I have to. I use it to do a job, which is to make a book. I could never go through all my photographs I've taken of different things and make a book out of it."

Do you mean, I ask, that you can't conceive of a *Greatest Hits of Ed Ruscha*, with two parking lots and one swimming pool and three palm trees? "Well, no, I wouldn't say that . . . " He laughs.

Having run out of questions and tape, we begin to pack up. Ruscha answers a knock at his door and admits Billy Al Bengston, resplendent in a bright red hat, looking—somewhat studiedly—like a refugee from an Al Capp panel. Ruscha gives Bengston a box of trout flies, a belated Christmas gift. Then he inquires as to whether I like anchovies and, upon receiving an affirmative response, gives me two tubes of anchovy paste and two cans of rolled filets of anchovy with capers. He explains that he hates anchovies, and had used a number of these same tins and tubes to surround a present for his wife, who despises them equally.

I accept the anchovies and ask Bengston if he considers Ruscha to be a photographer. "Oh, sure," Bengston replies. "He's a fine photographer. Ed's made pictures that don't look like anyone else's I've ever seen." He flashes an evil grin, and chortles.

Of those anchovies, one tube of paste has been sent to Van Deren Coke, author of *The Painter and the Photograph*, for his collection; one can of rolled filets has been sent to Peter Bunnell as a contribution to the collection of Princeton University. The second can of filets has been reserved for personal consumption at some future date, and the second tube is in the brown paper bag Ruscha offered them in, sitting in a cabinet outside my workroom, marked "Gift of Ed Ruscha."

Now isn't it nice to know these things?

Nancy Foote

The Anti-Photographers (1976)

Originally published in *Artforum* 15 (September 1976): 46–54.

The distinction between art and photography, historically fraught with anxieties, has ceased to be one of definition; nevertheless, it continues to bug us. Though the postmodernist revolution has (as in many other disciplines) eradicated traditional boundaries and brought about a tremendous increase in "esthetic mobility,"

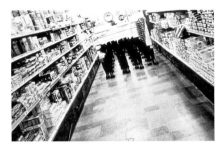

Eleanor Antin; *100 Boots in the Market*, 1971; black-and-white picture postcard; 4½ x 7 in. (11.4 x 17.8 cm); courtesy Ronald Feldman Fine Arts, New York

Eleanor Antin; *100 Boots Parking*, 1971; black-and-white picture postcard; 4½ x 7 in. (11.4 x 17.8 cm); courtesy Ronald Feldman Fine Arts, New York

Eleanor Antin; *100 Boots on the Road*, 1971; black-and-white picture postcard; 4½ x 7 in. (11.4 x 17.8 cm); courtesy Ronald Feldman Fine Arts, New York

photography's status in the art world remains problematic. For every photographer who clamors to make it as an artist, there is an artist running a grave risk of turning into a photographer. The level of absurdity to which such maneuvering can descend is exemplified, perhaps, by the importance placed on the image of the surroundings in which one exhibits. A gallery's reputation often has as much to do with sealing the fate of a work as does the character of the art itself. Nowhere are such hierarchies more clearly visible than at the galleries Castelli, where photographs are shown Downstairs Uptown, with the prints, but very much Upstairs Downtown (in the front parlor, that is)—if they come properly introduced as conceptual art.

Oddly enough, conceptual art has never been plagued with accusations that it belongs on photography's side of the tracks, yet the condition in which much of it could or would exist without photography is open to question. Photographs are crucial to the exposure (if not to the making) of practically every manifestation of conceptual-type art—Earthworks, process and narrative pieces, Body Art, etc.[1] Their first function is, of course, documentation; but it can be argued that photography offers certain specific qualities and possibilities that have done much to inform and channel artistic strategies and to nurture the development of idea-oriented art. Despite its dependence on photography, however, conceptual art exhibits little *photographic* self-consciousness, setting itself apart from so-called serious photography by a snapshot-like amateurism and nonchalance that would raise the hackles of any earnest professional. In fact many conceptual artists consider it irrelevant whether or not they take their own pictures. Some do it themselves, of course. Others, Eleanor Antin, for instance, employ someone else. Photos of Body Art, where the artist himself is the subject of the picture, have to be taken by other people. It would be interesting to know how many of such images may actually be the work of aspiring art photographers!

The artistic success of these anonymous and technically unremarkable pictures provides, perhaps, a clue to the root of photography's difficulties. Over half a century ago, Alfred Stieglitz conducted a massive p.r. campaign for photography's acceptance as art within an emerging

climate of modernism which he himself did much to foster. He translated the self-referentiality of the modernist position in painting into a self-consciousness about photography for photography's sake. Much was made of the importance of the unique photographic print. Abstract formal values were, as in painting, given high priority, heavily influencing the photographer's choice of subject, as well as his compositional tactics. Ironically, a medium which started out as an image recorder and replicator came to look on itself as a producer of sacred objects. But the strength of photographs lies in their unique ability to gather, preserve and present outside information, not to "make art." Thus the contents of a photograph are inherently extra-photographic; a fact which, though not profitably reconcilable with modernism, offers considerable potential of its own. The extent to which Stieglitz may have been unwittingly responsible for stifling that potential remains to be explored elsewhere. Conceptual artists, however, in espousing photography for expedient recordmaking purposes, have begun to extend its ideological potential.

Conceptual art's Duchampian underpinnings strip the photograph of its artistic pretensions, changing it from a mirror into a window. What it reveals becomes important, not what it is. It doesn't matter to conceptual art whether the photographic prints that testify to its occurrence come from a fancy darkroom or the drugstore; the view's the same. Nor does it matter if they're reproductions, thus opening up the whole area of publications as possible territory for art. Seth Siegelaub has made this distinction:

> When art does not any longer depend upon its physical presence, when it becomes an abstraction, it is not distorted and altered by its reproduction in books. It becomes PRIMARY information, while the reproduction of conventional art in books and catalogues is necessarily (distorted) "SECONDARY" information. When information is PRIMARY, the catalogue can become the exhibition.[2]

Photographers' photographs, of course, also become "secondary" information when reproduced in books. Conceptual artists' do not. In fact, the final form of the work may well be its publication. Robert Smithson's *Incidents of Mirror-Travel in the Yucatan*, for example, documents nine

"Mirror Displacements" placed in various locations, photographed, then packed up and moved to the next place. Smithson published the photographs in *Artforum*, along with an extensive commentary, as the completed work.[3] Ed Ruscha has a similar attitude toward the final form of his work and the printed reproduction of photos:

Mine are simply reproductions of photos. Thus [*Twentysix Gasoline Stations*] is not a book to house a collection of art photographs—they are technical data like industrial photography.[4]

Eleanor Antin's *100 Boots* series took the form of industrially printed postcard reproductions; certainly in this case the production and distribution of the cards

was as integral a part of the work as the antics of the boots themselves.

Art that does not depend, as Siegelaub says, on its physical presence relies heavily on photography for its credibility. Though few make the pilgrimage necessary to see Earthworks firsthand, or preside over the machinations that comprise Body Art, photographic reports from the front tell

Robert Smithson, *Yucatan Mirror Displacements (1–9)*, 1969 (cat. no. 175)

it like it was to all the (art) world. And though the photographs started out as documentation, once the act is over, they acquire eyewitness status, becoming, in a sense, the art itself. A grayish close-up of the teeth-marks on Vito Acconci's arm (*Trademarks*, 1970) or the barely distinguishable figure of Chris Burden sitting in a dark boiler-room (*The Visitation*, 1974) is hardly the photographer's idea of a masterpiece. And yet, we may ask ourselves, how much of such art would continue to be made were it not for photography's flawless credibility record in swearing to the truth of such occurrences?

Photos also allow artists to carry over Duchamp's Readymade esthetic into the realm of conceptual art. Richard Long and Hamish Fulton stake artistic claim to various sections of the landscape by photographing it—Long according to predetermined systems ("walking a 10-mile line, filming every half mile out and back, 42 shots"), Fulton by isolating certain memorable moments, also on lengthy walks. With both artists, the act of photographing is as much a part of the work as the resulting images. In Long's case, it determines the conceptual structure of the piece; with Fulton, it enables him to "charge" the landscape esthetically.

Smithson's *Monuments of Passaic*, in which he photographed, among other things, a rotating railroad bridge and dubbed it "Monument of Dislocated Directions," is another instance of art status being conferred on a nonart place by an artist's act of selection and photography.[5] The photo itself, taken with an

Instamatic, is predictably banal, and does not even show the bridge in action, though its swiveling function is what actually grants it admission to Smithson's repertory of "monuments."

If photography makes it possible to confer Readymade status on otherwise untransportable places and deposit them in one's *oeuvre* (or gallery), it also expedites the collection of such material for later artification by juxtaposition, group presentation or serial publication. Bernd and Hilla Becher ignore the architectural or engi-

neering achievements of the buildings that make up their work, photographing them so as to categorize types, compare similar formal elements, and arrange them in sequences (or pseudo-sequences) that suppress the structures' individual characteristics in favor of what they call "typologies." The conceptual precision of their enterprise would be impossible without photography because, as Carl Andre has pointed out, it allows them to equalize the proportions of buildings that are not the same size, for purposes of presentation.[6] The Bechers claim not to care

Richard Long; *A Line in the Himalayas*, 1975; black-and-white photograph; dimensions variable; courtesy the artist

Hamish Fulton; plate from untitled book of photographs printed by Franco Toselli, Milan, 1974; courtesy the artist

Vito Acconci; *Trademarks* (detail), 1970; lithograph on paper; 20 1/8 x 20 3/16 in. (51.1 x 51.3 cm); Walker Art Center

whether or not the resulting grids of images are works of art; nevertheless, their relevance to current art ideas is inescapable.

Ed Ruscha's photographic gatherings, though deliberately trivial in subject matter, undergo similar transformations when placed between the covers of his enigmatic small books. He is not interested in a formal comparison of structures, though *Twentysix Gasoline Stations* and *64 Parking Lots*, when viewed together, offer provocative visual commentary. But the presentation itself, with each image isolated on a separate page, indicates that Ruscha's choices stem from other ideas. Just what those ideas are remains problematic. *Colored People* (16 color photos of cactuses) and *A Few Palm Trees* (annotated with their locations) manage to convey an uncannily anthropomorphic sense of presence which is very amusing; but, as is often the case with humor, the easy access which it grants to the work is deceptive. (The same can be said of John Baldessari and William Wegman, whose surface levity masks a more complex content.)

The idea of art through selection, harking back to Duchamp and vastly enlarged in scope through the use of photos, is gently parodied by Baldessari in his *Choosing* series. Here photographs of the artist's finger pointing to one of three similar items (green beans, chocolates, etc.) call attention to the process involved in making choices.

In addition to being a means of gathering information, photography offers a number of structural strategies which play a greater part in the conception of many works than they are usually given credit for. An important, if obvious, difference between traditional photography and art comprised of or documented by photos is the use of several pictures rather than a single image. This immediately alters the sort of content possible within the overall work, offering the chance for a conceptual complexity rarely found in a single picture. The artist has a number of options—photos can be serial, sequential, in suites; they can be narrative, documentary, even components of abstractions. Usually any given group of photos serves several of these functions simultaneously.[7]

In documenting gestures and processes, the photograph allows the artist to eliminate the problem of duration, either by isolating a specific moment or by presenting a linear sequence without having to endure the possible monotony of a film or videotape of the actual event. This absence of real time is often compensated for by notations as to how long the process took, the distance covered, the size of intervals, number of occurrences, etc. Unlike a performance, theatrical or otherwise, in which the only way to see it is actually to be there in person from beginning to end (likewise a film or video), a process piece takes on its final *public* form in its documentation and is experienced by the viewer as a more or less simultaneous whole, in the same way that one would confront a painting or sculpture. This submergence of the temporal in favor of the visual is possible only with still photographs, which punctuate action and hand back the concept of the work edited of its durational aspects. Even, as in large series of photographs, when it is impossible to take in the whole work at once, our sense of ongoing time remains negligible.

If photography can eliminate the duration of process, it can also telescope distance, allowing one to relate isolated situations or events that derive their conceptual strength from juxtaposition and comparison.

Bernd and Hilla Becher; *Cooling Towers*, 1972; gelatin silver prints; 60 x 40 in. (152.4 x 101.6 cm); courtesy Sonnabend Gallery, New York

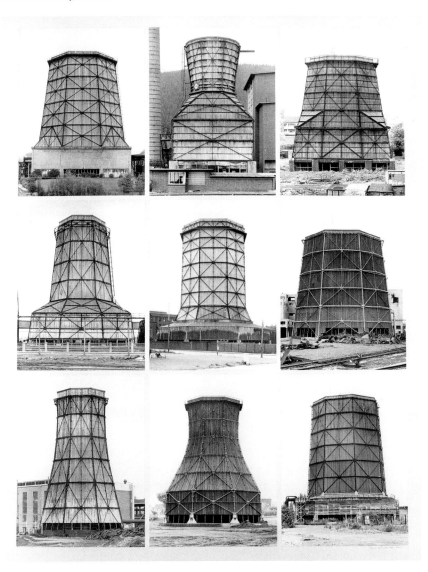

Eleanor Antin's ubiquitous *100 Boots* seem ubiquitous precisely because their getting from place to place has been edited out. Smithson's "Mirror Displacements" can't exist as a unit except in photos, since their enabling rationale was that each should occur in a different location. Thus it can be argued that this work's final structure *is* photos, unlike an Earthwork in a single location which, though dependent on

John Baldessari; *Choosing (A Game for Two Players): Green Beans*, 1971; color photographs; 12 ³/₁₆ x 22 ³/₈ in. (31 x 57 cm); courtesy the artist.

photos as records, could (though won't, by most people) be seen "in the flesh." The "Mirror Displacements" cannot be, any more than can, say, Dennis Oppenheim's *Parallel Stress*, where the artist positioned his body in a V-shaped pose that conformed to two different locations. The final form of this work becomes the juxtaposition of the two photographs. Much of Douglas Huebler's work also relies on juxtaposing isolated instances. *Variable Piece 1ᴬ* relates the facial expressions of eight people in five different countries upon being told, as we learn in an accompanying statement, that they have beautiful/special/remarkable faces. (This piece, incidentally, was distributed in an *Art & Project* bulletin, another case of the art taking its final form as a publication.)

Photographs can constitute physical as well as conceptual structure, as in the work of Jan Dibbets and Jared Bark. Both use sequences of photos artificially juxtaposed to produce nature-defying fantasies. Dibbets' *Dutch Mountain* series, where photos of the horizon are successively tipped to give the illusion of a hill, comment on that country's characteristic flatness. Bark, who uses the most banal form of photography imaginable—the subway photo booth—collages pictures of various parts of his body in elaborate series to form trees, animals, etc. In one respect they are reminiscent of certain 17th-century portraits by Archimboldo—grotesqueries where faces are composed entirely of vegetables.

If photography's widespread acceptance as the currency of conceptual art has had an effect on the structure of such art, it has also opened new possibilities for many who consider themselves primarily photographers. The sequence-serial-narrative issue deserves further consideration in this respect, for photographers have been drawing on its didactic capacities for the extra-photographic content which they are increasingly interested in incorporating into their work. Some manipulate the characteristics of narrative or sequence, juxtaposing presentational formats that are habitually read in certain ways (left to right, top to bottom) with photographed information that does not necessarily relate accordingly. Jan Groover's photographs of cars and trucks passing specific points along streets and highways are presented horizontally so that one first

assumes they represent the passage of time. In fact, their order is established purely visually within the overall composition, making space their primary concern. Bernd and Hilla Becher's use of the grid format produces a similar disruption of traditional expectations; usual readings of objects arranged in grids, with their implied serial progressions and relationship, do not apply.

Sequences do not need to progress horizontally; Duane Michals reverses photography's usual method of showing an overall view and details of varying closeness, gradually dispensing additional information about his subject by moving farther and farther away. Tableaux which at first appear to contain bizarre discrepancies in scale reveal their true identities as the camera recedes, clarifying by degrees the structure of the scene. Al Sousa has also done series which play on this idea of photographic depth. He starts with a small object, photographs it, photographs the resulting photo, etc., exhibiting them in sequence together with the original object. The resulting series shifts scale in a sort of photographic perspective as well as offering damning evidence of the inaccuracies of color film, which are compounded as the series progresses.

Collecting for conceptual purposes is also gaining appeal for photographers. Lewis Baltz's photographs of industrial parks, for instance, though perhaps more closely related to Minimalism in their frontality and sparse geometry, converge with Ruscha's gas stations in their banal subject matter and with the Bechers in their structural comparisons. And Bill Owens' *Suburbia*, a collection of photographs of middle-class America, is as deliberate a social commentary as any of Hans Haacke's slumlord documentaries. Both Baltz and Owens, along with numerous others, have gone in for publishing such collections, indicating, perhaps, that they are less interested in the autonomy of the original photograph than in its capacity to transmit ideas.

Over the past few years, as photographers have experimented with conceptual tactics, artists have begun to be seduced by the technical capacities of the photographic process. Baldessari, for example, has concentrated increasingly on the professional quality of his photographs. What

Edward Ruscha; pages from *A Few Palm Trees*, 1971; photo-offset-printed book; 7 x 5 ½ in. (17.8 x 14 cm); Walker Art Center

Island at Hollywood Blvd. & La Brea Ave. *S. W. corner of McCadden Pl. & Yucca st.* *N. W. corner of Valley Oak Dr. & Canyon Dr.* *N. W. corner of Canon Dr. & Park Way*

Douglas Huebler; *Variable Piece 1ᴬ, the Netherlands, United States, Italy, France, and Germany, January 1971*, 1971; courtesy Darcy Huebler

 variable piece 1^A
(the netherlands, united states, italy, france, and germany)

eight people were photographed at the instant exactly after
each had been told: 'you have a beautiful face', or, 'you
have a very special face', or, 'you have a remarkable face',
or in one instance, nothing at all. the artist knew only
one person among the eight; it is not likely that he will
ever again have a personal contact with any of the others.

the eight photographs join with this statement to constitute
the form of this piece.

january, 1971 douglas huebler

was once presented in standard-sized polaroid snapshots has begun to appear in larger, much slicker form. A recent strobe series recording the motion of objects required a much higher degree of technical skill than the casualness of his earlier work. And Hamish Fulton's photographs, extremely large in size and meticulously framed and matted, exploit the graininess which photographers often rely upon for special effects; they also allude to the romanticism which Ansel Adams, for instance, seeks in his landscapes. Even in the work of such artists as Ben Vautier, Peter Hutchinson, Jean Le Gac, Bill Beckley, etc., which I have not considered in detail as its narrative is essentially verbal rather than visual, the accompanying photographs that serve as punctuation to the texts have shown a tendency to become more professional in quality.

On the purely documentary side of things, perhaps the quintessential example of heightened attention to technical quality would be the elaborate photographic records and resulting coffee-table book that attest to Christo's *Valley Curtain*. It's ironic that an art whose generating impulse was the urge to break away from the collectible object (and hence the gallery/collector/artbook syndrome) might, through an obsession with the extent and quality of its documentation, have come full circle.

Photography obviously cannot claim sole credit for the rise of the prevailing ephemeral art styles; nor is it fair to say that conceptual art is produced purely to be photographed. It isn't. But there can be little doubt that photography's role has extended far beyond its original archival function, entering into dialogue with artistic ideas in mutually reinforcing ways. Certainly the production of impermanent works is encouraged by the status accorded the photographic stand-in. Works don't have to locate themselves in remote places, self-destruct in five seconds, or cease to exist at the end of a gesture to benefit from a photographic after-life. Even ephemeral gallery-installation exhibitions, a recent but ever more common phenomenon, owe the luxury of their three-week fling to the reassurance that there'll always be the photos. (Walter De Maria's gallery full of dirt, a key installation gesture, has become famous through its photographs.)

If photography has encouraged such transitory indulgences, it has also, in many cases, helped shape their character. The extent to which the two have become inseparable was noted by Robert Morris in a conceptual / photographic / publication piece of his own, where he invented three artists and discussed their work (accompanied by drawings and, of course, photos) in *Artforum*. One of the "artists," Marvin Blaine, had dug an elaborate cave which, though suspiciously prophetic of Alice Aycock's recent burrowings, he insisted was not art and would not allow to be photographed:

Blaine simply said that the cave was a private thing and he was consciously removing these

Installation view with Jan Dibbets' *Little Comet—Sea 9°−81°* (1973) and *Big Comet 3°−60°, Sky/Sea/Sky* (1973), Stedelijk Museum, Amsterdam

Dennis Oppenheim; *Directed Seeding*, 1969; site-specific project in Finsterwolde, Holland; courtesy the artist

private efforts from his mind as art. The easiest way to remove the efforts from being taken as art by others was to have no photographic memory exist.[8]

Notes

1. Photographs are also involved in the making of many other types of art—photo-Realist paintings, Samaras's Photo-transformations, Warhol's silkscreens, and Rauschenberg's collages, to list a few. I am concerned here only with its documentary or notational functions.
2. Ursula Meyer, *Conceptual Art* (New York, 1972), p. xiv.
3. Robert Smithson, "Incidents of Mirror-Travel in the Yucatan," *Artforum*, September 1969, pp. 28–33.
4. John Coplans, "Concerning 'Various Small Fires': Edward Ruscha Discusses His Perplexing Publications," *Artforum*, February 1965, p. 25.
5. Robert Smithson, "The Monuments of Passaic," *Artforum*, December 1967, pp. 48–51.
6. Carl Andre, "A Note on Bernhard and Hilla Becher," *Artforum*, December 1972, p. 59.
7. In the catalogue for an exhibition of sequenced photographs *((photo) photo)²* ... *(photo)ⁿ*, University of Maryland Art Gallery, Feb. 26–March 25, 1975) David Bourdon touched upon these distinctions in establishing the criteria for inclusion in the show. He differentiates between a sequence and a suite, and on those grounds eliminates Ed Ruscha but includes the Bechers and Jan Dibbets. A sequence, however, implies linear continuity, a progressional order which the Bechers' work lacks, falling more in the category of collection. Dibbets is even more problematic,

for though he arranges the photos in an order, it relates only to his final abstract construction and not to the subjects of the photos. Such inconsistencies, far from being intended as a criticism of Bourdon's choices, underline the very blurriness of the whole question and emphasize the depth which photography can bring to such work.
8. Robert Morris, "The Art of Existence: Three Extra-Visual Artists: Works in Process," *Artforum*, January 1971, p. 30.

Installation view of Walter De Maria's *Munich Earth Room* (1968), Heiner Friedrich Gallery, Munich

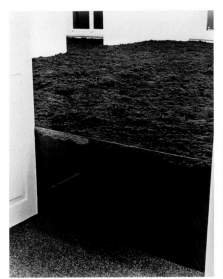

Lewis Baltz; *East Wall, Western Carpet Mills, 1231 Warner, Tustin,* 1974; gelatin silver print; 5⅞ x 9 in. (15.1 x 22.8 cm); courtesy Stephen Wirtz Gallery, San Francisco, and Gallery Luisotti, Santa Monica, California

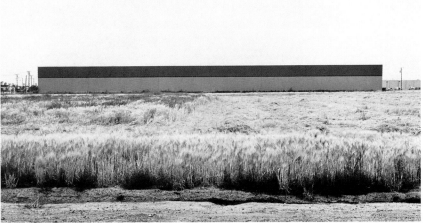

Jeff Wall

"Marks of Indifference": Aspects of Photography in, or as, Conceptual Art (1995)

Originally published in Ann Goldstein and Anne Rorimer, *Reconsidering the Object of Art, 1965–1975*, exh. cat. (Los Angeles: Museum of Contemporary Art, 1995), 247–267.

Preface

This essay is a sketch, an attempt to study the ways that photography occupied Conceptual artists, the ways that photography decisively realized itself as a modernist art in the experiments of the 1960s and 1970s. Conceptual art played an important role in the transformation of the terms and conditions within which established photography defined itself and its relationships with other arts, a transformation which established photography as an institutionalized modernist form evolving explicitly through the dynamics of its auto-critique.

Photography's implication with modernist painting and sculpture was not, of course, developed in the 1960s; it was central to the work and discourse of the art of the 1920s.

But, for the sixties generation, art-photography remained too comfortably rooted in the pictorial traditions of modern art; it had an irritatingly serene, marginal existence, a way of holding itself at a distance from the intellectual drama of avant-gardism while claiming a prominent, even definitive place within it. The younger artists wanted to disturb that, to uproot and radicalize the medium, and they did so with the most sophisticated means they had in hand at the time, the auto-critique of art identified with the tradition of the avant-garde. Their approach implied that photography had not yet become "avant-garde" in 1960 or 1965, despite the epithets being casually applied to it. It had not yet accomplished the preliminary autodethronement, or deconstruction, which the other arts had established as fundamental to their development and their *amour-propre*.

Through that auto-critique, painting and sculpture had moved away from the practice of depiction, which had historically been the foundation of their social and aesthetic value. Although we may no longer accept the claim that abstract art had gone "beyond" representation or depiction, it is certain that such developments added something new to the corpus of possible artistic forms in Western culture. In the first half of the 1960s, Minimalism was decisive in bringing back into sharp focus, for the first time since the 1930s, the general problem of how a work of art could validate itself as an object among all other objects in the world. Under the regime of depiction, that is, in the history of Western art before 1910, a work of art was an object whose validity as art was constituted by its being, or bearing, a depiction. In the process of developing alternative proposals for art "beyond" depiction, art had to reply to the suspicion that, without their depictive, or representational function, art objects were art in name only, not in body, form, or function.[1] Art projected itself forward bearing only its glamorous traditional name, thereby entering a troubled phase of restless searching for an alternative ground of validity. This phase continues, and must continue.

Photography cannot find alternatives to depiction, as could the other fine arts. It is in the physical nature of the medium to depict things. In order to participate in the kind of reflexivity made mandatory for modernist art, photography can put into play only its own necessary condition of being a depiction-which-constitutes-an-object.

In its attempts to make visible this condition, Conceptual art hoped to reconnect the medium to the world in a new, fresh way, beyond the worn-out criteria for photography as sheer picture-making. Several important directions emerged in this process. In this essay I will examine only two. The first involves the rethinking and "refunctioning" of *reportage*, the dominant type of art-photography as it existed at the beginning of the 1960s. The second is related to the first, and to a certain extent emerges from it. This is the issue of the de-skilling and re-skilling of the artist in a context defined by the culture industry, and made controversial by aspects of Pop art.

1. From Reportage to Photodocumentation

Photography entered its post-Pictorialist phase (one might say its "post-Stieglitzian" phase) in an exploration of the border-territories of the utilitarian picture. In this phase, which began around 1920, important work was made by those who rejected the Pictorialist enterprise and turned toward immediacy, instantaneity, and the evanescent moment of the emergence of pictorial value out of a practice of reportage of one kind or another. A new version of what could be called the "Western Picture," or the "Western Concept of the Picture," appears in this process.

Edward Ruscha; *1555 Artesia Blvd.* and *6565 Fountain Ave.*, from *Some Los Angeles Apartments*, 1965; photo-offset-printed book; 7 1/8 x 5 5/8 in. (18.1 x 14.3 cm); Walker Art Center

1555 ARTESIA BLVD. 6565 FOUNTAIN AVE.

The Western Picture is, of course, that *tableau*, that independently beautiful depiction and composition that derives from the institutionalization of perspective and dramatic figuration at the origins of modern Western art, with Raphael, Dürer, Bellini and the other familiar *maestri*. It is known as a product of divine gift, high skill, deep emotion, and crafty planning. It plays with the notion of the spontaneous, the unanticipated. The master picture-maker prepares everything in advance, yet trusts that all the planning in the world will lead only to something fresh, mobile, light and fascinating. The soft body of the brush, the way it constantly changes shape as it is used, was the primary means by which the genius of composition was placed at risk at each moment, and recovered, transcendent, in the shimmering surfaces of magical feats of figuration.

Pictorialist photography was dazzled by the spectacle of Western painting and attempted, to some extent, to imitate it in acts of pure composition. Lacking the means to make the surface of its pictures unpredictable and important, the first phase of Pictorialism, Stieglitz's phase, emulated the fine graphic arts, re-invented the beautiful book, set standards for gorgeousness of composition, and faded. Without a dialectical conception of its own surface, it could not achieve the kind of planned spontaneity painting had put before the eyes of the world as a universal norm of art. By 1920, photographers interested in art had begun to look away from painting, even from modern painting, toward the vernacular of their own medium, and toward the cinema, to discover their own principle of spontaneity, to discover once again, for themselves, that unanticipated appearance of the Picture demanded by modern aesthetics.

At this moment the art-concept of photojournalism appears, the notion that art can be created by imitating photojournalism. This imitation was made necessary by the dialectics of avant-garde experimentation. Non-autonomous art-forms, like architecture, and new phenomena such as mass communications, became paradigmatic in the 1920s and 1930s because the avant-gardes were so involved in a critique of the autonomous work of art, so intrigued by the possibility of going beyond it into a utopian revision of society and consciousness. Photojournalism was created in the

framework of the new publishing and communications industries, and it elaborated a new kind of picture, utilitarian in its determination by editorial assignment and novel in its seizure of the instantaneous, of the "news event" as it happened. For both these reasons, it seems to have occurred to a number of photographers (Paul Strand, Walker Evans, Brassaï, Henri Cartier-Bresson) that a new art could be made by means of a mimesis of these aims and aspects of photography as it really existed in the world of the new culture industries.

This mimesis led to transformations in the concept of the Picture that had consequences for the whole notion of modern art, and that therefore stand as preconditions for the kind of critique proposed by the Conceptual artists after 1965. Post-pictorialist photography is elaborated in the working out of a demand that the Picture make an appearance in a practice which, having already largely relinquished the sensuousness of the surface, must also relinquish any explicit preparatory process of composition. Acts of composition are the property of the tableau. In reportage, the sovereign place of composition is retained only as a sort of dynamic of anticipatory framing, a "hunter's consciousness," the nervous looking of a "one-eyed cat," as Lee Friedlander put it. Every picture-constructing advantage accumulated over centuries is given up to the jittery flow of events as they unfold. The rectangle of the viewfinder and the speed of the shutter, photography's "window of equipment," is all that remains of the great craft-complex of composition. The art-concept of photojournalism began to force photography into what appears to be a modernistic dialectic. By divesting itself of the encumbrances and advantages inherited from older art forms, reportage pushes toward a discovery of qualities apparently intrinsic to the medium, qualities that must necessarily distinguish the medium from others, and through the self-examination of which it can emerge as a modernist art on a plane with the others.

This force, or pressure, is not simply social. Reportage is not a photographic type brought into existence by the requirements of social institutions as such, even though institutions like the press played a central part in defining photojournalism. The press had some role in shaping the new equipment of the 1920s and 1930s, particularly

the smaller, faster cameras and film stock. But reportage is inherent in the nature of the medium, and the evolution of equipment reflects this. Reportage, or the spontaneous, fleeting aspect of the photographic image, appears simultaneously with the pictorial, tableau-like aspect at the origins of photography; its traces can be seen in the blurred elements of Daguerre's first street scenes. Reportage evolves in the pursuit of the blurred parts of pictures.

In this process, photography elaborates its version of the Picture, and it is the first new version since the onset of modern painting in the 1860s, or, possibly, since the emergence of abstract art, if one considers abstract paintings to be, in fact, pictures anymore. A new version of the Picture implies necessarily a turning-point in the development of modernist art. Problems are raised which will constitute the intellectual content of Conceptual art, or at least significant aspects of that content.

One of the most important critiques opened up in Conceptual art was that of art-photography's achieved or perceived "aestheticism." The revival of interest in the radical theories and methods of the politicized and objectivistic avant-garde of the 1920s and 1930s has long been recognized as one of the most significant contributions of the art of the 1960s, particularly in America. Productivism, "factography," and Bauhaus concepts were turned against the apparently "depoliticized" and resubjectivized art of the 1940s and 1950s. Thus, we have seen that the kind of formalistic and "re-subjectivized" art-photography that developed around Edward Weston and Ansel Adams on the West Coast, or Harry Callahan and Aaron Siskind in Chicago in those years (to use only American examples) attempted to leave behind *not only* any *link* with agit-prop, but even any connection with the nervous surfaces of social life, and to resume a stately modernist pictorialism. This work has been greeted with opprobrium from radical critics since the beginnings of the new debates in the 1960s. The orthodox view is that Cold War pressures compelled socially-conscious photographers away from the borderline forms of art-photojournalism toward the more subjectivistic versions of *art informel*. In this process, the more explosive and problematic forms and concepts of radical avant-gardism were driven from view, until they made a return in the activistic neo-avant-gardism of the 1960s. There is much truth in this construction, but it is flawed in that it draws too sharp a line between the methods and approaches of politicized avant-gardism and those of the more subjectivistic and formalistic trends in art-photography.

The situation is more complex because the possibilities for autonomous formal composition in photography were themselves refined and brought onto the historical and social agenda by the medium's evolution in the context of vanguardist art. The art-concept of photojournalism is a theoretical formalization of the ambiguous condition of the most problematic kind of photograph. That photograph emerges on the wing, out of a photographer's complex social engagement (his or her assignment); it records something significant in the event, in the engagement, and gains some validity from that. But this validity alone is only a social validity—the picture's success as reportage *per se*. The entire avant-garde of the 1920s and 1930s was aware that

validity as reportage *per se* was insufficient for the most radical of purposes. What was necessary was that the picture not only succeed as reportage and be socially effective, but that it succeed in putting forward a new proposition or model of the Picture. Only in doing both these things simultaneously could photography realize itself as a modernist art form, and participate in the radical and revolutionary cultural projects of that era. In this context, rejection of a classicizing aesthetic of the picture—in the name of proletarian amateurism, for example—must be seen as a claim to a new level of pictorial consciousness.

Thus, art-photography was compelled to be both anti-aestheticist and aesthetically significant, albeit in a new "negative" sense, at the same moment. Here, it is important to recognize that it was the content of the avant-garde dialogue itself that was central in creating the demand for an aestheticism which was the object of critique by that same avant-garde. In *Theory of the Avant-Garde* (1974) Peter Bürger argued that the avant-garde emerged historically in a critique of the completed aestheticism of nineteenth-century modern art.[2] He suggests that, around 1900, the avant-garde generation, confronted with the social and institutional fact of the separation between art and the other autonomous domains of life felt compelled to attempt to leap over that separation and reconnect high art and the conduct of affairs in the world in order to save the aesthetic dimension by transcending it. Bürger's emphasis on this drive to transcend Aestheticism and autonomous art neglects the fact that the obsession with the aesthetic, now transformed into a sort of taboo, was carried over into the center of every possible artistic thought or critical idea developed by vanguardism. Thus, to a certain extent, one can invert Bürger's thesis and say that avant-garde art not only constituted a critique of Aestheticism, but also re-established Aestheticism as a permanent issue through its intense problematization of it. This thesis corresponds especially closely to the situation of photography within vanguardism. Photography had no history of autonomous status perfected over time into an imposing institution. It emerged too late for that. Its aestheticizing thus was not, and could not be, simply an object for an avant-gardist critique, since it was brought into existence by that same critique.

In this sense, there cannot be a clear demarcation between aestheticist formalism and various modes of engaged photography. Subjectivism could become the foundation for radical practices in photography just as easily as neo-factography, and both are often present in much of the work of the 1960s.

The peculiar, yet familiar, political ambiguity *as art* of the experimental forms in and around Conceptualism, particularly in the context of 1968, is the result of the fusion, or even confusion, of tropes of art-photography with aspects of its critique. Far from being anomalous, this fusion reflects precisely the inner structure of photography as potentially avant-garde or even neo-avant-garde art. This implies that the new forms of photographic practice and experiment in the sixties and seventies did not derive exclusively from a revival of anti-subjectivist and anti-formalist tendencies. Rather, the works of figures like Douglas Huebler, Robert Smithson, Bruce Nauman, Richard Long, or Joseph Kosuth emerge from a space constituted by the already-matured transformations of both types of approach—factographic and subjectivistic, activist and formalist, "Marxian" and "Kantian"—present in the work of their precursors in the 1940s and 1950s, in the intricacies of the dialectic of "reportage as art-photography," as art-photography *par excellence*. The radical critiques of art-

André Kertész; *Meudon, 1928*, 1928; gelatin silver print; 16⁷⁄₁₆ x 12½ in. (41.8 x 31.8 cm); courtesy Estate of André Kertész

photography inaugurated and occasionally realized in Conceptual art can be seen as both an overturning of academicized approaches to these issues, and as an extrapolation of existing tensions inside that academicism, a new critical phase of academicism and not simply a renunciation of it. Photoconceptualism was able to bring new energies from the other fine arts into the problematic of art-photojournalism, and this had tended to obscure the ways in which it was rooted in the unresolved but well-established aesthetic issues of the photography of the 1940s and 1950s.

Intellectually, the stage was thus set for a revival of the whole drama of reportage within avant-gardism. The peculiar situation of art-photography in the art market at the beginning of the 1960s is another precondition, whose consequences are not simply sociological. It is almost astonishing to remember that important art-photographs cold be purchased for under $100 not only in 1950 but in 1960. This suggests that, despite the internal complexity of the aesthetic structure of art-photography, its moment of recognition as art in capitalist societies had not yet occurred. All the aesthetic preconditions for its emergence as a major form of modernist art had come into being, but it took the new critiques and transformations of the sixties and seventies to actualize these socially. It could be said that the very absence of a market in photography at the moment of a rapidly booming one for painting drew two kinds of energy toward the medium.

The first is a speculative and inquisitive energy, one which circulates everywhere things appear to be "undervalued." Undervaluation implies the future, opportunity, and the sudden appearance of something forgotten. The undervalued is a category akin to Benjaminian ones like the "just past," or the "recently forgotten."

The second is a sort of negative version of the first. In the light of the new critical skepticism toward "high art" that began to surface in the intellectual glimmerings around Pop art and its mythologies, the lack of interest of art marketers and collectors marked photography with a utopian potential. Thus, the thought occurred that a photograph might be the Picture which could not be integrated into "the regime," the commercial-bureaucratic-discursive order which was rapidly becoming the object of

criticisms animated by the attitudes of the Student Movement and the New Left. Naive as such thoughts might seem today, they were valuable in turning serious attention toward the ways in which art-photography had not yet become Art. Until it became Art, with a big A, photographs could not be *experienced* in terms of the dialectic of validity which marks all modernist aesthetic enterprises.

Paradoxically, this could only happen in reverse. Photography could emerge socially as art only at the moment when its aesthetic presuppositions seemed to be undergoing a withering radical critique, a critique apparently aimed at foreclosing any further aestheticization or "artification" of the medium. Photoconceptualism led the way toward the complete acceptance of photography as art—autonomous, bourgeois, collectible art—by virtue of insisting that this medium might be privileged to be the negation of that whole idea. In being that negation, the last barriers were broken. Inscribed in a new avant-gardism, and blended with elements of text, sculpture, painting, or drawing, photography became the quintessential "anti-object." As the neo-avant-gardes re-examined and unraveled the orthodoxies of the 1920s and 1930s, the boundaries of the domain of autonomous art were unexpectedly widened, not narrowed. In the explosion of post-autonomous models of practice which characterized the discourse of the seventies, we can detect, maybe only with hindsight,

the extension of avant-garde aestheticism. As with the first avant-garde, post-autonomous, "post-studio" art required its double legitimation—first, its legitimation as having transcended—or at least having authentically tested—the boundaries of autonomous art and having become functional in some real way; and then, secondly, that this test, this new utility, result in works or forms which proposed compelling models of art as such, at the same time that they seemed to dissolve, abandon, or negate it. I propose the following characterization of this process: autonomous art had reached a state where it appeared that it could only validly be made by means of the strictest imitation of the non-autonomous. This heteronomy might take the form of direct critical commentary, as with Art & Language; with the production of political propaganda, so common in the 1970s; or with the many varieties of "intervention" or appropriation practiced more recently. But, in all these procedures, an autonomous work of art is still necessarily created. The innovation is that the content of the work is the validity of the model or hypothesis of non-autonomy it creates.

This complex game of mimesis has been, of course, the foundation for all the "endgame" strategies within avant-gardism. The profusion of new forms, processes, materials and subjects which characterizes the art of the 1970s was to a great extent stimulated by mimetic relationships with other social production processes:

Richard Long; *England 1968*, 1968; black-and-white photograph; dimensions variable; courtesy the artist

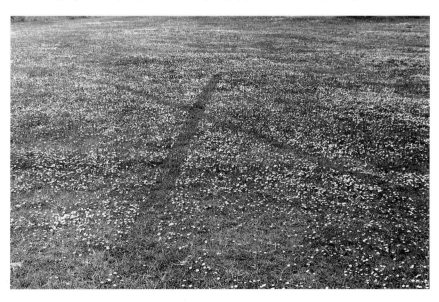

industrial, commercial, cinematic, etc. Art-photography, as we have seen, had already evolved an intricate mimetic structure, in which artists imitated photojournalists in order to create Pictures. This elaborate, mature mimetic order of production brought photography to the forefront of the new pseudo-heteronomy, and permitted it to become a paradigm for all aesthetically-critical, model-constructing thought about art. Photoconceptualism worked out many of the implications of this, so much so that it may begin to seem that many of Conceptual art's essential achievements are either created in the form of photographs or are otherwise mediated by them.

Reportage is introverted and parodied, manneristically, in aspects of photoconceptualism. The notion that an artistically significant photograph can any longer be made in a direct imitation of photojournalism is rejected as having been historically completed by the earlier avant-garde and by the lyrical subjectivism of 1950s art-photography. The gesture of reportage is withdrawn from the social field and attached to a putative theatrical event. The social field tends to be abandoned to professional photojournalism proper, as if the aesthetic problems associated with depicting it were no longer of any consequence, and photojournalism had entered not so much a postmodernist phase as a "post-aesthetic" one in which it was excluded from aesthetic evolution for a time. This, by the way, suited the sensibilities of those political activists who attempted a new version of proletarian photography in the period.

This introversion, or subjectivization, of reportage was manifested in two important directions. First, it brought photography into a new relationship with the

problematics of the staged, or posed, picture, through new concepts of performance. Second, the inscription of photography into a nexus of experimental practices led to a direct but distantiated and parodic relationship with the art-concept of photojournalism. Although the work of many artists could be discussed in this context, for the sake of brevity I will discuss the photographic work of Richard Long and Bruce Nauman as representative of the first issue, that of Dan Graham, Douglas Huebler, and Robert Smithson of the second.

Long's and Nauman's photographs document already conceived artistic gestures, actions, or "studio-events"—things that stand self-consciously as conceptual, aesthetic models for states of affairs in the world, which, as such, need no longer appear directly in the picture. Long's *England 1968* (1968) documents an action or gesture, made by the artist alone, out in the countryside, away from the normal environs of art or performance. Generically, his pictures are landscapes, and their mood is rather different from the typologies and intentions of reportage. Conventional artistic landscape photography might feature a foreground motif, such as a curious heap of stones or a gnarled tree, and counterpoint it to the rest of the scene, showing it to be singular, differentiated from its surroundings, and yet existing by means of those surroundings. In such ways, a landscape picture can be thought to be a report on a state of affairs, and therefore be consistent with an art-concept of reportage. Long's walked line in the grass substitutes itself for the foreground motif. It is a gesture akin to Barnett Newman's notion of the establishment of a "Here" in the void of a primeval terrain.

It is simultaneously agriculture, religion, urbanism, and theater, an intervention in a lonely, picturesque spot which becomes a setting completed artistically by the gesture and the photograph for which the gesture was enacted. Long does not photograph events in the process of their occurrence, but stages an event for the benefit of a preconceived photographic rendering. The picture is presented as the subsidiary form of an act, as "photo-documentation." It has become that, however, by means of a new kind of photographic mise-en-scène. That is, it exists and is legitimated as continuous with the project of reportage by moving in precisely the opposite direction, toward a completely designed pictorial method, an introverted masquerade that plays games with the inherited aesthetic proclivities of art-photography-as-reportage. Many of the same elements, moved indoors, characterize Nauman's studio photographs, such as *Failing to Levitate in the Studio* (1966) or *Self-Portrait as a Fountain* (1966–67/70). The photographer's studio, and the generic complex of "studio photography," was the Pictorialist antithesis against which the aesthetics of reportage were elaborated. Nauman changes the terms. Working within the experimental framework of what was beginning at the time to be called "performance art," he carries out photographic acts of reportage whose subject-matter is the self-conscious, self-centered "play" taking place in the studios of artists who have moved "beyond" the modern fine arts into the new hybridities. Studio photography is no longer isolated from reportage: it is reduced analytically to coverage of whatever is happening in the studio, that place once so rigorously controlled by precedent and formula, but which was in the process of being reinvented once more as theater, factory, reading room, meeting place, gallery, museum, and many other things.

Nauman's photographs, films, and videos of this period are done in two modes or styles. The first, that of *Failing to Levitate*, is "direct," rough, and shot in black and white. The other is based on studio lighting effects—multiple sources, colored gels, emphatic contrasts—and is of course done in color. The two styles, reduced to a set of basic formulae and effects, are signifiers for the new co-existence of species of photography which had seemed ontologically separated and even opposed in the art history of photography up to that time. It is as if the reportage works go

Bruce Nauman, *Self-Portrait as a Fountain*, 1966–1967/1970 (under cat. no. 106)

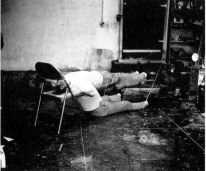

Bruce Nauman; *Failing to Levitate in the Studio*, 1966; black-and-white photograph; 20 x 24 in. (50.8 x 60.9 cm); courtesy the artist

back to Muybridge and the sources of all traditional concepts of photographic documentary, and the color pictures to the early "gags" and jokes, to Man Ray and Moholy-Nagy, to the birthplace of effects used for their own sake. The two reigning myths of photography—the one that claims that photographs are "true" and the one that claims they are not—are shown to be grounded in the same praxis, available in the same place, the studio, at that place's moment of historical transformation.

These practices, or strategies, are extremely common by about 1969, so common as to be *de rigueur* across the horizon of performance art, earth art, Arte Povera, and Conceptualism, and it can be said that these new methodologies of photographic practice are the strongest factor linking together the experimental forms of the period, which can seem so disparate and irreconcilable.

This integration or fusion of reportage and performance, its manneristic introversion, can be seen as an implicitly parodic critique of the concepts of art-photography. Smithson and Graham, in part because they were active as writers, were able to provide a more explicit parody of photojournalism than Nauman or Long.

Photojournalism as a social institution can be defined most simply as a collaboration between a writer and a photographer. Conceptual art's intellectualism was engendered by young, aspiring artists for whom critical writing was an important practice of self-definition. The example of Donald Judd's criticism for *Arts Magazine* was decisive here, and essays like "Specific Objects" (1964) had the impact, almost, of literary works of art. The interplay between a veteran littérateur, Clement Greenberg; a young academic art critic, Michael Fried; and Judd, a talented stylist, is one of the richest episodes in the history of American criticism, and had much to do with igniting the idea of a written critique standing as a work of art. Smithson's "The Crystal Land," published in *Harper's Bazaar* in 1966, is an homage to Judd as a creator of both visual and literary forms. Smithson's innovation, however, is to avoid the genre of art criticism, writing a mock-travelogue instead. He plays the part of the inquisitive, belletristic journalist, accompanying and interpreting his subject. He narrativizes his account of Judd's art, moves from critical commentary to storytelling and re-invents

the relationships between visual art and literature. Smithson's most important published works, such as "The Monuments of Passaic," and "Incidents of Mirror-Travel in the Yucatan" are "auto-accompaniments." Smithson the journalist-photographer accompanies Smithson the artist-experimenter and is able to produce a sophisticated apologia for his sculptural work in the guise of popular entertainment. His essays do not make the Conceptualist claim to be works of visual art, but appear to remain content with being works of literature. The photographs included in them purport to illustrate the narrative or commentary. The narratives, in turn, describe the event of making the photographs. "One never knew what side of the mirror one was on," he mused in "Passaic," as if reflecting on the parody of photojournalism he was in the process of enacting. Smithson's parody was a way of dissolving, or softening, the objectivistic and positivistic tone of Minimalism, of subjectivizing it by associating its reductive formal language with intricate, drifting, even delirious moods or states of mind.

The Minimalist sculptural forms to which Smithson's texts constantly allude appeared to erase the associative chain of experience, the interior monologue of creativity, insisting on the pure immediacy of the product itself, the work as such, as "specific object." Smithson's exposure of what he saw as Minimalism's emotional interior depends on the return of ideas of time and process, of narrative and enactment, of experience, memory, and allusion, to the artistic forefront, against the rhetoric of both Greenberg and Judd.

His photojournalism is at once self-portraiture—that is, performance—and reportage about what was hidden and even repressed in the art he most admired. It located the impulse toward self-sufficient and non-objective forms of art in concrete, personal responses to real life, social experiences, thereby contributing to the new critiques of formalism which were so central to Conceptual art's project.

Dan Graham's involvement with the classical traditions of reportage is unique among the artists usually identified with Conceptual art, and his architectural photographs continue some aspects of Walker Evans's project. In this, Graham locates his practice at the boundary of photojournalism, participating in it, while at the same time placing it at the service of other aspects of his oeuvre. His architectural photographs provide a social grounding for the structural models of intersubjective experience he elaborated in text, video, performance and sculptural environmental pieces. His works do not simply make reference to the larger social world in the manner of photojournalism; rather they refer to Graham's own other projects, which, true to Conceptual form, are models of the social, not depictions of it.

Graham's *Homes for America* (1966–67) has taken on canonical status in this regard. Here the photo-essay format so familiar to the history of photography has been meticulously replicated as a model of the institution of photojournalism. Like Walker Evans at *Fortune*, Graham writes the text and supplies the pictures to go along with it. *Homes* was actually planned as an essay on

Cover of *Artforum*, no. 1 (September 1969), with photography of Robert Smithson's *First Mirror Displacement*, 1969

Robert Smithson, *The Bridge Monument Showing Sidewalks*, 1967, from *Monuments of Passaic* (cat. no. 173)

suburban architecture for an art magazine, and could certainly stand unproblematically on its own as such. By chance, it was never actually published as Graham had intended it. Thereby, it migrated to the form of a lithographic print of an apocryphal two-page spread.[3] The print, and the original photos included in it, do not constitute an act or practice of reportage so much as a model of it. This model is a parody, a meticulous and detached imitation whose aim is to interrogate the legitimacy (and the processes of legitimation) of its original, and thereby (and only thereby) to legitimate itself as art.

The photographs included in the work are among Graham's most well-known and have established important precedents for his subsequent photographic work. In initiating his project in photography in terms of a parodic model of the photo-essay, Graham positions all his picture-making as art in a very precise, yet very conditional, sense. Each photograph may be—or, must be considered as possibly being—no more than an illustration to an essay, and therefore not an autonomous work of art. Thus, they appear to satisfy, as do Smithson's photographs, the demand for an imitation of the non-autonomous. *Homes for America*, in being both really just an essay on the suburbs and, as well, an artist's print, constituted itself explicitly as a canonical instance of the new kind of anti-autonomous yet autonomous work of art. The photographs in it oscillate at the

threshold of the autonomous work, crossing and recrossing it, refusing to depart from the artistic dilemma of reportage and thereby establishing an aesthetic model of just that threshold condition.

Huebler's work is also engaged with creating and examining the effect photographs have when they masquerade as part of some extraneous project, in which they appear to be means and not ends. Unlike Smithson or Graham, though, Huebler makes no literary claims for the textual part of his works, the "programs" in which his photographs are utilized. His works approach Conceptual art per se in that they eschew literary status and make claims only as visual art objects. Nevertheless, his renunciation of the literary is a language-act, an act enunciated as a manoeuvre of writing. Huebler's "pieces" involve the appropriation, utilization and mimesis of various "systems of documentation," of which photography is only one. It is positioned within the works by a group of generically related protocols, defined in writing, and it is strictly within these parameters that the images have meaning and artistic status. Where Graham and Smithson make their works through mimesis and parody of the forms of photojournalism, its published product, Huebler parodies the assignment, the "project" or enterprise that sets the whole process into motion to begin with. The seemingly pointless and even trivial procedures that

constitute works like *Duration Piece #5, Amsterdam, Holland* (1970) or *Duration Piece #7, Rome* (1973) function as models for that verbal or written construction, which, in the working world, causes photographs to be made. The more the assignment is emptied of what could normatively considered to be compelling social subject matter, the more visible it is simply as an instance of structure, an order, and the more clearly it can be experienced as a model of relationships between writing and photography. By emptying subject matter from his practice of photography, Huebler recapitulates important aspects of the development of modernist painting. Mondrian, for example, moved away from depictions of the landscape, to experimental patterns with only a residual depictive value, to abstract works which analyze and model relationships but do not depict or represent them. The idea of an art which provides a direct experience of situations or relationships, not a secondary, representational one, is one of abstract art's most powerful creations. The viewer does not experience the "re-representation" of absent things, but the presence of a thing, the work of art itself, with all of its indwelling dynamism, tension and complexity. The experience is more like an encounter with an entity than with a mere picture. The entity does not bear a depiction of another entity, more important than it; rather, it appears and is experienced in the way objects and entities are experienced in the emotionally-charged contexts of social life.

Dan Graham, "Homes for America," *Arts Magazine* 41 (December 1966–January 1967): 21–22

Huebler's mimesis of the model-constructive aspects of modernist abstract art contradicts, of course, the natural depictive qualities of photography. This contradiction is the necessary center of these works. By making photography's inescapable depictive character continue even where it has been decreed that there is nothing of significance to depict, Huebler aims to make visible something essential about the medium's nature. The artistic, creative part of this work is obviously not the photography, the picture-making. This displays all the limited qualities identified with photoconceptualism's de-skilled, amateurist sense of itself. What is creative in these works are the written assignments, or programs. Every element that could make the pictures "interesting" or "good" in terms derived from art-photography is systematically and rigorously excluded.

At the same time, Huebler eliminates all conventional "literary" characteristics from his written statements. The work is comprised of these two simultaneous negotiations, which produce a "reportage" without event, and a writing without narrative, commentary, or opinion. This double negation imitates the criteria for radical abstract painting and sculpture, and pushes thinking about photography toward an awareness of the dialectics of its inherent depictive qualities. Huebler's works allow us to contemplate the condition of "depictivity" itself and imply that it is this contradiction between the unavoidable process of depicting appearances, and the equally unavoidable process of making objects, that permits photography to become a model of an art whose subject matter is the idea of art.

II. Amateurization

Photography, like all the arts that preceded it, is founded on the skill, craft, and imagination of its practitioners. It was, however, the fate of all the arts to become modernist through a critique of their own legitimacy, in which the techniques and abilities most intimately identified with them were placed in question. The wave of reductivism that broke in the 1960s had, of course, been gathering during the preceding half-century, and it was the maturing (one could almost say, the totalizing) of that idea that brought into focus the explicit possibility of a "conceptual art," an art whose content was none other than its own idea of itself, and the history of such an idea's becoming respectable.

Painters and sculptors worked their way into this problem by scrutinizing and repudiating—if only experimentally—their own abilities, the special capacities that had historically distinguished them from other people—non-artists, unskilled or untalented people. This act of renunciation had moral and utopian implications. For the painter, a radical repudiation of complicity with Western traditions was a powerful new mark of distinction in a new era of what Nietzsche called "a revaluation of all values."[4] Moreover, the significance of the repudiation was almost immediately apparent to people with even a passing awareness of art, though apparent in a negative way. "What! You don't want things to look three-dimensional? Ridiculous!" It is easy to experience the fact that something usu-

ally considered essential to art has been removed from it. Whatever the thing the artist has thereby created might appear to be, it is first and foremost that which results from the absence of elements which have hitherto always been there. The reception, if not the production, of modernist art has been consistently formed by this phenomenon, and the idea of modernism as such is inseparable from it. The historical process of critical reflexivity derives its structure and identity from the movements possible in, and characteristic of, the older fine arts, like painting. The drama of modernization, in which artists cast off the antiquated characteristics of their *métiers*, is a compelling one, and has become the conceptual model for modernism as a whole. Clement Greenberg wrote: "Certain factors we used to think essential to the making and experiencing of art are shown not to be so by the fact that Modernist painting has been able to dispense with them and yet continue to offer the experience of art in all its essentials."[5]

Abstract and experimental art begins its revolution and continues its evolution with the rejection of depiction, of its own history as limning and picturing, and then with the deconsecration of the institution which came to be known as Representation. Painting finds a new *telos*, a new identity and a new glory in being the site upon which this transformation works itself out.

It is a commonplace to note that it was the appearance of photography which, as the representative of the Industrial Revolution in the realm of the image, set the historical process of modernism in motion. Yet photography's own historical evolution into modernist discourse has been determined by the fact that, unlike the older arts, it cannot dispense with depiction and so, apparently, cannot participate in the adventure it might be said to have suggested in the first place.

The dilemma, then, in the process of legitimating photography as a modernist art is that the medium has virtually no dispensable characteristics, the way painting, for example, does, and therefore cannot conform to the ethos of reductivism, so succinctly formulated by Greenberg in these lines, also from "Modernist Painting": "What had to be exhibited was not only that which was unique and irreducible in art in general, but also that which was unique and irreducible in each particular art. Each art had to determine, through its own operations and works, the effects exclusive to itself. By doing so it would, to be sure, narrow its area of competence, but at the same time it would make its possession of that area all the more certain."[6]

The essence of the modernist deconstruction of painting as picture-making was not realized in abstract art as such; it was realized in emphasizing the distinction between

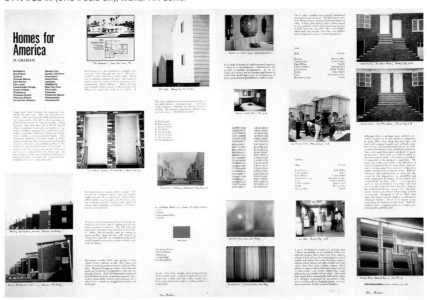

Dan Graham; *Homes for America*, 1966–1967; photo-offset reproduction of layout for *Arts Magazine*; 34 1/2 x 25 in. (87.6 x 63.5 cm); Walker Art Center

the institution of the Picture and the necessary structure of the depiction itself. It was physically possible to separate the actions of the painter—those touches of the brush which had historically always, in the West at least, led to a depiction—from depiction, and abstract art was the most conclusive evidence for this.

Photography constitutes a depiction not by the accumulation of individual marks, but by the instantaneous operation of an integrated mechanism. All the rays permitted to pass through the lens form an image immediately, and the lens, by definition, creates a focused image at its correct focal length. Depiction is the only possible result of the camera system, and the kind of image formed by a lens is the only image possible in photography. Thus, no matter how impressed photographers may have been by the analytical rigor of modernist critical discourse, they could not participate in it directly in their practice because the specificities of their medium did not permit it. This physical barrier has a lot to do with the distanced relationship between painting and photography in the era of art-photography, the first sixty or so years of this century.

Despite the barrier, around the middle of the 1960s, numerous young artists and art students appropriated photography, turned their attention away from *auteurist* versions of its practice, and forcibly subjected the medium to a full-scale immersion in the logic of reductivism. The essential reduction came on the level of skill. Photography could be integrated into the new radical logics by eliminating all the pictorial suavity and technical sophistication it had accumulated in the process of its own imitation of the Great Picture. It was possible, therefore, to test the medium for its indispensable elements, without abandoning depiction, by finding ways to legitimate pictures that demonstrated the absence of the conventional marks of pictorial distinction developed by the great auteurs, from Atget to Arbus.

Already by around 1955, the revalorization and reassessment of vernacular idioms of popular culture had emerged as part of a new "new objectivity," an objectivism bred by the limitations of lyrical *art informel*, the introverted and self-righteously lofty art forms of the 1940s and 1950s. This new critical trend had sources in high art and high academe, as the names Jasper Johns and Piero Manzoni, Roland Barthes and Leslie Fiedler, indicate. It continues a fundamental project of the earlier avant-garde—the transgression of the boundaries between "high" and "low" art, between artists and the rest of the people, between "art" and "life." Although Pop art in the late fifties and early sixties seemed to concentrate on bringing mass-culture elements into high-culture forms, already by the 1920s the situation had become far more complex and reciprocal than that, and motifs and styles from avant-garde and high-culture sources were circulating extensively in the various new Culture Industries in Europe, the United States, the Soviet Union, and elsewhere. This transit between "high" and "low" had become the central problematic for the avant-garde because it reflected so decisively the process of modernization of all cultures. The great question was whether or not art as it had emerged from the past would be "modernized" by being dissolved into the new mass-cultural structures.

Hovering behind all tendencies toward reductivism was the shadow of this great "reduction." The experimentation with the "anaesthetic," with "the look of non-art," "the condition of no-art," or with "the loss of the visual," is in this light a kind of tempting of fate. Behind the Greenbergian formulae, first elaborated in the late 1930s, lies the fear that there may be, finally, no indispensable characteristics that distinguish the arts, and that art as it has come down to us is very dispensable indeed. Gaming with the anaesthetic was both an intellectual necessity in the context of modernism, and at the same time the release of social and psychic energies which had a stake in the "liquidation" of bourgeois "high art." By 1960 there was pleasure to be had in this experimentation, a pleasure, moreover, which had been fully sanctioned by the aggressivity of the first avant-garde or, at least, important parts of it.

Douglas Huebler; *Duration Piece #7, Rome, March 1973* (detail), 1973; 14 black-and-white photographs and statement; overall dimensions 39¼ x 32½ in. (99.7 x 81.9 cm) framed; courtesy Darcy Huebler

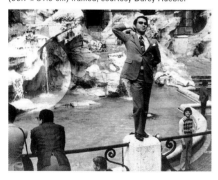

Duration Piece #7
Rome

Fourteen photographs were made, at exact 30 second intervals, in order to document specific changes in the relationship between two aspects of the water falling from the rocks in one area at the base of the Fountain of Trevi.

The photographs, undesignated by the sequence in which they were made, join with this statement to constitute the form of this work.

March, 1973 Douglas Huebler

Radical deconstructions therefore took the form of searches for models of "the anaesthetic." Duchamp had charted this territory before 1920, and his influence was the decisive one for the new critical objectivisms surfacing forty years later with Gerhard Richter, Andy Warhol, Manzoni, John Cage, and the rest. The anaesthetic found its emblem in the Readymade, the commodity in all its guises, forms, and traces. Working-class, lower-middle class, suburbanite, and underclass milieux were expertly scoured for the relevant utilitarian images, depictions, figurations, and objects that violated all the criteria of canonical modernist taste, style, and technique. Sometimes the early years of Pop art seem like a race to find the most perfect, metaphysically banal image, that cipher that demonstrates the ability of culture to continue when every aspect of what had been known in modern art as seriousness, expertise, and reflexiveness had been dropped. The empty, the counterfeit, the functional, and the brutal themselves were of course nothing new as art in 1960, having all become tropes of the avant-garde via Surrealism. From the viewpoint created by Pop art, though, earlier treatments of this problem seem emphatic in their adherence to the Romantic idea of the transformative power of authentic art. The anaesthetic is transformed as art, but along the fracture-line of shock. The shock caused by the appearance of the anaesthetic in a serious work is calmed by the aura of seriousness itself. It is this aura which becomes the target of the new wave of critical play. Avant-garde art had held the anesthetic in a place by a web of sophisticated manoeuvres, calculated transgressive gestures, which always paused on the threshold of real abandonment. Remember Bellmer's pornography, Heartfield's propaganda, Mayakovsky's advertising. Except for the Readymade, there was no complete mimesis or appropriation of the anaesthetic, and it may be that the Readymade, that thing that had indeed crossed the line, provided a sort of fulcrum upon which, between 1920 and 1960, everything else could remain balanced.

The unprecedented mimesis of "the condition of no art" on the part of the artists of the early sixties seems to be an instinctive reflection of these lines from Theodor Adorno's *Aesthetic Theory*, which was being composed in that same period: "Aesthetics, or what is left of it, seems to assume tacitly that the survival of art is unproblematic. Central for this kind of aesthetics therefore is the question of how art survives, not whether it will survive at all. This view has little credibility today. Aesthetics can no longer rely on art as a fact. If art is to remain faithful to its concept, it must pass over into anti-art, or it must develop a sense of self-doubt which is born of the moral gap between its continued existence and mankind's catastrophes, past and future," and "At the present time significant modern art is entirely unimportant in a society that only tolerates it. This situation affects art itself, causing it to bear the marks of indifference: there is the disturbing sense that this art might just as well be different or might not exist at all."[7]

The pure appropriation of the anaesthetic, the imagined completion of the gesture of passing over into anti-art, or non-art, is the act of internalization of society's indifference to the happiness and seriousness of art. It is also, therefore, an expression of the artist's own identification with baleful social forces. This identification may be, as always in modernism, experimental, but the experiment must be carried out in actuality, with the risk that an "identification with the aggressor" will really occur and be so successful socially as art that it becomes inescapable and permanent. Duchamp gingerly seemed to avoid this; Warhol perhaps did not. In not doing so, he helped make explicit some of the hidden energies of reductivism. Warhol made his taboo-breaking work by subjecting photography to reductivist methodology, both in his silkscreen paintings and in his films. The paintings reiterated or appropriated photojournalism and glamour photography and claimed that picture-making skills were of minor importance in making significant pictorial art. The films extended the argument directly into the regime of the photographic, and established an aesthetic of the amateurish which tapped into New York traditions going back via the Beats and independents to the late 1930s and the film experiments of James Agee and Helen Levitt. To the tradition of independent, intimate, and naturalistic filmmaking, as practiced by Robert Frank, John Cassavetes, or Frederick Wiseman, Warhol added (perhaps "subtracted" would be the better word) the agony of reductivism. Cassavetes fused the documentary tradition with method acting in films like *Faces* (1968), with the intention of getting close to people. The rough photography and lighting drew attention to itself, but the style signified a moral decision to forego technical finish in the name of emotional truth. Warhol reversed this in films like *Eat, Kiss,* or *Sleep* (all 1963), separating the picture-style from its radical humanist content-types, in effect using it to place people at a peculiar distance, in a new relationship with the spectator. Thus a methodological model is constructed: the non-professional or amateurist camera technique, conven-

Publicity still from John Cassavetes' *Faces* (filmed 1965/released 1968); courtesy Photofest

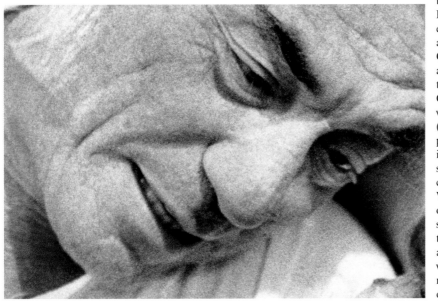

tionally associated with anti-commercial naturalism and existential, if not political, commitment, is separated from those associations and turned toward new psycho-social subjects, including a new version of the glamour it wanted to leave behind. In this process, amateurism as such becomes visible as the photographic modality or style which, in itself, signifies the detachment of photography from three great norms of the Western pictorial tradition—the formal, the technical, and the one relating to the range of subject-matter. Warhol violates all these norms simultaneously, as Duchamp had done before him with the Readymade. Duchamp managed to separate his work as an object from the dominant traditions, but not until Warhol had the picture been accorded the same treatment.[8] Warhol's replacement of the notion of the artist as a skilled producer with that of the artist as a consumer of new picture-making gadgets was only the most obvious and striking enactment of what could be called a new amateurism, which marks so much of the art of the 1960s and earlier 1970s.

Amateurish film and photographic images and styles of course related to the documentary tradition, but their deepest resonance is with the work of actual amateurs—the general population, the "people." To begin with, we must recognize a conscious utopianism in this turn toward the technological vernacular: Joseph Beuys's slogan "every man is an artist," or Lawrence Weiner's diffident conditions for the realization and possession of his works reflect with particular clarity the idealistic side of the claim that the *making* of artworks needs to be, and in fact has become, a lot easier than it was in the past. These artists argued that the great mass of the people had been excluded from art by social barriers and had internalized an identity as "untalented," and "inartistic" and so were resentful of the high art that the dominant institutions unsuccessfully compelled them to venerate. This resentment was the moving force of philistine mass culture and kitsch, as well as of repressive social and legislative attitudes toward the arts. Continuation of the regime of specialized high art intensified the alienation of both the people and the specialized, talented artists who, as the objects of resentment, developed elitist antipathy toward "the rabble" and identified with the ruling classes as their only possible patrons. This vicious circle of "avant-garde and

kitsch" could be broken only by a radical transformation and negation of high art. These arguments repeat those of the earlier Constructivists, Dadaists, and Surrealists almost word for word, nowhere more consciously than in Guy Debord's *The Society of the Spectacle* (1967): "Art in the period of its dissolution, as a movement of negation in pursuit of its own transcendence in a historical society where history is not directly lived, is at once an art of change and a pure expression of the impossibility of change. The more grandiose its demands, the further from its grasp is true self-realization. This is an art that is necessarily *avant-garde*; and it is an art that *is not*. Its vanguard is its own disappearance."[9]

The practical transformation of art (as opposed to the idea of it) implies the transformation of the practices of both artists and their audiences, the aim being to obliterate or disable both categories into a kind of dialectical synthesis of them, a Schiller-like category of emancipated humanity which needs neither Representation nor Spectatorship. These ideals were an important aspect of the movement for the transformation of artistry, which opened up the question of skill. The utopian project of rediscovering the roots of creativity in a spontaneity and intersubjectivity freed from all specialization and spectacularized expertise combined with the actual profusion of light consumer technologies to legitimate a widespread "de-skilling" and "re-skilling" of art and art education. The slogan "painting is dead" had been heard from the avant-garde since 1920; it meant that it was no longer necessary to separate oneself from the people through the acquisition of skills and sensibilities rooted in a craft-guild exclusivity and secrecy; in fact, it was absolutely necessary not to do so, but rather to animate with radical imagination those common techniques and abilities made available by modernity itself. First among these was photography.

The radicals' problem with photography was, as we have seen, its evolution into an art-photography. Unable to imagine anything better, photography lapsed into an imitation of high art and uncritically recreated its esoteric worlds of technique and "quality." The instability of the concept of art-photography, its tendency to become reflexive and to exist at the boundary-line of the utilitarian, was muffled in the process of its "artification." The criteria

of deconstructive radicalism—expressed in ideas like "the conditions of no art," and "every man is an artist"—could be applied to photography primarily, if not exclusively, through the imitation of amateur picture-making. This was no arbitrary decision. A popular system of photography based on a minimal level of skill was instituted by George Eastman in 1888, with the Kodak slogan, "you push the button; we do the rest." In the 1960s, Jean-Luc Godard debunked his own creativity with the comment that "Kodak does 98 percent." The means by which photography could join and contribute to the movement of the modernist autocritique was the user-friendly mass-market gadget-camera. The Brownie, with its small gauge roll-film and quick shutter was also, of course, the prototype for the equipment of the photojournalist, and therefore is present, as a historical shadow, in the evolution of art-photography as it emerged in its dialectic with photojournalism. But the process of professionalization of photography led to technical transformations of small-scale cameras, which, until the more recent proliferation of mass-produced SLRs, reinstituted an economic barrier for the amateur that became a social and cultural one as well. Not until the 1960s did we see tourists and picnickers sporting Pentaxes and Nikons; before then they used the various Kodak or Kodak-like products, such as the Hawkeye, or the Instamatic, which were little different from a 1925-model Brownie.[10]

Andy Warhol; *KISS*, 1963; film still, black-and-white, silent; The Andy Warhol Museum: Founding Collection

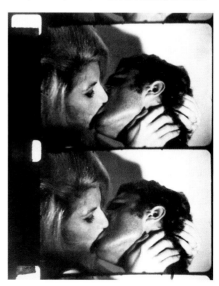

It is significant, then, that the mimesis of amateurism began around 1966; that is, at the last moment of the "Eastman era" of amateur photography, at the moment when Nikon and Polaroid were revolutionizing it. The mimesis takes place at the threshold of a new technological situation, one in which the image-producing capacity of the average citizen was about to make a quantum leap. It is thus, historically speaking, really the last moment of "amateur photography" as such, as a social category established and maintained by custom and technique. Conceptualism turns toward the past just as the past darts by into the future; it elegizes something at the same instant that it points toward the glimmering actualization of avant-garde utopianism through technological progress.

If "every man is an artist," and that artist is a photographer, he will become so also in the process in which high-resolution photographic equipment is released from its cultish possession by specialists and is made available to all in a cresting wave of consumerism. The worlds of Beuys and McLuhan mingle as average citizens come into possession of "professional-class" equipment. At this moment, then, amateurism ceases to be a technical category; it is revealed as a mobile social category in which limited competence becomes an open field for investigation.

"Great art" established the idea (or ideal) of unbounded competence, the wizardry of continually-evolving talent. This ideal became negative, or at least seriously uninteresting, in the context of reductivism, and the notion of limits to competence, imposed by oppressive social relationships, became charged with exciting implications. It became a subversive creative act for a talented and skilled artist to imitate a person of limited abilities. It was a new experience, one which ran counter to all accepted ideas and standards of art, and was one of the last gestures which could produce avant-gardist shock. The mimesis signified, or expressed, the vanishing of great traditions of Western art into the new cultural structures established by the mass media, credit financing, suburbanization, and reflexive bureaucracy. The act of renunciation required for a skilled artist to enact this mimeses, and construct works as models of its consequences, is a scandal typical of avant-garde desire, the desire to occupy the threshold of the aesthetic, its vanishing-point.

Many examples of such amateurist mimesis can be drawn from the corpus of photoconceptualism, and it could probably be said that almost all photoconceptualists indulged in it to some degree. But one of the purest and most exemplary instances is the group of books published by Edward Ruscha between 1963 and 1970.

For all the familiar reasons, Los Angeles was perhaps the best setting for the complex of reflections and crossovers between Pop art, reductivism, and their mediating middle term, mass culture, and Ruscha for biographical reasons may inhabit the persona of the American Everyman particularly easily. The photographs in *Some Los Angeles Apartments* (1965), for example, synthesize the brutalism of Pop art with the low-contrast monochromaticism of the most utilitarian and perfunctory photographs (which could be imputed to have been taken by the owners, managers, or residents of the buildings in question). Although one or two pictures suggest some recognition of the criteria of art-photography, or even architectural photography (e.g. "2014 S. Beverly Glen Blvd."), the majority seem to take pleasure in a rigorous display of generic lapses: improper relation of lenses to subject distances, insensitivity to time of day and quality of light, excessively functional cropping, with abrupt excisions of peripheral objects, lack of attention to the specific character of the moment being depicted—all in all a hilarious perform-

ance, an almost sinister mimicry of the way "people" make images of the dwellings in which they are involved. Ruscha's impersonation of such an Everyperson obviously draws attention to the alienated relationships people have with their built environment, but his pictures do not in any way stage or dramatize that alienation the way that Walker Evans did, or that Lee Friedlander was doing at that moment. Nor do they offer a transcendent experience of a building that pierces the alienation usually felt in life, as with Atget, for example. The pictures are, as reductivist works, models of our actual relations with their subjects, rather than dramatized representations that transfigure those relations by making it impossible for us to have such relations with *them*.

Ruscha's books ruin the genre of the "book of photographs," that classical form in which art-photography declares its independence. *Twentysix Gasoline Stations* (1962) may depict the service stations along Ruscha's route between Los Angeles and his family home in Oklahoma, but it derives its artistic significance from the fact that at a moment when "The Road" and roadside life had already become an auteurist cliché in the hands of Robert Frank's epigones, it resolutely denies any representation of its theme, seeing the road as a system and an economy mirrored in the structure of both the pictures he took and the publication in which they appear. Only an idiot would take pictures of nothing but the filling

Edward Ruscha, *Union, Needles, California*, from *Twentysix Gasoline Stations*, 1962 (cat. no. 129)

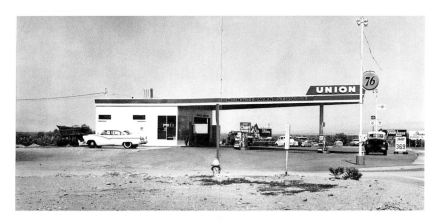

UNION, NEEDLES, CALIFORNIA

stations, and the existence of a book of just those pictures is a kind of proof of the existence of such a person. But the person, the asocial cipher who cannot connect with the others around him, is an abstraction, a phantom conjured up by the construction, the structure of the product said to be by his hand. The anaesthetic, the edge or boundary of the artistic, emerges through the construction of this phantom producer, who is unable to avoid bringing into visibility the "marks of indifference" with which modernity expresses itself in or as a "free society."

Amateurism is a radical reductivist methodology insofar as it is the form of an impersonation. In photoconceptualism, photography posits its escape from the criteria of art-photography through the artist's performance as a non-artist who, despite being a non-artist, is nevertheless compelled to make photographs. These photographs lose their status as Representations before the eyes of their audience: they are "dull," "boring," and "insignificant." Only by being so could they accomplish the intellectual mandate of reductivism at the heart of the enterprise of Conceptual art. The reduction of art to the condition of an intellectual concept of itself was an aim which cast doubt upon any given notion of the sensuous experience of art. Yet the loss of the sensuous was a state which itself had to be experienced. Replacing a work with a theoretical essay which could hang in its place was the most direct means toward this end; it was Conceptualism's most celebrated action, a gesture of usurpation of the predominant position of all the intellectual organizers who controlled and defined the Institution of Art. But, more importantly, it was the proposal of the final and definitive negation of art as depiction, a negation which, as we've seen, is the *telos* of experimental, reductivist modernism. And it can still be claimed that Conceptual art actually accomplished this negation. In consenting to read the essay that takes a work of art's place, spectators are presumed to continue the process of their own redefinition, and thus to participate in a utopian project of transformative, speculative self-reinvention: an avant-garde project. Linguistic conceptualism takes art as close to the boundary of its own self-overcoming, or self-dissolution, as it is likely to get, leaving its audience with only the task of rediscovering legitimations for works of art as they had existed, and might continue to exist. This was, and remains, a revolutionary way of thinking about art, in which its right to exist is rethought in the place or moment traditionally reserved for the enjoyment of art's actual existence, in the encounter with a work of art. In true modernist fashion it establishes the dynamic in which the intellectual legitimation of art as such—that is, the philosophical content of aesthetics—is experienced as the content of any particular moment of enjoyment.

But, dragging its heavy burden of depiction, photography could not follow pure, or linguistic, Conceptualism all the way to the frontier. It cannot provide the experience of the negation of experience, but must continue to provide the experience of depiction, of the Picture. It is possible that the fundamental shock that photography caused was to have provided a depiction which could be experienced more the way the visible world is experienced than had ever been possible previously. A photograph therefore shows its subject by means of showing what experience is like; in that sense it provides "an experience of experience," and it defines this as the significance of depiction.

In this light, it could be said that it was photography's role and task to turn away from Conceptual art, away from reductivism and its aggressions. Photoconceptualism was then the last moment of the pre-history of photography as art, the end of the Old Regime, the most sustained and sophisticated attempt to free the medium from its peculiar distanced relationship with artistic radicalism and from its ties to the Western Picture. In its failure to do so, it revolutionized our concept of the Picture and created the conditions for the restoration of that concept as a central category of contemporary art by around 1974.

Notes

1. Cf. Thierry de Duve's discussion of nominalism, in *Pictorial Nominalism: On Marcel Duchamp's Passage from Painting to the Readymade*, trans. Dana Polan with the author (Minneapolis: University of Minnesota Press, 1991).

2. Peter Bürger, *Theory of the Avant-Garde*, trans. Michael Shaw (Minneapolis: University of Minnesota Press, 1984).

3. A variant, made as a collage, is in the Daled Collection, Brussels.

4. Friedrich Nietzsche, "Ecco Homo," in *On the Genealogy of Morals and Ecce Homo*, ed. Walter Kaufmann and trans. Kaufmann and R. J. Hollingdale (New York: Vintage Books, 1967), 290.

5. Clement Greenberg, "Modernist Painting," in *Clement Greenberg: The Collected Essays and Criticism*, vol. 4: *Modernism with a Vengeance, 1957–1969*, ed. John O'Brian (Chicago: University of Chicago Press, 1993). 92.

6. Ibid., 86.

7. Theodor Adorno, *Aesthetic Theory*, trans. C. Lenhardt (London: Routledge & Kegan Paul, 1984), 464, 470.

8. Cf. de Duve's argument that the Readymade can/should be nominated as painting.

9. Guy Debord, *The Society of the Spectacle*, trans. Donald Nicholson-Smith (New York: Zone Books, 1994), 135 (thesis 190).

10. Robert A. Sobieszek discusses Robert Smithson's use of the Instamatic camera in his essay, "Robert Smithson: Photo Works," in *Robert Smithson: Photo Works*, exh. cat. (Los Angeles: Los Angeles County Museum of Art and Albuquerque: University of New Mexico Press, 1993), 16, 17 (note 24), 25 (note 61).

Edward Ruscha, *Every Building on the Sunset Strip*, 1966 (cat. no. 131)

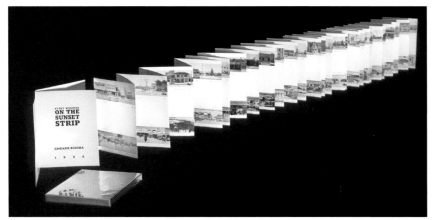

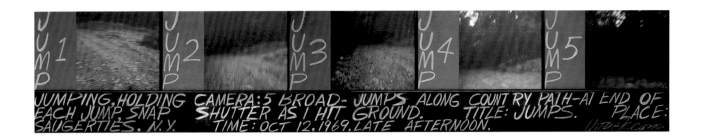

Vito Acconci, *Jumps*, 1969 (cat. no. 1)

Vito Acconci, *Margins*, 1969 (cat. no. 2)

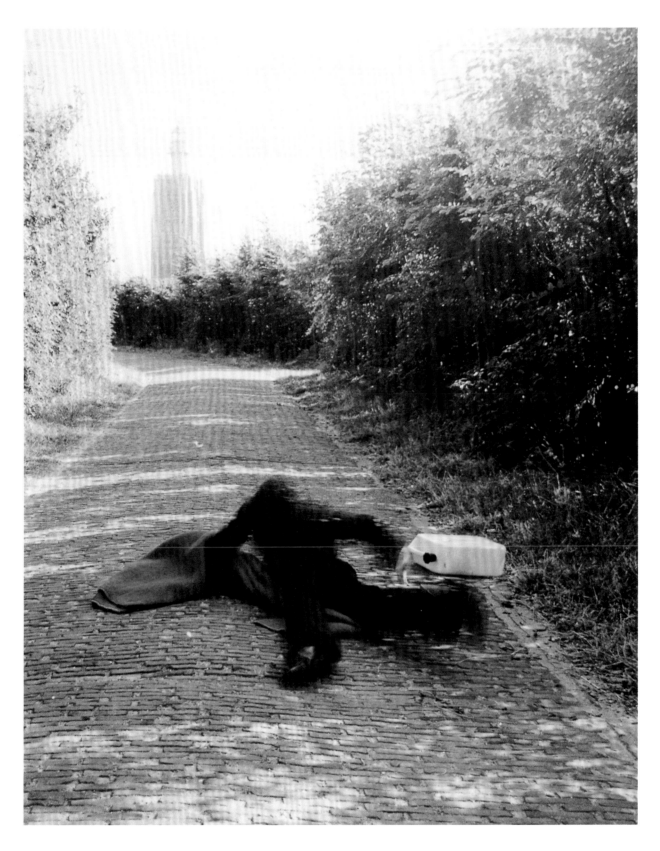

Bas Jan Ader, *Pitfall on the Way to a New
Neo Plasticism, Westkapelle, Holland*, 1971
(cat. no. 4)

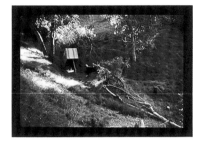

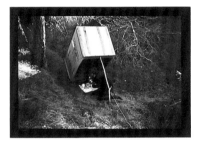

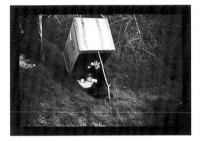

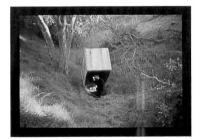

Bas Jan Ader, *Untitled (Tea Party)*,
1972 (cat. no. 5)
Right: detail

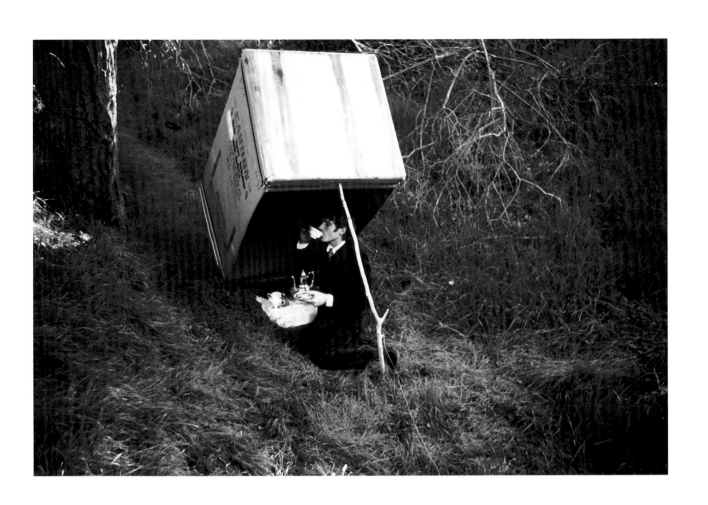

Giovanni Anselmo, *Lato destro*
(Right side), 1970
(cat. no. 8)

Giovanni Anselmo, *Entrare nell'opera*
(Entering the work), 1971 (cat. no. 9)

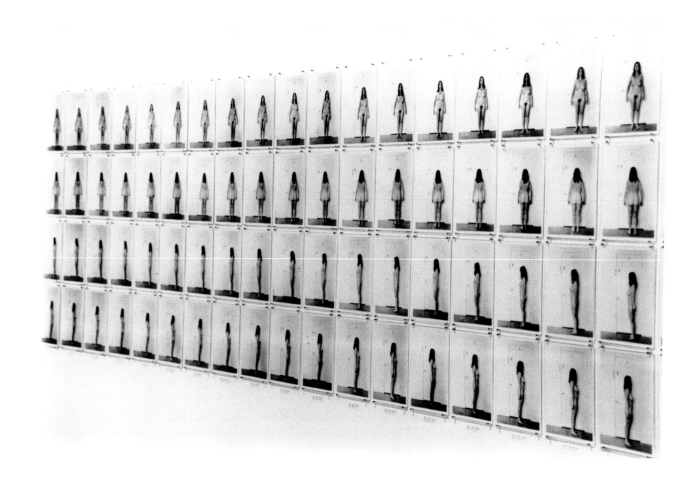

Eleanor Antin, *Carving: A Traditional Sculpture*, 1972 (cat. no. 10)
Right: detail

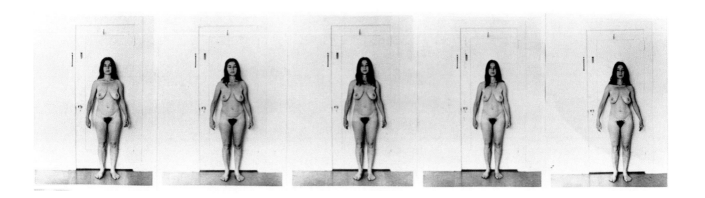

John Baldessari, *Choosing*
(A Game for Two Players): Rhubarb, 1972
(cat. no. 12)

John Baldessari, *A Movie: Directional Piece. Where People Are Looking (with R, V, G, Variants and Ending with Yellow)*, 1972–1973 (cat. no. 13)

John Baldessari, *Alignment Series:
Things in My Studio (by Height)*, 1975
(cat. no. 15)

John Baldessari, *Embed Series: Oiled
Arm* (*Sinking Boat and Palms*), 1974
(cat. no. 14)
Bottom: details

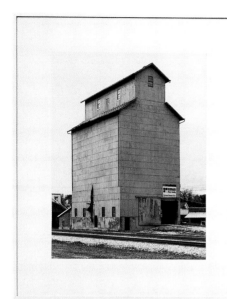

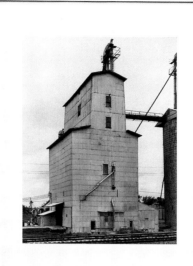

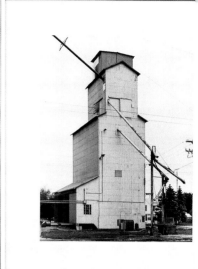

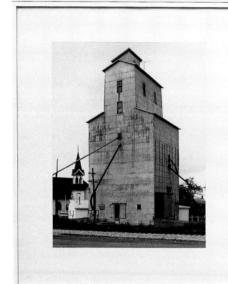

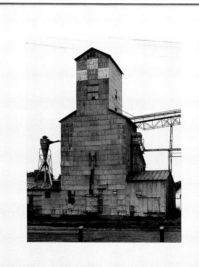

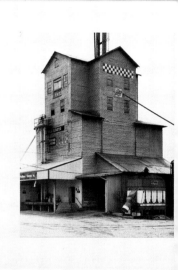

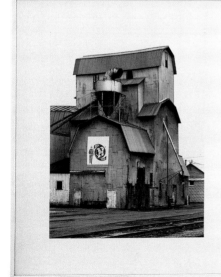

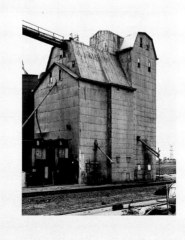

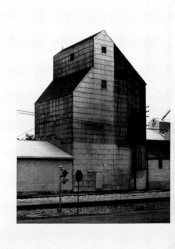

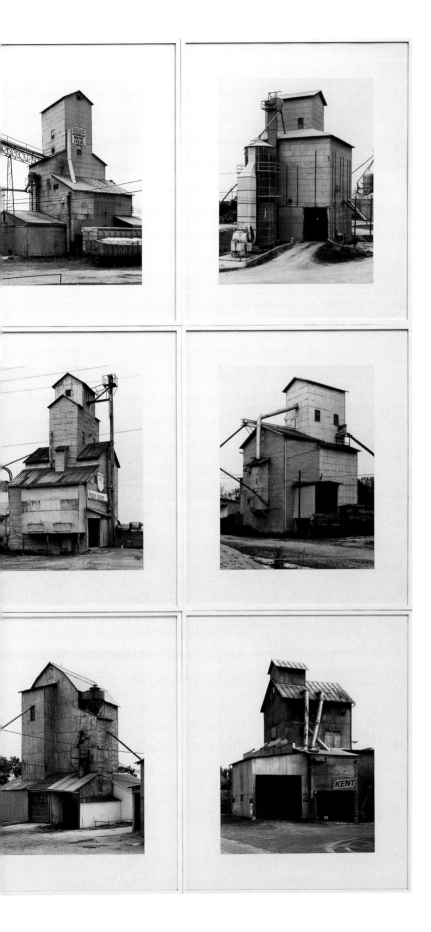

Bernd and Hilla Becher,
Grain Elevators USA, 1977/1995
(cat. no. 18)

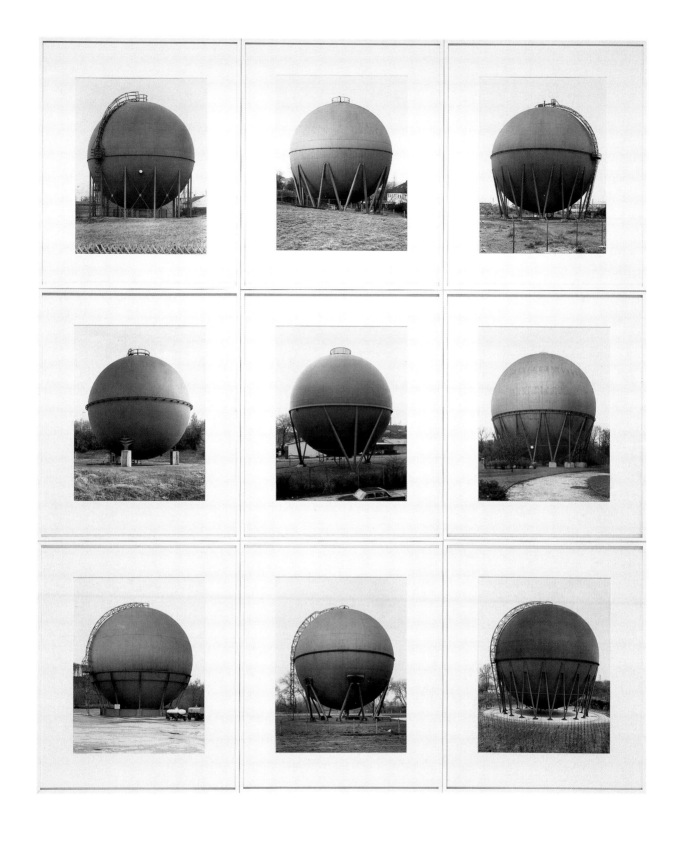

Bernd and Hilla Becher,
Gas Tanks (*Spherical*), 1963
(cat. no. 16)

Right:
Joseph Beuys,
La rivoluzione siamo noi, 1972
(cat. no. 20)

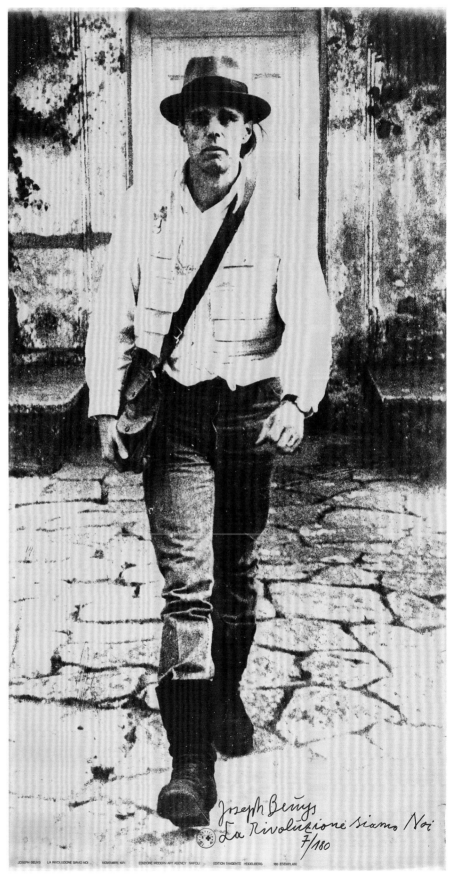

JOSEPH BEUYS LA RIVOLUZIONE SIAMO NOI NOVEMBRE 1971 EDIZIONE MODERN ART AGENCY NAPOLI EDITION TANGENTE HEIDELBERG 180 ESEMPLARI

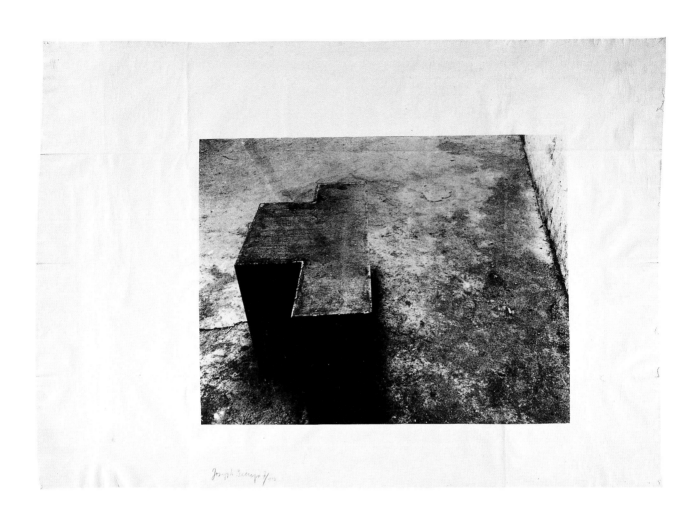

Joseph Beuys, *Vakuum ↔ Masse*
(Vacuum ↔ mass), 1970 (cat. no. 19)

Joseph Beuys,
Enterprise 18.11.72, 18:5:16 Uhr
(Enterprise 11/18/72, 18:5:16 hours), 1973
(cat. no. 21)

Mel Bochner, *Surface Deformation/Crumple*
1967/2000 (cat. no. 23)

Mel Bochner, *Crumple*, 1967/1994
(cat. no. 22)

Mel Bochner, *Surface Dis/Tension*, 1968
(cat. no. 24)

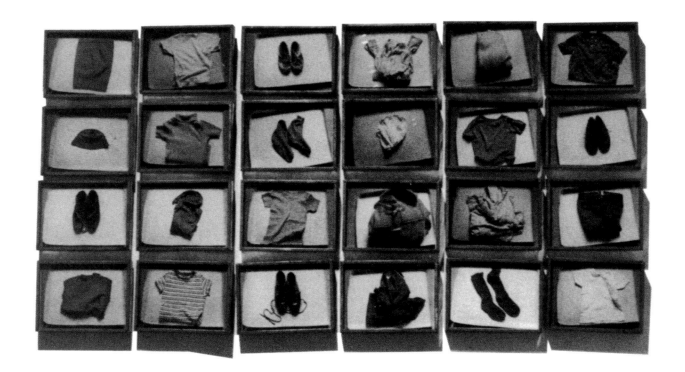

Christian Boltanski,
Les habits de François C.
(The clothes of François C.), 1972
(cat. no. 25)

Christian Boltanski, *Les 62 membres du Club Mickey en 1955* (The 62 members of the Mickey Mouse Club in 1955), 1972 (cat. no. 26)
Right: detail

Marcel Broodthaers, *No Photographs
Allowed/Défense de photographier*, 1974
(cat. no. 27)

Marcel Broodthaers, *La soupe de Daguerre*
(The soup of Daguerre), 1974
(cat. no. 28)

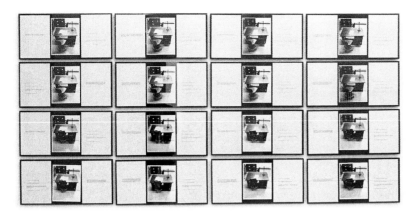

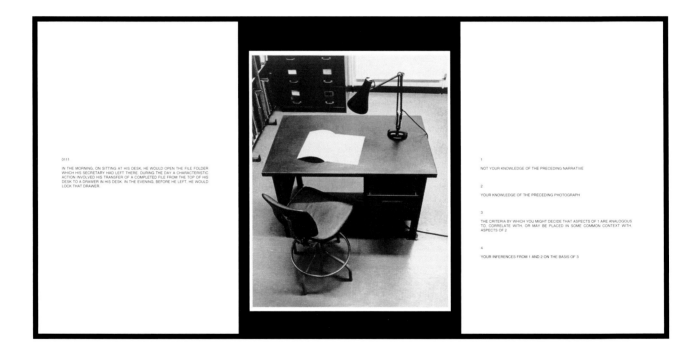

Victor Burgin, *Performative/Narrative*, 1971
(cat. no. 29)
Bottom and right: details

0101

BEFORE REACHING THE DOOR HE HAD STOPPED HIS HITHERTO RAPID PROGRESS DOWN THE DARKENED ROOM AND WAS NOW EXAMINING A FOLDER WHICH WAS LYING ON A DESK. A YEAR LATER HIS SON WAS, AT THAT SAME DESK, TO READ THE CONTENTS OF THAT IDENTICAL FILE WHICH HIS SECRETARY HAD THAT MORNING DISCOVERED IN A DRAWER.

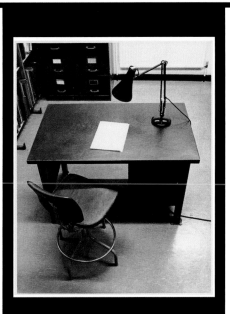

1

NOT YOUR KNOWLEDGE OF THE PRECEDING NARRATIVE

2

YOUR KNOWLEDGE OF THE PRECEDING PHOTOGRAPH

3

NOT THE CRITERIA BY WHICH YOU MIGHT DECIDE THAT ASPECTS OF 1 ARE ANALOGOUS TO, CORRELATE WITH, OR MAY BE PLACED IN SOME COMMON CONTEXT WITH, ASPECTS OF 2

4

YOUR INFERENCES FROM 1 AND 2 ON THE BASIS OF 3

0001

THE GIRL HAD OBVIOUSLY BEEN ABOUT TO SPEAK AS SHE HAD INTERRUPTED HER ACTION OF PLACING THE FOLDER UPON THE COUNTER. LATER, AT THE OFFICE, HER EMPLOYER APPEARED TO LISTEN TO HER WHILE STARING AT THE SAME FILE WHICH WAS NOW UPON HIS DESK. YESTERDAY HIS SON HAD SEEMED SIMILARLY TRANSFIXED AS HE READ THOSE IDENTICAL PAPERS AT HIS HOME.

1

NOT YOUR KNOWLEDGE OF THE PRECEDING NARRATIVE

2

NOT YOUR KNOWLEDGE OF THE PRECEDING PHOTOGRAPH

3

NOT THE CRITERIA BY WHICH YOU MIGHT DECIDE THAT ASPECTS OF 1 ARE ANALOGOUS TO, CORRELATE WITH, OR MAY BE PLACED IN SOME COMMON CONTEXT WITH, ASPECTS OF 2

4

YOUR INFERENCES FROM 1 AND 2 ON THE BASIS OF 3

Sarah Charlesworth, *April 21, 1978*,
from *Modern History*, 1978 (cat. no. 30)
Above and right: details

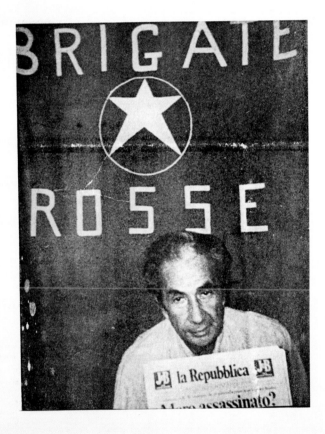

la Repubblica

Direttore Eugenio Scalfari

Anno 3 - Numero 95 - L. 200

Redazione, Amministrazione: 00185 ROMA, Piazza Indipendenza, 11-b, tel. 497941 telex 68180-64005 (ccc. post. 2412 Roma AD Spad. in abb. post. gr. 1/70 — Abbonamenti: ITALIA (c.c.p. n. 11200063 - Roma) anno L. 40.000, semestre 25.000, trimestre 15.000 - ESTERO: anno 80.500, semestre 41.500, trimestre 21.500 (posta ordinaria) — Copia arretrata L. 400 — Redazione di Milano, via Turati 3, tel. 659525 - 9571717 - telex 25283
Concessionaria per la pubblicità: A. MANZONI & C. S.p.A., 20121 MILANO - via Agnello 12

venerdì 21 aprile 1978

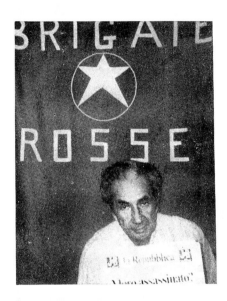

Sarah Charlesworth, *April 21, 1978*,
from *Modern History*, 1978 (cat. no. 30)
Above and right: details

Anno 103 · N. 94 · L. 200 (Arretrato L. 400) Venerdì 21 aprile 1978 · L. 200

CORRIERE DELLA SERA

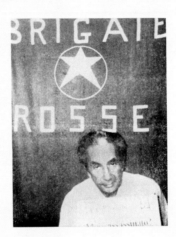

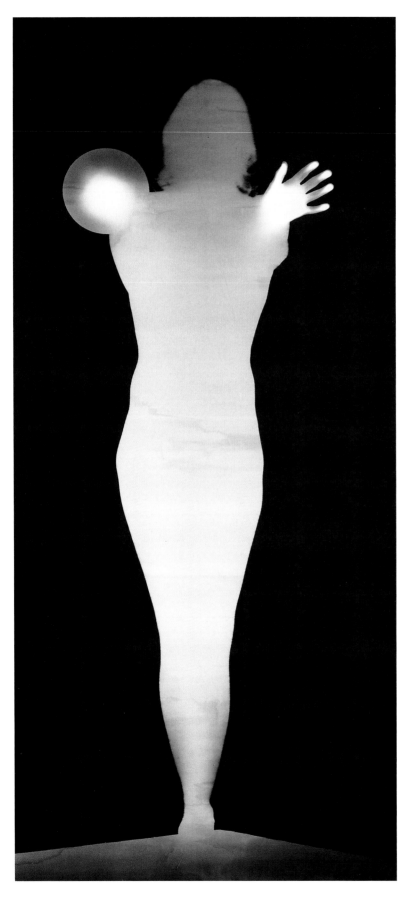

Bruce Conner, ANGEL, 1975
(cat. no. 31)

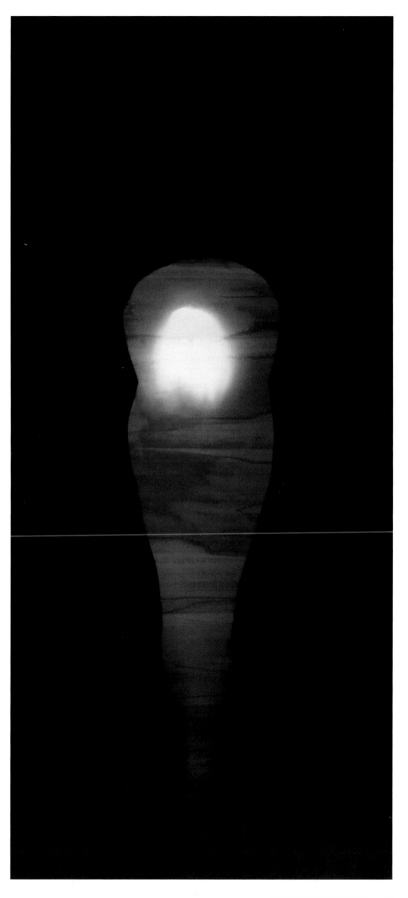

Bruce Conner, NIGHT ANGEL, 1975
(cat. no. 32)

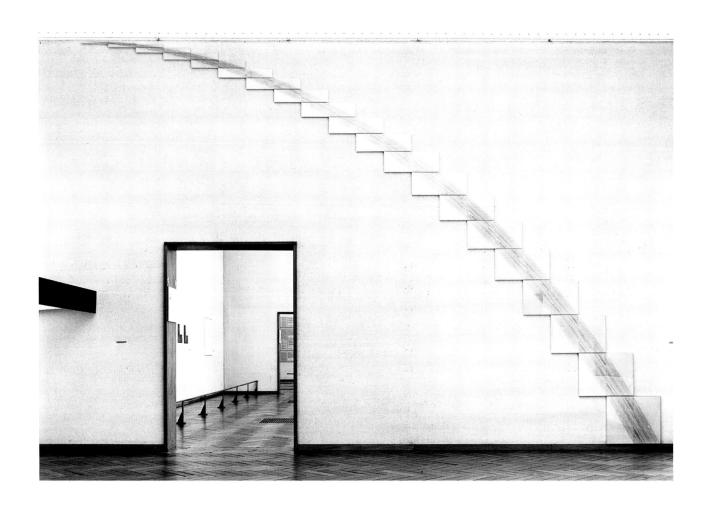

Jan Dibbets; *Big Comet 3°– 60°*,
Sky/Sea/Sky, 1973; 20 color photographs;
177 x 236 in. (450 x 600 cm) overall;
Collection Stedelijk Museum, Amsterdam

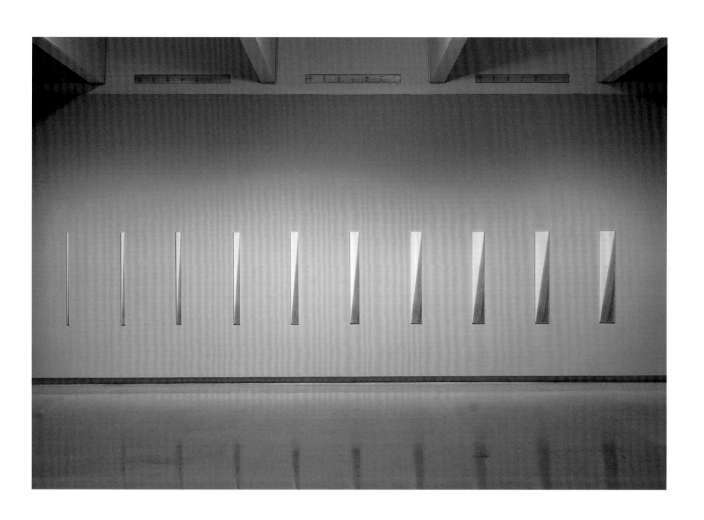

Jan Dibbets, *Horizon 1°– 10° Land*, 1973
(cat. no. 34)

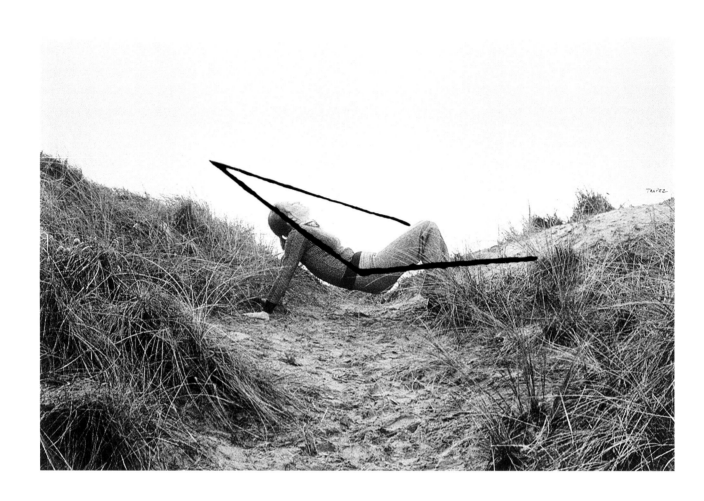

Valie Export, *Trapez* (Trapezoid), 1972
(cat. no. 38)

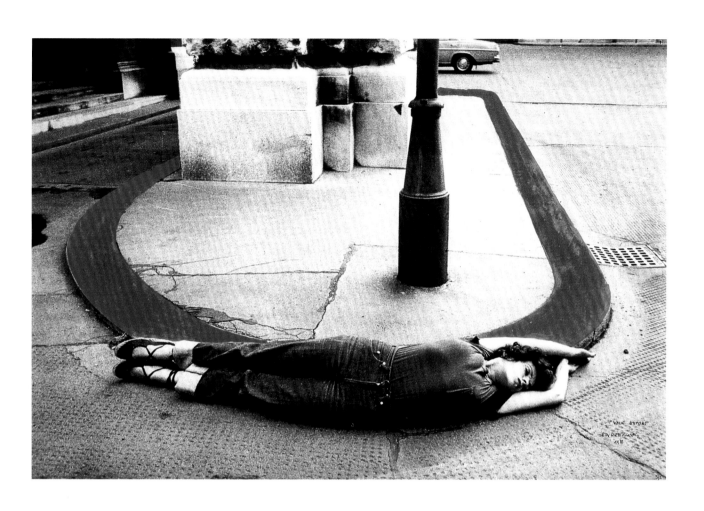

Valie Export, *Einkreisung* (Encirclement),
1976 (cat. no. 42)

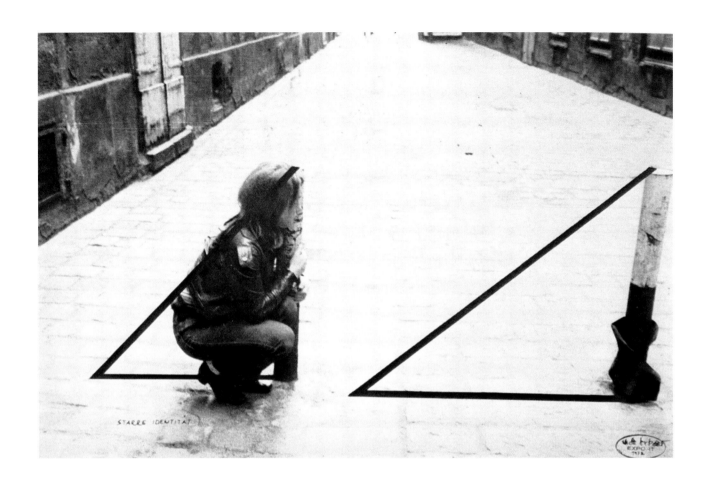

Valie Export, *Starre Identität*
(Fixed identity), 1972 (cat. no. 37)

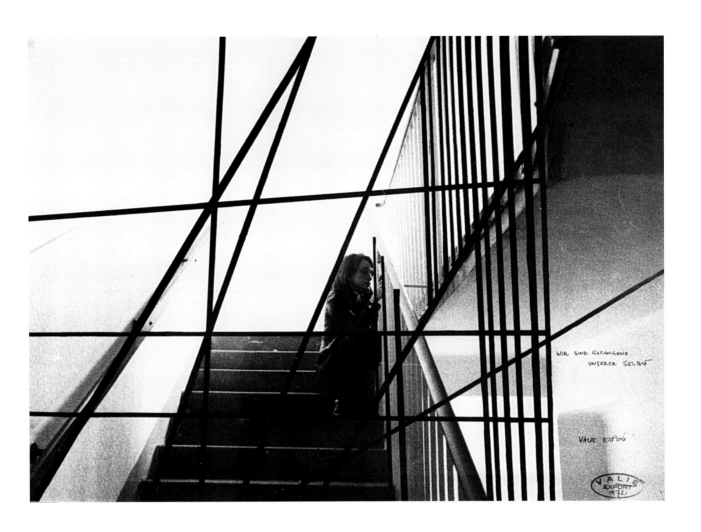

Valie Export, *Wir sind Gefangene unserer Selbst* (We are prisoners of ourselves), 1972 (cat. no. 39)

Stefan Gronert

Alternative Pictures: Conceptual Art and the Artistic Emancipation of Photography in Europe

Stefan Gronert is chief curator of the graphics department at the Kunstmuseum Bonn. He also teaches the history of modern photography at the University of Bonn. He has curated numerous exhibitions on modern art at the Kunstmuseum Bonn, including *Thomas Struth: Strassen/Streets* (1995), *Drawing Now* (1997, 1999, 2001, 2003), and *Great Illusions: Demand–Gursky–Ruscha* (1999).

Translated by Jeanne Haunschild.

Conceptual Art—a term that describes heterogeneous aesthetic approaches—and the artistic use of the pictorial medium of photography have certainly not evolved along parallel tracks, either historically or methodologically. Nevertheless in the late 1960s and the 1970s there was a strong affinity between these categories. Although the use of text is often seen as a trademark of Conceptual Art,[1] photography also took on new importance at this time. One could argue, in fact, that the use of photography by Conceptual artists effected a fundamental shift in the history of the modern picture. This comparatively unspectacular change differed from all of modernism's previous transformations, above all, in that the concept of "picture" no longer simply coincided with that of "painting," but was expanded to encompass other media, which took on the status of fine art for the first time.[2]

In contrast to Minimal Art, which came on the scene several years earlier, Conceptual Art was not a purely or specifically American phenomenon.[3] Its emergence could be observed more or less simultaneously in Europe and the United States.[4] Any history of photoconceptualism in Europe must take into account, however, that the development of photography as a pictorial medium followed a completely different course in Europe than it did in the United States. In 1976 Nancy Foote coined the rubric "anti-photographers" to describe

artists working in the United States whose strength "lies in their unique ability to gather, preserve and present outside information, not to 'make art.'"[5] This attitude cannot be found in the work of European artists of that time. Since no genuine fine art photography had existed in Europe in the decades leading up to the emergence of the Conceptual Art movement, there was no possibility for an *anti*-photography to develop. For this reason the historical logic of the revolution that photoconceptualism brought about in the way a picture could be defined (which Jeff Wall worked out so impressively for North American art in 1995)[6] must be reformulated for the European situation.

A Brief Prehistory

In the United States there was, despite some internal disruptions, a continual engagement between art and photography, so that by the early twentieth century the latter had become an established sphere of artistic activity. European art photography, by contrast, experienced a deep rupture in the 1930s. The careers of such recognized pioneers as August Sander (1876–1964) and Albert Renger-Patzsch (1897–1966) were brought to an end by National Socialism. Karl Blossfeldt (1865–1932) and Aenne Biermann (1898–1933) died in the 1930s and remained forgotten into the 1970s. Following a period of engagement with the Central European avant-garde, Aleksandr Rodchenko (1891–1956) returned to the Soviet Union. There were other important photographers who decided to emigrate during World War II: André Kertész (1894–1985), Herbert Bayer (1900–1985), and László Moholy-Nagy (1895–1946) to the United States; Germaine Krull (1897–1985) to Brazil and Africa. Berenice Abbott exported a large proportion of the estate of Eugène Atget (1857–1927) to the United States in 1928, laying the groundwork for its reception there.

Book burnings and the expulsion of intellectuals of the literary establishment such as Walter Benjamin, Alfred Döblin, Hermann Hesse, Thomas Mann, and Kurt Tucholsky, all of whom had recognized the artistic significance of photography as early as the 1920s, sounded the final knell. Gisèle Freund's dissertation, "La photographie en France au XIXe siècle: Essai de sociologie et d'esthétique" (1936),

which examined photography as a social force, was published in Paris shortly before the war, but the work was little known until the publication of a revised and expanded version in 1968. By contrast, in 1937 Beaumont Newhall, curator of photography at the Museum of Modern Art (MoMA) in New York, published his influential *History of Photography*, which has been reprinted and revised many times.[7]

Symptomatic for the break in the theoretical discussion of photography in Europe was the reception of what were surely the most influential twentieth-century essays on photography: Walter Benjamin's "A Short History of Photography" and "The Work of Art in the Age of Mechanical Reproduction," published in 1931 in French and in 1936 in German, respectively, then outlawed by the National Socialists and not republished in tandem until 1963. Although the late reception of Benjamin's writings certainly promoted a general interest in photography, it left its fine art status untouched, especially since he did not espouse photography as an autonomous art form.

In analogy to the hindered reception of these texts, the artistic emancipation of photography—that is, the use of this utilitarian medium for artistic purposes—had pretty much come to an end by the second half of the 1930s in the centers of European modernism, such as Paris and especially Germany. The instrumental use of photography for propaganda purposes by the totalitarian regimes of the 1930s and 1940s interrupted an art historical development whose continuation was limited almost exclusively to North America.[8] In the landmark postwar photography exhibition *The Family of Man* (1955), organized by Edward Steichen for the Museum of Modern Art, the artistic significance of photography was almost completely sacrificed to a cold war ideological agenda, yet it would have been nearly inconceivable for a major European museum to put on such an exhibition, even shortly after the war.[9]

The reinstatement of photography as an art form in Europe was gradual and difficult. As far as the German-speaking countries go, Otto Steinert deserves special mention; the *Subjektive Photographie* exhibitions—which he organized in 1951, 1954–1955, and 1958 in Saarbrücken—

featured works by individual artists who were carrying on the experimental tradition of the Bauhaus and of the Deutsche Werkbund's famous *Film und Foto* exhibition of 1929.[10] While the work of most of the photographers in other European countries, such as France,[11] was more focused on non-art areas such as photojournalism, Steinert tried to create a link to the avant-garde approaches of early modernist photography. Even though his crusade in Germany was not without an effect—think of photographers such as Chargesheimer (Karl-Heinz Hargesheimer), Peter Keetman, and Stefan Moses[12]—and was supported journalistically by Franz Roh (already in the 1920s one of the promoters of photography as art)[13] and especially by Schmoll gen. Eisenwerth,[14] Steinert's efforts remained largely ineffectual as far as the art world was concerned.

Since there were no comparable efforts in the neighboring European countries, Steinert's attempt at a broad-based tie-in to early modernist photography seems at least worthy of mention. What must not be forgotten is that this occurred at a time when painting absolutely dominated the scene. In the whole of postwar Europe the abstract painting that held sway was mostly the gestural-expressive kind. "Peinture informel"[15] was often regarded as an individualist statement of liberation from the totalitarian compulsion to paint realistically for the sake of propaganda. After the rediscovery of, and reoccupation with, the vanishing tradition of so-called classical modernism (exemplified by the work of Kandinsky, Klee, and other early twentieth-century artists) at *Documenta 1* in 1955 and the inclusion of American postwar art in *Documenta 2* (1959), what was by then a historical painting style continued to dominate the European art discourse until the mid-1960s.[16]

Tied in with this was the sociological study that Pierre Bourdieu and his colleagues in France carried out under the revealing title *Un art moyen* (1965), which also verified through empirical methods the aesthetic undervaluation of photography at the time.[17] Rosalind Krauss, among others, pointed out the limitation and inappropriateness of Bourdieu's theses insofar as he insisted that one could not even discuss photography in the context of aesthetic value. As cogent as Krauss' criticism of Bourdieu was in principle, she was obviously unaware that in the mid-1960s a discourse on the aesthetic dimension of photography was in fact not possible anywhere in Europe.[18] There would not be any decisive change in this situation until the 1970s,[19] namely, after Conceptual Art had been able to act as a catalyst for the acceptance of the photograph as art.

Conceptual Art in Europe: Jan Dibbets' Photography

Conceptual Art fell on fertile ground in Europe.[20] The year 1969—that is, parallel to the first exhibitions devoted to this work organized by Seth Siegelaub in New York and to Lucy Lippard's exhibition *557.087* in Seattle—"became the year of its breakthrough and acknowledgement in Europe."[21] It was above all two exhibitions mounted almost simultaneously in the spring of that year that left a lasting impression: *Op losse schroeven* at the Stedelijk Museum in Amsterdam (subsequently at the Museum Folkwang in Essen) and *Live in Your Head: When Attitudes Become Form* at the Kunsthalle Bern (subsequently at the Museum Haus Lange in Krefeld and the Institute of Contemporary Arts [ICA], London). In addition, the exhibition *Konzeption—Conception* made a big splash in the fall of that year at the Städtisches Museum in Leverkusen. In contrast, the first major museum exhibition in the United States to address Conceptualism—the Museum of Modern Art's *Information*—did not take place until the following year.

The Amsterdam and Bern exhibitions featured both pure Conceptual Art and land art, and a close thematic tie between the two shows is documented not only by the list of artists but also by the programmatic comments of Harald Szeemann, curator of *When Attitudes Become Form*. After differentiating his exhibition from the 1968 *Documenta 4* and stressing the fact that the very latest developments in art could be seen in Bern, he stated: "But the artists in this exhibition are not object-makers; instead they seek freedom from the object, and thus add to its layers of meaning the very significant dimension of also being a situation beyond the object. . . . Many artists, including the 'earth artists,' are no longer represented by works at all, only by information, while the 'Conceptual Artists' are represented only by instructions for the work, which no longer needs to be materialized."[22]

Although Szeemann later cited an encounter with Jan Dibbets in July 1968 as the catalyst for the exhibition's conception,[23] Dibbets and Robert Smithson were the only artists using photography who appear in the exhibition checklist. The same is true of the Amsterdam exhibition;

Otto Steinert; *Ein-Fuß-Gänger* (A pedestrian), 1950; gelatin silver print; 11 5/16 x 15 3/4 in. (28.7 x 40 cm); Museum Ludwig, Cologne

in fact, with two exceptions, all of the artists who took part in *Op losse schroeven* in Amsterdam could also be seen in Bern.[24] In any event, however, the list of participants in these two central exhibitions underlines my initial claim of a loose, and in no way logical, link between Conceptual Art and photography. While in the United States Edward Ruscha, with his books (starting in 1962), and Dan Graham, with "Homes for America" (1966–1967), had already published decisive "anti-photographic" works, the significance of photography in the context of Conceptual Art was not immediately apparent in Europe.

What was already intimated by the Bern and Amsterdam shows was the emergence of Dibbets, who became a crucial figure in the integration of photography as an art practice. His work can be directly linked to the land art works of Richard Long, Robert Smithson, and Dennis Oppenheim,[25] as well as to that of artists working serially, such as Buren or On Kawara, and, not least of all, to (anti-)photographers such as Ruscha. Dibbets' "perspective corrections"—which carried on the tradition of seventeenth-century Dutch and Flemish interiors—and his studies of light and shade were, despite their historical quotations, as unpretentious as they were elementary and were thus understandable in any cultural context. It is therefore not surprising that his photographs were part of major American exhibitions, including Siegelaub's shows, Lippard's *587.087*, and MoMA's *Information*.[26] There were also important solo presentations of Dibbets' work in Europe—in 1969–1970 at Museum Haus Lange, Krefeld, and in 1972 at the Venice Biennale—as well as at leading galleries: Yvon Lambert in Paris (1970) and Konrad Fischer in Düsseldorf (1968, 1971).[27] As was recognized as early as 1970, Dibbets is an artist whose conceptual program is not so radical that it leads to what Lippard described as the total dematerialization of the art object, but is first and foremost carried out in pictorial—that is, photographic—form.[28]

"A Certain Support": The Bechers' Self-Evaluation

In 1984, following the heyday of Conceptual Art, Jan Dibbets became a professor at the Düsseldorf Art Academy, where in 1976 Bernd Becher had been named the first professor of fine art pho-

tography at a West German art institution.[29] Although Dibbets' work from around 1970 was represented in every survey of the art of that time, from the perspective of the present it almost seems as if it was the Bechers who were essentially responsible for the renewed appreciation of the aesthetic significance of photography. At the time, Bernd Becher attributed Dibbets' appointment in Düsseldorf to the importance of Conceptual Art.[30] This makes it all the more striking that the Bechers did not participate in *Op losse schroeven* and *When Attitudes Become Form*; nor were they represented in the various publications on Conceptual Art in Europe.[31] Klaus Honnef, too, in his definitive survey *Concept Art* (1971), did not link the Bechers to this movement (although he did Dibbets).

In the United States, however, the Bechers' work was specifically seen within the context of Conceptual Art. They were thus included in the anthologies on Conceptual Art by Ursula Meyer and Lucy Lippard[32] and also took part in the exhibition *Information*. The Bechers, not least of all through contact with the artists at Galerie Konrad Fischer, became acquainted with Sol LeWitt, Douglas Huebler, and Carl Andre.[33] And it was Andre who, early on, supported their work journalistically in the United States. In December 1972, only a few months after the Bechers' first exhibition at the New York gallery of Ileana Sonnabend, he published an article in *Artforum* under the title "A Note on Bernhard and Hilla Becher." His short, informative text ended with a quotation from Hilla Becher that was characteristic of the era: "The question if this is a work of art or not is not very interesting for us. Probably it is situated in between the established categories. Anyway the audience which is interested in art would be the most open-minded and willing to think about it."[34]

It is possible to track the change in the interpretation of the artistic value of photography in the 1960s and 1970s by taking as an example the way the Bechers' comments on their own work varied over time. Since the Bechers did not think of themselves as theorists, and since comments and texts by them are comparatively rare, this may help us to gain a different understanding of their work.

Especially at the start of their collaboration in 1959, we encounter the view that the Bechers were using their photographs as documents to preserve a vanishing era and thus saw themselves as caretakers of historical monuments.[35] This corresponds to a story told by Bernd Becher, repeated again and again in the literature, of how he came to the medium of photography. While Hilla Becher had already taken part in the photographic documentation of the Potsdam castle of Sanssouci in 1953–1954,[36] Bernd—a painter and graphic artist inspired by the Neue Sachlichkeit, or New Objectivity, of the 1920s—was noticing how quickly the subject matter he was trying to draw, namely the industrial region of Siegerland, was disappearing. Since the medium of painting was too slow and, as he had yet to learn, motion pictures were too fast, he decided in 1957 to resort to the camera.[37]

As early as 1970—in their first book, *Anonyme Skulpturen*—the Bechers spoke of documenting: "The illustrations are part of a *documentation* of technical buildings."[38] And at around the same time, in another publication but also under the heading "Anonyme Skulpturen," they wrote more emphatically: "This is about objects, not motifs. The photo is only a substitute for an object; it is unsuitable as a picture in its customary sense."[39] In 1969 the Bechers credited the photograph with this documentary function and stressed the aesthetic indifference of the resulting pictures when they wrote under this title for the mass-produced *Kunst-Zeitschrift*: "Our camera does not produce pretty pictures, but exact duplications that, through our renunciation of photographic effects, turn out to be relatively objective. The photo can optically replace its object to a certain degree. This takes on special meaning if the object cannot be preserved."[40]

With this formula the Bechers consented to a characterization that their earlier mentor the art historian Volker Kahmen had assigned them on the occasion of a solo exhibition entitled *Anonyme Architektur* in June 1965 at the Galerie Pro in Bad Godesberg, writing, "The photo fulfills no art-for-art's-sake end; it subordinates itself as documentation to a way of looking at things as objectively as possible."[41] In 1973 Kahmen published a survey of the history of photography that was important for German-speaking countries. The title alone—*Fotografie als Kunst* (Photography

as art)—demonstrates the swift change that had taken place in the meantime.[42]

In the second half of the 1970s there was a slight change in the Bechers' formal style (one that was hardly noted by most observers).[43] In 1981 the couple freely acknowledged their affiliation with an aesthetic discourse: "Actually the inquiry into the artistic value of photography should present no big problem. Photography is a visual medium. Whether it is used for art or for something else is merely a question of interpretation. . . . Photographs lined up one after the other not only provide information but also have an aesthetic dimension."[44] The explicit announcement of a non-aesthetic intention or an indifference to the aesthetic dimension of their photographs is characteristic of the Bechers' early statements. But even though in the late 1960s and the early 1970s they still denied that their pictures had any autonomous fine art status, their work was nevertheless accorded such a status by others, who may have been influenced by the change in the couple's formal approach. The Bechers themselves gradually became aware of this fact, and this led to a change in their self-definition.

What contributed considerably to this development was the Bechers' inclusion in the group exhibitions of the period, for, as Hilla Becher recalled in 1995, "with the advent of Conceptual Art it became possible for photography to gain acceptance as art."[45] Although the Bechers still do not want their work to be categorized as Conceptual Art today, they have made concessions: "And since it was then the era of Conceptual Art, we landed, like it or not, within this context. What also certainly played a role was the fact that our work is systematically built up, that our way of looking at things is 'cool' and without an artist's subjective expression. . . . But this kinship with the methodology of Conceptual Art was probably given exaggerated importance at the time. Perhaps also because there was no other art movement to which they could have assigned us."[46]

Under the aegis of 1970s Conceptual Art and employing a social documentary approach to photography that was informed by the tradition of industrial architecture and by the photography of the Neue Sachlichkeit, which they combined in an innovative way with the impersonal

and serial attitude of an archivist, the Bechers succeeded in renewing a critical link to modernist pictoriality. By contrast Otto Steinert's attempt twenty years earlier to revive the experimental approach of the early twentieth-century avant-garde while obscuring history had failed. In retrospect, the Bechers also saw Conceptual Art as providing them with "a certain support," yet "without our understanding ourselves as conceptual artists."[47]

The Bechers' supposedly "objective" photographic approach had to appear innovative against the background of the photography that was prevalent at the time, which was not considered "art" in the narrow sense. Their objectivity ran completely counter to the aesthetic of the "decisive moment"—in which the photographer captures the elusive instant that encapsulates the significance of an event—whose most eminent practitioner was photojournalist Henri Cartier-Bresson.[48] It is precisely the Bechers' reliance on a comparative typological approach that precludes traditional formal composition; the standard procedure thus replaces the inspired recognition of the chance moment. In this process, the formal subject is not eliminated but rendered anonymous through the establishment of very specific pictorial premises. The double perspective of this approach—consciousness of tradition and engagement with the present—was aptly documented at *Documenta 6*, where Hilla and Bernd Becher were not only represented by their own work but were also lenders of the Peter Weller (1868–1940) photographs from the years 1900–1920 and of the recent color photographs by Stephen Shore.[49]

While Dibbets was categorized as a Conceptual artist from 1968 at the latest, the Bechers—who still resist this label—were not shown in Europe under the rubric of Conceptualism until 1972. The factor behind this was their participation in *Documenta 5*.[50]

Documenta 5 and *Documenta 6*: Emancipation through Idea and History

Documenta, which from its inception in 1955 until 2002 had always been organized by European curators, has historically expressed a specifically European view of contemporary art. After *Documenta 4* in 1968 was criticized for ignoring the latest

tendencies in contemporary art, Harald Szeemann was appointed curator of the 1972 *Documenta 5*, replacing Arnold Bode. While Szeemann had presented a loosely organized collection of divergent aesthetic approaches in his 1969 exhibition *When Attitudes Become Form*, three years later he chose a seemingly systematic subdivision into thematic categories for *Documenta 5*. As he stressed in the preface to the catalogue, there were three main sections, each with its own organizing idea: "Parallel Picture Worlds," "Individual Mythologies," and "Conceptual Art" (or "Idea").[51]

Photography was represented in all three sections, but especially in the section "Idea," which was curated by Klaus Honnef and Konrad Fischer. Honnef, the theoretical mind behind this section, saw photography—along with maps, drawings, and text—completely in terms of Conceptual Art, that is, as a means of documenting an idea.[52] And in this regard he mentioned Dibbets, but not the Bechers, in his catalogue introduction.[53] John Baldessari, Hamish Fulton, Douglas Huebler, Allen Ruppersberg, and Edward Ruscha were shown along with the Bechers.[54]

In the wake of this Documenta, several exhibitions devoted to photography took place at European visual arts institutions,[55] and European art museums also opened their collections to photographs. In March

Sigmar Polke; *Höhere Wesen befahlen: Rechte obere Ecke schwarz malen!* (Higher beings command: Paint the upper right corner black), 1969; lacquer on canvas; 59 1/16 x 49 7/16 in. (150 x 125.5 cm); Museum für neue Kunst, Zentrum für Kunst und Medien, Karlsruhe

1976 Honnef noted in his diary: "How much weight did August Sander, Albert Renger-Patzsch, Walker Evans, Karl Blossfeldt, Eugène Atget, Paul Strand (whose retrospective incidentally will soon be held at the Palais de Beaubourg in Paris), Gisèle Freund, etc., carry even ten years ago in the art world? None! Now major exhibitions and fat catalogues are dedicated to them."[56]

In addition, galleries began to emerge that focused exclusively on photography. In Hannover the Galerie Clarissa opened its doors in 1965; it specialized in nonfigurative, experimental photography but folded after three years.[57] In Milan there was the Galleria Il Diaframma, which concentrated on photo books. In 1970 the gallery "Die Brücke" opened in Vienna, followed a year later by the Photographers' Gallery in London. The first German example, Album Fotogalerie, opened in Cologne in 1972 (since 1973 it has gone by the name Galerie Wilde, after its founder). The Spectrum Photogalerie followed in Hannover. A year later in Aachen, Rudolf Kicken and the photographer Wilhelm Schürmann opened Lichttropfen, which after 1979 continued in Cologne under a new name. These developments reflect the emergence of an art market for photography in central Europe at that time.

The actual acceptance of photography by the European art world did not take place until 1977. Apart from the exhibition *Malerei und Photographie im Dialog* (Painting and photography in dialogue) at Kunsthaus Zürich, organized by Erika Billeter, it was, of course, *Documenta 6* that provided the impetus. For the first time there was a separate photographic section, curated by art historian Evelyn Weiss, together with Honnef. In her introduction to the catalogue, Weiss not only stressed the differences in the historical development of photography in Europe and the United States but also dissociated photography from the context of Conceptual Art, with which it had been linked at *Documenta 5*.[58] In the detailed essay by Honnef (who went on to organize many important museum exhibitions on the history of photography), the term Conceptual Art crops up only once, in a footnote.[59] This was only one of several indications that photography had been liberated from what was initially the legitimate framework of Conceptual Art and

that the process of its establishment in Europe as an autonomous form of visual art was more or less concluded.

In his 1976 exhibition proposal, the curator of the next Documenta, Manfred Schneckenburger, had already underlined the fact that media hierarchy was a thing of the past.[60] The gap that had occurred in the history of photography in Europe and the suppressed knowledge of these facts, however, called for more than a concentration on current art, and so the exhibition included a historical survey.[61] In analogy to the 1955 *Documenta 1*, in which modernist painting and sculpture of the prewar period that had been defamed by the Nazis as "degenerate" was displayed, works by Louis Daguerre, William Henry Fox Talbot, and other nineteenth-century photographers were put on view here, in proximity to works by the Bechers, Shore, and others.

Historical legitimation of photography as an autonomous art form, then, replaced an emphasis on contemporary art. No such legitimation was needed in North America, where no comparable break occurred, and to American audiences this historical aspect of *Documenta 6* must have seemed rather uninteresting. The critic for the *Washington Post* wondered at this "seemingly endless and unedited history of photography show, evidently one of the first to be mounted in a contemporary art context on the continent. Though it may be a revelation for European audiences, not

to mention a boost for the undeveloped photography market here, it holds few surprises for Americans."[62]

"My Last Painting": Reality Strikes Back

Tracing the history of the renewed artistic emancipation of photography in Europe, it becomes clear that the use of this medium within the context of Conceptual Art cannot be understood using the criterion of an American anti-photographic standpoint. For, some ten years after Ruscha's 1965 announcement—"I think photography is dead as a fine art"[63]—it was in fact just beginning in Europe. Several factors contributed to this transformation. Without attempting to reconstruct the art historical context of the late 1960s,[64] I would like to analyze aspects of the link between Conceptual Art and photography by taking up several exemplary cases.

It is plain that we need to examine the criticism of painting that emerged in Europe (and elsewhere) in the early 1960s, which was expressed in actions and happenings, as well as in three-dimensional works. Rejecting the still-dominant Abstract Expressionism, which was considered bourgeois and empty of content, this impulse was driven especially by the efforts of the Fluxus artists and Joseph Beuys to expand the definition of art. Within the framework of these many different types of artistic activity, the medium of photography found its use, but predominantly as

Sigmar Polke; *Gilbert and George*, 1974; 2 gelatin silver prints with hand-colored application; 11¾ x 9⅜ in. (30 x 23.8 cm) each; collection Thomas Lee and Ann Tenenbaum

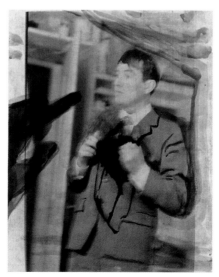

a documentary tool—that is, to transmit and preserve happenings and actions—rather than being used to expand the pictorial vocabulary available to artists.[65]

This is also, ultimately, true of Marcel Broodthaers, who characteristically deployed photographs to challenge our conventional underlying structure of reference, as in his *Musée d'Art Moderne, Département des Aigles* (Museum of modern art, department of eagles, 1972). Although his ironic comments on the history of photography (e.g., *La soupe de Daguerre* [The soup of Daguerre], 1974) occasionally allow us to presume differently, photography plays only a subordinate role in Broodthaers' work, subsumed under his broader concern with reflecting on life under cover of art.

Thus the two preeminent European artists of the late 1960s, Beuys and Broodthaers, did not play any significant role in emancipating photography from its pragmatic function. And as appealing as it may seem to switch the name of the medium in the American explanatory model of "anti-photography" to "anti-painting," this is not sufficient to explain the reemergence of photography in Europe. The criticism of Abstract Expressionist painting (or *art informel*) was not articulated as polemically in Europe as it was in the United States and was generally conducted without reference to the theoretical commentary of the artists themselves.[66] In addition, in Europe

there were no highly developed critical positions concerning painting, such as those proposed by Clement Greenberg in the United States, that had to be contended with. The critique of pure painting should be mentioned, however, because one of its indirect consequences was the reintegration of photography into the visual arts and its elevation as an art form.

A prominent example is the 1969 painting by Sigmar Polke *Höhere Wesen befahlen: Rechte obere Ecke schwarz malen!* (Higher beings command: Paint the upper right corner black!), which commented ironically on the metaphysical claims of abstract painters such as Barnett Newman. Polke, who is known primarily as a painter, also worked extensively in photography and film. He began using photography very early, for example, in *Menschenkreis* (Circle of humankind, 1964), which incorporates portrait photos of ordinary people into the form of a sculpture.[67] While the installation of the pictures on the wall appeals to the tradition of painting, the use of lines (in the form of the pieces of string that connect the photographs) seems to ironize the mythical aura of the Fluxus artists while also alluding to the painter Gerhard Hoehme, Polke's former teacher at the Kunstakademie in Düsseldorf, who was known for his integration of lines into his late works. The example of Polke's 1974 pictures of the "living sculptures" of Gilbert & George shows how he cleverly thematized the particularities of photogra-

phy as a physical and chemical medium by using multiple exposures and manipulating the development of the print. He reinforced this process by overpainting several areas of the photographs.

Shortly after Polke made this work, Gilbert & George were also the subject of eight paintings made by Gerhard Richter based on superimposed photographs. Richter's early work from the 1960s was also quite obviously founded on the struggle between painting and photography. In his paintings based on enlarged black-and-white snapshots by amateurs, the obvious painterly gesture of blurring the image can be seen as recording the lack of sharpness in the original, although it is perceived mainly as an effect of the painting style. Many of Richter's paintings of that time were derived from the picture collection he called *Atlas*, for which he had been collecting material since 1964. To the degree that Richter confronts the private and the public therein, the status of *Atlas* also fluctuates, going far beyond Aby Warburg's famous image archive, the Mnemosyne Atlas (1929), and opening a multiple view onto what is a cross between an independent work and a material collection. *Atlas* had its first public exhibition in 1970.[68]

Gerhard Richter; *Woman Descending the Staircase*, 1965; oil on canvas; 79 x 51 in. (200.7 x 129.5 cm); The Art Institute of Chicago

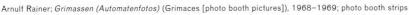

Arnulf Rainer; *Grimassen (Automatenfotos)* (Grimaces [photo booth pictures]), 1968–1969; photo booth strips

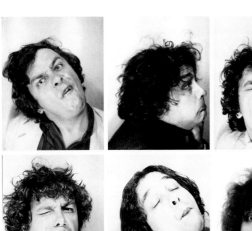

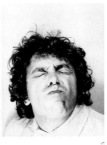
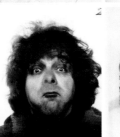

Further, there is the example of the Austrian painter Arnulf Rainer, who incorporated his body into his art activities. Along with Gilbert & George, Rainer was represented at *Documenta 5* in the section "Individual Mythologies, Self-Presentation, Processes," curated by Szeemann.[69] In addition to his paintings, Rainer also showed twenty photographs there. In 1968 he began to make self-portraits at an automatic photo booth, using extreme, almost surreal facial distortions that in their radicalness went far beyond the photos Andy Warhol began making in 1963,[70] manifesting a link to Rainer's interest in the mentally ill. Later he began to rework these images with paint, and in the overpainted photographs shown at *Documenta 5*, Rainer engaged in a productive dialogue with the two pictorial media. Through the contrast between an expressive application of paint, reminiscent of *art brut*, and a comparatively dematerialized photograph, the distinctive character of both media was thematized.

Interesting experiments combining both painting and photography have been undertaken not only by Polke and Rainer but also by a lesser-known Portuguese artist, Helena Almeida. In her series of the mid-1970s *Pintura habitada* (Inhabited painting), the theme is the status of time in the two media. The blue paint that she illusionistically applied to black-and-white photographs of herself holding a paintbrush was the second step in an analytical action, so that the time difference and the difference in the representational form of the two acts is reflected in a picture that pretends to show a painting process as a simultaneous

action. If Rainer in his overpaintings responded with painterly gestures to the motif of an existing photograph, Almeida painted in reaction to a photograph that had been staged for exactly this act of paint application.

These examples alone show that art that makes use of photography in no way defines itself as anti-painting in the sense of a true "abandonment of the picture frame."[71] This would simply be a helpless recapitulation of the avant-garde aporia of the end of painting. Instead, the medium of photography makes an iconoclastic criticism of painting possible, but one that is not aimed at the picture form per se and is capable of paving the way to a new alternative. A 1968 statement by Dibbets, in which he explained his rejection of painting in

favor of three-dimensional scenes set up specifically to be photographed, can be understood in this sense: "I stopped painting in 1967. . . . Simultaneously I began my 'corrected perspective.' . . . I make most of these works with ephemeral materials: sand, growing grass, etc. These are demonstrations. I do not make them to keep, but to photograph. The work of art is the photo."[72]

For those who, like Dibbets, worked exclusively with photography, it was often a question not of criticizing painting, but of reflecting on photography as a medium. The resulting work differs from the self-referential painting of the previous period in its ability to incorporate external reality, thus allowing social problems to be addressed.

John Hilliard; *Camera Recording Its Own Condition*, 1971; black-and-white photographs on card mounted on Plexiglas; 85 x 72 in. (216 x 183 cm); Tate Gallery, London

Helena Almeida; *Pintura habitada* (Inhabited painting) 1975; black-and-white photograph with blue acrylic paint; 18⅝ x 20 in. (47.3 x 50.8 cm); Graphische Sammlung Staatsgalerie Stuttgart, Sammlung Dr. Rolf H. Krauss

An examination of the work of the French artist Christian Boltanski can also make the expansion of pictorial possibilities through photography clearer. Boltanski's work was included in the same section of *Documenta 5* as that of Rainer and Gilbert & George, and for him, as for those artists, the portrait plays a decisive role, yet he pursues a completely different approach. The issue for him is historicity and the memory linked to it, which is conveyed not through objects, but essentially through photographs. Although Boltanski too painted at the beginning of his career, he gave it up, as did many of his contemporaries, in the 1960s.[73] Using anonymous photographs, which he collected and presented in large numbers, sometimes filling an entire room, he neutralized the category of authorship, at the same time suggesting a general social relevance for his pictures that goes beyond their aesthetic context. Above all, through his choice of the thematic framework for assembling the pictures, as well as by means of their disconcerting enlargement, Boltanski generated a fictionalization of his black-and-white snapshots that sometimes raised doubts about the authenticity of the context or even of the pictures.

The approach that the German artist Hans-Peter Feldmann adopted, although similar to Boltanski's, seems even more subversive in certain respects. By deploying widely distributed photos as readymades, he dissociated himself from the idea of authorship. His work can be understood as a critical reflection on photography and the social consumption of these "ideal" pictures (see his twenty-one-part work *Sonntagsbilder* [Sunday pictures], 1976–1977). Feldmann has been very consistent in not giving any biographical information in publications in which his pictures appear. The anonymity he has adopted would appear to be an intentional rejection of the excessive individualism still being cultivated in the 1970s by Andy Warhol, since it was irreconcilable with the cult of the artist-star. Despite his proximity to Ruscha in his use of both banal imagery and the medium of the artist's book, Feldmann started from a different premise; his work was first and foremost social criticism and not a criticism of art photography as it was currently being established in Europe.[74]

Feldmann's media criticism can be seen as an artistic reflection of the ordinary, non-artistic use of photography. In response to the so-called flood of images, he consequently relativized the status of the single image in producing open-ended picture groups. Although the typologies of the Bechers, Dibbets' panoramas, Giovanni Anselmo's *Documentazione di interferenza umana nella gravitazone universale* (Documentation of human interference in universal gravitation, 1969), and John Hilliard's *Camera Recording Its Own Condition* (1971) also present groups of images, they link aspects of the photographic tradition to the look of the "systematic painting" of the same period.[75] The time sequences in, for instance, several works by Dibbets or Almeida point in a historically somewhat different direction, to the sequential photographs of movement by Eadweard Muybridge. Muybridge's photos were of interest to the Minimalists and to Sol LeWitt[76] in his proto-Conceptualist phase because of their formal qualities. In contrast, artists such as Dibbets and Almeida used the specific sequentiality of the photographic medium to recover the narrative potential of the picture and thus to join the contemplative image of aesthetic modernism to the dynamism of society's most pervasive pictorial medium, film.

This is also the case for the series Bild-analytische Photographie (Image-analytical photography) by Timm Rautert, done between 1968 and 1974 and seldom discussed in this context.[78] The German photographer, who at the time was also in New York and exhibited photographs together with Walter De Maria, is worth noting not only for this reason but also for his reflections on the medium, which exhibit a subtle humor. (Thus the hand held against the sun in his untitled photograph of 1974 darkens the ground, which is then clearly recognizable once the hand is lowered.) Rautert, a heretical student of Otto Steinert, moreover proved that it was possible to pursue Conceptual approaches via traditional "subjective photography," which is not connected with questions of seriality or formalism.

We end here with a borderline case of photography's use outside the parameters of Conceptual Art. Victor Burgin—who in the 1970s was active not only as an influential art theorist but also as an artist— was represented in the London showing of *When Attitudes Become Form* by *Photopath* (1967). He gave the following description of this work: "A path along the floor, portions 1 x 21 units, photographed. Photographs printed to the actual size of objects and prints attached to the floor so that the images are perfectly congruent with their objects."[78] The work in question is visually attractive and semantically com-

Timm Rautert; Untitled, 1974; gelatin silver prints; 8 x 5⅜ in. (20.5 x 13.8 cm); courtesy the artist

plex, having much to do with Wittgenstein's "Philosophical Investigations" and nothing, as can well be surmised, to do with Carl Andre's floor sculptures.[79]

Burgin's perceptual analyses, however, led a bit later to semiotic analyses in a confrontation between picture and text, in which the photo was often subordinate to language or to social ideology .[80] In this form of social criticism, which evidences a certain proximity to the magazine works of Dan Graham, Burgin overlooked the aesthetic limitations that Graham had already recognized by the end of the 1960s. For, in the process of privileging the text above the picture—which the Art & Language group favored by Burgin also tended to do—there is the danger of a suspension, or even a dismissal, of the visuality of art and its aesthetic dimension. Photography, however, could link up only with quite specific aspects of Conceptual Art in order to find its way to a renewed affirmation of the picture form, which at the same time meant a criticism of painting: although photography tends to dematerialize the conventional painted image, it functions first as art. And so, from the genesis of photography and its establishment as an art form in Europe, an alternative pictorial form developed that could continue to evolve independently from Conceptual Art.

A New Scale: European Photography after Conceptual Art

The gradual transformation of what is understood by a picture—from an apotheosis of painting (of a kind whose aesthetic and social meaning was fundamentally called into question in the 1960s) to alternative picture forms (especially as represented by the rediscovery of fine art photography)—was considerably furthered by Conceptual Art. While Jeff Wall, somewhat arbitrarily, set the year 1974 as the time when the understanding of a picture was changed by art photography in North America,[81] this was delayed by several years in Europe.

What is striking is that this development was characterized by a widespread abstinence from color photography, despite the fact that (or perhaps because) it had been available for some time and was already used by amateurs. Up to then color had been encountered chiefly in the picture material found in everyday life.

Not until American pioneers such as William Eggleston and Stephen Shore made it acceptable in the mid-1970s did the mid-1980s usher in a proper photo boom in Europe.

Color was not the sole factor responsible for this rapidly increasing acceptance of photography; the availability of larger formats contributed to it as well. Although large formats appeared rather early in Europe—for example, in Katharina Sieverding's *F-VI* (1969)—the easel-painting-cum-photo-tableau entered the scene in connection with color starting in the 1980s. As early as 1978 Jeff Wall began working with large-scale color photographs (e.g., *The Destroyed Room*), and from 1984, when he had his first major exhibitions at the ICA in London and the Kunsthalle Basel, Wall received more attention in Europe than in North America. In 1986 Thomas Ruff showed oversize portraits in Paris.[82] It is perhaps in Ruff's work that we find the most obvious continuation of Conceptualism, since he—in a radical inversion of the methods of his teachers Bernd and Hilla Becher—represents an approach in which photography is deconstructed using its own technical means.

Shortly after Ruff, other so-called Becher disciples, such as Andreas Gursky and Thomas Struth, took up a form of presentation in which the photograph is given a prefabricated frame by the artist and then directly laminated behind protective Plexiglas, thereby turning what was once a sheet of photographic paper into an object. Moreover, these artists sought a new post-Conceptual photographic language, drawing on Romantic or pictorial approaches that are often derived from the painting tradition and recombining them with new digital means. In other words, Conceptual Art's dematerialization of the art object ultimately led in photography to its exact opposite.

Notes

For discussions and the stimulus these gave me, I would like to acknowledge and thank Catharina Manchanda (New York), Dorothee Fischer and Ulla Wiegand (Düsseldorf), Volker Kahmen (Rheinbach), Philip Ursprung (Zurich), and Jeff Wall (Vancouver).

1. Thomas Dreher, *Konzeptuelle Kunst in Amerika und England zwischen 1963 und 1976* (Frankfurt am Main: Peter Lang, 1992).

2. For an analysis of the European context, see Stefan Gronert, "Die Abbildlichkeit des Bildes: Die mediale Reflexion der Fotografie bei Gerhard Richter und Jeff Wall," in *Zeitschrift für Ästhetik und allgemeine Kunstwissenschaft* 47 (2002): 37–72.

3. Cf. James Meyer, ed., *Minimalism* (London: Phaidon, 2000); Gregor Stemmrich, ed., *Minimal Art: Eine kritische Retrospektive* (Dresden and Basel: Verlag der Kunst 1995); Claude Gintz, "European Conceptualism in Every Situation," in *Global Conceptualism: Points of Origin, 1950s–1980s*, exh. cat. (Queens, N.Y.: Queens Museum of Art, 1999), 31–39.

4. Gregory Battcock, introduction to *Idea Art: A Critical Anthology* (New York: Dutton, 1973), 1. See also Lucy Lippard, *Six Years: The Dematerialization of the Art Object from 1966 to 1972* (London: Studio Vista, 1973), 8. In contrast, Jürgen Morschel in 1970 expressed the hardly less exaggerated view that Conceptual Art "was more durably established in the European art scene than in the American" ("Die Kunst nach Pop und Minimal: Die Manifestationen von Bern und Amsterdam und die Folgen," in *Kunstjahrbuch* 1, ed. Jürgen Harten et al. [Hannover: Fackelträger, 1970], 123).

5. Nancy Foote, "The Anti-Photographers," *Artforum* 15 (September 1976): 48.

6. See Jeff Wall, "'Marks of Indifference': Aspects of Photography in, or as, Conceptual Art," in *Reconsidering the Object of Art*, *1965–1975*, exh. cat., ed. Ann Goldstein and Anne Rorimer (Los Angeles: Museum of Contemporary Art, 1995), 247–267.

7. Gisèle Freund, *Photographie und bürgerliche Gesellschaft; eine kunst-soziologische Studie* (Munich: Rogner & Bernhardt, 1968); published in English as *Photography and Society* (Boston: D. R. Godine, 1980); Beaumont Newhall, *Photography, 1839–1937: A Short Critical History* (New York: Museum of Modern Art, 1937).

8. See, e.g., Newhall, *Photography, 1839–1937*; idem, *The History of Photography: From 1839 to the Present Day* (New York: Museum of Modern Art, 1949); Robert Doty, ed., *Photography in America*, exh. cat. (New York: Whitney Museum of American Art, 1974); Jonathan Green, *American Photography: A Critical History, 1945 to the Present* (New York: Harry N. Abrams: 1984).

9. On the history of photography at MoMA, see Christopher Phillips, "The Judgement Seat of Photography," *October*, no. 22 (fall 1982): 27–63.

10. On his work, see *Otto Steinert*, exh. cat. (Essen: Folkwang Museum, 1999).

11. I neglect the Czech situation here, although Jindřich Štyrský's *Na jehlách těcho dní* (1941, 1945), Zdeněk Tmej's *Abeceda* (1946), and *Josef Sudek Fotografie* (1956), all published in Prague, did not essentially affect the reception of

European photography.

12. See Ute Eskildsen, "Subjektive Fotografie," in *"Subjektive Fotografie": Images of the 50's*, exh. cat. (Essen: Fotografische Sammlung im Museum Folkwang, 1984); J. A. Schmoll gen. Eisenwerth, *"Subjektive Fotografie": Der deutsche Beitrag, 1948–1963*, exh. cat. (Stuttgart: Institut für Auslandsbeziehungen, 1992).

13. Franz Roh and Jan Tschichold, ed., *Foto-Auge: 76 Fotos der Zeit / Oeil et Photo: 76 photographies de notre temps / Photo-Eye: 76 Photoes* [sic] *of the Period* (Tübingen, 1929; London: Thames & Hudson, 1974).

14. J. A. Schmoll gen. Eisenwerth, *Vom Sinn der Photographie: Texte aus den Jahren 1952–1980* (Prestel: Munich, 1980).

15. See Susanne Anna, ed., *Die Informellen: Von Pollock bis Schumacher / The Informal Artists: From Pollock to Schumacher* (Ostfildern: Cantz, 1999); *Informel: Der Anfang nach dem Ende* (Dortmund: Museum am Ostwall, 1999).

16. See the review of the 1964 *Documenta 3* in the major weekly newspaper *Die Zeit*, written by Klaus Jürgen-Fischer: "Im Zeichen des Informalismus: Auf der Documenta III kommt die neue Malerei zu kurz," in *Documenta: Idee und Institution: Tendenzen, Konzepte, Materialien*, ed. Manfred Schneckenburger (Munich: Bruckmann, 1983), 81–82.

17. Pierre Bourdieu et al., *Un art moyen: Essai sur les usages sociaux de la photographie* (Paris: Minuit, 1965); published in English as *Photography: A Middle-Brow Art*, trans. Shaun Whiteside (Stanford: Stanford University Press, 1990).

18. Rosalind Krauss, "A Note on Photography and the Simulacral," *October*, no. 31 (winter 1984): 59, 63.

19. Cf. Jean-François Chevrier, "Die Abenteuer der Tableau-Form in der Geschichte der Photographie," in *Photo-Kunst: Arbeiten aus 150 Jahren*, exh. cat. (Stuttgart: Staatsgalerie Stuttgart, 1989), 9–45. Whereas Rolf H. Krauss moved this phenomenon back to the 1960s (*Walter Benjamin und der neue Blick auf die Photographie* [Ostfildern: Cantz, 1998]: 7), Heinrich Klotz saw in the recognition of photography as art a phenomenon of a "second modernism" ("Kunst der Gegenwart," in *Kunst der Gegenwart* [Karlsruhe: Museum für Neue Kunst, ZKM; Munich: Prestel, 1997], 20). On the difficulty photography had in being recognized as art in the 1970s, see Ulrich Domröse, "Positionen künstlerischer Photographie in Deutschland seit 1945," in *Positionen künstlerischer Photographie in Deutschland seit 1945*, ed. Ulrich Domröse (Cologne: DuMont, 1997), 32ff.

20. Recent research has rightly brought attention to the fact that there were also important approaches in Latin America and Africa that could and should come under the heading of Conceptual Art. See Tony Godfrey, *Conceptual Art* (London: Phaidon, 1998); Alexander Alberro, "Reconsidering Conceptual Art, 1966–1977," in *Conceptual Art: A Critical Anthology*, ed. Alexander Alberro and Blake Stimson (Cambridge: MIT Press, 1999): xvi–xxxvii, esp. xxvf.; *Global Conceptualism*; Anne Rorimer, *New Art in the 60s and 70s: Redefining Reality* (London: Thames & Hudson, 2001); Sabeth Buchmann, "Conceptual Art," in *DuMonts Begriffslexikon zur zeitgenössischen Kunst*, ed. Hubertus Butin (Cologne: DuMont, 2002), 49–53; Peter Osborne, ed., *Conceptual Art* (London: Phaidon, 2002).

21. Klaus Honnef, *Concept Art* (Cologne: Phaidon, 1971), 25. Cf. Peter Wollen, "Global Conceptualism and North American Concept Art," in *Global Conceptualism*, 73–85, esp. 74.

22. Harald Szeemann, "Zur Ausstellung," in *Live in Your Head: When Attitudes Become Form*, exh. cat. (Bern: Kunsthalle, 1969), unpaginated; translated by Shaun Whiteside, in *Arte Povera*, ed. Carolyn Christov-Bakargiev (London: Phaidon, 1999), 225.

23. Szeemann's journal was excerpted in the catalogue for the exhibition *Op losse schroeven* and then published in full in Jean-Christophe Ammann and Harald Szeemann, *Von Hodler zur Antiform: Geschichte der Kunsthalle Bern* (Bern: Bentelli, 1970), unpaginated, and again in the reprint of the Bern exhibition catalogue.

24. Work by Kakis and Marisa Merz could be seen in Amsterdam but not in Bern. On the difference between the two exhibitions, see also Harald Szeemann, "When Attitudes Become Form (Bern, 1969)," in *Die Kunst der Ausstellung: Eine Dokumentation dreißig exemplarischer Kunstausstellungen dieses Jahrhunderts*, ed. Bernd Klüser and Katharina Hegewisch (Frankfurt: Insel, 1991), 212–219.

25. See Helmut Friedel, "Fernsehgalerie Gerry Schum—Land Art" (Berlin, 1969), in Klüser and Hegewisch, *Kunst der Ausstellung*, 204–211.

26. See Lippard, *Six Years*, 106, 111, 178.

27. See *Jan Dibbets: Dutch Pavilion*, exh. cat. (Venice: XXXVI Biennale, 1972); *Jan Dibbets: Audio-visuelle Dokumentationen*, exh. cat. (Krefeld: Museum Haus Lange, 1969). The exhibition history shows that Dibbets took part in fifteen group exhibitions in 1969.

28. See Klaus Honnef, "Beschreibungen zu Projekten von Jan Dibbets," in *Jan Dibbets*, exh. cat. (Aachen: Gegenverkehr, Zentrum für aktuelle Kunst, 1970), unpaginated; E. de Wilde, "Over Jan Dibbets/About Jan Dibbets," in *Jan Dibbets*, exh. cat. (Amsterdam: Stedelijk Museum, 1972), unpaginated. Along with Gilbert & George, Dibbets was the sole European photographer represented by photographic work in Honnef, *Concept Art*, 50–53, 60–61.

29. German law did not permit the photographer couple to be appointed in tandem to a university post. This was also the case at the Kunstakademie in Hamburg; officially only Hilla Becher was named a guest lecturer there in 1972–1973.

30. Ulf Erdmann Ziegler, "The Bechers' Industrial Lexicon," *Art in America* 90 (June 2002): 93ff.: "Pressure to offer [an appointment] built up because of Conceptual Art" (140).

31. The Bechers did, however, take part in the Leverkusen exhibition *Konzeption—Conception* (1969).

32. See Ursula Meyer, *Conceptual Art* (New York: Dutton, 1972); Lippard, *Six Years*.

33. See Susanne Lange, ed., *Bernd und Hilla Becher: Festschrift Erasmuspreis 2002* (Munich: Schirmer & Mosel, 2002), 51ff.

34. Carl Andre, "A Note on Bernhard and Hilla Becher," *Artforum* 11 (December 1972): 59. As Hilla Becher told the present author in an interview on July 11, 1999, Andre's article, however, came about independently from and presumably also before the exhibition. Andre himself said that his contribution was based on the summary of a conversation between Marianne Scharn and the Bechers. See Susanne Lange, "A Conversation with Carl Andre," in *Bernd und Hilla Becher*, 56.

35. Later the Bechers themselves relativized this function: "Preservation wasn't the motivation. It's a side effect" (cited in Rorimer, *New Art*, 281, n. 21).

36. See Monika Steinhauser, ed., *Bernd und Hilla Becher: Industriephotographie—im Spiegel der Tradition* (Düsseldorf: Richter, 1994), 11.

37. On the Bechers' early career, see Wulf Herzogenrath, *Distanz und Nähe*, exh. cat. (Stuttgart: Institut für Auslandsbeziehungen, 1992): esp. 7ff.; Susanne Lange, "Von der Entdeckung der Formen: Zur Entwicklung des Werkes von Bernd und Hilla Becher," in *Bernd und Hilla Becher*, 11–31; on film, see Ziegler, "The Bechers' Industrial Lexicon," 100, 140.

38. Bernhard and Hilla Becher, *Anonyme Skulpturen: Eine Typologie technischer Bauten* (Düsseldorf: Art-Press, 1970), unpaginated (italics added by author).

39. Bernhard and Hilla Becher, "Anonyme Skulpturen," in *Kunstjahrbuch* 1, 442.

40. Bernhard and Hilla Becher, "Anonyme Skulpturen," *Kunst-Zeitung*, no. 2 (January 1969): unpaginated.

41. Volker Kahmen, "Die Industrieaufnahmen Bernhard Bechers," a flyer from the Galerie Pro, Bonn–Bad Godesberg, 1965.

42. Volker Kahmen, *Fotografie als Kunst* (Tübingen: Wasmuth, 1973).

43. Rolf Sachsse, *Hilla und Bernhard Becher: Silo für Kokskohle, Zeche Hannibal (Bochum-Hofstede, 1967): Das Anonyme und das Plastische*

der Industriephotographie (Frankfurt: Fischer, 1999), 46, even speaks of a "paradigm shift in the pictorial thinking and actions of the couple" by around 1977 at the latest.

44. Bernhard and Hilla Becher, in Armine Haase, *Gespräche mit Künstlern* (Cologne: Wienand, 1981), 23.

45. Cited in Helga Meister, "Bernd und Hilla Becher: Die Anfänge, die Schüler," in *Düsseldorfer Avantgarden: Persönlichkeiten— Bewegungen—Orte*, ed. Arbeitsgemeinschaft 28 Düsseldorfer Galerien (Düsseldorf: Richter, 1995), 48.

46. Michael Köhler, interview with Bernd und Hilla Becher, in *Künstler: Kritisches Lexikon der Gegenwartskunst*, ed. Lothar Romain and Detlef Bluemler (Munich: Bruckmann, 1989), 15.

47. See Hilla and Bernd Becher, in an interview with Heinz Liesbrock, "His Photos Have Something of a First Encounter," in *Stephen Shore: Fotografien, 1973 bis 1993*, ed. Heinz Liesbrock (Munich: Schirmer & Mosel, 1993), 28.

48. See Henri Cartier-Bresson, *The Decisive Moment* (New York: Simon & Schuster, 1952).

49. See *Documenta 6*, exh. cat. (Kassel: P. Dierichs, 1977), vol. 2, 74, 82, 132.

50. After the Bechers' work was shown only once (Nuremberg, 1971) in the context of Conceptual Art following the Leverkusen exhibition, it was characteristically excluded from the exhibition *Konzept Kunst*, organized by Konrad Fischer and Klaus Honnef, which took place at the Kunstmuseum Basel from March 18 to April 23, 1972, that is, immediately before *Documenta 5*.

51. Harald Szeemann, in *Documenta 5*, exh. cat. (Kassel: Bertelsmann, 1972), 10.

52. See Klaus Honnef and Gisela Kaminski, "Einführung," ibid., 17.1–17.9.

53. Since it was Konrad Fischer who—in collaboration with Rolf Wedewer—in Europe had first linked the Bechers to Conceptual Art (see the exhibition *Konzeption—Conception*, Leverkusen, 1969) and in addition exhibited their work in his own gallery in 1970, we can assume that the inclusion of the Bechers was due to his initiative and that it was Fischer, and not Honnef, who discovered them. Dorothee Fischer confirmed this in an interview on January 31, 2003.

54. See *Documenta 5*, 23.42–23.44.

55. See *Medium Fotografie: Fotoarbeiten bildender Künstler von 1910 bis 1973*, exh. cat. (Leverkusen: Städtisches Museum Leverkusen, 1973); *Kunst aus Photographie: Was machen Künstler heute mit Photographie?* exh. cat. (Hannover: Kunstverein Hannover, 1973); *Combattimento per un' immagine, fotografi e pittori*, exh. cat. (Turin: Galleria Civica d'Arte Moderna, 1973).

56. Klaus Honnef, "Tagebuch," *Kunstforum International* 16 (1976): 273.

57. See esp. Anna Auer, *Die Wiener Galerie Die Brücke: Ihr internationaler Weg zur Sammlung Fotografis: Ein Beitrag zur Sammlungsgeschichte der Fotografie* (Passau: Dietmar Klinger, 1999); *Mechanismus und Ausdruck: Die Sammlung Ann und Jürgen Wilde: Fotografien aus dem 20. Jahrhundert*, exh. cat. (Hannover: Sprengel-Museum; Munich: Schirmer & Mosel, 1999); Stuart Alexander, "Fotografische Institution und fotografische Praxis," in *Neue Geschichte der Fotografie*, ed. Michel Frizot (Cologne: Könemann, 1998), 695–707.

58. See Evelyn Weiss, "Einführung in die Abteilung Fotografie," in *Documenta 6*, vol. 2, 7–10.

59. Klaus Honnef, "Fotografie zwischen Authentizität und Fiktion," in *Documenta 6*, vol. 2, 27, n. 93. Since 1974 Honnef has organized exhibitions at the Rheinisches Landesmuseum in Bonn featuring the Bechers (1975), Karl Blossfeldt (1976), Albert Renger-Patzsch (1977), and Germaine Krull (1977), among others.

60. See Lothar Romain and Manfred Schneckenburger, "Grundlagen der Documenta 6" (March 1976), in *Documenta: Idee und Institution: Tendenzen, Konzepte, Materialien*, ed. Manfred Schneckenburger (Munich: Bruckmann, 1983), 143–145.

61. We can see a prototype for this in a 1973 exhibition in Leverkusen organized by Lothar Romain and Rolf Wedewer which was based on the same model and included even more contemporary photographers; see *Medium Fotografie*.

62. Jo Ann Lewis, "Soho-on-the-Fulda: Home of the Bonapartes, the Brothers Grimm and the Avant-garde," *Washington Post*, July 10, 1977.

63. Cited in Meyer, *Conceptual Art*, 206.

64. See Thomas Crow, *The Rise of the Sixties: American and European Art in the Era of Dissent, 1955–69* (London: Calmann & King, 1996); Rorimer, *New Art*.

65. Paul Wember, in the foreword to the Krefeld edition of the exhibition catalogue *When Attitudes Become Form* (*Vorstellungen nehmen Form an*) accordingly pointed out Beuys and Fluxus as forerunners of the contemporary generation.

66. The exceptions to this, along with the British branch of Art & Language, are above all Daniel Buren, Victor Burgin, and the U.S. resident Hans Haacke.

67. See *Sigmar Polke Photoworks: When Pictures Vanish*, exh. cat. (Los Angeles: Museum of Contemporary Art, 1995).

68. On the paintings, see *Gerhard Richter*, exh. cat. (Bonn: Kunst- und Ausstellungshalle der Bundesrepublik Deutschland, 1993), vol. 3, nos. 379–384 (1975); Stefan Gronert, "Die Abbildlichkeit des Bildes: Die mediale Reflexion der Fotografie bei Gerhard Richter und Jeff Wall," *Zeitschrift für Ästhetik und allgemeine Kunstwissenschaft* 47 (2002): 37–72. On the Atlas, see Gerhard Richter, *Atlas van de foto's en schelsen*, exh. cat. (Utrecht: Hedendaagse Kunst, 1972); Gerhard Richter, *Atlas*, ed. Fred Jahn with a text by Armin Zweite, exh. cat. (Munich: Städtische Galerie im Lenbachhaus, 1989).

69. See *Documenta 5*, 16.65–68, 16.73–74, 16.107–109.

70. See *Andy Warhol: Photography*, exh. cat. (Hamburg: Hamburger Kunsthalle; Pittsburgh: Andy Warhol Museum, 1999).

71. Laszlo Glozer, "Ausstieg aus dem Bild: Wiederkehr der Aussenwelt," in *Westkunst: Zeitgenössische Kunst seit 1939* (Cologne: DuMont, 1981): 234–238; Peter Weibel and Christian Meyer, eds., *Das Bild nach dem letzten Bild / The Picture after the Last Picture*, exh. cat. (Vienna: Galerie Metropol, 1991); Johannes Meinhardt, *Ende der Malerei und Malerei nach dem Ende der Malerei* (Ostfildern: Cantz, 1997).

72. Cited in Lippard, *Six Years*, 59.

73. See his own account in *Documenta 6*, 154.

74. On the changes in Ruscha's criticism of photography up to the present, see Stefan Gronert, "'Reality Is Not Totally Real': The Dubiousness of Reality in Contemporary Photography," in *Great Illusions: Demand—Gursky—Ruscha*, exh. cat. (North Miami, Fla.: Museum of Contemporary Art, 1999), 12–30.

75. As exemplified by the work of Josef Albers, Ellsworth Kelly, Robert Ryman, and Frank Stella, among others; see *Systematic Painting*, exh. cat. (New York: Solomon R. Guggenheim Museum, 1966); *Serial Imagery*, ed. John Coplans, exh. cat. (Pasadena, Calif: Pasadena Art Museum, 1968).

76. On the significance of LeWitt for Conceptual Art, see Benjamin H. D. Buchloh, "Conceptual Art, 1962–1969: From the Aesthetics of Administration to the Critique of Institutions," *October*, no. 55 (winter 1990): 136–143; on the significance of the filmic in photo sequences, see Dreher, *Konzeptuelle Kunst*, 135–136.

77. See *Timm Rautert: Bildanalytische Photographie, 1968–1974* (Cologne: Verlag der Buchhandlung Walther König, 2000).

78. Victor Burgin, quoted in Osborne, *Conceptual Art*, 126.

79. See Godfrey, *Conceptual Art*, 203–205; Osborne, *Conceptual Art*, 126.

80. Cf. Godfrey, *Conceptual Art*, 327; Rorimer, *New Art*, 153; Dreher, *Konzeptuelle Kunst*, 78f.

81. Wall, "'Marks of Indifference,'" 267.

82. See Matthias Winzen, ed., *Thomas Ruff: Fotografien 1979–heute* (Cologne: Verlag der Buchhandlung Walther König, 2001), 184, 254; Peter Galassi, "Gursky's World," in *Andreas Gursky*, exh. cat. (New York: Museum of Modern Art, 2001), 27.

Dan Graham

Photographs of Motion (1969)

Originally published in *Endmoments* (New York: Privately printed, 1969).

The subject of motion through historical time has been pictured paradoxically: Zeno's early Greek word picture goes: "If at each instant the flying arrow is at rest, when does it move?" (Zeno's object was to prove that continuous motion in time did not, logically, exist)—forward to Joseph Pennell's observation on the early photographic object about the time of its first appearance in the middle Nineteenth Century: "If you photograph an object in motion, all feeling of motion is lost."

Just as an abstraction of "subject"/"object" framed and measured by verbal logic produces an equivalent illusion: paradox; a look at the historical framework of motion picture photography permits multiple reference points—suggestive a(illusions)—between the mechanism of its appearance and what we refer to be objective ("reality").

The earliest devices made movement to reproduce movement, done either by moving the pictures themselves, by moving their projected image optically, or by projecting upon a mobile medium. The Laterna Magica, used glass slides introduced from the sides. From this developed the technique of putting a sequence of several pictures on the same slide and showing them in succession in a continuous motion (an impression given like that of seeing through the window of a moving car the world go by with the single inversion that the movement represented here by objectively *real* motion is an illusory one—i.e. the subjective experience of seeing the world slide by the window). For the next step it was necessary to invert the process: to fixate the real mobile to be reproduced as an illusion by means of the immobile. A series of still photos provided the means . . .

A time exposure of someone stationed before a camera as he changes expression yields a blurred picture due to the successive phases of the expression being overlaid (in time?). The recording of periodic events represents a borderline case: the photograph of an oscillating pendulum will produce sharp images of the two extreme positions on each side. The "image" of periodic movement in time is made evident by the fact it gives an impression of complete rest.

In 1865 Jules Marey was investigating the problem of accurately recording the motion of a horse trotting or galloping so that the period during which each of the horse's feet touched the ground could be established. His solution was to insert in the hollow of each hoof of his subject, a rubber ball from which a long rubber hose led to an inked pen, which in turn drew a line on a piece of paper stretched around a continuously rotating drum whenever the animal placed its foot to the ground and so increased the pressure of the rubber ball. A registering instrument carried in the horserider's hand had four tubes inserted which led to four corresponding pens arranged one above the other. So that the length of time, in addition to the coincidence or succession of these strokes on the registration paper showed the time elapsed and the reciprocal relation between the lowering and the rise of each of the four feet of the horse. Later Eadweard Muybridge was commissioned by ex-Governor Leland Stanford of California to prove Marey's conclusions wrong. The Governor wagered $10,000 in support of his belief that at some point all four legs were off the ground. Progress was made on the test when a new "lightning process" in printing greatly reduced the exposure time required and also with the introduction of drop shutters activated by strings and rubber bands set off in succession by a string broken by the racing horse (later made electric). Soon the successful photographs

(Stanford had been right) were extended by Muybridge to all types of animal (man included) locomotion and shown to the public by means of another Muybridge "invention"—a modified stereopticon renamed, the *zoogyscope*. (The original stereopticon had been invented by Roget when he observed two principles: that a standing man walking on the other side of a slatted fence appeared through the slits to be in movement and that due to the parallax: disparity between the images of each of the observer's eyes as they viewed the flickering images from slightly different perspectives the image had the appearance of depth: a series of figures painted on the inside of a revolving glass cylinder which were seen through slits in the cylinder so the figures appeared animated was the modus vivendi of the device Roget perfected.)

Muybridge mounted transparencies of his photographic series on a circular glass plate. A second plate, of metal, was then mounted parallel to the glass, but turning on a concentric axis in the other direction. The second plate was slit at intervals, so that when the two plates rotated the metal plate became a shutter. An arc lamp projected the image on a screen. Later, in addition to twenty-four fixed cameras, Muybridge used two batteries of twelve so that rear views and 60-degree angle shots taken simultaneously with the front view by the use of an electric circuit (connected to a tuning fork which left graphic records on a sheet of paper) were taken. Exact time calculations could be made in relation to a grid marked upon the background to relate time to motion to perspective system.

The photographs were published, three angles in series as run per page. In looking at a Muybridge series: there is no fixed point of view when a group of cameras

Eadweard Muybridge; *Pugilist Striking a Blow*, from the book *Animal Locomotion*, c. 1887; sheet: 7⅛ x 17½ in. (18.1 x 44.5 cm); Smithsonian American Art Museum, Gift of Paul and Laurette Laessle

photograph the moving object in succession, a set of phases being ordered. But since several cameras can't be set up in the same place, the station point keeps changing. The relationship between the camera and moving object may be kept constant by using a different camera for each phase along the path. The releasing mechanism is dependent upon the movement of the object. The resulting photos are arranged in two-dimensional rows on the pages so as to have multiple, static points of reference.

There is no single, fixed point of view. The changes are positional and only involve the motion of the *reader's* eye (not the artist's "I"). This is unlike Renaissance perspective where there is a linear vanishing point "inside" the image. Photography eliminates this dimensionality; for there is no central or climatic point (unless the figure suddenly collapses into the ground). Each image is always in the present. No moment is created: things—moments—are sufficient unto themselves. In Mallarmé's words: "nothing shall take place except place." We see and measure things only by related distance or in terms of ordinal placement. What separates one moment (shot) from another is simple alteration in the positioning of things. Each shot-moment can be read without relation to the preceding or following one as they aren't linked. Things appear not to come from other things. Things don't happen; they merely replace themselves relative to the framing edge and to each other.

The conventions of black and white still photography: two-dimensional objects which appear at once solid and transparent functioning simultaneously in two entirely different planes of reference (the two-dimensional and the three-dimensional) so as one identical object it fulfills two different functions in two contexts, an image per frame which is always in the present—there being no before or after, except as reconstructed after the fact before (as read by) the viewer—the image fixed and limited to a contrast of light to be read all over horizontally, unlike Renaissance perspective in painting where the artist (not in the picture) was trying to re-present impressions by fixing (composing) for all time his exact "linear" perspective of things at a given moment, as pictorial depth is equated with the time it takes the eye to enter that depth . . .

Jules Marey, hearing of Muybridge's work, concluded that a battery of 24 separate cameras was too dumbly discrete—making it difficult to relate an action. Marey had by this time been influenced in his work by a French astronomer, Janssen, who in 1874 used photography to record the positions of Venus during its transit across the face of the sun, having invented a "photographic revolver" in which 48 instantaneous shots in juxtaposition were taken around the margin edges of the negative (a circular plate) as it rotated. The plate was timed to move forward at intervals, but remain stationary during the exposure. Marey's improvements on this method began in 1882 with the invention of a device with stationary plates and a moveable disk shutter to record in equal time intervals pictures of successive phases of motion of objects on black background: when an object to be photographed changes location on the plate while it is moving, the phases that follow each other in time can be presented next to each other on a two-dimensional plane. The same year, Marey devised a set-up with moveable plates which closely followed Janssen's "gun," but equipped with a sight and clock movement for picking up birds in flight. A few years later a "chrono photograph" with stationary plates was installed in a moveable darkroom. In consisted of a 41 feet in diameter rotating disk with a slot opening so that the disk turned ten times a second, each exposure 1/1000 of a second. Here the continuum is broken up into separate sharp images—the recording interrupted periodically and the resulting exposure short enough to yield sharp pictures. After 1890, Marey utilized a new serial device in which was used a strip of a negative paper which moved by a string, wound itself continuously from spool to spool and remained stationary for a moment during the exposure. These photographs, however, were not suitable for projection because of the unequal distances between pictures. There was also at the time no transparent film suitable for projection. All that remained was the invention of the celluloid filmstrip and a camera and a projector recording a projecting device to provide the package continuity of images: that was "invented" by the American packaging genius, Thomas A. Edison.

Ironically it wasn't the new medium of cinema which evolved from Edison's

invention, but the steps along its path—the analysis of motion—which first "moved" artists. Marey's work is recalled by the Futurists and most notably, by Marcel Duchamp's paintings, culminating in *Nude Descending a Staircase* whose overlapping time-space was directly modeled after Marey's superimposed series. Léger, Moholy-Nagy and others did utilize the motion picture (also Duchamp at a later date), but only as an available tool and not in terms of its structural underpinnings. It wasn't until recently, with the "Minimalist" reduction of the medium to its structural support in itself considered as an "object" that photography could find its own subject matter.

The use of the inherent transparent "flat," serialized space was why I turned to the 35mm slide (color transparency) as art "structure" in itself in a series shot in 1965 and 1966 of architectural alignments and another series of transparent-mirror "spaces"; these were exhibited in 1966 at Finch College's "Projected Art" (they dated from 1965 and 1966) and then in "Focus On Light" in Trenton, N.J. Some of these photographs also appeared in black and white as "documentation" contained in a two-dimensional projective network of schematic "information" about land use economics, standardization and serialization of buildings and buildings schematically relating the appearance of large-scale housing "tracts" (See "Homes for America," *Arts Magazine*, December–January, 1967). This was the first published appearance of art construed by the reader in a mass-readable-then-disposable context-document in place of the fact (neither before the fact as a Judd or after the fact as in current "Concept" art). Place in my article is decomposed into multiple and overlapping points of reference—mapped "points of interest"—in a two-dimensional point to point "grid." There is a "shell" present placed between the external "empty" material of place and the interior "empty" material of language; a complex, interlocking network of systems whose variants take place as information present (and) as (like) the medium—information—(in) itself.

James Lingwood

The Weight of Time (2002)

Originally published in *Field Trips: Bernd and Hilla Becher, Robert Smithson*, exh. cat. (Porto: Museu de Arte Contemporanea de Serralves; Turin: Hopefulmonster, 2002), 70–79.

On a cold December day in 1968, Bernd Becher took the German gallery owner Konrad Fischer and the visiting American artist Robert Smithson on a field trip. They set off from Düsseldorf, where Fischer had recently opened his gallery, and headed for Oberhausen, some twenty miles away, one of the largest industrial complexes in the Ruhr district, itself one of the most concentrated areas of industrial production in Western Europe at that time.

The field trip was for the benefit of Smithson, who was scheduled to open his first one-person exhibition in Europe in Fischer's gallery in Andreastrasse in a couple of weeks' time. In the summer of 1968 Fischer had invited Smithson to show, perhaps as a consequence of his participation in the groundbreaking "Minimal Art" exhibition at the Gemeentemuseum in The Hague in May 1968. Smithson accepted the invitation and wrote back in August "I think I would like to do an 'indoor earthwork' (a non-site) based on some rock or sand deposits in Germany—if you know of any quarries, we could collect the material when I get over there. Slag heaps, slate, coal, limestone, shale or other mining areas could be used. After I get the gallery plans, I'll send you my plans for the non-site 'containers'—that hopefully you could have fabricated before I arrive in November. Some geological maps of German rock and mineral deposits would be a help . . ."[1]

Oberhausen was a site which Bernd and Hilla Becher already knew well. They had begun to work there in 1963 (photographing the blast furnaces at Gutehoffnungshütte West), and continued between 1967 and 1969, this time concentrating on the other blast furnace, Gutehoffnungshütte Ost. It was an area with which, for a very different reason, Fischer was intimately familiar, since his grandfather's family had owned the entire complex as part of one of the oldest and largest steel companies in Germany, Hanel & Lueg. Although Smithson had made several excursions to quarries and mining areas as well as distressed industrial sites in his native New Jersey, the journey to Oberhausen was his first prospecting visit to an industrial site in Europe.

The rolls of film which Smithson took with his Instamatic refract the Oberhausen site through the restless lens of Smithson's eye. There is no particular route or narrative development within these photographs. What appears to be the first roll follows a pathway into one of the entrances to the site and includes details of trodden down grass, stone and slag, mud imprinted with the tracks of heavy lorries, as well as photographs of Smithson with his fellow prospectors. The other rolls contain many more close-ups of industrial wreckage, pools of solidified asphalt, mounds of broken-up slag, and cracked earth. Smithson kept close to the elemental details of the site, though these photos are interspersed with occasional glimpses through the smog of the blast furnaces which had spewed out all the waste. The sequences of prosaic black and white snapshots do more than describe an industrial wasteland. They conjure up an almost apocalyptic vision of an exhausted world. Oberhausen isn't so much documented as subjected to a temporal transformation, characteristic of Smithson's penchant for dramatic mental leaps in time and space, from the prehistoric (before anything had emerged from the primordial soup) to the posthistoric (when everything would return to a similarly undifferentiated state).

The wasted landscapes Smithson found at the edges of the Oberhausen site matched perfectly the exhortation of one of Smithson's favourite writers T. E. Hulme—"Great men, go to the outside, away from the Room, and wrestle with the cinders."[2] By the late 60s, Smithson was already clear that his operational zone of preference was away from 'the Room,' at the periphery, where he could locate "the memory-traces of an abandoned set of futures,"[3] before bringing them back to the centre in the form of non-sites and displacements, films and writings which would collectively "surmount the perimeters of the old sensibility."[4]

Bernd and Hilla Becher saw the Oberhausen site differently. They knew the whole Ruhr district intimately, and had reconnoitred every industrial complex in the area, large and small. They had begun

Bernd and Hilla Becher; *Bergwerk Concordia, Oberhausen, D*, 1967; black-and-white photograph; 19¾ x 23⅝ in. (50 x 60 cm); courtesy Sonnabend Gallery, New York

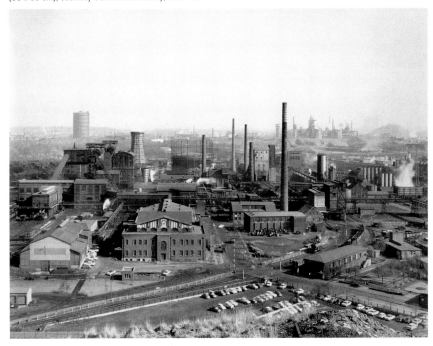

to photograph in the mining area around Siegen, where Bernd had grown up, in the early 1960s and quickly formulated working methods which remain essentially unchanged today. In the Robert Smithson papers in the Archives of American Art, there is a single black and white photographic print given to Smithson by the Bechers: a panoramic view of the industrial landscape of Oberhausen, with the coal mining complex Zeche Concordia in the foreground, and Gutehoffnungshütte Ost and West, the two huge steel-making factories, in the background. Many of the types of industrial buildings which were central to the photographic project of the Bechers feature in this panorama: winding-towers and water towers, coal silos, cooling towers, gas holders, and blast furnaces as well as factory buildings of many different kinds. This overview is reproduced on the first pages of their 1971 book *Die Architektur der Förder- und Wassertürme* in juxtaposition to an engraving of an industrial landscape from 1800, a comprehensive summary of forms of buildings clustered in a heavily industrialised landscape.

By the time of the trip, the Bechers had already conceived their immensely ambitious, open-ended project—nothing less than to create a quasi-encyclopedic record

of the vernacular buildings of the industrial age first in their immediate region, and then beyond. Since the end of the Second World War, photography in Germany had turned away from the shattered landscape towards manipulated "subjective" worlds. The Bechers faced out again, picking up the disrupted (and at the time largely forgotten) approach of the Neue Sachlichkeit. Sander's photographs of German citizens were a revelation and Blossfeldt's book of close-ups of plants and flowers—*Urformen der Kunst*—provided them with a precedent of precise description and delineation of different forms.

The terrain of the Bechers' project was the industrial world. Both the Bechers and Smithson shared a mutual fascination for the sites of heavy industry and an interest in a certain aesthetic ambiguity which issued from their uses of photography. They shared many friends amongst the rapidly evolving international art milieu of the late 60s, including most notably Carl Andre and Sol LeWitt, both of whom had already showed in Fischer's gallery. They exchanged works. The Bechers remember giving Smithson several photographs of cooling towers which apparently hung in his bedroom (a painting by Kosuth based on a blow-up of the dictionary entry for

"Entropy" was in the dining room). Smithson gave the Bechers a small non-site in 1969, for which they gathered the slag themselves in Oberhausen. But the modus operandi of the artists could hardly have been more different. The photographic tool of the Bechers was a wieldy plate camera (first an old wooden plate camera, and then a Plaubel 13/18) which enabled them to make photographs with an exceptional degree of definition. Smithson on the other hand used an Instamatic camera in an apparently casual manner to produce small snapshots. The Bechers arrived to photograph at a particular site following detailed research and they methodically applied a pre-determined formal system. Smithson arrived somewhere in a far less deliberate way, improvising on the themes he had coursing around his fertile mind. Where the Bechers saw forms and structures within a working industrial complex, Smithson sought out formlessness, disintegration and waste.

Oberhausen was a particularly rich seam for the Bechers to mine. Though they had already travelled extensively through Northern Europe as their project began to take shape, Oberhausen was one of the largest sites closest to home. They worked there extensively between 1968 and 1972, making as many visits as possible when the weather conditions were right (essentially a neutral and cloudless sky—nothing could be more different than the murky atmosphere in Smithson's snaps). At the time, they had begun to exhibit in Germany and to find their work placed within the context of conceptual art and they were building up groupings of buildings for their first book—*Anonyme Skulpturen*—published in 1970. The book enabled the Bechers for the first time to present many of the key types in their natural history of industrial buildings or objects. In the back of the book, they articulate with typical conciseness their intentions. "In this book we show objects predominantly instrumental in character whose shapes are the results of calculation and whose processes of development are optically evident. They are generally buildings whose anonymity is accepted to be the style. Their peculiarities originate not in spite of, but because of the lack of design."[5]

Robert Smithson; from Oberhausen Photographs, 1968; black-and-white photograph; 8 x 10 in. (20.3 x 25.4 cm); Robert Smithson Papers, Archives of American Art, Smithsonian Institution, Washington, D.C.

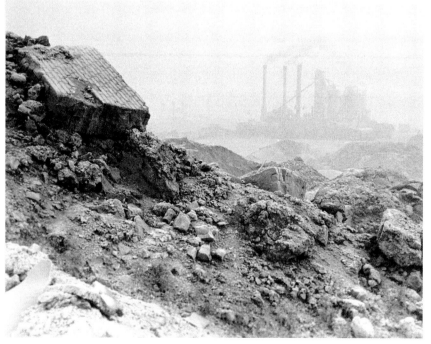

The objects the Bechers presented were organised into families of forms, sequenced to emphasise the way in which

different vernacular forms evolved in response to different needs and developing technologies. The categories they chose to present in this first publication were lime kilns, cooling towers, blast furnaces, winding towers, water towers, gasholders, and silos. The book included photographs from Oberhausen in several of these sections, amongst them portraits of many of the individual buildings which feature in the overview photograph of Oberhausen such as the cooling towers, winding towers, water towers, and gasholders from Zeche Concordia and the blast furnaces at Gutehoffnungshütte.

The Oberhausen "archive" gradually found its way into different families of types. The Bechers were more interested in showing how one form related to another in terms of form than in terms of function. But occasionally, the family of buildings on one particular site have also been shown together, as was the case with the Gutehoffnungshütte site which was the subject of an exhibition of photographs at Konrad Fischer's gallery in 1976.[6]

The first book by the Bechers already embodies their refined aesthetic of hard facts. Each building or structure has been photographed and presented in as clear, as frontal, and as apparently unmediated a form as possible. Each seems to present itself directly to the camera, so that the character of each building is as clearly delineated as possible. They share similarities, but they are never precisely the same. As Hilla Becher has stated, "You can only see the differences between the objects when they are close together, because

they are sometimes very subtle. All the objects in one family resemble each other, they are similar. But they also have a very special individuality."[7]

At the same time, the sequencing of the photographs expresses the relationship of the individual variations to basic, general forms in a vernacular equivalent to the development of different sculptural languages in Medieval Europe. It may appear that the Bechers' work is cool, controlled and detached. But rarely can such apparent detachment have been allied to such enduring passion—in this case to attest to the endless variations of vernacular industrial form—and rarely can such apparent stylelessness have evolved into such a singular style. Their immersion in the overlooked and unaestheticised landscapes of the industrial era is not based on a mental projection of time, as it is with Smithson, but on a desire to engage the viewer in the mentality of a particular time—the era of heavy industrial production.

Days after their joint expedition to Oberhausen, Smithson's exhibition opened at the Galerie Konrad Fischer. He presented two works. The sculpture he had described to Fischer became the most ambitious articulation of his "non-site" idea to date: *Non-Site (Oberhausen)*, 1968. In one of Smithson's characteristically laconic inversions, he deposited bits of slag, the waste product from the industrial process used to produce steel, in five steel bins, painted white. The slag, collected on the field trip, filled each container like specimens in a geological display. At the same time, protruding from the top bar of

the stratified steel, they look like ranges of disrupted landmass.

On the wall to the side of the containers, Smithson installed five panels. Each panel had the same detail of the map of the Oberhausen site, a description of the site written by Smithson, and five photographs from the rolls taken on the field trip.[8] Different kinds of evidence rubbed up against each other—hard geological facts, photographic impressions, and cartographic description—in a display which mirrors Smithson's own restless mind as it oscillates between microcosm and macrocosm, scientific specimen and imaginative project.

The second work Smithson exhibited in Düsseldorf in December 1968 was a lump of asphalt, picked up on site and deposited on the floor of the gallery without further artistic intervention and without any additional information. Asphalt is the residue from refining coal, just as slag is the byproduct of steel-making. Nothing in Smithson's previous work quite prepares us for this radical gesture, except perhaps the playful, provocative tone of his writing. *Asphalt Lump* is a post-industrial readymade, an object of pure impurity, a black formless counterpoint to Duchamp's white shrine. No bin contained the lump, it was framed only by a white rectangle painted on the gallery floor. It just sits there, an absurd specimen of solidified formlessness, the very embodiment of entropy—that state of inert equivalence which fascinated Smithson and which was the polar opposite of the Bechers' interest in the differentiation of objects.

Invitation to Robert Smithson exhibition, *Non-site*, Galerie Konrad Fischer, Düsseldorf, December 20, 1968–January 17, 1969, with map of Oberhausen

Smithson had been prospecting with friends and fellow artists in the US since the early 1960s. Usually accompanied by Nancy Holt, and most often in the hinterlands of New Jersey, Smithson made expeditions with, amongst others, Carl Andre, Donald Judd, Michael Heizer, Sol LeWitt, Robert Morris (Andre and LeWitt were also close friends of the Bechers) as well as Virginia Dwan in whose New York gallery he would present a substantial non-site exhibition in February 1969. In one of his first non-sites (*A Nonsite, Franklin, New Jersey*) realised in May 1968, Smithson juxtaposed an aerial photograph of the site cut up into five sections with five bins containing mineral deposits from Franklin. In a text which was part of the work, he wrote "The map is

three times smaller than the non-site. Tours to sites are possible. The 5 outdoor sites are not contained by any limiting parts—therefore they are chaotic sites, regions of dispersal, places without a Room—elusive order prevails, the substrata is disrupted (see snapshot of the five shots)."

During this period of intense development from his quasi-minimal sculpture, Smithson articulated the formulation of the site/non-site dialectic in a key essay published in *Artforum* in September 1968, "A Sedimentation of the Mind—Earth Projects." The essay foregrounds more intensively than any of Smithson's previous writing his obsession with structures and their inevitable collapse. "A bleached and fractured world surrounds the artist. To organize this mass of corrosion into patterns, grids, and subdivisions is an aesthetic process that has scarcely been touched . . . construction takes on the look of destruction; perhaps that's why certain architects hate bulldozers and steam shovels. They seem to turn the terrain into unfinished cities of organized wreckage. . . . The actual disruption of the earth's crust is at times very compelling, and seems to confirm Heraclitus Fragment 124 'The most beautiful world is like a heap of rubble tossed down in confusion.'" And then later, "The strata of the Earth is a

jumbled museum. Embedded in the sediment is a text that contains limits and boundaries which evade the rational order, and social structures which confine it. In order to read the rocks, we must become conscious of geologic time."[9]

Smithson's interest in "geologic time" echoes the strata of time which the great French historian Fernand Braudel described as co-existing within the present. Braudel articulated three different temporal modes: the time of the individual, which he called "biological time," the "social time" of human cultures, their mental structures, beliefs, habits and customs, and, finally, a much slower time of environmental, climatic, and demographic change which he termed "geographical time." Smithson's interest in "geologic time" echoes this final temporal mode of Braudel's but it also exceeds it, since geologic time was too slow and too deep to take any account of humankind at all. It stretched back to the cataclysmic movements of landmass and catastrophic shifts in temperature which preceded any signs of human life on earth.

His fascination with the elemental facts of geology had grown from this adolescent excursions to the Museum of Natural

History in New York (a site to which he returned in the *Spiral Jetty* film) to the field trips with his co-artists until, by the end of 1968, he wanted to go further than the quasi-scientific observation and presentation of geologic time. He wanted not only to observe "geologic" time but to imitate its vastness and depth: to play at *being* it. Informed by his research into land-slides, avalanches and eruptions, he began to make drawings of these phenomena. The drawings projected imaginary flows of mud, asphalt, and cement on to the landscape and a trilogy of actions emulating geological movements were performed in late 1969 and early 1970. *Asphalt Rundown* was realised in a quarry outside Rome in the autumn of 1969 (the location of the quarry on the run-down periphery of the epicentre of classical civilisation was particularly pleasing to Smithson), followed by *Concrete Pour* in a quarry near Chicago, and soon after a smaller scale work, *Glue Pour* in Vancouver.[10]

Smithson had stated in an interview: "It is sort of interesting to take on the persona of a geologic agent where man actually becomes part of that process rather than overcoming it."[11] In taking on that persona, he could play at escaping the constraining structures of aesthetic convention of his time—notably the preoccupation with the unity of the gestalt. In a letter from 1968 he wrote that "geologic time has a way of diminishing 'art history' to a mere trace."[12] Similarly, following his encounter with the crumbling chaos of the slate quarries in Bangor in Pennsylvania, he rejoiced that "All boundaries and distinctions lost their meaning in this ocean of slate and collapsed all notions of gestalt unity. The present fell forward and backward into tumult of 'de-differentiation.'"[13] Smithson was not alone in co-opting the power of natural disaster in an assault on modernist aesthetics. In 1967 his friend Carl Andre had proposed to make a work of art which was an explosion, and Walter de Maria had earlier suggested that an earthquake was a work of art. Smithson however pushed further into the territory of the imagination with projects which specifically confronted the habitat of man—symbol of Braudel's social time—with the geologic time of earth movement.

In April 1969 on a field trip with Nancy Holt and Virginia Dwan to the Yucatan, Smithson had initially thought to head for

Robert Smithson; from Oberhausen Photographs, 1968; black-and-white photograph; 8 x 10 in. (20.3 x 25.4 cm); Robert Smithson Papers, Archives of American Art, Smithsonian Institution, Washington, D.C.

the famous Mayan ruins. Instead, he became preoccupied with a small hotel. *Hotel Palenque* was a site on which it was unnecessary to perform any action. It already epitomised the irreversible force of entropy. From a series of colour slides made in 1969, Smithson eventually invented a laconic travel guide (returning to the mode he had deployed in his earlier piece of writing and photography "A Tour of the Monuments of Passaic, New Jersey" published in *Artforum* in December 1967) which he delivered to students at the University of Utah. Rather than relocating his project in the remnants of an earlier civilisation, he located it in the ruins of his own. One part of the tourist hotel was in the process of being constructed, whilst other parts of the building were already in the process of falling apart. His drawing of the lay-out of the hotel noted areas of garbage, rubble and ruins as well as the rooms which had been finished, a dried out swimming pool and a dance hall with a stuffed hawk.

Smithson was not, as were the Bechers, an observer by disposition. Standing at the threshold of awesome nature was insufficient. He wanted to cross that threshold, and simulate that power himself. When invited to make a work at Kent State University in Ohio in January 1970, he had initially proposed a mud flow. When that proved impossible, because it was too cold in Ohio in the winter for mud to flow, he rethought his project in relation to a small construction at the edge of the University campus. Photographs of destroyed human habitats had long fascinated Smithson— houses overwhelmed by lava or mud, villages destroyed by earthquakes or landslides. On the Kent State campus, he again emulated the destructive force of nature by organising a bulldozer to load earth onto an abandoned woodshed until the weight of earth had cracked the central supporting beam. At the point at which the central structure was destroyed, Smithson declared the work to be complete. *Partially Buried Woodshed* was a perfect embodiment of Smithson's equation of mental and physical de-construction. "One's mind and the earth are in a constant state of erosion," he wrote, "mental rivers wear away abstract banks, brain waves undermine cliffs of thought, ideas decompose into stones of unknowing, and conceptual crystallisations break apart into deposits of gritty reason. Vast moving faculties

occur in this geological miasma, and they move in the most physical way. This movement seems motionless, yet it crushes the landscape of logic under glacial reveries."[14]

Smithson's actions in the landscape— culminating in the vast *Spiral Jetty* which he realised later that same extraordinary fertile year—contrast vividly with the testament of the Bechers. Smithson's work from this period is full of real or implied sound; the crash of huge earth-moving machines, the cracking of structures, the whirring of film, the torrent of words. The world of the Bechers' photographs, on the other hand, irrespective of whether the sites in which they photograph are active or obsolete, is muted and silent.

Because of the formal resolution and consistency of their work, it is tempting to call the Bechers' work timeless. But it is in fact full of time—a time which Braudel called "social" but which in the case of the Bechers could be called "historic" time, in distinction to the "geologic" time of Smithson's projections. In their books and exhibitions, they invite first a concentrated scrutiny of their chosen objects, a meditation on their sameness and difference, form and function, and through this comparative reading, a reflection on the form of the society that produces them. The individual forms may be presented excised from context, but the Bechers remain acutely aware of the forces at work in the construction and ultimate obsolescence of these forms. The plants begin to die the moment they cease to produce, their instability masked by their massive physical presence. In their inevitable fate as much as their huge scale, these buildings embody, as Hilla Becher has remarked, "the mentality" of the industrial age.[15]

To the Bechers it was already clear in the 1960s that these structures were essentially nomadic and had a comparatively short life compared with more classical or sacred architectural forms. Their first two books already presented many industrial sites which had closed down, particularly coal-mines no longer productive in the 1960s. They present these objects in precisely the same way as any others, without comment and without sentiment. When they visited the United States on a long working trip in 1973, they photographed extensively throughout the coal-mining area of Pennsylvania, where a particular

kind of winding tower, called coal mine tipples, had been constructed by small-scale coal-mining enterprises. Strips of wood and bits of steel were fastened together with only the most functional aim in mind—to enable coal to be brought to the surface—and the Bechers hurried to photograph them in all their apparent frailty. These provisional wooden constructions apparently on the point of collapse or abandonment mirror the fragility of the simple woodshed which Smithson had overloaded.

On the same trip to the US, the Bechers also photographed huge steel mill complexes in Pennsylvania and Alabama. Amongst the portraits of blast furnaces and cooling towers, they made photographs of the landscape in which these sites were located. Perhaps inspired by the example of Walker Evans who had also photographed in some of these areas, some of these photographs embody a less reserved description of the mentality of the age. The huge blast furnaces at Ensley, Alabama, for example, are juxtaposed with a large scrapyard of discarded automobiles: symbols of the quickening cycles of construction and production, usefulness and uselessness at the heart of the post-war economic miracle.

Smithson wanted his work to emulate the process of entropy. He wanted to play with time, to wrestle with it, to accelerate or decelerate it to a point of disintegration, to quicken the collapse of the belief systems and structures which underpinned this "historic" time. Smithson, the great artist/entropologist of his generation projected his work into the greatest expanses

Robert Smithson, *Hotel Palenque* (detail), 1969 (cat. no. 174)

of time and imagined its ultimate cooling down, to the point where nothing could be differentiated and everything would be formless.

By contrast the Bechers, his guides to the Oberhausen site and our guides to a "historic" time, have built a structure to meditate on the difference of things. Theirs is a work of patient construction, as Smithson's is one of impatient deconstruction. In their immense photographic project, their natural history of industrial form, the Bechers have slowed time down. It is almost as if the Bechers, the great artist/encyclopedists of

their generation, want us not simply to see the very singularity of every object, but to hold them, to feel their weight, and through them to feel the very weight of time.

Notes

1. Unpublished letter from Robert Smithson to Konrad Fischer, August 9, 1968, Archives of American Art, Smithsonian Institution, Washington D.C.
2. T. E. Hulme, "Cinders—A New Weltanschauung," in *Speculations*, London, 1936, p. 236.
3. Robert Smithson, "A Tour of the Monuments of Passaic," *Artforum*, December 1967, reprinted

in *The Writings of Robert Smithson*, ed. Nancy Holt, New York University Press, New York, 1979, p. 5.
4. Mel Bochner and Robert Smithson, "The Domain of the Great Bear," *Art Voices*, Fall 1966. Also reprinted in *The Writings of Robert Smithson*, op. cit., p. 26.
5. *Anonyme Skulpturen*, Artverlag Press, Düsseldorf, 1970 (n.p.).
6. This exhibition is now in its entirety in the Crex Collection at Schaffhausen. The photographs are also reproduced over 4 pages of the catalogue published by the Van Abbemuseum, Eindhoven, in 1981, pp. 38–41.
7. Hilla Becher, conversation with James Lingwood, 1995.
8. Smithson had the rolls of film developed in Düsseldorf for the exhibition. Twenty-five were used in the *Non-Site (Oberhausen)* work, now in the Flick collection. The remaining photographs were retained at the Galerie Konrad Fischer. A group of 28 of these photographs subsequently entered first a private collection in Germany and then a private collection in the United States, which also has a further group of three photographs. The artist's widow, Nancy Holt, bequeathed the negatives as well as a series of 60 10 x 8" black and white prints to the Archives of American Art in Washington D.C.
9. "A Sedimentation of the Mind: Earth Projects" in *The Writings of Robert Smithson*, op. cit., p. 83.
10. *Concrete Pour* was realised for the exhibition "Art by Telephone" at the Museum of Contemporary Art in Chicago, November 1 to December 14, 1969 and *Glue Pour* was realised as part of Lucy Lippard's exhibition "955,000" at the Vancouver Art Gallery from January 14 to February 8, 1970.
11. Conversation with Gianni Pettena, *Domus*, November 1972. Also reprinted in *The Writings of Robert Smithson*, op. cit., p. 187.
12. Unpublished letter to Martin Friedman, May 30, 1968, Archives of American Art, Washington D.C.
13. "A Sedimentation of the Mind: Earth Projects," op. cit., p. 89.
14. Ibid., p. 82.
15. Hilla Becher, conversation with James Lingwood, 1995.

Bernd and Hilla Becher; *Reed & Herb Coal Co., Joliett, Schuylkill County, Pa., USA*, 1975, from Pennsylvania Coal Mine Tipples; black-and-white photograph; 16 x 12 ¼ in. (40.4 x 30.9 cm); courtesy Sonnabend Gallery, New York

Robert Smithson

Art through the Camera's Eye (c. 1971)

Originally published in Eugenie Tsai, *Robert Smithson Unearthed: Drawings, Collages, Writings* (New York: Columbia University Press, 1991), 88–92.

There is something abominable about cameras, because they possess the power to invent many worlds. As an artist who has been lost in this wilderness of mechanical reproduction for many years, I do not know which world to start with. I have seen fellow artists driven to the point of frenzy by photography. Visits to the cults of Underground filmmakers offer no relief. In the dark chamber of the Film Archives, my eyes have searched in vain for the perfect film. I have disputed arcane and esoteric uses of the camera in murky bars, and listened to vindications of the Structural Film, the Uncontrolled Film, the Hollywood Film, the Political Film, the Auteur Film, the Cosmic Film, the Happy Film, the Sad Film, and the Ordinary Film. I have even made a film. But the wilderness of Cameraland thickens.

Artists suffering from a sense of unreality suspect the camera's eye. "There are enough shadows in my life," declares Carl Andre in a discussion on photography. "I have looked at so many photographs, I can not see them anymore," says Michael Heizer. "I would like to make an abstract film," says Andy Warhol. As long as cameras are around no artist will be free from bewilderment. Mel Bochner's "Theory of Photography" is called *Misunderstandings*. Once in the Chateau Marmont on Sunset Boulevard, I talked to Claes Oldenburg about his *Photo Death*. He said it concerned "shooting" pretty fashion models on atomic bomb testing grounds.

Physical things are transported by heliotypy into a two-dimensional condition. Under red lights in a dark room worlds apart from our own emerge from chemicals and negatives. What we believed to be most solid and tangible becomes in the process slides and prints. Artists still involved in handy craft (some painters and some sculptors) can not escape the perilous eye of the camera. Consider the thousands of 8" x 10" glossies piling up in the galleries, waiting to be reproduced in some newspaper or magazine. To be sure, there remain those half-crazed artists that try to find hideouts for their work. Yet, the totems of art and the taboos of the camera continue to haunt them.

Some artists are insane enough to imagine they can tame this wilderness created by the camera. One way is to transfer the urge to abstraction to photography and film. A camera is wild in just anybody's hands, therefore one must set limits. But cameras have a life of their own. Cameras care nothing about cults or isms. They are indifferent mechanical eyes, ready to devour anything in sight. They are lenses of the unlimited reproduction. Like mirrors they may be scorned for their power to duplicate our individual experiences. It is not hard to consider an Infinite Camera without an ego.

Somewhere between the still and movie camera, I postulate the Infinite Camera (no truth value should be attached to this postulation, it should be regarded as something to write about).

I am looking through a magazine called *35MM Photography*, Spring 1971—"A Complete Guide," and on the inside of its cover is a marvelous advertisement. It is a photograph of a still camera half submerged in polar waters. I do not know which pole. Of course, the camera is made in Japan—it is a Yashica. In the background of the advertisement is an iceberg. "Like the Iceberg, the greatest part of Yashica's TL Electro-X is hidden beneath the surface." Now who could ask for a more Infinite Camera than that? The camera "eliminates troublesome needles, coils, springs, galvanometers—all moving parts." With this in mind, one can imagine thousands of tourists wandering on one of the ice caps taking countless snapshots of snow drifts. Such slides could be made into a motion picture. But as one goes deeper into this magazine, the camera wilderness grows denser. We see the "quick change artist," the Capro FL-7, the Ricoh ("You'd have to buy two cameras to get these features"), the Leicoflex SL ("You can hear the precision"), and so it goes. Who knows the right camera to choose? Actually, when I walk into a camera store, I am overcome by enervation. The sight of rows of equipment fills me with lassitude and longing. Lenses, light meters, filters, screens, boxes of film, projectors, tripods, and all the rest of it makes me feel faint. A camera store seems a perfect setting for a horror movie. A working title might be, *Invasion of the Camera Robots*; it would be based on the Cyclops myth, with the camera clerk as Ulysses. A camera's eyes alludes to many abysses. Each click would expose the clerk and his store to partial annihilation. I leave the ending for readers to figure out.

Nevertheless, those abysmal speculations do not keep me away from my own Kodak Instamatic reflex camera. Surrounding the aperture is a lens-opening scale made for determining light conditions—it carries the symbols of "cloud" and "sun." The more I consider them, the more they become hieroglyphics—a secret code. There are times when light readings are governed by the cloud. Natural forces combine with automatic functions to create a region of overcast grayness, an area of inarticulation, dullness, and ambiguity. All and all light is diminished. On the right side of the cloud is the symbol of the sun. The camera thus reminds us of that most brilliant object the sun—no it is not an object, but rather an undifferentiated condition from which there is no escape. Photographs are the results of a diminution of solar energy, and the camera is an entropic machine for recording gradual loss of light. No matter how dazzling the sun, there is always something to hide it, therefore to cause it to be desired. One tends to forget this, when firing flashbulbs in the shadows. As Paul Valéry pointed out, the sun is a "brilliant error." And I should like to add, that the camera records the result of that "error."

Above the symbols of cloud and sun on the focusing index is the symbol of "infinity." Once I had somebody take 400 snapshots of horizons in Seattle, the recording of such stigmatic vistas and unreachable limits resulted in a collection of banished bits of space. Taking such photos puts the human eye in exile and brings on a cosmic punishment. The measurable lengths of objects give comfort and certainty in the face of the infinite. Length tells us how long a thing is, it is a measurement of anything from end to end. This unit leaves out width and breadth and is opposed to "shortness." Art yearns to be long not short.

The comparison of narrative structure to architecture is right, insofar as both a story and a building make an arrangement or an enclosed place for living, a field of presence for the mind, by which everything outside of it can be dismissed from concern. It functions like the frame of a picture, to isolate what goes on inside it for complete attention and realization.—quoted in Donald Sutherland, *Gertrude Stein: A Biography of Her Work*

Richard Serra's film *Frame* exposes the contradictions of the measured unit. The problem that once attended painting, namely locating the "framing edge," is parodied in this film. Measurable lengths are reduced to a joke, and towards the end of the film Serra himself is caught in an illusion. It has also been brought to my attention that this film would not fit on the carefully constructed screen at the Film Archive.

Michael Snow's film *Wavelength* could be seen as a documentary of a single still photograph of the ocean: the length of the wave is in the slow zoom shot, that advances through a series of pulsations and color disturbances. The inexhaustible ocean flux is absorbed by the infinity of the camera flux. Both wave and length are alienated from time and space. No distances remain to be measured, no points are to be connected— the ocean dries up into a photograph. It is interesting to see Snow now moving into the actual landscape with a delirious camera of his own invention.

The *Land Art* films shot by Gerry Schum of the Fernsehgalerie in Berlin leave something to be desired, nevertheless they do indicate an attempt to deal with art in the landscape. Television has the power to dilate the "great outdoors" into sordid frontiers full of grayness and electrical static. Vast geographies are contracted into dim borders and incalculable sites. Schum's "Television gallery" proliferates the results of Long, Flanagan, Oppenheim, Beuys, Dibbets, De Maria, Heizer, and myself over unknown channels which bifurcate into dissolving terrains.

Yet, within the range of public television as it exists in terms of contraction and diffusion, each artist retains his individual perception of order. An artist may operate in a "closed landscape." His point of view is then based on deliberate restrictions, he intends to define or plot a self-sustaining autonomous limit within a containing framework. Thus, the landscape plays the role of an "object" or "unit" that excludes breaks or interruptions. One order or view is carried to its logical conclusion. On the other hand there is the "open landscape" which embodies multiple views, some of which are contradictory, whose purpose is to reveal a clash of angles and orders within a sense of simultaneity, this shatters any predictable frame of reference. Intentional "concepts" are subverted. If the closed landscape is a matter of faith and certainty, the open landscape is a matter of skepticism and uncertainty. Many artists involved with the landscape have developed out of abstraction which is based, for the most part, on interior enclosures of sculpture parks. The studio and gallery are taken for granted. Abstraction emerges from a psychological fear of nature, and a distrust of the organic. Cities are abstract complexes of grids and geometries in flight from natural forces. The primitive dread of nature that Wilhelm Worringer put forth as the root of abstraction has devolved into what David Antin calls "affluent spirituality." Rather than turn their backs on nature, certain artists are now confronting it with the medium of the camera, as well as working directly with it.

It appears that abstraction and nature are merging in art, and that the synthesizer is the camera. As soon as one mentions abstraction or nature, many abstractions and natures come to mind. The degrees of abstraction diminish as one goes from the "city" with its squares and structures to the "country" with its plowed fields and farm yards, until it vanishes into the "wilderness" with its un[. . .]frontiers. The patterns of [abstraction] order things [in] the world [into] countless frameworks that counter nature's encroachments. We live in frameworks and are surrounded by frames of reference, yet nature dismantles them and returns them to a state where they no longer have integrity.

Today's artist is beginning to perceive this process of disintegrating frameworks as a highly developed condition. Claude Levi-Strauss has suggested we develop a new discipline called "Entropology." The artist and the critic should develop something similar. The buried cities of the Yucatan are enormous and heterogeneous time capsules, full of lost abstractions, and broken frameworks. There the wilderness and the city intermingle, nature spills into the abstract frames, the containing narrative of an entire civilization breaks apart to form another kind of order. A film is capable of picking up the pieces.

Let's face it, the "human" eye is clumsy, sloppy, and unintelligible when compared to the camera's eye. It's no wonder we've had so many demented and conflicting views of nature. As it turns out, ecology is the latest notion of humanized nature, or what used to be called "naturalism." Confidence in "human nature" has gone sour, the unproblematic sense of being human in the midst of a naive anthropomorphic pantheism leaves mother nature wading through polluted rivers. But how human is a flood or a hurricane? Surely, they are just as menacing as machines used wrongly. Just when Positivist thought he had it made, the Cartesian Spectre comes back to haunt us. Michel Foucault has gone so far as to say that "man" like "God" will disappear as an object of our knowledge. Hopefully "objects" themselves will disappear "specific" or otherwise. Abstraction like nature is in no way reassuring. Things-in-themselves are merely illusions.

A few weeks ago, I read in the *New York Times* that Alain Resnais is working on a film that deals with a frustrated movie producer, who turns to fighting pollution. The relationship between pollution and filmmaking strikes me as a worthwhile area of investigation. Resnais's landscapes and sites have always revealed a degree of horror and entrapment. In *Night and Fog*, Resnais contrasts a pastoral site (shot in technique color) of a concentration camp overgrown with grass and flowers, with black and white photographs of horrors from its past. This suggests that each landscape, no matter how calm and lovely, conceals a substrata of disaster—a narrative that discloses "no story, no buoyancy, no plot" (Jean Cayrol: *Lazare parmi nous*). Deeper than the ruins of concentration camps, are worlds more frightening, worlds more meaningless. The hells of geology remain to be discovered. If art history is a nightmare, then what is natural history?

Mel Bochner

Misunderstandings
(A Theory of Photography)
(1967–1970)

Originally published by Multiples Inc., New York,
as part of *Artists and Photographs* (1970).
The project consists of ten photo-offset prints
on note cards (5 x 8 in. [12.7 x 20.3 cm] each).

I WOULD LIKE TO SEE PHOTOGRAPHY MAKE PEOPLE
DESPISE PAINTING UNTIL SOMETHING ELSE WILL
MAKE PHOTOGRAPHY UNBEARABLE.

MARCEL DUCHAMP

I WANT TO REPRODUCE THE OBJECTS AS THEY
ARE OR AS THEY WOULD BE EVEN IF I DID
NOT EXIST.

TAINE

PHOTOGRAPHY CANNOT RECORD ABSTRACT IDEAS.

ENCYCLOPEDIA BRITANNICA

LET US REMEMBER TOO, THAT WE DON'T HAVE TO
TRANSLATE SUCH PICTURES INTO REALISTIC ONES
IN ORDER TO 'UNDERSTAND' THEM, ANY MORE THAN
WE NEED TRANSLATE PHOTOGRAPHS INTO COLORED
PICTURES, ALTHOUGH BLACK-AND-WHITE MEN
OR PLANTS IN REALITY WOULD STRIKE US AS
UNSPEAKABLY STRANGE AND FRIGHTFUL.
SUPPOSE WE WERE TO SAY AT THIS POINT:
'SOMETHING IS A PICTURE ONLY IN A PICTURE-
LANGUAGE!

LUDWIG WITTGENSTEIN

THE TRUE FUNCTION OF REVOLUTIONARY ART IS THE CRYSTALLIZATION OF PHENOMENA INTO ORGANIZED FORMS.

MAO TSE-TUNG

IN MY OPINION, YOU CANNOT SAY YOU HAVE THOROUGHLY SEEN ANYTHING UNTIL YOU HAVE A PHOTOGRAPH OF IT.

EMILE ZOLA

PHOTOGRAPHY IS THE PRODUCT OF COMPLETE ALIENATION.

MARCEL PROUST

THE PHOTOGRAPH KEEPS OPEN THE INSTANTS WHICH
THE ONRUSH OF TIME CLOSES UP; IT DESTROYS
THE OVERTAKING, THE OVERLAPPING OF TIME.

MAURICE MERLEAU-PONTY

PHOTOGRAPHS PROVIDE FOR A KIND OF PERCEPTION
THAT IS MEDIATED INSTEAD OF DIRECT...
WHAT MIGHT BE CALLED 'PERCEPTION AT
SECOND HAND.'

JAMES J. GIBSON

Jean-François Chevrier

The Adventures of the Picture Form in the History of Photography (1989)

This essay is a slightly abridged translation of "Les aventures de la forme tableau dans l'histoire de la photographie," originally published in *Photo-Kunst: Arbeiten aus 150 Jahren*, exh. cat. (Stuttgart: Graphische Sammlung, Staatsgalerie Stuttgart, and Edition Cantz, 1989), 47–81.

Translated by Michael Gilson.

It might be possible, despite the sheer diversity of photographic images produced (and reproduced) since the process was invented, to imagine a history of photography—if the process itself were enough of a common denominator. Any narration, any reconstruction, would have to be preceded by an enormous job of conceptual and methodological framing, so as to distinguish and articulate radically heterogeneous—both socially (or anthropologically) and aesthetically—uses and production. The insufficiency of the process as common denominator, however, would soon become apparent, and its necessity would be reduced to being purely instrumental in value.

Luckily, even in this anniversary year, neither the Staatsgalerie Stuttgart nor I, as guest curator, is called upon to imagine such a history. The museum's very function, as well as the starting point represented by the two recently acquired collections, restricts our study to two fairly tightly circumscribed areas: images considered as works (or, potentially, as aesthetic documents), on the one hand, and artistic uses of the recording process (or, potentially, of preexisting images), on the other. Indeed, the avenues for exploration afforded by the collections of Rolf Mayer (from Fox Talbot to Man Ray) and Rolf H. Krauss (artists having made use of photography in the 1970s) are by themselves sufficiently distinct as to be termed heterogeneous.

To begin with, then, we have a group of images produced from the 1840s to 1930, which can be described as strictly photographic works—that is to say, singular, autonomous prints resulting from a twofold process of picture taking and developing. It is a homogeneous corpus, testifying to the development of a specific art, within a sphere of competencies defined by the nature of a common process. The diversity of functions and interests (psychological, sociological, and otherwise) that originally informed these pictures' creation tends to fade and be supplanted by an aesthetic diversity that proves the hypothesis of photography as art—without necessarily proving that all of the creators of these images are to be considered artists.

Second, we have another set of images, materially very diverse this time, whose commonality resides not in the photographic image as such, but in the place occupied by that photograph, the role played by it, in extremely variable ways, in an artistic process that is not necessarily defined (determined) by it. Here all bets are off as to the artistic nature of photography, but all of the creators represented must be considered artists, insofar as they have manifested themselves as such. More than two periods, there are two approaches, two points of view, that can be distinguished, and they are largely in opposition. Rather than seek some historical (or historicist) form of reconciliation, by dint of differentiations and rectifications, we should seek to understand that opposition. By "understand," I mean to analyze and explain it, but also to locate it in a broader, more contemporary context than did the dated debates that cast it in a mostly ideological light, to the detriment of artistic and historical fact. The opposition between photographers (or photographer-artists who produce photographic works) and artists using photography is, to us, a legacy of the 1970s. But that legacy has been transformed—at the hands of artists themselves, who use it in particular ways.

In 1973 Jean Clair, then editor-in-chief of *L'art vivant*, wrote in a special issue of the magazine on photography:

> The entire history of modern art remains to be written, because none of the existing histories restores to photography the crucial role it has played. . . . No history has yet been written

of the radical upheaval wrought to our sensibilities by this invention, perhaps analogous to that wrought by the discovery of oil painting at the close of the Middle Ages. It is just as well that photography is above all else a technical process and that a fair share of the debates and polemics surrounding it, from Baudelaire to the present, would not have taken place had there not been a desire to make it into an art in and of itself. Talking about photography as art was to distort the debate right from the start: it subjected a new medium to purposes, and aesthetic apriorisms, that were alien to it. Problematizing photography anew, as Walter Benjamin has suggested we do, we must no longer speak of photography as art, but of art as photography. So in this issue we will only exceptionally refer to "art photography" and "photographers." Photography is something much too serious to be left in the hands of photographers. We shall speak of artists using photography. Some among them also happen to be photographers.[1]

As we come to the end of the 1980s, these words still have currency. There is an ever-pressing need to at last rewrite the history of modern art and "restore to photography the crucial role it has played." It is also time to break with a certain narrow-minded and timid view of "photography as art," especially in light of the recent manifestations of so-called creative photography, which, increasingly, resembles a developing "cottage industry of art"— flourishing to a great extent but of little real consequence—compared with the other specialties practiced by professional photographers in traditional fields (e.g., journalism, fashion, advertising, illustration). As Jean Clair warned, "photography is something much too serious to be left in the hands of photographers"—or in those of the medium's agents of cultural dissemination, in an age when demagoguery and opportunism have largely supplanted the indifference so vigorously denounced in the past. Lastly, without denying or rejecting the historical accumulation of images that have value as works (or masterworks, even) that may devolve upon us, it now appears more practical—if one is to favor interactions among the arts (which have always nourished photographic creation) over the production of legitimate works (legitimized by the canonizing effect of history)—to consider the medium as a tool for artistic expression rather than make it into an "art in and of itself."

Clair cited Benjamin as early as 1973, and the reference is crucial to more recent critical and theoretical thinking, especially in the United States, that repudiates the institutional framing of photographic culture as autonomous, constructed according to the model of "modernist" specificity, and the concomitant application, based on that model, of traditional art historical criteria of aesthetic (read formalist) evaluation and genealogical derivation. Without necessarily adhering to the myriad theories developed around the concepts of "loss of the original" (associated with the destruction of the traditional "aura" of the work of art, as analyzed by Benjamin), "deconstruction," "simulation," "appropriation," and the like, we can acknowledge that "talking about photography as art" is indeed "to distort the debate right from the start" and to subject "a new medium to purposes, and aesthetic apriorisms, that [are] alien to it."

We cannot, however, subscribe fully to an analysis that dates from the early 1970s, because in hindsight we understand the historical context of that analysis and so are led to modify it substantially. It was only with the emergence of the Conceptualist approaches of the late 1960s that the opposition between artists using photography and photographers became explicit. Clair's condemnation of an alienation (or reduction) of photography to "art" must be understood in this context. Photography had been detached from the painterly model and again placed in the service of information, as a medium. With the challenging in the late 1960s of the very notion of an artwork, and the shift in focus to idea and process, it was understandable that reference to the painterly subject and the paradigm of the picture as an autonomous form should lose the ascendancy they had enjoyed since the earliest days of modern art, when Baudelaire, in the *Salon de 1846*, asserted the superiority of a painted picture over sculpture as a three-dimensional object submitted to variations in point of view: "A picture . . . is only what it wants to be; there is no way of looking at it than on its own terms. Painting has but one point of view; it is exclusive and absolute."[2] In the United States the reaction against the dominant model of the picture form was even more animated because of the ascendancy of the modernist theory forged by Clement Greenberg and his formalist circle. Michael Fried's essay "Art and

Objecthood," which denounced the theatricality of Minimalist sculpture, appeared in *Artforum* in 1967.[3] It had come in response to Robert Morris' "Notes on Sculpture," published a year earlier in the same journal, which used the radical anti-illusionism of the three-dimensional object to assert the spatial value, which he believed was variable, of the new "unitary" forms of Minimalism. "The better new work," Morris remarked, "takes relationships out of the work and makes them a function of space, light, and the viewer's field of vision. . . . One is more aware than before that he himself is establishing relationships as he apprehends the object from various positions and under varying conditions of light and space."[4]

All this is dated. So-called Conceptual Art came about in that context. And if, around 1970, photography, as used by the Conceptualists, broke the mirror of painting—or, rather, of the picture—and allowed a privileged observer such as Clair to reject the "aesthetic apriorisms" to which it had been submitted, the evolution of artistic exploration and experimentation has, since then, largely restored the model that had previously been overturned. Many artists, having assimilated the Conceptualists' explorations to varying degrees, have reused the painterly model and use photography, quite consciously and systematically, to produce works that stand alone and exist as "photographic paintings." Thus we can no longer say that, among artists who make use of photography, there are some who "happen to be" photographers. Chance has nothing to do with it.

And yet it is these photographer-artists who stand apart, more than ever, from professional photographers (for whom they are often still mistaken), who can facilitate our rewriting of the history of "photography as art" by enabling us to consider it not only in the light of the modernist precept of the aesthetic summation of the medium's specific characteristics but according to other criteria as well. These criteria allow us to account for, on the one hand, the multitude of cultural interactions that have opened up the very definition of art since the advent of photography as a new technical process and, on the other, the many procedures for using the medium that have been devised by artists using extremely varied (or even hybridized)

models. It will also become clear that the eternal debate about the merits of photography, to which Clair alluded, has been "distorted" in many other ways than that which he exposed, and that the debate is further distorted every time a historical interpretation (or dogma) hinders, or underestimates, the interplay of models used by artists and every time such interpretation seeks to ascribe specificity more to the medium than to artistic procedures.

•

As we arrive at the end of the 1980s, the overly rigid antinomies of the preceding decade have, of course, failed to miraculously vanish. In 1976, in a special *Artforum* issue on photography, Nancy Foote's essay "The Anti-Photographers" examined the uses of photography in the various Conceptual-type approaches to art: "Earthworks, process and narrative pieces, Body Art, etc." The piece included a prominent pull-quote: "For every photographer who clamors to make it as an artist, there is an artist running a grave risk of turning into a photographer."[5] Although a number of eclectic, consensual convergences of opinion suggested that some reconciliation was in the offing, the divisions created by market forces persist, as Foote so caustically made clear. It is also true that an art critic, today as well as in the past, will not hesitate for long if given the choice between an artist who exhibits a reflective, procedural, exploratory approach and a photographer (displaying varying degrees of talent) who is content to create variations on the heritage of painterly (or photographic) culture.

At the same time, it is possible today, where it was impossible ten years ago, to measure the boundaries, at once symmetrical and complementary, of the two antithetical systems. One can differentiate between, on the one hand, the dangers of conceptual predetermination, which excessively constrains or limits the potential for experimentation, and, on the other, the reduction of that potential to an interplay of stylistic digressions and of transgressions that are part of an ordered, normative reference grid.

Here we find a plethora of works by auteurist photographers who can be grouped under a tradition of "creative" photography, of which Otto Steinert in Europe (with his notion of Subjective

Photography) and Minor White in the United States (as a disciple of Alfred Stieglitz) were the key postwar exponents.[6] This output can also be assimilated (either alternatively or simultaneously) to a painterly model updated by integration of techniques and effects borrowed from the theater and from advertising. In the 1976 issue of *Artforum* cited above, the New York critic A. D. Coleman analyzed the resurgence of Pictorialism in American photography of the late 1960s, exemplified by the pioneering imagery of Duane Michals and Les Krims. He proposed the term "directorial mode" to describe this attitude, which favored fiction over recording and invention and fantasy over respect for the possibilities inherent in the medium. He denounced the purism of the modernists, who had initially rejected Pictorialism, as institutionalist dogma.[7] Coleman attempted to forge a sort of alternative aesthetics, in reaction against what he saw as "official realism," the canonical genesis of which had been written (and rewritten) over a period of thirty years by Beaumont Newhall, author of the Museum of Modern Art's famous *History of Photography*. Not unexpectedly, though, what was still merely an alternative avenue in 1976 has since become a dominant current in the new specialized institutions. Coleman's "directorial mode" has not endured as a term, but the concepts of "staged photography" and the "manufactured image" have become the secret passages to a new formalism that celebrates the specificity of the medium by taking stock of its transgressions.

On the conceptual side we find, in recent production as well as that of the 1970s, multiple examples of the occultation or blurring of the aesthetic and emotional content of the "image as an image," in the name of the primacy of idea and theory that too often stems from an "artistic" apriorism. Christian Boltanski commented on this in a 1975 essay. After noting the freedom that the "photographer painters" had brought to photography—precisely because, as painters, they could more easily step away from the "domination of painting"—he added: "But the photographer painters have only rarely attempted to use photography alone, in and of itself; they have almost always used it in conjunction with text, either greatly enlarged or in a sequence, to distinguish themselves from photographers and show themselves as

artists—the brush stroke being replaced by a text." Boltanski, who at the time was working on his Images modèles series, specified his wish that, on the contrary, an individual photograph should "exist, separate from the others, on its own terms."[8]

In recent years a number of artists, notably Americans, have continued—in very systematic fashion or from a "critical" perspective—to work with snapshots and common spaces, as had Boltanski and, earlier, Andy Warhol. But it would appear that in most cases, once the fascination with the initial discoveries wears off (I am thinking here of Cindy Sherman and Richard Prince, among others), the submission and reduction of the act of seeing to verbal analysis (the equivalent of the simulacrum and simulation theory, incidentally) are now stronger than ever, to the point where the effectiveness of the "critic's" voice is exhausted, practically automatically, by the very process of the "critic" expounding upon his or her premises.

The Mayer collection, which ends at the 1930s, contains no examples of so-called creative photography or of Neo-Pictorialism, the two movements having emerged after World War II. The Krauss collection clearly reveals the ambiguities noted by Boltanski, though the Neo-Conceptualist and post-Pop currents in American photography of the 1980s are not represented. It was not necessary for the purposes of this exhibition to include the trend spearheaded by Steinert or the multiple avatars of Neo-Pictorialism, which has no lack of defenders. The principal goal, however, was to state as clearly as possible from what positioning (as well as choices and biases) in contemporary art (and strictly contemporary art) sets of images and works like those amassed by Mayer and Krauss can be articulated, if not linked. The works of five artists—John Coplans, Bill Henson, Craigie Horsfield, Suzanne Lafont, and Jeff Wall—delineate that positioning, outside of any theoretical homogenizing, via their irreducible singularity.

Working in the United States (New York, to be precise), Australia, Great Britain, France, and Canada, these artists—schooled in different ways and living in similarly differing contexts—have until now had few opportunities to meet and exchange ideas. We may sense the differences between them more immediately

than any proximity. But we may also define a minimum common ground to justify and impose a rapprochement among them for our purposes, and it is precisely that quality—their singularity—that prevents us from grouping them together as a movement or "school." But it is not a singularity of isolation in precious idiosyncrasies, nor one that is reducible to any of the convenient categories used to describe the exceptional or the unorthodox.

These artists are not eccentric or "original." They are historical actors constructing a project while simultaneously experimenting with its potential. This is where the specificity of their explorations is manifest, and whence it can sustainably resist ideological (or mercantile) agendas and the encroachment of dogmas. No doubt it is too early to say whether such projects can be considered as major (we might even question the relevance of the idea in a critical endeavor that lacks the proper historical perspective). They have already pushed past the boundaries to which the majority of contemporary artistic attitudes, when expressed through a process that includes photography, restrict themselves. The developmental thrust of these projects is not obsession (as the subjective power of variation); it is not systematic (the authoritarian and static organization of diversity); nor is it the exercise of availability (worship of chance and celebration of found objects). It is not bricolage (the arrangement of leftovers) or the pursuit of critical efficacy (a series of actions taken within a cultural system). The last two attitudes have recently found favor over the others in the context of postmodern strategies. They seem, however, to be increasingly subject to the law of production and rapid obsolescence of artistic objects and "ideas" as merchandise. A project, by contrast, implies formulation over time and—if objects are manufactured, as they are in this case—the production of durable works.

These five artists adhere to a traditional definition of the artwork as artifact, distinguishable from other made objects (both mechanical and artisanal) by its "artistic" value and its value as an "object of thought" (to borrow Hannah Arendt's term). They have inherited and transformed the picture-form model on which were erected, first, the hierarchy of the fine arts and then, starting in the second half

of the nineteenth century, individual modernist projects. In so doing, they have already set their sights, if you will, beyond the image as the simple result of an experience of vision (photography as a way of seeing) or as a more or less systematic deciphering of the world—regardless of how successful one or the other conception proves to be. But they have also assimilated the propositions of the 1960s: the problematizing of the body and space, of context and perception. They produce object-images and explore both the space in which these images are perceived and photographic perception itself.

Their images are not mere prints—mobile, manipulable sheets that are framed and mounted on a wall for the duration of an exhibition and go back into their boxes afterward. They are designed and produced for the wall, summoning a confrontational experience on the part of the spectator that sharply contrasts with the habitual processes of appropriation and projection whereby photographic images are normally received and "consumed." The restitution of the picture form (to which the art of the 1960s and 1970s, it will be recalled, was largely opposed) has the primary aim of restoring the distance to the object-image necessary for the confrontational experience, but implies no nostalgia for painting and no specifically "reactionary" impulse. The frontality of the picture hung on or affixed to the wall and its autonomy as an object are not sufficient as finalities. It is not a matter of elevating the photographic image to the place and rank of the painting. It is about using the picture form to reactivate a thinking based on fragments, openness, and contradiction, not the utopia of a comprehensive or systematic order. There is a return to classical compositional forms, along with borrowings from the history of modern and premodern painting, but that movement is mediatized by the use of extra-painterly models, heterogeneous with canonical art history—models from sculpture, the cinema, or philosophical analysis.

These five artists enable us to take up a critical position with respect to the normalizing sociocultural structures of "contemporary art" and of "photography." They afford us a vantage point from which to reassess the works and propositions of their predecessors. By following the avenues of interpretation that they open

up for us, we can reconsider the contributions of the nineteenth and early twentieth centuries. By way of conclusion, however, after our perusal of the Mayer and Krauss collections, we must return to the present, and to do so, we have chosen to present a number of artists conducting similar, contiguous explorations in very specific contexts, spaces, and cities. Having posited and explored the idea of singularity in the opening of the exhibition (and of this essay), we can again question the relevance of the notions of artistic communities and centers. Düsseldorf, Paris, and Vancouver appear more interesting in this regard than New York, London, or Rotterdam, to name some other active centers.

•

We see clearly that the history of photography, from its origins to the present day, cannot be viewed as linear, as continuous, as a simple progression. With the 1970s came a break—and I am here adopting the "self-interested" point of view of the contemporary art critic, who necessarily tends to see the past through the mirror of his commitments. This back-and-forth motion from the present to the past is in fact inevitable—it is only more or less acknowledged. The history of any art form, insofar as it is constructed by those who tell it and according to their interests, must proceed by successive stages of interpretation (and retrospection). Thus, as seen in the Mayer collection, the history of photography from its beginnings to 1930 was written according to specific interests that appeared in (or were at least framed in) historical terms at the end of that very period. Our own interests are different. But we can assert their difference all the more clearly because we have been able to see it more clearly. And, to return to the nineteenth century, before coming back to the current period by way of the 1970s, which is the goal of this essay, we must again proceed via an intermediary stage—which, incidentally, is itself a subject for interpretation on our part.

During the 1930s, beginning in the German-speaking countries, and later in the United States, photography began to be studied as an emerging art form, as a historical articulation of corpora of images that could be ascribed to authors (or artists). The first monograph devoted to a photographer was that written in 1932 by Heinrich Schwarz (a disciple of Aloïs

Riegl by way of Max Dvorak) on David Octavius Hill (1802–1867), whom the Pictorialists had rediscovered around the turn of the twentieth century. The study therefore proceeded from an interest recently expressed in an "old master" by photographers who claimed for themselves a new status as artists. It also validated the research direction taken by Beaumont Newhall, which would eventually lead to the 1937 publication of *The History of Photography*, a work that earned canonical status in its expanded edition of 1949 and was subsequently updated many times. If we consider that the book's initial incarnation was as the catalogue of a 1937 exhibition held at the Museum of Modern Art—founded eight years previously according to the principles of Bauhaus—we only have to recall the importance and specificities of photographic creation in Europe (especially Germany) and the United States of the 1920s, as apprehended and interpreted by Newhall, to locate the privileged position of this author and the effectiveness of his message. The modernist view of photography as a specific art form came together in the collision of an actuality and an ordered set of historical proofs. "Pure," or "straight," photography, explicitly disengaged from Pictorialism by Paul Strand and practiced by a growing number of artists (e.g., Edward Weston, Ansel Adams), appeared at once as the culmination of Stieglitz's Photo-Secession (which had disengaged photographic art from an overly narrow naturalist aesthetic, derived from functional practices) and as the summation of trends that had appeared, more or less naively, since the medium's infancy.

Riegl's strongly Hegelian idea of *Kunstwollen*, or "artistic urge," was taken up by Newhall, who used it to posit that the history of photography proceeded first from the necessary invention of an artistic tool, to be followed by the development, no less necessary, of a style in conformity with that tool.[9] Such development is autonomous and removed from external socioeconomic factors; it proceeds across culturally heterogeneous production registers. According to this model, Pictorialism, as the assimilation of photography into the fine arts and the subjection of the recording technique to painterly paradigms, represents a point of crisis in the culmination of a style. The crisis was already evident, however, in the earliest

coherent experimentation with the emergent art form (e.g., writings about Hill), because it was constituent of the struggle for independence seen in the view of the history of photography as the affirmation of a new aesthetics in conformity with specific technical means. The best contemporary photographers—those who have opted for pure or direct photography— have a single (but considerable) advantage over their predecessors: they can do consciously (read explicitly or systematically) what their forebears had had the chance to discover by situating themselves in the current of history.

This model had an advantage: it was extremely cogent. Today, armed with the conclusions of more recent studies (of nineteenth-century France, for instance), we view it as concomitant with the reemergence in the 1920s (especially in Germany and the United States) of the question of Realism, or Naturalism (the two terms having often been almost interchangeable), which had marked the first golden age of photographic creation around 1850, in France and Great Britain. In the years between these two periods, however, the question had been largely ignored, so much so that Newhall himself never clearly posited the relationship and was to remain for many years extremely ill informed about French photography of the 1800s. He preferred the "Naturalist" British tradition, which in his eyes had reached its apogee in the work of P. H. Emerson at the close of the nineteenth century. What had been "illusion" (albeit an "exact" one, conferred by mechanical precision) for the public of the nineteenth century became, in the 1920s, exploration and transformation of the act of seeing. Where the debates of Gustave Courbet's time and the "return to nature" (in response to the idealism of the "École" and Romantic subjectivism) were centered on the artistic value and legitimacy of mechanical precision, the photographers of the 1920s, in their association with avant-gardist movements (e.g., Constructivism), believed in experimental usage of the recording process, which should lead not only to an increase in the visual information presented but also to a widening of the potential of vision itself. In doing so, artists of the period revisited, often unwittingly, the explorations of the medium's earliest experimenters (for example, producing prints directly, without employing optics).

The key transition between the two periods was the perfecting of instant exposures, along with the invention and coming into widespread use of portable cameras, which brought photography within reach of virtually anyone, whereupon it became a tool for the automatic recording and storage of events, great and small, in public and private life. From then on, the medium multiplied not only the number of descriptive points of view of the world but also the number of events in social life worthy of visual description. The Surrealists coined the term "objective chance" to describe this radical challenging of the interpretive intentionality that traditionally undergirded any descriptive endeavor. It is particularly significant that it was precisely at this moment of widening of the potential of recording (both technologically and socially speaking), and even more precisely at the moment that the cinema came into being, that the so-called Pictorialist photographers turned, as no group before them ever had, to painting (as well as traditional artisanal techniques of image production, such as printmaking) as a model. In so doing, they ascribed to the photographic print the quality of an autonomous object—one that could not be reduced to the simple data recorded, or to the "picture" as a neutral, transparent medium for the transmission of visual information. Moreover, this value of autonomy, derived from the painterly tradition (and the hegemony of the picture form in Western visual culture since the Renaissance) is the main appeal of Pictorialism in its most ambitious, overt expression: the Photo-Secession movement of Stieglitz's circle. It took this traditional act of secession, borrowed from Central Europe, for Pictorialism to move away from overly nostalgic (or reactionary) references to painting and, via an open interplay of models, toward the modernist aesthetic of Paul Strand.

At the turn of the twentieth century, then, the Photo-Secession marked the turning point for the integration of photography into the development of modern art, centered around the visual arts (painting and sculpture). Three decades or so later, for the organizers of the famous 1929 *Film und Foto* event in Stuttgart (including László Moholy-Nagy), and later for Beaumont Newhall (who for the 1937 MoMA exhibition paired film screenings with photographic prints), photographic

creation was also, and above all, associated with the cinema. At the same time, though, three important factors were converging: the advent of the first "talkies" and the consolidation of the film industry; the development of photography as a key component of the mass print media (from which most photographer-artists retreated, in such large numbers that the so-called creative photography that emerged in the postwar years is still defined essentially by that rupture); and the institutionalized compartmentalization of the arts into their respective fields of competency, against a backdrop of modernist theory that before long would neglect the experimental merits of interactions between art forms. During the 1930s these factors combined to cause the liquidation (accelerated by World War II) of the experimental culture that had flourished in the earliest years of the century and that photography and cinema had jointly embraced in the 1920s. *Film und Foto*, especially, was an apotheosis, signaling the end of an era; the Newhall exhibition was by then already engaged in latter-day, distant, institutional analysis of a movement that had run its course.

In an open letter published in 1934, Moholy-Nagy, commenting on the decline of so-called independent cinema, wrote: "Yesterday there were still crowds of pioneers in all countries; to-day the whole field is made a desert, mown bare. . . . The industry carefully stamped out anything which was even suggestive of pioneer effort."[10] And it would appear that, right up to the end of the 1960s and the explosion of "attitude" and "concept" art, the role played by the majority of that experimental culture's mediators in the history of modern art has been largely forgotten. Particularly revealing are the many omissions by Newhall in the 1949 edition of *The History of Photography*, which stemmed from more than just a certain chauvinism. These have barely been rectified in the years since: even in the most recent edition, Marcel Duchamp is worthy of inclusion only as having drawn inspiration for his *Nude Descending a Staircase* from Étienne-Jules Marey's chronophotographs. The omissions are so constricting as to be repeated and amplified in the treatment of more recent periods—artists such as Robert Rauschenberg and Andy Warhol, for example, are not even mentioned in the current edition.

The history of photography that we have inherited, as written since the 1930s, is therefore constructed along an axis, which is that oscillation between one well-defined period, the 1920s, and another, the 1850s. In one, the focus was on visual research through direct (straight) and experimental photography; in the other, artists had sought to transform an illusionist tradition via descriptive realism. If we consider the circle described by that axis, we can systematically shed light on and trace, to their current positions, the "vanishing lines" drawn on that circle: the work of singular artists who used photography without being "photographers" (Duchamp, of course, but also Edvard Munch, Egon Schiele, Stanislaw Witkiewicz, the Italian Futurists, René Magritte, and others—all systematically ignored by Newhall); the proximity of the cinema (more important than ever since the discovery of the close-up); photomontage; the scientific model (in analytical-type approaches and serial work); and the logic of experimentation itself, as a type of game, seen in optical processes or the reuse of existing images. The issue of realism, which lies at the center of the circle, would thus appear in a new light, and the excessively rigid oppositions of the 1970s, to which I referred in the opening pages of this essay, would have no other raison d'être except the symmetrical conformities of the art market and the "photography milieu."

In the nineteenth century the question of realism in photography, excessively conditioned by the art versus industry debate (for proof one need only see Baudelaire's famous repudiation of "industry . . . invading the territories of art" in his *Salon de 1859* essay),[11] truly emerged only in the wake of the aesthetic squabbling touched off by the work of Courbet. At the time, theory and practice were located and constituted according to a set of differences, or antinomies, that had to do more with iconography than with form. Realism was a reaction against Idealism and Romanticism, founded in philosophical and political ideologies (positivism and anarchism) rather than in any clearly elaborated aesthetic tenet. Indeed, Realism's main defenders, such as Champfleury, distanced themselves from the term as soon as it gained currency as a label. For realism, in *reality*, is imperceptible; it cannot be defined in and of itself. The same was true of photography at the time. When

Francis Wey, a friend of Courbet's, writing in the inaugural issue of the magazine *La Lumière* in 1851, took up the defense of photography, his aim was not to establish the intrinsic merits of a new art form, but to predict the regenerative and liberating effects on traditional art (painting) of a "pure, faithful technique for reproducing nature." The technique, Wey insisted, had already transformed public taste, and so would also transform art. "This is the seed of a revolution against the system of stencillers [*poncifs*], to the benefit of reality. . . . it would seem already that the public, more desirous of truth, is growing less demanding in terms of preconceived ideas of style and beauty, and displaying curiosity toward the cult of the real."[12]

Under cover of this issue of the effects, whether positive (in the view of authors such as Wey) or negative (according to the opponents of realism in art, like Baudelaire), and the uses, whether legitimate or not, of the technique of "reproduction" (a debate that, as mentioned, hinges on a highly flexible view of the very notion of realism), the earliest successes of photography speak to an analytical, experimental approach adopted by informed amateurs, which effectively took advantage of the painterly traditions of the period. Indeed, the very criticisms leveled at photographic realism, and the limits imposed upon it, paradoxically proved the effectiveness of that experimentation. Baudelaire, for instance, writing in the *Salon de 1859*, denounced his contemporaries' adherence to the "silly cult of . . . nature" fostered by photography. Yet when he assailed the "modern school of landscape-painters" for the same fault, he indirectly pointed to exactly what the photographers of the time were doing with their research: "Thus they open a window, and the whole space contained in the rectangle of that window—trees, sky and house—assumes for them the value of a ready-made poem. Some of them go even further. In their eyes a study is a picture. M. Français shows us a tree—an enormous, ancient tree, it is true—and he says to us, 'Behold a landscape.'" Later, commenting on a landscape painting by Théodore Rousseau, Baudelaire explained how the picturesque aspect of a piece, or fragment, of nature had supplanted the imaginary order of composition, which traditionally formed the foundation of a picture's autonomy: "And then he falls into that famous modern fault which is born

from a blind love of nature and nothing but nature; he takes a simple study for a composition. A glistening marsh, teeming with damp grasses and dappled with luminous patches, a rugged tree-trunk, a cottage with a flowery thatch, in short a little scrap of nature, becomes a sufficient and perfect picture in his loving eyes."[13]

Ten years later, in 1868, by which time Impressionism had succeeded the Barbizon School, another writer/art critic, Émile Zola, described trends in modern landscape painting in very similar (but this time positive) terms. Where Baudelaire criticized Rousseau's canvases for their "absence of construction" ("all the charm which he can put into this fragment torn from our planet is not always enough to make us forget the absence of construction in his pictures"), Zola pitted the freedom of the Naturalist's observation of nature against the constraints of the architectonic ideal in classical landscape painting: "The paysagistes composed landscapes like one puts up a building. . . . There is not the slightest concern for truth and life. There is only the desire for grandeur, a majestic architectural ideal."[14] And this was in fact how, starting from experimentation with the very means of the new technique of "reproduction," photographic creation also asserted itself, in the domain of landscape painting more than any other, by default. By default of "construction," by giving itself the freedom authorized by the "study," as an auxiliary exercise (applied to a minor genre, moreover), by acknowledging, in accordance with Baudelaire's wish, that it had to avoid the pure speculations of the imagination and that the domain of huge historical compositions—which still dominated the official hierarchy of painting—was off limits.[15]

In the nineteenth century the dialectic between the study and the finished painting thus opened up the first area of experimentation for a type of photographic creation that cast flexibility and the fragmentation of vision against the ordered stability of architectonic composition; this occurred simultaneously with the development in painting of the "pure" landscape (removed from its documentary function) as the rarefied crucible of modern art. But just as the value of the study relates to the finished painting, so the experience of fragmentation, when expressed more strongly (in the twentieth century, at the

same time as the logic of experimentation), could only lead to a new "constructivism." It can be said, schematically, that the photographer of the nineteenth century cut out a window in the world spread out before him like a spectacle, and his gaze then examined and explored in depth the portion of space so isolated. The world was a vast tableau that he studied piece by piece, analyzed, examined, and "reproduced" (as with painting). The oft-evoked opposition at the time between the "picturesque" (or poetic) effect and objective description remained secondary to the overall quest for illusion (and to the evaluative criterion stemming therefrom).

By the 1920s that quest had not completely lost currency, and it was to reemerge during the 1930s and 1940s: consider the evolution of Ansel Adams, from his first studies and close-ups, systematically favored in Stieglitz's exhibition of 1936, to the grandiose views of Yosemite from the 1940s, with their spectacular effects, unintentional caricatures of the works of the great landscape artists of the American West of the previous century.[16] The theatrical model of illusionist composition, however, lost its primacy, and the metaphor of the picture was no longer so easily applied to the spectacle of the world. The era of the "great scenes of nature"[17] seemed at an end.

The "thing seen" and the image fragment became autonomous realities (disengaged from the relationship to the scenographic tableau that defines the study); they required a new mode of construction that could reveal the secret, invisible, abstract structure of the world that resides in the internal arrangement of things rather than in their "composition" (i.e., the way they combine outwardly). By dint of wanting to penetrate the details of "things" (the word had never before carried so much weight), the gaze turned upon itself, toward its own constitution. Contemplative order, founded on objective proof or on the power of illusion, was exploded; a new subjectivity sought to articulate itself around the power of the camera lens and its "microscopic revelations" (to take up an expression used by Ansel Adams in 1934). The infinite was no longer that indefinitely extended continuity symbolized by the vanishing point on the horizon; its new definition was a multiplication of points of view.

In breaking with the classic (and classicizing) idea of beauty as conformity with general, universal standards—a break symbolized by the focus on notions of "the picturesque" and "the sublime"—the nineteenth century, following from the already "romantic" eighteenth, had doubtless pushed the performances of description to the limit, represented by Realism's initial rupture with the illusionist tradition. No less a commentator than Baudelaire correctly sensed this when he exclaimed: "I would rather return to the diorama, whose brutal and enormous magic has the power to impose a genuine illusion upon me! I would rather go to the theatre and feast my eyes on the scenery, in which I find my dearest dreams artistically expressed, and tragically concentrated! These things, because they are false, are infinitely closer to truth; whereas the majority of our landscape-painters are liars, precisely because they have neglected to lie."[18] But, seen in hindsight, in the light of later developments (and not through Baudelaire's eyes), the same nineteenth century not only retained the essential value of the illusionist criterion (i.e., as a standard, a direction, and a framework for vision, according to the model of the picture as spectacle); it also, and especially, sought (or perhaps invented), within photographic objectivity, harmony between a patient, attentive subjectivity and a depiction of nature brought back to its primitive scale (prior to any cultural ordering) and simultaneously conveyed in minutest detail. It was that very harmony that was shattered in the twentieth century, and the consequences were quite different indeed from those of the initial break with the classical standards of beauty.

That harmony was shattered not because photographers were no longer pursuing it, but, paradoxically, because they were more aware and systematic in their pursuit and because they had to contend with opposing forces, with inequities, with quick decisions and what one might term precipitations of vision (brought on by the mechanical nature of the recording process) that tended to destroy the model whereby a picture would be composed, unified. In trying to seize the continuity of the world (and the subject-object relationship) in a fragmentary condensation or in metaphorical objectivity, as Edward Weston did, photographers were already setting in motion—"provoking," if you

will—all of the centrifugal drifts of subjectivity, when the goal was to "mobilize" them. The picture could no longer be that "form of pacification" that Lacan spoke of (in response to the "pacifying function of the ideal Me"), in which one finds the fiction of an imaginary totality (anticipated based on the subject's being and becoming), which resolves ahead of time and reveals the turbulence of impulses.[19] When photomontage, conversely, sought to welcome that turbulence and give it its true shape, photography itself, as the setting of an imaginary identity (and the standardization of a vision limited to recognition) had to be contested. In 1921 Raoul Hausmann published a manifesto entitled "We Are Not Photographers," which included the declaration: "Creative vision is the configuration of the tensions and distensions of the essential relationships of a body, whether man, beast, plant, stone, machine, part or entity, large or small: it is never the center, coldly and mechanically seen."[20] Any attempt at restoring order to representation (the famous "return to order" of the 1920s) and returning to the picture-as-spectacle now had to contend with the relativism of points of view. Photography had shattered once and for all the sumptuous "tableau de la nature" that Cézanne still dreamt of.

Today we simultaneously consider the whole and the details ("part or entity," to use Hausmann's terms), the composition and the fragment. We now know that a composition is a construction, and that construction is "ruin in reverse" (in Robert Smithson's view). We can still accept, with a certain delight, a view of nature in black and white—even though no painter since Gerhard Richter has executed such a view—because we can better accept the miniaturization of vision than the miniaturization of the painterly gesture. We accept photographic reduction, because we know that it is usually temporary and instrumental. We accept that photographers play at being painters, because we know very well that they are not. We accept photographers' large-scale views, because we know that they have not been "composed," but "cut out." These are perhaps remembrances of painting. Yet we believe, with some satisfaction (and pride), that this must be how nature herself remembers painting. We accept the large-scale views of a landscape, because they are discreet (and discontinuous)—because any

photographic composition remains a fragment of the world. And we tend to prefer the work of photographers, as it traditionally presents itself, in the form of a small, manipulable print, over that of painters (the Photorealists, for instance, who have sought to transfer the precision of the photographic fragment onto the picture plane, transposing onto it the glazed surface of the mechanical image)—because the print brings us back to the moment of discovery, the first glance, the barely assured capturing, the moment when a singularity discreetly breaks free, isolating itself.

There is a persistent difficulty, however. If one accepts the flexibility of photographic vision as the culmination of a long process begun at the same time as the medium, that flexibility has failed to eliminate the haunting question of the picture, as form (or model for autonomy) and even as spectacle (or illusion), as has been mentioned several times in this essay. The criterion of "vision," liberating as it may have been, has produced as many "stencils" (*poncifs*) as it has "good pictures" since the 1920s. It authorized the "autobiographical" blending of formalism and pseudolyricism that characterizes a large part of so-called creative photography (alongside what I have chosen to term "Neo-Pictorialism"). It replaced the realist "cult of nature" denounced by Baudelaire with a romantic—and no less naive—faith in the spontaneity of the gaze as a quasi-miraculous source of "good pictures" or as an inspired manipulation of the visible world. A chatty rhetoric emerged beginning in the 1920s; *found objects*, *surprise*, and *strangeness* were common terms. Nevertheless, the evolution of the picture (beyond illusionism and within the search for abstractions) begins to resemble a new effort at "realism," in terms of the painted object and the "concrete" experiences that it generates (in the sphere of perception as well as in those of expression or speculation). Small wonder that photographer-artists increasingly were not content to produce simple prints as "documents of vision."

After the quasi-encyclopedic inventory conducted by Eugène Atget at the turn of the twentieth century, via all of the inherited genres and beyond, auteurs such as Walker Evans, André Kertész, and the young Henri Cartier-Bresson did provide proof of the great flexibility offered by the new mechanical method of recording as

long as it is used as a tool for lyricism, and for responding as spontaneously as possible to the attractions and surprises of vision. Newhall, and the majority of historians of photography after him, did not hold to this line of interpretation, not only because they did not perceive it (with the possible exception of John Szarkowski) but also because it was untenable. Nor has any photographer since those I mention held to it: neither Robert Frank (too romantic) nor Lee Friedlander (too systematic) nor Garry Winogrand nor Robert Adams (their fields of exploration being too restricted) nor, a fortiori, any European. The photographers of today who consider themselves and manifest themselves as artists—taking into consideration the public spaces in which they exhibit—can no longer merely "take" pictures; they must cause them to exist, concretely, give them the weight and gravity, within an actualized perceptual space, of an "object of thought." They do not necessarily have to "make" (in the sense of manufacture) them—much less leave their trademarks on them—but they must, before producing them, plan how they will be, where they will be situated, into what narrative they will be integrated. They can no longer deny, or pretend to deny, that the image is a reification of recorded vision and cannot be directly transmitted. They know that it is the image in its actuality that constitutes "the thing seen"—as much as, and perhaps more than, the contrary proposition. Finally, a relative cultural marginalization, which for the earliest experimenters became in the end a situation conducive to research, must itself be desired and reconstructed as a form of retreat, and this is extremely problematic. It is highly unlikely that creators such as Stieglitz or Weston, who by their own examples nourished a sort of mystical image of the photographer-artist, can still serve as models.

•

For many artists at the close of the 1960s, the value of the autonomous work, as the necessary finality of an artistic project, seemed to lie in the exchange value of the reified process. That finality had to be discontinued, or placed in parentheses, so that the truth of the process of experimentation and research could be got at. Art had to resemble life—as action and transformation, expression and communication. Photography became extremely useful as a recording technique and an information

medium. Because it produced simple documents and not autonomous works, it necessarily referred the spectator (gazer) to the idea, action, and process developed by the artist. An image was no longer offered, either in or of itself, for the public's enjoyment, or for its freedom of perception or interpretation; rather it was produced so that the public might, through it, rediscover and reconstitute an approach, an experiment (in the scientific sense), a procedure, or a system. Douglas Huebler, for example, who was the first artist to employ photography in a Conceptual project, beginning in 1968, created "well-made" images, "in the sense that they were technically perfect," but specified that "their beauty proceeds from the strategy that I use, which is to liberate things present in the world from the weight and pressure of their specificity: I devise systems that allow me to subject things to a model of thought. In my work on duration, for instance, every event—even the most unexpected—occurs in conformity with the system I have previously set up. And the result can sometimes be quite beautiful, because it is arbitrary and because I have not chosen it to become a plastic object."[21]

An approach like Huebler's posited a model founded on play (there can be many players) and freedom. Two main purposes guided this attitude: assign to the artistic experience the value of the generality of the concept (even if the specific production of each piece demands specific aesthetic choices) and thus open up, to the experience of man in the world, a field of "possibilities" without adding any new objects to those already existing.[22] The Conceptual artists refused to produce specific objects because these necessarily would be labeled according to preexisting aesthetic categories. For Joseph Kosuth, the only relevant question was that of art in general—or, put another way, that of the generic definition of art. Huebler, meanwhile, declared that "art has limited our experience of the world by introducing categories." "Beauty" must therefore be arbitrary, as the Dadaists had already imagined it—more so, I should point out, than the Surrealists, despite Lautréamont and Breton's infamous "Beau comme . . ." For in this case there was not a reliance on chance as subjective revelation, but—much more than that—an exploration, similar to that of Musil, of generality as the suspension of preexisting definitions and

"particularities," and a widening of the possible. "All I am doing with my concepts is pointing out the world, directing attention in a certain direction—without constraints and without pushing," Huebler continued. "I do not mean to 'seize' the world; nor do I wish to impose the weight of my impulses on it. I want to give the spectator/conceiver the means to think independently; to fill in the frame of the concept, if you will, by him- or herself."[23] Working from a conceptual predetermination and a "system" laid down as the (arbitrary) framework for an action, Huebler conducted experiments (one could even call them campaigns) of picture-taking, the results of which sustain a comparison with the street pictures produced around the same period by other American artists: photographers such as Friedlander or Winogrand. The main difference lay in Huebler's consistent use of language as his primary tool for formalizing the experiment (and, in that regard, his approach was not unlike that that of Robert Barry or Lawrence Weiner).

A very similar attitude—and, often, the same street-bound source material—is to be found in the earliest artistic and photographic output of another American artist, Vito Acconci, who had initially chosen poetry (the evolution from poet to photographer-artist was fairly common at the time; a good European example is Jochen Gerz). For Acconci, as for Huebler, the specific experience of photographic vision was predetermined by conceptual choices that call upon the value of abstract designation afforded by language. Acconci too considered his photographic work as an "activity" that deployed and produced a model, according to explicit rules and coordinates. For these artists, the use of language (as the medium of the "general") and the experience of the urban environment constituted the necessary supposition and exploration of a public space antagonistic to the private (or intimate) context of the traditional artistic experience, symbolized by the closed studio. But Acconci, unlike Huebler, conceived his actions in the environment as activities of the body, physically placing himself in public spaces. In fact his later research essentially developed, by a feedback effect, at the more restricted level of experiments on his own body, leading to what was eventually termed Body Art (other practitioners of the time included Bruce Nauman and Dennis Oppenheim). Huebler, mean-

while, sought—in an essentially nonviolent manner, as nonaggressively as possible—to "integrate the whole world" into his work and located his action with respect to a natural totality (including the data of urban life). Acconci, while initially mistrustful of overly subjective expression, took the reverse route, having chosen to describe his surroundings according to the movements of his body (within a given time period) and to restrict his primary field of experience to the interrelationships between the body and space, which were conceived of as two "system[s] of possible movements."[24]

In this regard, Acconci was another artist whose work (probably even more so than Huebler's) has affinities with the contemporary explorations (albeit begun earlier) of Friedlander and Winogrand. The latter was doubtless the greatest street artist of the 1960s; his capturing of the gestures and intersecting trajectories of urban choreography was freer and more just than William Klein's. The former was paid homage in 1970 by Ugo Mulas, who noted in the second of his *Verifiche* (the first had been devoted to Niépce): "It seems to me that, until Friedlander, there had never been a photographer so aware of what is implied in a photographic operation; who sensed the extent to which the photographer can be 'inside,' in the camera or in the action, physically, I should say, to such an extent that he can invest a picture with all of the ambiguities characteristic of first-person narrative."[25] At the same time, in Vancouver, Ian Wallace had begun applying New York school conceptual models to the urban iconography established by Friedlander in the early 1960s, for Friedlander had emerged in the tradition of Walker Evans but, importantly, had brought to photography the aesthetics of collage, which had recently been revived in "the art of assemblage" (to take up the description used by William Seitz when he curated the famous MoMA exhibition of 1961).

In his unfinished series of Verifiche, produced between 1970 and 1972, near the end of his life, Mulas revisited, analytically and systematically, the same reflection on photography (i.e., its material and symbolic constituents) that countless photographers before him, beginning with Niépce, had already conducted in practice, less systematically. His "Photographic

Operation" (subtitled "Self-Portrait for Lee Friedlander") articulated precisely the two principal interests that characterized the artistic uses of photography from the end of the 1960s and into the next decade, which we have already detected in Huebler and Acconci: analysis of perception and representation, on the one hand, which grafts a reflection on language as a symbolic process onto the phenomenological issues surrounding Minimalism, and experimentation with the body and imaginary identity, on the other. These two interests dovetail very often, for example, among artists concerned with the issue of space and, more specifically, the contemporary environment. A reciprocal metaphorization emerges between the body and language with respect to the larger question of identity (subdivided into the linguistic, psychological, and sociological spheres, seen as proceeding from conceptual designation/naming, acknowledgment or transformation of the self, and membership in society or distinction therefrom). Many artists—some Conceptualist, some less so—began to treat words and utterances as physical beings, as things inscribed in the environment (which, in return, took on the quality of a mental space)—and, as such, transportable (e.g., inscriptions or lighted signs in the white cube spaces of galleries, or on the picture/screen). Others explored the body, considering its workings as if they were a language, and these artists, more than those who came before them, needed photography to do so.

For instance, the Viennese artist Arnulf Rainer (to cite a creator who appears to be at odds with American Conceptualism) wrote in 1978: "The language of the body, as it exists in all animal societies, has been accounted for only by the art of dance. In the fine arts, it was used indirectly, in a secondary manner, in the representation of human figures. In our day, such a language, as spontaneous as it is primitive, is attractive even to ethnologists." Rainer, who is generally associated with an expressionist tradition, recalled his first experiments: "In 1951 I undertook for the first time to conceptualize this entire problem. I attempted to record the motions of a hand at work, operating in the fashion of a motor." He continued: "Certainly one could have interpreted my didactic work as a pure and simple negation of the body as such."[26] The same doubt might well have been expressed by Klaus Rinke in regard

to his photographic work of the 1970s, especially when contrasted with his earliest self-portraits, taken in Greece in 1960.

In reality, these 1970s artists' photographic approach to the body owed as much to a mechanistic, analytical tradition common to modern dance and photography (going back to Schlemmer's ballets) as to mythological residue in industrial society. This is strongly evident in the work of Rebecca Horn, particularly in a 1974 piece in the Krauss collection entitled *Mechanischer Körperfächer*. In Rinke's work the potential of ritual is reconstituted in the geometry of space and the regularity of time, measured by reiterated gestures and decomposed movements. In the art of Barbara and Michael Leisgen, the body is a tool for exploring and interpreting shapes/signs inscribed in natural space, a technique for the mimetic revelation of "the language of nature." The process is analogous to dance, which through formalization of physical expression and the geometricization of gestures and movements "allows the expression of an inner-outer equilibrium; that is to say, a discourse on the correspondences between man and nature."[27] Outside the German tradition, the clearest expression of this redefinition of the ritual hermeneutics of nature by the physical and photographic *inscription* of a geometrical scheme is to be found in the work of England's Richard Long—more precisely in the paradigmatic summation of all his artistic explorations, the 1967 work *A Line Made by Walking*.[28]

Here I must make a brief digression in order to prove my point in a backhanded manner. It is significant that the majority of artists who, in the 1960s, had ambitiously delved into the realm of mythology, with a strong physical involvement, such as Joseph Beuys and Mario Merz, used photography either very little (Beuys) or not at all, or only exceptionally (Merz), having rejected painting and the picture form: they preferred direct exploration of materials (especially organic), energies (or forces), and symbolic or archetypal forms, eschewing a form of imagery considered cold, distant, and simplistic (because of its miniaturizing effect). Within the mainstream of Arte Povera, as posited in Germano Celant's 1969 book, the most analytical artists (for whom the problem of vision, and its relativity, remained a key concern) were the ones who used

photography the most—Giulio Paolini, of course, but also Giuseppe Penone and Luciano Fabro (not to mention Michelangelo Pistoletto, associated above all with Pop Art). And Harald Szeemann, in the "Personal Mythologies" section of the 1972 *Documenta*, somewhat ambiguously equated Beuys and Merz with the voluntarily minor expressions of younger artists such as Christian Boltanski and Jean Le Gac, who clearly did not proceed from the same ambitions. Indeed, for those artists (as their later research would confirm) the traditional model of myth, as a collective representation of a society founded on the sacred, had been largely transformed—devalued, even—by the new quotidian "mythology" of the petite bourgeoisie, which since the work of Roland Barthes was suspected of having produced an antihistorical naturalization of cultural phenomena. Their "personal" mythologies could not help but be fragmentary, allusive, and "anecdotal" (to use Le Gac's description); they could generate only lacunary, ironic narratives—little "captions," not unlike those appearing under photos. They could not leave photography behind any more than they could banish the common spaces of verbal communication.

In hindsight, if we can still find some relevance in the notion of "personal mythologies," we must also admit that it means something completely different depending on the cultural (and national) context in which it manifests itself. If we consider the same generation of artists, born around 1940 (Rinke was born in 1939, and Boltanski in 1944), the French followed the route of doubt, and their use of photography was informed by an attraction to a cause and an object of that doubt. The Germans, conversely, were nourished by the presence of Beuys and, through him, the persistent Romantic tradition; they used more "violent" humor (or at least a more structured violence, compliant with the standards of painterly provocation) to express themselves both with photography and against it—that is, when it did not serve, more serenely, an analytical, constructive approach (seen, for example, in the work of Rinke, Horn, and the Leisgens). Still, it was up to Jochen Gerz to locate a sort of passage—or, better, a no-man's-land—between the two territories, by demonstrating that doubt was already part of German Romanticism. And, while a number of Beuys's disciples (and, today,

those of Sigmar Polke) as well as more singular artists like Jürgen Klauke chose to go the way of provocation (more or less expected and more or less programmed, along a clownish, parodic line that reached back to Dadaism), Gerz articulated his critique of art and the media ("Caution: Art corrupts," he famously warned in 1968) according to a strategy of dissociation that was simultaneously more conceptual and more ambiguous. Dissociation between words and images, between myth and quotidian triviality, so as to explore and reveal not the world and its objects as a pseudo-exteriority, nor even the visible, but the gaps between images, the space for interplay, and the invisible parts of the too tightly knit fabric of representations.[29]

At any rate, what emerges from these cultural shifts and these debates about photography as a paradigm for the modern imagination (which are not unlike those of the nineteenth century concerning art and industry) is a vision of a surprisingly unstable art form that, removed from the tradition founded on the autonomy of the work, necessarily recorded and transmitted contemporary cultural interests, philosophical and scientific models, et cetera, more directly (and, doubtless, more naively) than art had ever done before. The very notion of "model" (as previously seen with Huebler and Acconci) was stronger and more open than ever, since it no longer designated only examples (even less rules or canons) drawn from art history, but any schema/framework, thought process, or experimental approach potentially available to the artist via any cultural activity. It was natural that this should then lead to surprising encounters and "curious" crossbreedings of very free (unsettling, according to the art "categories" rejected by Huebler) forms of experience and expression, on the one hand, and extremely rigid systematizations, on the other. Thus we had artists like Bernd and Hilla Becher—using an approach resembling industrial archaeology—adapting photography, as a mechanical tool for documentary reproduction, to a typological analysis model the likes of which no one had dared construct even in the heyday of the classification of natural species throughout the entire nineteenth century. It bears mentioning that the Bechers had conceived of their project and defined their method as far back as the late 1950s—well before the emergence of the Minimalist, Conceptualist, Systematic,

and other approaches to which they were assimilated during the 1970s (in the wake of Carl Andre's famous 1972 article about them in *Artforum*). This proves the argument that photography, because of the exacting nature of its documentary function, could itself acquire the quality of model, as long as its practitioners sought to restore its functions as "testimonial" (to use the Bechers' term) and a source of historical knowledge.

If we consider the genesis of the Bechers' work (which lay more in a singular decision than in the internal evolution of avant-garde art, as in the New York view), it is easier to see how the interest in invisible structures, or patterns, that characterized the modernist realism of the 1920s (and sometimes imparted a mystical inflection) was, by the 1960s, as much transformed as replaced by a new penchant for serial and sequential devices. This had already been part of nineteenth-century scientific experiments using photography, principally in the fields of astronomical observation and the physiological analysis of bodies in motion, exemplified by the work of Eadweard Muybridge and Étienne-Jules Marey. Thus it was not surprising that Muybridge should become, around 1970, a key historical reference for contemporary American artists (a 1973 essay by Hollis Frampton in *Artforum* comes to mind). The division of movement visualized by Muybridge constituted an intermediate solution—an intermediation, if you will—between the snapshot and the cinematic illusion of movement. More generally, series emerged as the exemplary format for any analytical process, whatever the subject—a shape, a gesture, a narrative situation—whereas a single photograph was merely the flat, documentary reconstitution of the analytical experience, employed only casually by the artist as a quick, convenient, and efficient means of verifying a conceptual hypothesis.

Conversely, as long as the artistic experimentation follows the scientific method closely enough, the means of verification becomes a determining factor in that experimentation, to the point that it simultaneously becomes an object of analysis (without, I should clarify, once again becoming the finality of the experimentation). This is particularly palpable in the work of Rinke and even more so in that of John Hilliard, where it produces a sort

of allegorical mannerism (in the illustrated inventory of optical transformation and displacement processes produced by the vagaries of the recording process). When systematically harnessed to a physical experience in space, sequential analysis—as a first-person experience of a process of cognition—finally acquired the expressive or descriptive value of an autonomous image (a singular one, even). Acconci, Rinke, and the Leisgens thus show affinities with Richard Long, but also with Bruce Nauman and his "action images" (e.g., the famous *Self-Portrait as a Fountain*) and with Hamish Fulton, whose captioned "views" revisit, in picture format, the tradition of plate illustrations in books.

Concept and "activity" (the term is more accurate than "attitude") art of the 1970s was characterized as much by a sort of experimental bulimia as by a desire for formal simplification and reserve in response to the accumulative aesthetic of collage and assemblage as well as to the proliferation of words and images produced by the media and disseminated into the environment. The notion of information was thus central by this time. Huebler, for instance, noted in a 1971 interview how repetition (or redundancy) of information was a fundamental, constitutive aspect of culture and the social fabric.[30] The nature and the potential of differences consequently emerged as questions of social identity, of public representation or expression—as much as or more than perceptual and formal distinctions. In the early 1960s, prior to the Conceptual Art movement, Andy Warhol had already experimented with processes of differentiation (or modulation) through repetition, on images borrowed from the media—images that had therefore been reproduced thousands of times before he made use of them. But where the variations that eventually appeared in the media's reproductions were fundamentally "imperceptible" (or at least, strictly secondary), Warhol used repetition precisely to explore variations in the prototype image; the difference engendered by such repetition (or reproduction) could now be apparent and create an event. After Warhol, Sigmar Polke in turn used the procedure to great effect, considering the transposing of a photograph onto canvas as a phenomenon of reproduction—and one must insist on the meaning "re-production," that is, the actualization of the dramatic value of

the image. This is probably best exemplified by the 1982 canvas *Lager*.[31]

In comparison to that of Warhol, the work of the most conceptual and analytical artists of the 1960s and 1970s was neither as relevant nor as effective with respect to the question of reproduction, and to the play between repetition and difference apparent in the redundancy of media-generated imagery and information. It was up to other artists to extend the Warholian attitude: Richter, of course, but also Boltanski, albeit in a minor mode (as he himself acknowledged).[32] Both found, in media-derived imagery as well as in family photo albums, invaluable and powerful stereotypes and, in so doing, that generalized aesthetic to which they chose to adapt (via deflected reproduction or differential repetition) rather than resisting it. After initially abandoning painting and the picture form for a logic of stock taking and accumulation, Boltanski, as I noted earlier, revived the paradigm of painterly composition—and thus the picture—when he asserted the beauty of amateur photographs. Richter, meanwhile, had started from the same appreciation: "I do not mean," he said, "to attack anything at all. The most seemingly banal pictures are on the contrary the richest. . . . A snapshot, when one conforms to it, becomes an extremely powerful factor. . . . The family photo, with everyone well portrayed in the center of the image, is literally overflowing with life."[33]

I should add at this juncture that Jochen Gerz was probably the one who most strongly refuted Richter's ideas, proceeding from the observations that "the media do not allow reality to be communicated or reproduced" and that images are "the wall of visibility encircling the non-experienced."[34] Gerz thus sought to break this rigidity of images (while exposing it) by creating between them an interplay of gaps and a "blurring," introducing a "shifted" language, whereas Richter created the blurring in the images themselves, during their transposition to the canvas. Yet despite this difference, both re-created in this way the effects of distancing and of annihilation of the represented object previously exploited by the German Romantic painters. And while Gerz seemed to reject the painterly solution proposed by Richter, the latter, in his refusal in turn to restrict his explorations to performances of

painted photography and in his return to abstraction and his vigorous insistence on being viewed as distinct from the American Photorealists, was also saying that all solutions were necessarily temporary and fragmentary, lest they lead to positivist dogmatism or an agenda of collective "salvation."[35]

Through this dialectic of difference and repetition (articulated around reproduction), with its gaps and reversals, we are led back to the crux of the debates about art around 1970: the general question of identity. And of the identity of art itself. Or, put another way, what is art, generically, as opposed to what is a painting, a sculpture, and so on? But also, what is an artist? Who is the "I" that claims the status of artist? Never before had artists been so "exhibited" to the public, as actors (in performance art), or gone so far as to imitate the artwork itself or, more precisely, to become it, by exposing (in the form of "living sculptures"—e.g., Gilbert & George) what it can be and the ways in which it can "appear" (in the sense that an actor "appears" in a play). And never before in the history of artists using photography (despite a longstanding tradition of staged self-portraits) had they been so engaged in games and simulacra (with varying degrees of seriousness and risk) of imaginary changes in identity, age, or gender (e.g., Lucas Samaras, Urs Lüthi) and even of cadaveric likeness (Rainer, especially). The effects of doubles and doubling (of which William Wegman was the "master" and Man Ray the obedient pet) can be considered according to the same logic, and resonate in other ways when contrasted with all of the variations of the period on reproduction as the covering and masking of the model, on duplication as the signaling of difference (Wegman, with his famous *Crow/Parrot* of 1970), and on the shadow and the reflection in a mirror as paradigms of the doppelgänger (going back to German Romantic literature). The very fact that so many artists of the time chose to work as couples (Gilbert & George, Ulay-Abramovic, the Leisgens, Bernhard and Anna Blume, to name only those who appear in the work itself as couple and doubled author) thus takes on particular significance. The fictions of Michele Zaza, built around the parental dyad, reintroduce into this context the perspective of family legends populated by mythological

symbols. Following this line takes us to the mimetic fictions of Cindy Sherman, which, more than staged self-portraits, are creations and re-creations of characters.

With her Untitled Film Stills, produced starting in 1977, Sherman announced the turn of the next decade, insofar as she applied the logic of performance, photographic "activities," and image-actions—and, to a lesser extent, that of so-called narrative art—to imagery of the cinema and the media, by ascribing to each image in the series an autonomous value. The shift, in the next stage of her work, to color and a larger format validated the revival of the picture form in photographic experimentation (after all the analytical procedures that had been experimented with since the late 1960s), and this occurred at the very same time as the so-called return to representation in painting. In actuality, just as the figurative never left painting after the advent of abstraction—it had, on the contrary, changed enough, at the same time as abstraction, to render their usual opposition problematic—the picture model has never stopped informing the artistic uses of photography, but it has been largely transformed and adapted. We have seen how Hamish Fulton reconstituted the picture form in referencing plates from books. The same is true of several artists who used words and images together, such as Victor Burgin and, more recently, Barbara Kruger.

Sequential analysis—narrative fiction akin to a cinema sequence (see John Hilliard as well as Mac Adams) also signaled divisions in the image itself (never mind the division of images). The least satisfying solution proved to be that of multiple images within the same frame, proceeding from the simple addition of documents, especially when this is contrasted with the efficacy of a Rinke montage or one of Gilbert & George's giant grids. Processes of analytical repetition and differentiation acquire far more persuasiveness when they generate a real extension of forms and figures into the exhibition space, as in the work of Jan Dibbets and in some pieces by Michael Snow, like 1971's *Of a Ladder*, where the succession of cinematic frames becomes a simultaneous deployment of perceptual fragments. John Coplans has recently explored exactly this avenue in his latest work on the figuration of his own body.

Lastly, with Boyd Webb and Ger Van Elk, and to a lesser degree in the work of Jan Groover—but also that of Wall and Horsfield—the picture form recovers its traditional authority, as a principle for the arrangement, within the rigid framework of a "composition," of a fable or complex figure. In Van Elk, this composition is doubled, or self-contradicting, in its own mise-en-scène (as, for example, in the 1975 Symmetrical Landscape series) and can undergo the most extreme optical distortions, with the shape of the picture itself changing. But in all these cases we are a long way from an analytical approach. The artifices of painterly and dramatic fiction have again come together in the salient realm of the picture. Yet again in the history of art, the realm of the picture (as a world of fiction), with its inequities and its extravagances, has revived itself. At the same time, an exponent of landscape photography such as Robert Adams, with the series Los Angeles Spring, can continue to describe and celebrate the world as a (faraway) picture, while telling us that it no longer has the edifying appeal it had in the nineteenth century—it is now a ruined, fragmentary totality.

•

From our vantage point at the conclusion of the 1980s, the renewal and diversity of photographic creation in the Western world are clearly informed by two complementary phenomena: on one hand, the convergence, at last made possible, of histories of photographic works (as seen, for example, in the Mayer collection) and histories of the artistic uses of the medium (e.g., the Krauss collection) and, on the other, the function of articulation, conciliation, and—pun intended—mediation performed by photography, more than ever, between the sphere of the media (or its representations) and the traditional representational culture of the fine arts, which maintains its relevance (including through its representations in the media) in the face of the many attacks it has weathered from this or that avant-garde. It is useful to observe and describe these two phenomena, avoiding as much as possible any impulse to critical appreciation.

The first phenomenon obviates and fills in the historical hiatus described at the beginning of this essay, and only by noting the most recent creative developments can we appreciate just how effectively it does so.

(The choice of contemporary artists for the present exhibition, of course, is meant to point the way to a positive evolution.) Already, though, this is sufficient evidence to suggest that something beyond "modernism" is at issue. One might also note the unique situation experienced by the contemporary photographer, whereby potentially the entire corpus of photographic images produced in the history of modern art is available—in raw, uncategorized form—for purposes of reference or as tools for possible reflection (which, it must be said, has nothing to do with how eclectic an artist's tastes and aesthetic valuations are). The second phenomenon is highly ambiguous. At the very moment that it confers upon the photographic image a new place in our visual culture and, in so doing, generates a wealth of fascinating explorations by artists, it also provides the culture industry with a new tool and tends to reinforce the categorization of photography as a "midrange" art form at the mercy of the demagogic manipulations of the entertainment technocracy.

The picture's adventures in the history of photography and of its artistic uses, whatever the period, have now led us to the point where it has again, and more strongly so than ever, been embraced by the majority of contemporary photographers as a necessary, or at least sufficient, form of (or model for) artistic production and experience. This is increasingly true in the sociocultural context of "contemporary art," that is to say, in reaction to (or seceding from) the principles and habits followed in the various loci of the medium's functional application, such as documentation (and documentary aestheticization), illustration, entertainment, and so on. The traditional visual arts (painting and sculpture but also printmaking), meanwhile, have long since lost or pushed away, in part because of photography, their potential for functional application—but regretfully so, it would seem, judging from the Productivist and Bauhaus episodes, as well as all of the current trends toward decorative art and the production of entertainments. Unless it exploits the remnants of these historical episodes or adapts itself to new trends, photography is bound to follow the same path (and lead to the same regrets). In 1921, swept up in the utopian ideal of the Soviet Revolution, Nicolai Tarabukin posited the era of "the last painting" (which happened to be

Aleksandr Rodchenko's "pure" primary colors triptych), showing how and why the finality of the autonomous work of art—bereft of any role in practical, daily life—would (or should) be abandoned by artists once the mimetic tradition of painting had been exhausted. Since that prophecy (a better term would be "programmatical wish"), the picture has unceasingly transformed and reconstituted itself; the "last picture" has continued to reappear, either as it was in the beginning or in a new light, and the photographic image today provides it with some of its surest content, for better and for worse. By "worse" I mean, as mentioned earlier, the multiplication of "Neo-Pictorialist" apings of ancient or modern painting, wherein auteurist photography confirms its vocation as a midrange art form by blindly fulfilling the mediator role mentioned above.

The Düsseldorf-, Paris-, and Vancouver-based artists presented here all work more or less systematically (and exclusively) in the tradition of the descriptive picture; it can even be said that most of them espouse the tradition of description as picture. They are wary of an overly fragmented and subjective vision, which remains the hallmark of much of so-called creative photography (also called "independent" not so long ago). They do not mean to reject artifice and fiction—quite the opposite is true—but they refuse to be their "authors," preferring instead to "find," recognize, and reveal them in preexisting visual material, be it objective or imaginary, part of the order of things in the world or that of images (which, by the way, appear also as things in the world). All this is already sufficient justification for bringing them together. But they work in contexts as well as historical and cultural settings that are very different, and it is through those differences that we may explore their shared options, as well as their more or less shared ones.

With the exception of Lothar Baumgarten, the Düsseldorf artists—Andreas Gursky, Thomas Ruff, and Thomas Struth—all studied under Bernd Becher at the Kunstakademie (where Klaus Rinke and Gerhard Richter both taught). From Bernd and Hilla Becher they learned the example of a thorough, analytical, serial approach, aimed at precision—and, even better, a precise, descriptive rendering. By freely revisiting, via that example, the Realist and Neue Sachlichkeit models of the 1920s, they

sidestepped the complementary culs-de-sac of abstract lyricism and positivist impersonality. While the latter hindrance essentially affected American photography (notable exceptions include auteurs such as Robert Adams and William Eggleston), the former made for a more proximate risk, as it was that of Subjective Photography, as advocated by Otto Steinert, which in Europe was seen as the most comprehensive framework for the "creative" photography of the postwar era, opposed to the objectivity of the 1920s as well as to the trends toward social, political, and humanitarian commitment. Importantly, Subjective Photography had developed against the backdrop of the Cold War and the U.S.-supported economic and democratic "reconstruction" of Germany. It had a dual function: in standing against totalitarian oppression and collectivist standardization, it had to assert individual freedom and demonstrate the individual's capacity for expression, but it also had to remove the potential for a new consensus among the divisions engendered by the war. Thus it could not but reject any form of description that was overly functional and impersonal (cf. Albert Renger-Patzsch) or excessively sociological (August Sander). And, in partaking of the experimental abstractifying logic of the 1920s, it fit into a historical continuity of "modern" photography, opposed to Pictorialist archaisms. In so doing, it gave rise to a purist aesthetic in line with a subjectivity effectively *abstracted* from its historical determinations, as is natural for a culture industry centered on the purely ideological assertion of the individual (so as to better direct and control that individual's experience). The Bechers opened up exactly this type of completely other, contrary avenue. At the risk of disavowing the true lyrical quality still permitted in this context (and exemplified by a scant few works produced in Steinert's circle, such as the earliest images by Christer Strömholm [alias Christen Christian] and Peter Keetman), the Bechers reintroduced photography into contemporary art, as a tool for historical testimony and analysis, by strictly adapting their method—with room for improvisation reduced as much as possible—to the very nature of the objects they had chosen to study. The many successes and the diversity of explorations by their disciples today demonstrate the extent to which the method may be adapted and transformed, for example, when applied to contemporary objects or to living beings.

Thomas Struth, in his series of urban scenes and architectural portraits, is faithful to the method but considerably relaxes the tenet of typological comparison, via the empathic flexibility of a gaze that is attentive to the diversity of cultural (and anthropological) situations reflected in the environment. Thomas Ruff, by contrast, after his early descriptions of interiors (which are veritable X rays of a certain private, kitsch, petit bourgeois culture), has limited his discourse as a portraitist to rigorous stock taking of the programmed traits of physiognomic singularity, demonstrating how that programming stems as much from historical generic conventions (going back to portraiture of the German Renaissance) as from the standards of a social identity conditioned by technical reproduction. Andreas Gursky, at the other end of the spectrum of possibilities unlocked by the Bechers, strays as far from the method as does Ruff, extending the precision of documentary description toward the clarity of lyrical transposition. Baumgarten, for his part, though for a variety of reasons he cannot be assimilated to this group of photographers (and can doubtless be more spontaneously compared with Hamish Fulton), finds in his memoirs of travel the "exotic" component that has always been a part of photographic objectivity since the nineteenth century. As long as one understands that exoticism in the same manner as Victor Segalen—as a perception of difference and an "aesthetics of diversity"—for it is "not that kaleidoscopic vision of the tourist or of the mediocre spectator, but the forceful and curious reaction to a shock felt by someone of strong individuality in response to some object whose distance from oneself he alone can perceive and savor."[36]

In Vancouver, as in Düsseldorf, artists using photography today form another fairly homogeneous group. A shared learning experience under the same teachers (Ian Wallace and later Jeff Wall) and the isolating context of a remote city lacking any tradition of cultural cosmopolitanism (in spite of its multiracial demographic) promote a communitarian attitude. But these artists have constructed their identities much more via their transformation of models for artistic and theoretical activities imported from the United States. Where the earlier generation (Wallace and Wall) was initially located within the Post-Minimalist/Conceptualist movement—

later developing, through a semiological approach to the image, a critical reflection on the environment as a structure of communication, subjective isolation, and cultural segregation—the second generation took advantage of the vernacular models so constituted and set itself considerably apart from the Neo-Conceptual (and especially "Neo-Pop") leanings that had emerged in the meantime in the United States (mainly in New York). The interest in media representations and a theoretical corpus centered on the "contextual" analysis of artistic culture form the common ground for a meeting (more than an exchange) of the two "schools." But if one compares, for example, the images of Richard Prince with those of Ken Lum, the differences are blatantly evident—so much so that the Vancouver artists, in the end, appear to be much closer to European attitudes (and to the Düsseldorf circle, among others) than to New York trends.

By confining his definition of his activity to the recycling of consumer imagery, with an empathic rather than an analytical or critical gaze, and taking a serial approach whose goal is limited to creating voluntarily ludicrous interpretive effects, Richard Prince has reduced the register of artistic production (i.e., emptied it of all constructive operations) to that of imaginary consumption. When a "gazer," removed from the privileged space of the museum, looks at a billboard and again finds (re-cognizes) the shape or ready-made picture that Prince himself had found, the circular play of "recognitions" has at last produced a pure simulacrum, stripped of all semblance of originality and difference. The productivists' utopia of "art into life" is realized by the mutual annihilation of the two. The Vancouver artists, in contrast, have retained a constructivist attitude (even if they are not entirely immune to dandyist, faux fin-de-siècle indulgings in stereotypes, which perfectly describes Prince). Lum produces his own images, and in setting his portraits next to huge logos, he is not attempting to undo the specific likeness of the model (by a contagious oversimplification of signage), nor does he seek to invalidate the realist effect of the mimetic image. His goal is to bring to the image a "contradiction," a visual counterweight and an ornamental (or musical) counterpoint, thereby enhancing its eloquence, its gravity, and its realism. Similarly, when Roy Arden affixes his monochromatic

photographs to archival images, or fragments one of these images after the fashion of the detailed views of a painting reproduced in a book, or when Stan Douglas juxtaposes his TV spots in color with images in black-and-white and adds a script, like so many false cues, the documentary role of photography melds with a heterogeneous reality that is open to an "off-screen" space (or a countershot) that gives it its "visibility"—that is, form (sequential, narrative, fragmentary) and dialectical value, but also (especially in Arden), a rhythmic tonality and an immediate emotional resonance. In the context of the widespread exchange of signs of communication, the work of art retains, or rediscovers, its function of differentiation and public expression.

The Vancouver artists have heeded the lesson of the "deconstruction" approaches, which proceed from the principle that all things are already "constructed," and poorly so, as rigid representations, reifications, processes that run counter to the modernist optimism for which new representations had to be constructed. But they have also measured the rhetorical closure of these processes. In *Two or Three Things That I Know about Her* (1971), Jean-Luc Godard's off-screen voice asks: "Why all these signs around us that end up making me doubt language and submerge me in meanings, drowning reality instead of extracting it from the imaginary?" Without responding directly (i.e., by a strictly political engagement), the Vancouver artists, who have moved beyond the conceptual/analytical attitude that informed their initial training, now seek to construct semiological, poetic realism beyond the surfeit of "meanings" Godard spoke of (even though they continue to nourish it by rhetorical inflation of a certain critical didacticism). They have also—Roy Arden's work is proof enough—heeded Allan Sekula, who warns in "The Traffic in Photographs" (originally a lecture given in 1981 in, coincidentally, Vancouver): "Just as money is the universal gauge of exchange value, uniting all the world goods in a single system of transactions, so photographs are imagined to reduce all sights to relations of formal equivalence. Here, I think, lies one major aspect of the origins of the pervasive formalism that haunts the visual arts of the bourgeois epoch. Formalism collects all the world's images in a single esthetic emporium, torn from all the contingencies

of origin, meaning and use."[37] But Lum, Arden, and Douglas, like Wall, regardless of the value of historical interpretation they wish to ascribe to their work, are also, and primarily, defined as producers of *aesthetic occurrences*, which act upon forms (those of information, but also those of art history) and transform them. This is why their realism is a "formalism," as was that of the early 1920s, as is that of the Bechers, to which one may readily apply Barthes' definition of structuralist activity (1963) as the search for intelligibility through processes of dissection and articulation.[38]

The French artists too paid attention to the issue raised by Godard (rather, it was an exclamation and warning from someone who had heard what Lacan had to say about the real, the imaginary, and the symbolic), and it would seem more so than to Sekula, for their work seems to indicate at once a firm concern for "realism" and a remarkable indifference to history. Where Ruff, in his indulgence of simulacra, is the most cynical of the artists shown, the French (Patrick Faigenbaum, Jean-Louis Garnell, Christian Milovanoff, and Patrick Tosani) are the most obviously "formalist" (in the sense that Sekula might employ). In truth, this apparent and often explicit retreat is in itself a historical occurrence. It comes from their extreme mistrust of the myriad overly virtuous discourses and commitments to "the right causes," the leftist clichés, the didactic (and often opportunist) naïveté of all art that calls itself "critical," the semiological guerilla skirmishes. There are few countries in which political ideologies had such a destructive effect on art culture around 1970. And in the domain of photography, there is only one in which an auteurist journalistic tradition (aided in this case by the prestige, and self-interested guidance, of Cartier-Bresson) has sustained so durable a compromise between the provision of information, humanitarian values, and resolutely individualist expression. When that compromise emerged, in all of its archaism, and all the best efforts proved powerless before the inexorable development of the culture industry, models for "creative" photography found room to expand into the space thus liberated. The artists under consideration here could not, and cannot, but stand apart from these movements—it was either that or retreat into their studios, as Tosani freely admitted to doing.[39] This is why Faigenbaum,

Garnell, and Milovanoff also chose to explore closed, nostalgic, or comical worlds (e.g., the vestigial palaces of Italian aristocracy, the disordered buildings and ruined landscapes of petit bourgeois intimacy, or the kitsch temples of mass consumption), and Tosani worked with collections of fetishized artisanal artifacts. And they did so in the complete absence of provocation or even parodic intention—merely in response to a need to reinvent a sort of objective, "common" lyricism.

In the end, it is that need (which cannot as yet be considered a project or, even less, a "program") which constitutes the most secure meeting ground for the French photographers and the Düsseldorf group. It should not be expected to lead to a widening of perception, as the experimenters of "new vision" had hoped in the 1920s (when the memory of that idea seems to produce only conventional, citational effects), but we should at least know how to recognize in it, more modestly, the principle of paying proper attention to things, in the irreducible gap that separates seeing and saying, the visible and the speakable, the present and the possible. That the macrophotographic reproduction of a drum (Tosani) or the description (and concomitant restitution) of the scenographic structures that condition the experience of urban life (Struth) should provide comparable, if not analogous, tableaux of our cultural geography (*Géographies* is the title of the Tosani images)—this is a daily occurrence in the visual arts, alien to the order of discourse. Just as the rapprochement of Faigenbaum's staged portraits and Ruff's sign effigies—via the dialectical, ornamental compositions of Lum—probably stems from the "formal equivalency" of photography but cannot, at any rate, be expected to sketch out, much less predict, the constitution of a universal language— even if one wished to ground the latter in pure (perfectly interchangeable) simulacra. For the mere onset of a difference—as discreet, discontinuous, or fragmentary as it may be—will always ensure that a gap exists in the picture.

Notes

1. Jean Clair, "L'inconscient de la vue," *Chroniques de l'art vivant*, no. 44 (November 1973): 6.
2. Baudelaire wrote in the same paragraph, regarding sculpture: "Though as brutal and positive as nature herself, it has at the same time a

certain vagueness and ambiguity, because it exhibits too many surfaces at once. It is in vain that the sculptor forces himself to take up a unique paint [*sic*] of view, for the spectator who moves around the figure can choose a hundred different points of view, except for the right one, and it often happens that a chance trick of the light, an effect of the lamp, may discover a beauty which is not at all the one the artist had in mind" ("The Salon of 1846: XVI: Why Sculpture Is Tiresome," in Charles Baudelaire, *Art in Paris, 1845–1862: Salons and Other Exhibitions*, trans. and ed. Jonathan Mayne [London: Phaidon, 1965], 111).
3. Michael Fried, "Art and Objecthood," *Artforum* 5 (June 1967); reprinted in *Art and Objecthood: Essays and Reviews* (Chicago: University of Chicago Press, 1998).
4. Robert Morris, "Notes on Sculpture," pt. 2, *Artforum* 5 (October 1966); reprinted in Robert Morris, *Continuous Project Altered Daily: The Writings of Robert Morris* (Cambridge, Mass.: MIT Press, 1993). Part 1 of the article had previously appeared in the February 1966 issue of *Artforum*.
5. Nancy Foote, "The Anti-Photographers," *Artforum* 15 (September 1976): 46–54.
6. See Jean-François Chevrier, "L'invention de la photographie créative et la politique des auteurs," in *L'art en Europe: Les années décisives, 1945–1953* (Geneva: Skira; Saint-Étienne; France: Musée d'art moderne de Saint-Étienne, 1987), 252–261.
7. A. D. Coleman, "The Directorial Mode," *Artforum* 15 (September 1976): 55–71; reprinted in *Light Readings: A Photography Critic's Writings, 1968–1978* (New York: Oxford University Press, 1979), 246–257.
8. Christian Boltanski, interviewed by Jacques Clayssen in *Identités / Identifications*, exh. cat. (Bordeaux: Entrepôt Lainé, 1976), 23–25.
9. See Beaumont Newhall, "Cinquante ans d'histoire de la photographie," *Cahiers de la photographie*, no. 3 (1981): 5–9.
10. László Moholy-Nagy, "An Open Letter to the Film Industry and to All Who Are Interested in the Evolution of the Good Film," *Sight and Sound* 3 (spring 1934): 56–57.
11. Charles Baudelaire, "The Salon of 1859: II. The Modern Public and Photography," in *Art in Paris, 1845–1862*, 154.
12. Francis Wey, "De l'influence de l'héliographie sur les beaux-arts," *Lumière*, no. 1 (February 1951); reprinted in "Du bon usage de la photographie," *Photo-poche*, no. 27 (1987): 57–71.
13. Baudelaire, "The Salon of 1859: VIII. Landscape," in *Art in Paris, 1845–1862*, 194ff.
14. Émile Zola, "Mon Salon (1868): Les paysagistes," *Événement illustré*, 1 June 1868.

15. Discussing the legitimacy of F. Holland Day's historical "stagings," Commandant Puyo wrote, in the annual publication of the Photo Club de Paris, 1901: "History, religious or profane, is a domain forbidden to the photographer. . . . One thing is certain: to say that photography is a realist process is not saying enough. Its domain is even more limited: it is not realism, it is modernism, nothing more."

16. See Jean-François Chevrier and Sylviane de Decker Heftler, "Stieglitz, Ansel Adams," *Photographies*, no. 4 (April 1984): 100–105.

17. The expression in the original French, "les grandes scènes de la nature," refers to the title of an anthology of literary texts published by Hachette Éditions of Paris in 1872, which is widely distributed in French schools.

18. Baudelaire, "The Salon of 1859: VIII. Landscape," in *Art in Paris, 1845–1862*, 202–203.

19. See, for example, Jacques Lacan, "The Mirror Stage as Formative of the Function of the I as Revealed in Psychoanalytic Experience," in *Écrits: A Selection*, trans. Alan Sheridan (New York: Norton, 1977), 1–7.

20. Raoul Hausmann, "Wir sind nicht die Photographen" (1921), reprinted in *Zeitschrift für Dichtung, Musik und Malerei*, no. 1 (1959), excerpted (French translation) in *Courrier Dada* (1958) and reprinted in Michel Giroud, *Raoul Hausmann* (Paris: Chêne, 1975), 32.

21. Douglas Huebler, interviewed by Irmeline Lebeer, *Chroniques de l'art vivant*, no. 38 (April 1973): 20–23.

22. Ibid. This is essentially a restating of Huebler's famous 1969 statement: "The world is full of objects, more or less interesting; I do not wish to add any more. I prefer, simply, to state the existence of things in terms of time and/or place" (cited in Lucy Lippard, *Six Years: The Dematerialization of the Art Object* [New York: Praeger, 1973], 74).

23. Huebler, interviewed by Irmeline Lebeer.

24. Vito Acconci, "Notebook Excerpts, 1969," in *Vito Acconci: Photographic Works, 1969–1970* (New York: Brooke Alexander, 1988), unpaginated.

25. Ugo Mulas, "L'opération photographique (Autoportrait pour Lee Friedlander)," text and illustrations reprinted in *Ugo Mulas, fotografo, 1928–1973*, exh. cat. (Geneva: Musée Rath; Zurich: Kunsthaus Zürich, 1984).

26. Arnulf Rainer, 1978 Venice Biennale catalogue, reprinted in *Art Press*, special issue on Vienna (1984): 49.

27. Barbara and Michael Leisgen, interviewed by Jacques Clayssen in *Identités/Identifications*, 51–54.

28. See Rudi Fuchs, *Richard Long* (New York: Solomon R. Guggenheim Museum; London: Thames and Hudson, 1986).

29. See the interview with Jochen Gerz in Suzanne Pagé and Bernard Ceysson, *Jochen Gerz: Les pièces* (Paris: Musée d'art moderne de la Ville de Paris; Musée d'art et d'industrie de Saint-Étienne, 1975), 4–8.

30. Huebler stated in a conversation with Donald Burgy in October 1971: "One of the things that holds a culture together is redundancy of information. You say the same prayers over again, the same stories. You go to the same meetings and meet people saying the same things. . . . That kind of redundancy is precisely what forms the cultural base" (in Lippard, *Six Years*, 252).

31. Polke has said of this work: "*Lager* is not painting. It is a reproduction. It is something that cannot even be painted. . . . I used the narrative form as well as the objective form of photography, as the reproduction of a tragedy" (interview with Bice Curiger in *Art Press*, April 1985).

32. Boltanski himself has said: "Perhaps I am in the tradition of Warhol, but with me there is a desire to do cutesy, silly stuff. For the past few years, I've tried to work with 'sweet,' family-type themes, for all audiences—intimism as a reaction against 'hard' paintings, against the importance of art. That also has to do with my temperament; I have nothing of the heroic side of Warhol" (in *Façade*, no. 1 [1975], reprinted in Christian Boltanski and Bernard Blistène, *Boltanski* [Paris: Musée national d'art moderne, 1984], 112).

33. Gerhard Richter, interviewed by Irmeline Lebeer, in *Chroniques de l'art vivant*, no. 36 (February 1973): 15–16.

34. Jochen Gerz: "The blur is the expression of the highest realism of which I am capable. . . . My work is not about the real, nor about representation, but at best a sabotaged restitution—they are pieces of evidence that do not betray what happened but protect it. Between the real and its representation there is a no-man's-land. My work is located in that zone" (in Pagé and Ceysson, *Jochen Gerz*, n. 31).

35. Richter, interviewed by Irmeline Lebeer, n. 35: "The Photorealists. . . . They seem to believe in what they're doing. They've found their salvation once and for all; they can do Photorealism until the end of their days. I cannot, for my part, believe in it to that point. There is no longer any salvation possible. That would require a general consensus. Everyone under the same banner. Only Hitler has managed that in our time."

36. Victor Segalen, *Essay on Exoticism: An Aesthetics of Diversity*, ed. and trans. Yaël Rachel Schlick (Durham, N.C.: Duke University Press, 2002), 21; originally published as *Essai sur l'exotisme* (Paris: Fata Morgana, 1978).

37. Allan Sekula, "The Traffic in Photographs," *Art Journal* 41 (spring 1981): 15–24, reprinted in Allan Sekula, *Photography against the Grain: Essays and Photo Works, 1973–1983* (Halifax: Press of the Nova Scotia College of Art and Design, 1984), 99.

38. Roland Barthes, "Structuralist Activity," in *Critical Essays*, trans. Richard Howard (Evanston, Ill.: Northwestern University Press, 1972), 213–220. Originally published as *Essais critiques* (Paris: Seuil, 1964).

39. Patrick Tosani, interviewed by Jean-François Chevrier, in *Une autre objectivité / Another Objectivity* (Milan: Idea Books, 1989), 211–216.

Hans-Peter Feldmann, *Sonntagsbilder*
(Sunday pictures), 1976–1977 (cat. no. 56)

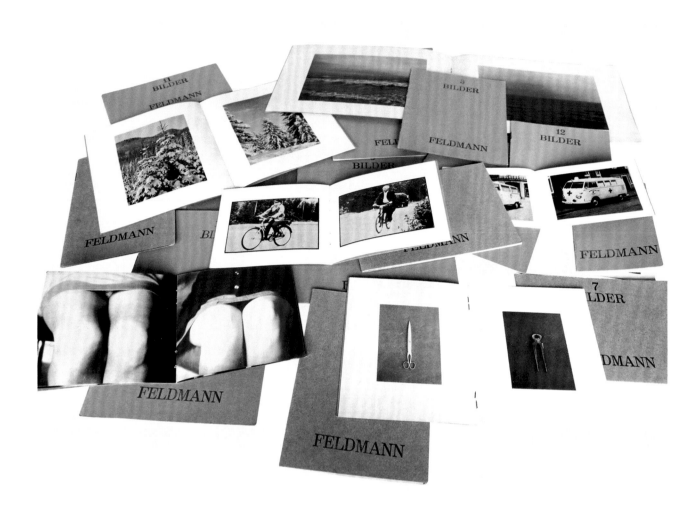

Hans-Peter Feldmann, *Bilder* (Pictures),
1968–1973 (cat. no. 43–55)

Peter Fischli and David Weiss, *Der Brand
von Uster* (The fire of Uster), 1979
(under cat. no. 57)

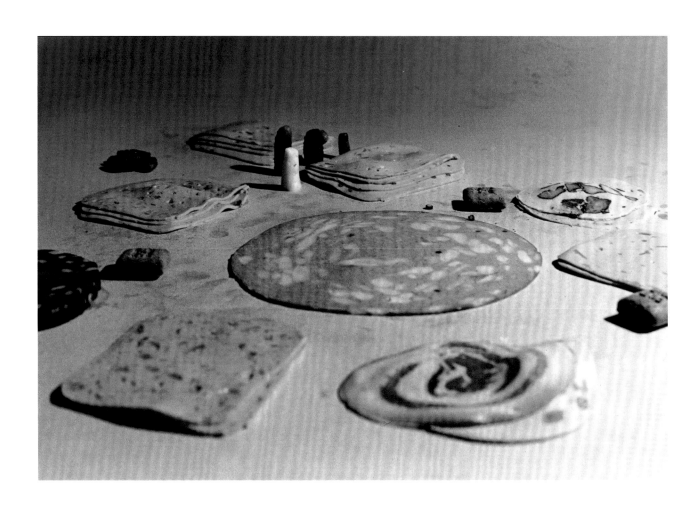

Peter Fischli and David Weiss,
Im Teppichladen (In the carpet shop), 1979
(under cat. no. 57)

Peter Fischli and David Weiss, *Modeschau*
(Fashion show), 1979 (under cat. no. 57)

Peter Fischli and David Weiss, *Moonraker*,
1979 (under cat. no. 57)

Peter Fischli and David Weiss, *Titanic*,
1979 (under cat. no. 57)

Left:
Gilbert & George, *Raining Gin*, 1973
(cat. no. 59)

Gilbert & George, *Dead Boards #5*, 1976
(cat. no. 60)

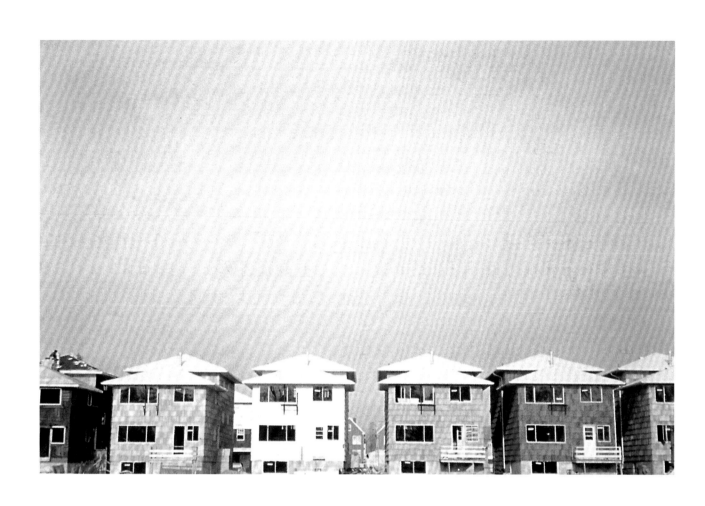

Dan Graham, *Homes for America*,
1966–1967 (cat. no. 61)
Above and right: details

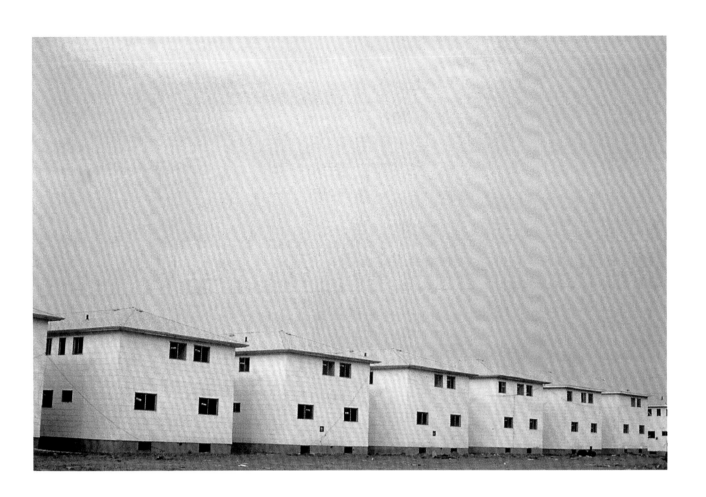

Dan Graham, *Homes for America*,
1966–1967 (cat. no. 61)
Above and right: details

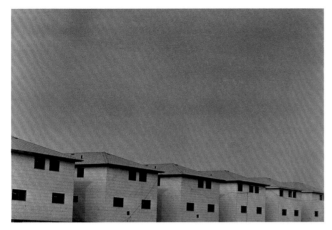

Dan Graham, *Homes for America* (detail),
1966–1967 (cat. no. 61)

Hans Haacke, *Cast Ice: Freezing and
Melting, January 3, 4, 5 . . . 1969*, 1969
(cat. no. 63)

Hans Haacke, *Spray of Ithaca Falls: Freezing and Melting on Rope, February. 7, 8, 9 . . . 1969*, 1969 (cat. no. 64)

Hans Haacke, *Live Airborne System,*
November 30, 1968, 1968
(cat. no. 62)

Variable Piece #99

Israel

From among a number of photographs made at randomly selected sites in Jerusalem enlargements have been examined to determine if any signs of the eternal presence of our Biblical ancestors could be found within the natural environment of the Holy Land.

The enlargements do, in fact, reveal the appearance of many faces; for this work the artist has made conventional renderings, in color, of some of the faces to assist the perception of those who may not perceive in the same manner.

Six photographs, an enlargement of one of them and the rendering join altogether with this statement as the final form of this piece.

July, 1973

Douglas Huebler

Douglas Huebler, *Variable Piece #99, Israel, July 1973*, 1973 (cat. no. 66)

```
                    Variable Piece #101
                        West Germany

On December 17, 1972 a photograph was made of Bernd Becher at the instant
almost exactly after he had been asked to "look like" a priest, a criminal,
a lover, an old man, a policeman, an artist, "Bernd Becher," a philosopher,
a spy and a nice guy ...in that order.

To make it almost impossible for Becher to remember his own "faces" more
than two months were allowed to pass before prints of the photographs
were sent to him; the photographs were numbered differently from the
original sequence and Becher was asked to make the "correct" associations
with the given verbal terms.

His choices were:

               1  Bernd Becher      6  Policeman
               2  Nice Guy          7  Priest
               3  Spy               8  Philosopher
               4  Old Man           9  Criminal
               5  Artist           10  Lover

Ten photographs and this statement join together to constitute the final
form of this piece.

March, 1973                                     Douglas Huebler
```

Douglas Huebler, *Variable Piece #101,*
West Germany, March 1973, 1973
(cat. no. 67)

THEATRE DU VIDE

UN HOMME DANS L'ESPACE !

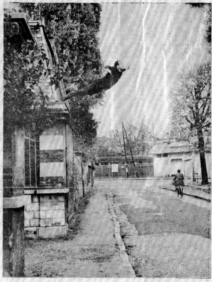

(Photo Shunk-Kender)

Le peintre de l'espace se jette dans le vide !

ACTUALITÉ

L'ESPACE, LUI-MÊME.

● SUITE EN PAGE 2

Sensibilité pure

● SUITE EN PAGE 2

Yves Klein, *Dimanche*, 1960
(cat. no. 68)

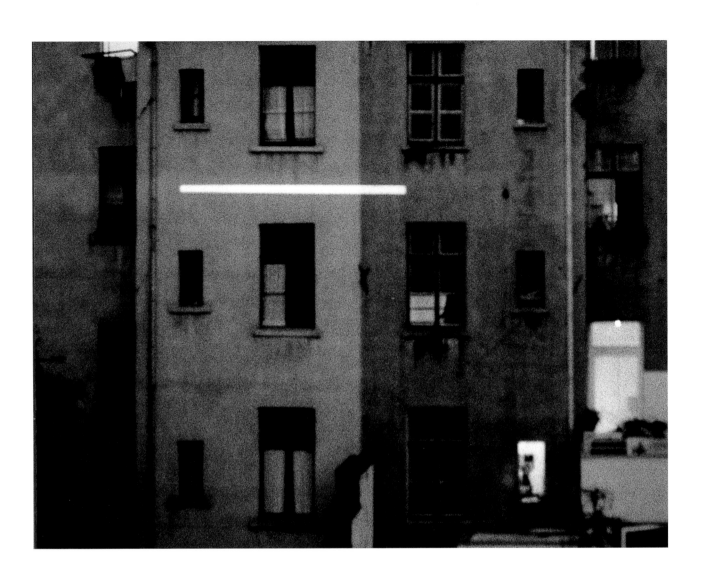

Imi Knoebel, *Aussenprojektion*
(Exterior projection), 1971
(under cat. no. 69)

Imi Knoebel, *Sternenhimmel* (Starry sky),
1974 (under cat. no. 71)

Imi Knoebel; *Abstrakte Projektion*
(Abstract projection) (detail), 1969; gelatin
silver print; 12 ⅜ x 7 ⅞ in. (30.5 x 20 cm);
courtesy the artist

Imi Knoebel, *Innenprojektion*
(Interior projection), 1969
(under cat. no. 69)

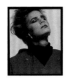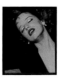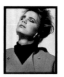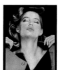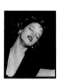

THE MAIDEN'S BLUSH.

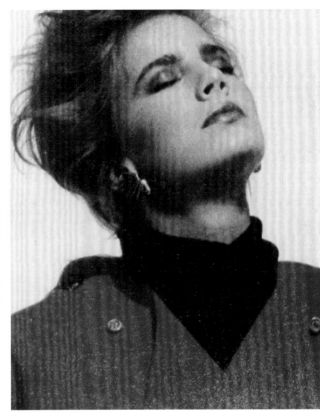

Silvia Kolbowski, *Model Pleasure 1*, 1982
(cat. no. 72)
Bottom: details

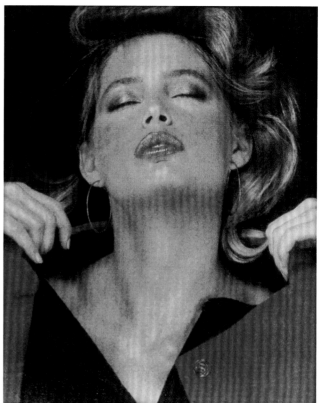

Silvia Kolbowski,
Model Pleasure 1 (details), 1982
(cat. no. 72)

Jeff Koons, *The New Jeff Koons*, 1981
(cat. no. 73)

Barbara Kruger, *Untitled*
(Your comfort is my silence), 1981
(cat. no. 74)

Barbara Kruger, *Untitled*
(You are not yourself), 1982
(cat. no. 75)

David Lamelas, *Rock Star*
(Character Appropriation) (detail), 1974
(cat. no. 76)

Right:
David Lamelas, *The Violent Tapes of 1975*,
1975 (cat. no. 77)

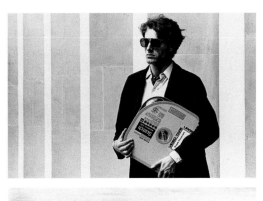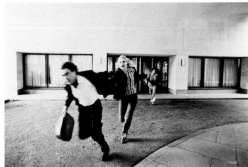

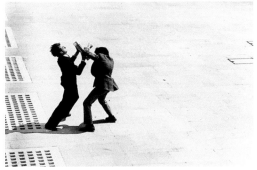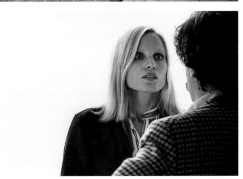

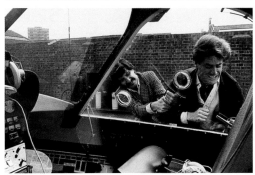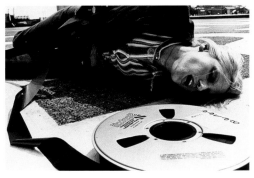

Louise Lawler, *Why Pictures Now*, 1981
(cat. no. 78)

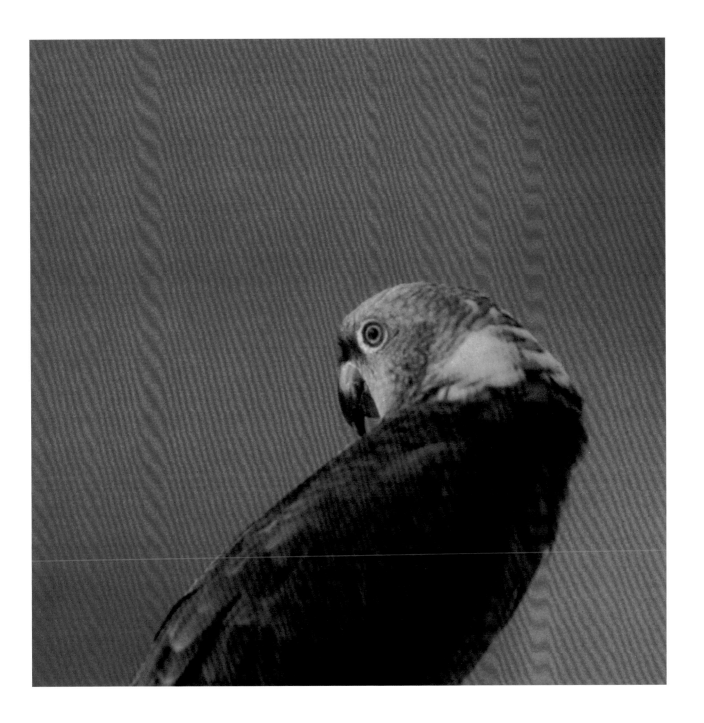

Louise Lawler, *Portrait (Parrot)*, 1982
(cat. no. 81)

Louise Lawler, *Arranged by Donald Marron, Susan Brundage, Cheryl Biship at Paine Webber, Inc.*, 1982 (cat. no. 80)

Sherrie Levine, *After Walker Evans: 3*, 1981
(under cat. no. 85)

Sherrie Levine, *After Walker Evans: 5*, 1981
(under cat. no. 85)

Sherrie Levine, *After Walker Evans: 18*,
1981 (under cat. no. 85)

Sherrie Levine, *Untitled (President: 5)*, 1979
(cat. no. 84)

Sherrie Levine, *Untitled (President: 2)*, 1979
(cat. no. 82)

Sol LeWitt, *Brick Wall*, 1977
(under cat. no. 86)

Sol LeWitt, *Photogrids*, 1978
(under cat. no. 87)

Sol LeWitt, *Autobiography*, 1980
(cat. no. 88)

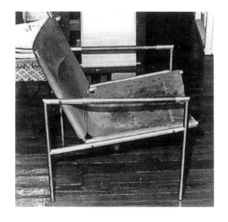

Following page:
Richard Long, *A Line Made By Walking,
England*, 1967 (cat. no. 90)

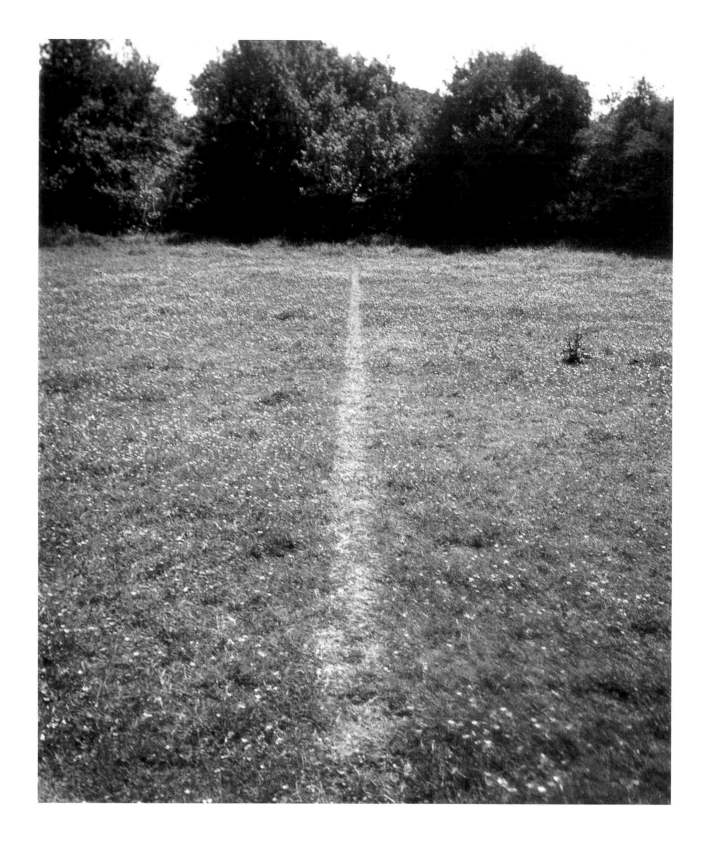

A LINE MADE BY WALKING

ENGLAND 1967

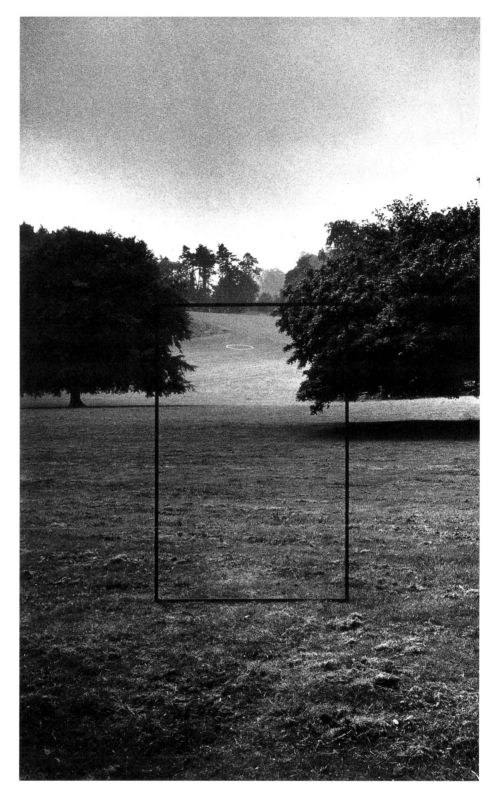

ENGLAND 1967

A SCULPTURE LEFT BY THE TIDE

CORNWALL ENGLAND 1970

Previous page:
Richard Long, *England*, 1967 (cat. no. 89)

Richard Long, *A Sculpture Left by the Tide,
Cornwall*, 1970 (cat. no. 91)

Geoffrey Batchen

Cancellation

Geoffrey Batchen teaches the history of photography at CUNY Graduate Center in New York. His most recent book is *Each Wild Idea: Writing, Photography, History* (MIT Press, 2001).

There is a certain history that could be told about the course of American art photography between 1960 and 1985. Sometime after World War II, so this story goes, a rupture took place between a modernist tradition stressing the production of fine photographic prints and a more conceptual use of the medium, championed by artists who identified themselves primarily as sculptors or painters. The outside came marauding across photography's border, bringing with it new ways of thinking that changed everything. It's a history that conveniently suits the myopia of the present, offering us a romantic clash of outsiders and insiders, conceptually inclined artists and mere photographers, even as it traces an ideal genealogy for the work of Cindy Sherman and other now-prominent photo artists. But what if we score a big *X* through this version of photography's story, ruining its pristine surface, even if not quite erasing it altogether? What would we see then? Well, for a start, seeing itself becomes a little more complicated. Having emulated the gesture that gives photographer Thomas Barrow's 1974 Cancellations series its name, we might now be forced to recognize, for example, that American art photography was in fact continually being ruptured from within, that conceptual practices of various kinds have always been rife within the photography community, and that inside and outside, art and photography, have never been as distinguishable as some might like to imagine.

Let's take Barrow's work as an example. The Cancellations series began only after he moved from Rochester, New York, to Albuquerque, New Mexico, in late 1972.[1] The work was initially based on photographs taken in and around Albuquerque, usually views of nondescript suburban sites populated by decaying buildings, commercial signs, or cars up on bricks. The style of image is a deadpan version of the photographic document, a type of photograph also being deployed around this same time by many other artists: Bernd and Hilla Becher (Cooling Towers series, from the late 1950s on), Edward Ruscha (*Every Building on the Sunset Strip*, 1966, and other publications), Ian Burn (Photographic Mirror series, 1967–1968), Hans Haacke (*Shapolsky et al.*, 1971), Lewis Baltz (New Industrial Park series, 1974), Martha Rosler (*The Bowery in Two Inadequate Descriptive Systems*, 1974), and Sol LeWitt (Brick Wall series, 1977), to name only a few. Although each of these projects was driven by different ambitions, they shared a desire to shift attention from the content of the image to the process of making or arranging it, from the subject of the photograph to the manner of its enunciation. They also exploited photography's capacity for seriality and multiple reproduction as well as for the presentation of affectless visual information. For a number of reasons, all of these attributes had become important to art practice in the late 1960s and early 1970s.

Barrow's decision to explore this genre was a particularly self-conscious one, given his training in the early 1960s at the Institute of Design in Chicago under Aaron Siskind, a training that, despite its grounding in interdisciplinary Bauhaus principles, emphasized a mastery of fine photographic printing technique.[2] Barrow had gone on to work at Eastman House in Rochester, thereby becoming familiar with the nation's major collection of historic photographs. So the Cancellations came out of a very photographic set of interests and knowledges. They also address a traditional photographic subject, the American landscape, but without any of the nationalist heroics associated with the work of, for example, America's best-known photographer, Ansel Adams. Most of Barrow's images seem to be of nothing in particular, capturing a seemingly arbitrary array of suburban grunge and decay rather than grand natural landmarks. His views were nevertheless carefully chosen, providing him with large expanses of unobstructed continuous tone and a scattering of vertical and diagonal elements to work against.[3] Barrow gave the final prints a brown tint (to differentiate them from his earlier Pink Stuff and Pink Dualities series, the choice of this color being his reaction to the pink shirts and charcoal suits popular in the 1950s). The brown color of the Cancellations is noncommittal (unaesthetic) and yet true to the dusty look of the Southwest. The titles are also drab and noncommittal (for example, *Mobile Home* of 1974 or *Tank* of 1975). But what is very committed, almost frighteningly so, are the prominent lines gouged into each and every image surface.

As with the work of Barrow's peers, both the serial nature of these gouges and the process of their making are central to their effects, for their look and feel are no accident. In fact, they took a bit of practice to get right. After some earlier experiments with thirty-five-millimeter film, during which Barrow found that the scale of scratch to image looked wrong, he had taken to using a medium-format camera and its 2 ¼-by-3 ¼-inch negative. With this larger celluloid surface, the cancellation lines seemed to work much more effectively. He used, of all things, an ice pick to cut into the backing side of the negative. Or, if the resulting mark wasn't jagged enough for his liking, he took to the emulsion with the end of a straightened paper clip. To ensure a certain degree of arbitrariness in the resulting marks, he first placed his negatives onto a dark surface so that their image was not easily seen as he worked. Sometimes, in his eagerness, he accidentally scored right through the negative. It's a nice irony (not lost on Barrow himself) that he then had to consult a book by Adams, doyen of the fine print tradition, to work out how to print from a warped and damaged negative.

The idea for the series was prompted by Barrow's encounter in about 1967 with an etching of a coffee-grinder image canceled by Marcel Duchamp, who had arranged for three parallel lines to be scored through its metal matrix. The print was being offered as a (presumably unauthorized) "restrike" for $7.50. Barrow didn't buy it, but he did buy (or at least steal) the gesture. It's one that obviously comes out of a long-standing printmaking tradition, in which lines scored through the matrix ensure that a series is indeed limited to a certain, preordained number of prints. The artist certifies this limit by performing one final creative act, disfiguring the original matrix using the same drawing or intaglio technique that produced its signifying capacity in the first place. The artist, giver of artistic life, makes the sign of death over the body of that same art. It's interesting that the

matrix is not always destroyed by this process, but is merely re-marked, branded as obsolete, as something whose use-by date has now passed. This allows for the possibility of a restrike, like the one offered to Barrow. The restrike is a certification of a matrix's obsolescence but also a refutation of it; it wants to have it both ways, to be, and also not to be, part of the series (to be a print and to be its repressed other, to be both but neither). The end result is a piece of contraband, a bootleg, an image that has escaped the control of its author. It refers back to its unmarked sibling, but it's also a new thing, a renegade art object in its own right. For Barrow, Duchamp's canceled print was itself a desirable readymade, complete with chance markings by the artist made all the more arbitrary by their lack of artistic intention (even as random operations).

Duchamp politely used three parallel lines to cancel his image, but Barrow adopted a more loaded iconography for his series. An X strongly implies the force of the gesture that made it; we feel the weight of this deliberated violence in all its ironic symmetry, as if it is our own skin that has been slashed. X means no; actually it means NO! In 1970 the murderer Charles Manson cut an X into his forehead to indicate that he was an outcast, or just to protest his incarceration, or perhaps to indicate that he was indeed an angel of death. The exact meaning may have been unclear (even to him), but the gesture of self-mutilation still signifies like a slap in the viewer's face. It hurts to look at it.

So it is with Barrow's Cancellations, especially if you happen to love photography. They seem to be saying "no" to photography as a whole, or at least to a certain understanding of photographic art. But this is too kind. They set out to kill that photography—and not in a nice way either. Barrow's ice pick carved deep into the body of the photograph, literally as well as symbolically seeking its disembowelment. In that context, the gesture could equally be traced back to the X struck by Aleksandr Rodchenko through a visual sampling of what he perceived to be his enemy (portraits of the capitalist ruling class and cuttings from its press) for the cover design of an issue of *LEF* magazine published in 1925. Barrow himself remembers buying a copy of Jay Martin's 1970 biography of author Nathanael West and seeing among its illustrations a manuscript page from *The Day of the Locust* through which West had penciled a big X. But he might as easily have been thinking of the crosses commonly used to indicate unusable images on a commercial photographer's contact sheet. British artist Richard Hamilton had, by 1965, already made a series of silkscreen prints from a selection of just such excised sheets and titled it My Marilyn.

But this reference to vernacular photographic practice and Pop appropriation fails to encompass the full ramifications of Barrow's action in the Cancellations. He didn't just write on the surface of his prints; he desecrated the negative itself. His X's are therefore right in the photographic print, part of its grain, as photographic as any other element in the picture plane. They show up as white scratches, like puckered scars on otherwise healthy skin. They don't cover over anything, and you don't see anything through them (they're not revelatory in that sense). Before all else, the X marks remind us of the matrix from which the print was taken, the negative— that unseen, forgotten element of the photographic process, that denizen of the darkroom. Barrow brought photography's means of production, the relationship of negative and positive, into the light. He (literally) drew attention to the surface of his print, to the flat, continuous plane of that surface and thus to the once-parallel planes of negative and paper when each was placed in an enlarger to enact photography's magical coming into being. Siskind's photography stresses a flatness of field that facilitates the abstract look of his found graffiti and weathered walls. Barrow had it both ways, maintaining the camera photograph's perspectival depth while insisting on breaking that illusion with his rough scratches. We are asked to look beyond these scratches, into the picture, and then out again, up to the picture's surface, and thus back to the plane of the paper itself. By this means, the photograph is declared to be both image and object, orchestrated picture and physical thing. Equally, we are made very aware of the process of our looking at it (that normally passive act is turned into a self-reflexive activity).

The Cancellations series also offers its viewer an intensely historical understanding of photography. As Barrow well knew, William Henry Fox Talbot had invented a cliché-verre process as early as 1834.[4] This involved etching a design by applying a needle's point to smoked and varnished glass and then making a photographic contact print from the resulting matrix. In the first-ever photographs, then, drawing, etching, and photography were all combined in a single visual enterprise. By taking the photographic negative as his darkened matrix, Barrow conjured photography's multimedia beginnings as a means to signal its monomedium ends. One print in the series,

Thomas Barrow; *Horizon Rib*, 1974, from the Cancellations series; toned gelatin silver print; 9¼ x 13½ in. (23.5 x 34.3 cm); courtesy the artist

Homage to Paula (1974), makes this explicit. The title is a reference to Alfred Stieglitz's *Paula, or Sun Rays, Berlin*, taken in about 1889. Following the composition of the Stieglitz image, Barrow's camera captured an ensemble of his own earlier work raked by strong, diagonal stripes of light and shade. He then scratched three lines across his negative against the slant of the light diagonals, effectively crossing out the picture. The work acknowledges Stieglitz's historical importance while simultaneously rejecting both the fine print tradition and the revelatory type of photographic practice for which he stands. In 1974 such a rejection was tantamount to an institutional critique, the institution in question being the Museum of Modern Art (MoMA) in New York and its effort, through curator John Szarkowski, to define photography in terms of purity and essence.

In his 1964 exhibition *The Photographer's Eye*, Szarkowski had organized his chosen photographs in terms of what he saw as "photographers' progressive awareness of characteristics and problems that have seemed inherent in the medium."[5] Although informed by the formalist art criticism of Clement Greenberg, Szarkowski was also repeating a notion of the photograph inherited from several generations of influential photographers. Figures such as Ansel Adams, who started making photographs in the late 1920s, believed "that the greatest aesthetic beauty, the fullest power of expression, the real worth of the medium lies in its pure form."[6] Opposing the hybrid, decorative surfaces of a still-popular Pictorialism in favor of a hermetic modernist tradition established by Stieglitz and Edward Weston, the f-64 group, to which Adams belonged, advocated a type of photography in which there was no manipulation, cropping, or retouching of the photographic print; only so-called straight photography was thought to have "real worth." Szarkowski and MoMA tended to favor this aesthetic attitude, as did, to take one other example, Beaumont Newhall in his series of books on the history of photography.

No institution is a monolith, however, and there were exhibitions held at MoMA in this period that did present another point of view. In 1970 curator Peter Bunnell organized an exhibition there entitled *Photography into Sculpture* (based on one of Bunnell's essays in *Art in America* from the year before).[7] A subsequent article of the same name stressed his twenty-three chosen artists' "commitment to the physical object," a commitment that Bunnell claimed "exploits the properties unique to photography itself." Nevertheless he also conceded that three-dimensional works by featured artists such as Californians Robert Heinecken and Jerry McMillan made it hard to sustain this residual formalist claim, precisely because in the presence of their work, it is "exceedingly difficult to state just what the [photographic] medium is."[8] Most of the twenty-three artists chosen for this exhibition came from the West Coast of North America, from Los Angeles to Vancouver. Bunnell explained this regional focus in terms of a reaction against the documentary approach associated with an earlier generation of Californian photographers, led by Weston. But he also traced a renewed interest in the materiality of the photographic medium back to photography's earliest manifestations—for example, to those cased daguerreotype photo-objects that rest heavily in one's hand and have to be manipulated into visibility each time they are examined—and to such formative twentieth-century art phenomena as Constructivism and Pop (both of which refused to recognize a hierarchy between photography and other media). But, as a number of more recent exhibitions have made clear, the major influence on photographic artists of this period was the Conceptual Art movement (or is it that photography influenced Conceptual Art?).[9] And indeed, as it so happened, the showing of *Photography into Sculpture* at MoMA briefly overlapped (for three days) with the museum's installation of *Information*, its first overview of the emerging Conceptual moment. Photography was featured prominently in this exhibition too (work by the Bechers and Ruscha was shown), as well in the pages of its catalogue.[10]

Bunnell sent Barrow a copy of the *Information* catalogue, but many of its ideas—in particular its critique of media purity—were already taken for granted in the photographic circles in which this artist moved. Barrow was part of the so-called Rochester Group, which also included photographers Alice Andrews, Robert Fichter, Betty Hahn, Harold Jones, Roger Mertin, Bea Nettles, and Keith Smith and curators Nathan Lyons and Robert Sobieszek. Each of these artists and curators was interested in contesting the conventions of straight photography, adopting a range of practices—from making artist's books to inscribing their pictures with text—in order to achieve this end.[11] To their number might be added figures such as Les Krims, who was teaching photography in nearby Buffalo. It is of perhaps greatest interest to this exhibition that the State University of New York at Buffalo is where Cindy Sherman went

Thomas Barrow; *Homage to Paula*, 1974, from the Cancellations series; toned gelatin silver print, 9¼ x 13⁹⁄₁₆ in. (23.5 x 34.5 cm); courtesy the artist

to art school from 1972 and where, after abandoning painting, she began making her now-famous performative photographs. I would prefer to maintain my focus where it is, however, on this relatively neglected older generation of American photo artists and the canceled history of photography that their work embodies.

Not that this history is by any means homogeneous. For instance, where Barrow took an ice pick to photography, Betty Hahn simply gave it the needle. And that difference (like all difference) is instructive in itself. Between 1970 and 1973 Hahn made a distinctive series of gum bichromate prints on cotton. These began as thirty-five-millimeter or 120 roll film negatives and were then enlarged onto graphic arts film before being contact-printed onto either unbleached or colored cotton rectangles. They were then embellished in various ways through the addition of colored embroidery thread.[12] The subjects of these images are self-consciously various, including portraits (some taken as snapshots, others from official passport pictures), landscapes, gardens, architecture, television images, fruits, and vegetables. The colors of Hahn's images are equally varied, from lampblack to orange to green. The undemonstrative titles—

Ellen II (1970), for example, or *Broccoli* (1972)—don't give much away.

Without knowing anything more, one senses a resistance in Hahn's work to the demand to make photographic art, at least as that demand was framed by institutional circles at that time. No fine prints, no aesthetic subject matter, no artistic pretensions (they're not even "untitled," thereby declining the opportunity to self-declare as "conceptual" art). Hahn's stitching is similarly enigmatic, simply following and accentuating certain features already present in her photographs. In *Mejo, Passport Photo* (1971), the stitching repeats a series of horizontal lines in a woman's shirt, adding red, yellow, blue, and green highlights to an otherwise monochrome image. But Hahn chose to emphasize quite different elements in *Road and Rainbow* (1971). There she added double yellow lines to the center of her eponymous road but also solidly filled in the side of a barn with multiple white threads and sketched in a cartoon version of a rainbow in arched consecutive colors. In both cases the weave of the brown cloth has become part of the picture, resulting in a pixilated, textured image, like those seen in paintings (this is a photography embedded right in the grain of its support).

The refusal of Hahn's work to signify (or, at least, to signify clearly either as "photography" or as "art") itself becomes significant when seen in context. Like Barrow, she comes from the first generation of American artists who gained master's degrees in their field (perhaps this explains the heightened level of their historical consciousness). From 1958 through 1966 she studied under Henry Holmes Smith at Indiana University (Fichter went to school there too).[13] Smith had fallen under the influence of László Moholy-Nagy in 1937, when the European émigré had invited him to teach at the New Bauhaus. Smith brought this Bauhaus, anything-goes, experimental sensibility to his teaching at Indiana, and Hahn readily adapted it to her own photographic practice. She began working with the gum bichromate process in 1965, as part of a design class she was taking. It's a relatively simple process but provides unpredictable results. Basically, you mix an orange, sugarlike substance (potassium dichromate) with a given watercolor and a glue (gum arabic) and then brush the resulting solution onto paper. Talbot's earliest photogenic drawings, incidentally, were also brushed on, thereby merging painting and photography in a single act of representation. Hahn's pictures were made in a similar fashion, and similar too was the slowness of their development and the paucity of the detail retained, so the process was suitable only for contact printing from large negatives. But it allowed images to be applied to all sorts of surfaces and was open to creative manipulations, including the choice of color of the final image, as in woodcut printing. No one was using the gum process much in the 1960s, so Hahn was forced to search out and translate the original essays of French pictorial photographer Robert Demachy from the 1890s. It was his gum bichromate formula that she ended up using in her work, in a sense coating her paper with a liquid version of photographic history. Smith sent one of Hahn's earliest efforts to Robert Heinecken in Los Angeles, and he sent back one of his own experimental prints. This connection to the West Coast scene (in effect, a counter to the perceived hegemony of the New York art world) remained a constant feature of the Rochester Group's outlook.

In about 1970 Hahn began applying her gum bichromate solution to scraps of fabric that happened to be in her studio, left over

Betty Hahn; *Road and Rainbow*, 1971; gum bichromate on embroidered fabric; 16 x 20 in. (40.6 x 50.8 cm); courtesy the artist

from a dress she was making. This choice of material was prompted by two telling encounters. In 1964 she had seen the work of Robert Rauschenberg and Andy Warhol in an exhibition at Indiana University's art gallery and was impressed by their obvious contempt for media boundaries and their interest in popular culture. But she was also, after she arrived in Rochester in 1967, a frequent visitor to Eastman House. There she was transfixed by an album she saw exhibited in one of the museum's glass cases, an album whose cover featured a brown portrait of Queen Victoria printed on silk (perhaps using the Van Dyke process). This particular photograph, an example of a common vernacular genre in the nineteenth century (often featuring wedding pictures on pillow slips and that kind of thing), reminded Hahn of the embroidered American album quilts that she had herself admired and collected. So she began making her own photographic album pages on cotton. And, from the very first one, she also took up her needle and added embroidered natural-color embellishments with a simple in-and-out stitch. From the artist's point of view, there was a high rate of failure in these photographic samplers, and she rejected many of the finished products (perhaps, then, they are not quite as arbitrary as they first appear). Initially they were exhibited unframed— these were photographs you could touch— but they came back to her so dirty (in one instance she had to scrub the edges clean with a toothbrush) that she took to framing them behind glass.

Hahn's decisions about process and material were obviously informed by the aspirations of the women's movement and by her interest in feminine creative traditions (even by a shared heritage of domestic labor). But this doesn't entirely explain her choice of images. She deliberately adopted the everyday aesthetic of the snapshot for her work, shooting her own portraits and scenes (these, significantly, are mostly not "found" images, but were instead preconceived to suit the artist's vision of her total series—among other things, she wanted a good range of picture types). This choice of aesthetic represented a calculated riposte to the fine print tradition in photography and its purist pretensions (the decision to photograph vegetables was, for example, a parodic response to the revered peppers and eggplants of Edward Weston). But it also suited Hahn's own interest in Zen

Buddhism. She was first exposed to this philosophy through an essay by photographer Minor White published in *Aperture* magazine and has read books and magazines dedicated to Zen ever since (*Zen and the Art of Archery* has been a constant source of inspiration). Zen stresses the importance of everyday life, finding spiritual potential in the most ordinary objects and experiences. In photographic terms, there was nothing more ordinary than the snapshot. It's a genre about conformity— one person's looks much the same as everyone else's. But it's also a genre peculiar to photography. And despite its odd combination of media, Hahn's is an intensely photographic series.

The ordinary was a common rhetorical trope in the art of this period. The subjects of the work of Ruscha and the Bechers, for example, were also self-consciously ordinary (whether parking lots or water towers), as were the photographs produced by, among others, Hollis Frampton, Dan Graham, and Bruce Nauman (Hilton Kramer disparagingly but accurately described Nauman's images as "photographs of no photographic interest").[14] But these artists' obsessive repetition of near-identical subjects was presented in a format self-consciously tied to a minimal aesthetic. This meant that the finished

work often continued to convey high art values; the ordinary was transformed and transcended through its incorporation into an obviously artistic taxonomic system.

Hahn's snapshot pictures were also transformed, but into something even more ordinary than before—a domestic, feminine craft object. The loss of the original image's detail in its gum bichromate manifestation significantly reduced its pictorial content (she was really working here with no more than a photographic residue), shifting the work's content from image to medium, from picture to process. But this process came not from the conventions of high art but from vernacular practice (women's practice at that). Hahn made (and the act of making is quite important here; it's foregrounded in your experience of the work) a banal photographic image and then penetrated it with her needle, puncturing it over and over again, dragging colored threads in her wake, mocking her own medium's artistic aspirations with her playful stitches and seemingly arbitrary highlights. There's an affectionate humor in this work (you find something of that same ironic humor in the work of Ruscha and John Baldessari from around this time too, perhaps a common response to the cloying seriousness and self-importance of prevailing modernist rhetoric). The end

Betty Hahn; *Broccoli*, 1972; gum bichromate on embroidered fabric; 16 x 20 in. (40.6 x 50.8 cm); courtesy the artist

result is a studied indifference to art photography's established conventions, a refusal to conform, but also an unruly regurgitation of the medium's own forgotten history.

The work of Barrow and Hahn (it's too easy to characterize that work in terms of masculine and feminine attributes, but you can understand the temptation) represents an important moment in American art photography. For this is work that looks back to photography's hybrid past and forward to an equally hybrid future, and in the process it offers a take-no-prisoners critique of the fine print fetishism then prevailing in art photography circles. But it also offers a critique of any more recent art history that would too simply separate inside from outside, and art from photography. In keeping with the work itself, a canceled account of this moment would have to place such boundaries under erasure. It would have to recognize both their historical reality and their rhetorical artifice, crossing out these boundaries even while leaving them in place, reproducing them to an extent but only as a way to penetrate their self-certainty and thereby render them entirely permeable.

Notes

Thanks go to Thomas Barrow, Betty Hahn, and Peter Bunnell for talking to me about their work in preparation for this essay.

1. For a more extensive discussion of Barrow's work and career, see Kathleen McCarthy Gauss, *Inventories and Transformations: The Photographs of Thomas Barrow* (Albuquerque: Published for the Los Angeles County Museum of Art by the University of New Mexico Press, 1986).

2. For a history of this institution and its incorporation of Bauhaus strategies, see Abigail Solomon-Godeau, "The Armed Vision Disarmed: Radical Formalism from Weapon to Style" (1983), in *Photography at the Dock: Essays on Photographic History, Institutions, and Practices* (Minneapolis: University of Minnesota Press, 1991), 52–84, 291–294, and David Travis, Elizabeth Siegel, and Keith Davis, eds., *Taken by Design: Photographs from the Institute of Design, 1937–1971* (Chicago: Art Institute of Chicago, 2002).

3. See the curators' essays in William Jenkins, *The Extended Document* (Rochester, N.Y.: International Museum of Photography at George Eastman House, 1975), and Van Deren Coke, *The Markers* (San Francisco: San Francisco Museum of Modern Art, 1981).

4. For accounts of Talbot's use of the cliché-verre process, see Aaron Scharf, *Art and Photography* (Harmondsworth: Penguin, 1968), and Larry J. Schaaf, *The Photographic Art of William Henry Fox Talbot* (Princeton and Oxford: Princeton University Press, 2000).

5. John Szarkowski, *The Photographer's Eye* (New York: Museum of Modern Art, 1966), unpaginated.

6. John Paul Edwards, "Camera Craft" (March 1935), in Beaumont Newhall, ed., *Photography: Essays and Images* (New York: Museum of Modern Art, 1980), 251.

7. Peter Bunnell, "Photography as Sculpture and Prints," *Art in America* 57 (September–October 1969): 51–61. Bunnell's exhibition *Photography into Sculpture* was shown at the Museum of Modern Art in New York, April 8–July 5, 1970, and then traveled to eight additional venues.

8. See Peter Bunnell, "Photography into Sculpture," in *Degrees of Guidance: Essays on Twentieth-Century American Photography* (Cambridge: Cambridge University Press, 1993), 163–167. For an overview of California photography in this period, see Louise Katzman, *Photography in California, 1945–1980* (New York: Hudson Hills Press in association with the San Francisco Museum of Modern Art, 1984).

9. See, for example, Charles Desmarais, *Proof: Los Angeles Art and the Photograph, 1960–1980* (Laguna Beach, Calif.: Laguna Art Museum, 1992), and Ann Goldstein and Anne Rorimer, *Reconsidering the Object of Art, 1965–1975* (Los Angeles: Museum of Contemporary Art; Cambridge: MIT Press, 1995).

10. See Kynaston McShine, ed., *Information* (New York: Museum of Modern Art, 1970). The exhibition ran from July 2 through September 20, 1970.

11. For just one example of these various practices, see Robert Sobieszek, *Robert Fichter: Photography and Other Questions* (Albuquerque: University of New Mexico Press, 1983).

12. See the catalogue entries prepared by Michele Penhall for Steve Yates, *Betty Hahn: Photography or Maybe Not* (Albuquerque: University of New Mexico Press, 1995).

13. A whole history could be written on the influence of teaching on photographic art practice in the United States, a history in which Smith, Barrow, and Hahn would all be prominent figures.

14. Hilton Kramer, "In Footsteps of Duchamp," *New York Times*, March 30, 1973. I have borrowed Kramer's description from MaryJo Marks, "Ordinary Pictures and Everyday Language: Photography and Text in 1960s American Art" (Ph.D. diss., CUNY Graduate Center, New York, 2003).

Vito Acconci

Notes on My Photographs, 1969–1970 (1988)

Originally published in *Vito Acconci: Photographic Work, 1969–1970*, exh. cat. (New York: Brooke Alexander, 1988), unpaginated.

These were some of the first pieces I did in an art context. Before that, my work had been poetry: the aim was to confine words to a page, to use that page as a container for words—inside that container, that trap, the words could move up against a barrier (the margin) and be beaten back into their cell (the page). But the words moved on their own: some of their connotations moved faster, farther, than others, out of my control. I had to let them go on without me; what I could do was to follow their direction, off the page and out into the world—the last poems functioned as measures of that world, marginal notes to the world considered as an illustration. Once I headed toward the world, I was in an art context, a field that (as far as I and other members of my generation saw it) had no life of its own, no prescriptions of its own, no inherent characteristics of its own, a field that existed only as it imported from other fields in the world. My first pieces, in an art context, were ways to get myself off the page and into real space. These photographic pieces were ways to, literally, throw myself into my environment. They were photos not of an activity, but *through* an activity; the activity (once I planted a camera in the instrument of that activity—once I, simply, held a camera in my hands) could produce a picture.

These were my first pieces, in an art context, that had a place in a gallery or museum. The last pieces I did, in a poetry context, were "poetry events": the occasion was a poetry reading—I used props (an audio recorder, the walls of the room or the chairs in that room)—the attempt was not to read from a page but to read the room. The first pieces I did, in an art context, were activities in the street, activities that only I knew I was performing; some of these were keyed into a performance situa-tion—all of them could be documented later, and hence made public. Once they were documented, either through words or photographs, they could be shown on the walls of a gallery or museum; but the documents were only souvenirs, after the fact, whose proper place was in the pages of a book or magazine. These photo-graphic pieces, on the other hand, were first-hand information: their only existence was as photographs—the activity of a pho-tograph wasn't an end in itself, the activity was performed only to cause a photograph. I wonder if, in the back of my mind, there wasn't the urge to prove myself as an artist, prove myself a serious artist, make my place in the art-world: in order to do this, I had to make a picture, since a picture was what a gallery and museum was meant to hold (all the while, of course, I was claim-ing that I was denying that standard, rejecting it, I was claiming that my work couldn't, shouldn't, have the finished qual-ity of a photograph, my work was an event and a process that couldn't, shouldn't, be stilled by a camera and hung up on a gallery wall—all the while I was claiming that my work was meant to subvert the clo-sure of museum and gallery). These photo-graphic pieces, then, might have been the first steps in taming, domesticating, an agent whose proper method should have been that of a wanderer.

These pieces were ways to put my work (put myself) up on the wall; these pieces were ways to push myself up against the wall. On the one hand, they were a way to make something like a landscape, a mural, a backdrop as if on a stage or in a movie; on the other hand, they were a way to drive myself into a dead-end position.

These pieces need to be seen all together; these pieces had to be done all together, quickly, in a short time period. There probably should have been more of them: the scheme they imply demanded exercis-ing every part of my body, every activity my body could do—there should have been an exhaustion of bodily activities, a drain-ing of behavior. On the other hand, there might already be too many; or maybe it has to seem that way, it has to seem as if there's just too much—it has to appear as if I'm grasping at straws, I have to keep searching for possible activities, for more and more activities, I have to find activities that almost don't exist. It was as if there was so much activity so that the body could be exhausted, so that the body no longer existed, so that the body drifted out of the body and into the environment. So maybe this wasn't exhaustion at all: rather, the body existed only as it blended into the environment—the body was growing up, out of privacy and becoming public.

After these pieces, that sent me out into my environment, I chose to go back into my "self." The next pieces set up occasions in which I could concentrate on myself—I brought stress from an outside world into my person, so that that person could change and develop. The shift of focus, from outside to inside, reveals that I was afraid of being lost in space, lost out in the world, I had to come back home, I had to—in the language of that time, the language of the 60's—"find myself." But of course the career of my work might have been different: I might have chosen to look more closely at the world outside me, I might have chosen to travel further through it—I could have looked at that world as a field for behavior, rather than at myself as an instrument of behavior. It turned out that, years later—now, in 1988—I *am* concen-trating on the environment as a place for activity, other people's activity rather than my own; whereas the early photographs put me into the street and the park, my recent pieces make a place in the street (a town square for public meeting), my recent pieces make a park (an enclave in the middle of a city that functions as the model of an alternative world, a utopia). I arrived at those places through a process of exercising "me," a process of expanding an "I": first "I" with "me," then "I" with "him" or "her," then "I" with "you," then a place where my voice can speak to "them," then a place where my voice might bring "you" together, then a place that "you" could make, and now a place where "we" might be. The early photographs sug-gest that I might have side-stepped this process, taken a short-cut directly into the street and the park. But then those places might have remained stilled, as if in a pho-tograph; or they might have been distant places, as if in a movie, places held up in front of the eye, places that could be only desired. Maybe I had to stop photograph-ing so that I could learn to touch.

Vito Acconci

Notebook Excerpts, 1969 (1969)

Originally published in *Vito Acconci: Photographic Work, 1969–1970*, exh. cat. (New York: Brooke Alexander, 1988), unpaginated.

Camera used as storage: it allows me to keep seeing (the photographs will show me what I couldn't see while performing the action). Once my place is set, I can exercise my body, move my body around that place (a place that, in turn, is exercised by my body's movement).

Ways to be in space (ways to consider that): "I am here"—"I" is different from "here"—"I" has to go "here"—"I have to go here"—I have to keep going to where I am (directing myself to where I am— where I am is directed by my body).

Where I am (my position when I take the photographs)—where I might be (the landscape photographed: where I am when I point in that direction)—my body as a system of possible movements transmitted from my body to the environment (the environment as a system of possible movements transmitted from the environment to my body).

Reasons to move: once the camera shows me something as far as my eye can see, I can move to make that something nearer, more accessible.

Contrast with poetry: rather than move toward a point (the page), I can be that point (the landscape is seen in relation to me); rather than move in one direction (toward the page), I can move freely (the landscape adjusts to me).

Once the body is in place, I can move to another place—the place is seen as entered, disturbed, by the body disturbing itself—drift of my body into the environment results in, is equivalent to, drift of the environment itself.

The real activity of these pieces—connecting my body with its surroundings—occurs somewhere between my action and the photographs. (I would have wanted to bring about more physical change either in myself or in the environment; connection as corruption.)

Reasons to move: performing as adhering to terms. I can adhere to the terms of my body make the space adhere to the terms of my body (the space takes my shape— place as body).

Vito Acconci; *Fall*, 1969; photograph, chalk, chalkboard spray on foam-core panels; 39 x 39 in. (99 x 99 cm); courtesy Brooke Alexander, New York

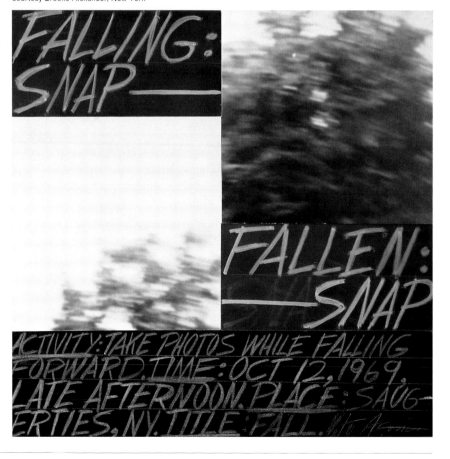

Pamela M. Lee

The Austerlitz Effect: Architecture, Time, Photoconceptualism

Pamela M. Lee is an associate professor of art history at Stanford University. She is the author of *Object to Be Destroyed: The Work of Gordon Matta-Clark* (MIT Press, 2000) and *Chronophobia: On Time in the Art of the 1960s* (MIT Press, forthcoming).

From the outset my main concern was the shape and self-contained nature of discrete things, the curve of banisters on a staircase, the molding of a stone arch over a gateway.... In my photographic work I was always especially entranced ... by the moment when the shadows of reality, so to speak, emerge out of nothing on the exposed paper, as memories do in the middle of the night, darkening again if you try to cling to them.

W. G. Sebald, *Austerlitz* [1]

In W. G. Sebald's *Austerlitz* (2001) the namesake of the book's title is a man whose historical identity has been obliterated through the trauma of war. Sent to Wales as a child in 1939, Austerlitz is a figure without family or country, place or home. Little wonder, then, that architecture exerts such a peculiar fascination on his historical imaginary: it is through his scholarly relationship to architecture that he seems to consolidate his lost genealogical bearings. In Sebald's devastating allegory of historical loss, a nameless interlocutor meets our antihero in 1967 and from then on serendipitously encounters him at a variety of sites throughout Europe. Train stations once heralded for their technological marvels, the faded bars of formerly grand hotels, libraries quiet with gathering dust: all conjure their own haunted memories. For Austerlitz, architecture makes material a conflicted temporality, a kind of push-pull tension between that which endures and that which falls apart, the solid and intransient versus the transitory and fleeting. While architecture has long been described as an art for the "ages"—the sheer weightiness of its structures projecting an air of permanence and stability—its very capacity to endure

likewise bears witness to temporal succession. Buildings, after all, grow progressively ruinous in time. They index historical passage—of exhaustion and use—just as a body registers its age.

In his scholarly obsession with what he calls "the architectural style of the capitalist era" and the "family resemblance" among all of its buildings, Austerlitz demonstrates a profound sensitivity not only to the historicity of such buildings but also to how that history unfolds relative to its economic exigencies. [2] Critical to his understanding of architecture, however, is that this engagement is largely mediated through the lens of photography. Persistently accompanied by an "old Ensign with telescopic bellows," Austerlitz amasses hundreds of pictures of buildings in the course of his wanderings, as if this encyclopedic record might restore in the present some shadowed recollection of the past. In one of many snapshots scattered throughout the book, we get a brief glimpse of Austerlitz's study, and that

cramped, claustrophobic space, like so many academic offices everywhere, no doubt contains many such documents. For the protagonist, photographs and buildings are deeply intertwined, thematizing the relationship between time and space.

Even so, the relationship is not quite what it seems. As the received wisdom would have it, photography is an art of time. It captures singular moments in the ebb and flow of duration—"decisive moments," as Henri Cartier-Bresson famously put it—and its media are likewise regarded as fugitive, ephemeral. By contrast, the massiveness of buildings—and the slow, steady labor required of their construction—serves to shore up an art of immanence or place. But Austerlitz's photography complicates this model, nuances its terms. His ever-expanding archive attests to the proliferation and serialization of the photographic image in the environment, while his fixation on the pastness of buildings dramatizes the loss of place in time.

Michael Brandon Jones, illustration from W. G. Sebald's *Austerlitz*

This triangulation among architecture, photography, and temporality produces what I call the "Austerlitz effect," which provides a useful means to approach the photoconceptualism of the 1960s and 1970s. Here we find that architecture tells us as much about the historical status of photography as photography tells us about the historical status of architecture. This is a moment when the ephemeral images of photography become progressively *spatialized* and a culture in which the notion of place—as metonymically represented by architecture—is progressively *temporalized*. In this historical encounter between photography and architecture, the roles traditionally assigned each medium begin to blur, are even inverted. One can trace this effect at work in the imaging of industrial edifices by Bernd and Hilla Becher, in the photo books of vernacular architecture of Edward Ruscha, in the "Nonsites" and tourist pictures of Robert Smithson, and in the crushed photographic collages of Gordon Matta-Clark, among many other examples. These works are roughly contemporaneous with the historical moment when Austerlitz is encountered on one of his architectural wanderings. Given the parallels between this character's interest in the "family resemblance" among the buildings of the capitalist era and the concerns of these artists, the

Austerlitz effect may help us to gain insight into the structural and thematic logic of much photoconceptual work.

As much as this work distills a question about the relationship among artistic media in the 1960s and 1970s, it also allows us to speculate on the moment of photography's "historical" closure. In this moment—our own moment—the relationship to time and place through the photograph would itself seem displaced by the burgeoning impact of digital media. Perhaps the seeming outmodedness of the traditional photograph stages a problematic about the stability of place, a place that might appear wholly unsettled from the concrete materiality of everyday life. How to reclaim that place for representation is the question a subsequent generation of artists will inherit from photoconceptualism. It is Austerlitz's example that will pave the way.

•

To get there, we need to account for the role of photography and architecture within Conceptual Art, as well as the latter's relation to the history of photography more generally. Surveying the annals of photoconceptualism, one is struck by the work's studied amateurism and its serialized modes of production and display: magazine articles, cheaply printed books,

seemingly countless iterations of the same photographic format. We note too a dogged insistence on the subject of architecture, typically classed as industrial or vernacular. We see the proliferation of suburban tract homes; an endless horizon of disused factories and warehouses; the unblinking sprawl of motels, gas stations, and parking lots. Pace Austerlitz, we confront the architecture of late capitalism, a field of dumb structures with little or nothing to recommend them aesthetically.

How might we characterize this phenomenon?[3] In an important essay on Conceptual Art, Benjamin Buchloh argued that the presentational strategies of Edward Ruscha and Dan Graham coincide with the representation of the architectural vernacular. In Ruscha's *Every Building on the Sunset Strip* (1966) and Graham's "Homes for America" (1966–1967), two works to which we will return in due course, the cheapness of mass-produced media (as in Ruscha's offset photo books) is equated with the expediency of mass-produced housing. For Buchloh, this equivalence between form and content underscores "the absence of a developed artistic reflection on the problematic of the contemporary publics."[4] By "problematic" he is referring in part to the increasingly precarious status of public discourse as shaped by both the media environment (as represented by the photographs) and the architectural environment. Buchloh's argument is unassailable in stressing the critical intertwining of photographic media with that which it represents. I will embroider upon this reading in describing how the relationship between architecture and photography participates in another genealogy, one whose relationship to time is the Austerlitz effect.

In order to do so, we need to acknowledge that photography has engaged the world of architecture from its very inception. Why this may be the case has been typically justified through considerations of process. A truism in the photographic literature holds that architecture keeps ready company with photography for a simple, seemingly unimpeachable reason: buildings don't move. The immobility of architecture, to follow this story, lends itself easily to the photographic medium, which in its early days demanded exposure times of six to eight hours. This argument hardly bears contradiction on a practical level—most buildings (but not all, as we shall see) *don't* move—

Nicéphore Niépce; *View from the Window at Le Gras*, 1826; heliograph; 8 x 10 in. (20.3 x 25.4 cm); Gernsheim Collection, Harry Ransom Humanities Research Center, the University of Texas at Austin

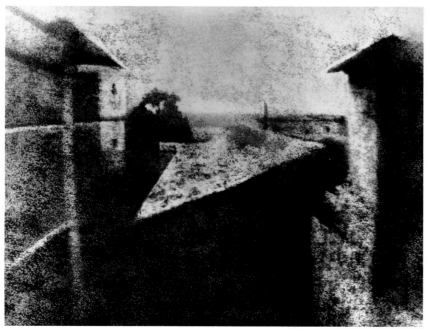

but it's a conceit whose understanding of both media is organized around a methodological impasse. In such formulations, photographic vision is understood as transparent, whereas architecture is treated as opaque. The implicit hierarchy that obtains from this reading suggests that photography dominates architecture, which is regarded as ancillary to—and uninflected by—the medium that represents it.[5]

But recent accounts in the history of architecture take up modernist architecture's *photographic* underpinnings, arguing that an architect such as Mies van der Rohe internalized photographic considerations in his designs.[6] Such readings open onto the possibility of architecture's deeply dialogical encounter with photography, one that we might argue is foundational to the medium itself. Take, for instance, the early photographic experiments of Nicéphore Niépce (1765–1833), who would come to devise a strange cocktail of silver salts, lavender oil, and bitumen of Judea. In combining this silver chemistry with pewter plates, Niépce produced what may well be the first "true" photograph, a view onto a building from his window at Le Gras.

It may seem odd to ascribe aesthetic or conceptual motivations to this picture, which are taken as incidental to Niépce's technical considerations. Yet when we look at this photograph, we confront an image at once palpable and obscure, in which architecture alternately emerges from and is submerged into the murk. In the picture's registration of temporal drift—the way light scans architectural surfaces or acts as ground to the lengthening shadows throughout the day—we see how architecture gives support to the passing of things. Time bears its fleeting impress against the seeming intransigence of buildings. By the same token, the picture lays bare a historical and conceptual paradox. Insofar as architecture has conventionally been understood as the "first" or "mother" art, here its representation coincides with the inaugural status of this photograph. Yet standing at the moment of the medium's historical origin—its foundation—the building nevertheless self-inscribes an image of historical passing, of things on the way.

With Niépce we could say that architecture serves as the allegorical ground of the photographic medium, even as it uncovers the photograph's very *groundlessness* through the fleeting time of the image. Not only is this so because one of the first examples of photography happened to be of an architectural subject. More to the point, the representation of that building as both materially immanent *and* transient is not unlike the spatio-temporal behavior of photographs themselves, which at once attempt to ground or situate a place in perpetuity and necessarily register a sense of historical loss in the process of doing so.

This idea finds a historically specific articulation in the photoconceptualism of the 1960s, work that departs radically from the "straight" photography of architecture in at least two ways: first, in its criticality and consciousness of such conditions as historical and, secondly, in its eschewal of aesthetic conventions typically associated with fine art photography. Indeed, the 1960s saw the values of time (and the attendant categories of space) undergo a pronounced shift within the culture. As I have argued elsewhere with respect to art, conceptions of temporality are subject to both an acute acceleration *and* repetition in that decade, in part a function of new media and communication technologies and the ideologies that supported their introduction and elaboration in turn.[7] While I cannot unpack this reading fully here, it will suffice to say that such modalities of time—recursive and endlessly pacing—are confirmed in the visual arts in diverse ways. The logic of both acceleration and repetition is emblematic to many of the practices of photoconceptualism. And it's no accident that these issues are addressed through the trope of architecture, which will serve as a figure of historical displacement and dislocation.

Earlier I described this mode of address in terms of the spatialization of the image and the temporalization of the environment in the 1960s. To expand on this

notion, the distribution of visual information assumed a progressively spatial force in that decade, "ungrounded" as those images were by the historical emergence of new technologies. Such developments would include the impact of television and other forms of mass media, the computer and cybernetic revolutions of the information age, the speed of automation, and the introduction of Portapak video systems.[8] Occupying the other side of the spatio-temporal spectrum—if contiguous with such developments in the world of images—we could also point to the historical conditions of architecture as temporally accelerating *and* repeating in the postwar era. On the one hand, the leveling force of urban development schemes quickened the temporal passage of industrial and urban architecture into ruin or disposability.[9] On the other, the concomitant explosion of building in the form of suburban tract homes, strip malls, housing projects, and other ready-made architectural types in the 1960s reveals, dialectically, the structure of repetition that underwrites the very process of construction.

Photoconceptualism appeals to this history in various ways. Under the sign of temporality, we observe that the semantics of such practices (the subject of architecture) converges seamlessly with its visual semiotics in the photographic medium.

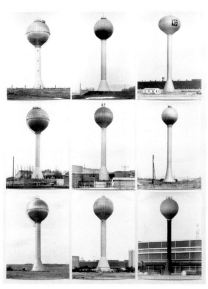

Bernd and Hilla Becher; *Wassertürme* (Water towers), 1972; gelatin silver prints mounted on paperboard; 15⅝ x 11¾ in. (39.7 x 29.8 cm); Walker Art Center, Justin Smith Purchase Fund, 1996

Dan Graham, *Homes for America* (detail), 1966–1967, (cat. no. 61)

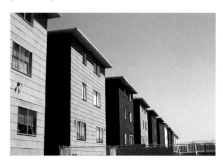

Among the strategies that characterize photoconceptualism, serialization stands as the most critical in its relationship to temporality. Through the repetition of a motif, operation, or system—by working to expose durational shifts in an object or process over time—serialization may well be the motor of Conceptual Art. But as theorists from the modern to the postmodern have also noted, serialization is the first principle of the photographic medium.[10] Photoconceptualism, as such, would seem especially suited to address the subject of postwar architecture. In Graham's canonical "Homes for America," for instance, the image of the suburban home, serialized like so many Minimalist cubes in space, finds its graphic displacement on a page layout, itself intended to be serialized in the form of a magazine.[11] Graham attested to the mobilization of place through that home's serialization: "His home isn't really possessable in the old sense . . . " he said of the new suburban home "owner," "it wasn't designed to 'last for generations'

and outside of its immediate 'here-and-now' context it is useless, designed to be thrown away."[12] Importantly, the repetition of those buildings in time, ever repeating, corresponds to their serial deployment relative to the space of the image.

There are perhaps no more committed practitioners of the Austerlitz effect than the German photographers Bernd and Hilla Becher, who have been making serialized images of industrial structures throughout Europe and the United States since 1959. Surveying the exhausted topoi of industry in the form of coal bunkers, water towers, lime kilns, blast furnaces, grain silos, winding towers, gas tanks, and pitheads, the Bechers have produced "typologies" of these structures in an unerringly consistent format. These eloquent black-and-white photographs, usually displayed in a grid formation, present a frontal view of each object, bathed in an even light and drained of radical contrast. They are devoid of human actors as well. No workers are represented in these count-

less images, as if each site had long been purged of labor's imperatives.

Two observations are invariably made about the Bechers' practice. The first claim dwells upon the structures depicted. Calling their works "typologies," they acknowledge the archaeological dimensions of their project, recording the morphologies of outmoded (or progressively obsolete) industrial edifices. That gesture of archiving buildings that can no longer accommodate the demands of contemporary production underscores that these structures are very much on the way out. Like Austerlitz's photographs of European buildings, which function as supplements of a kind to a lost personal history, the Bechers' typologies attest to a loss of space by the workers who once inhabited them. Critically, this spatial displacement is thematized through a temporal displacement. "Many of these structures are disappearing," the photographers stated, "all the time they are being dismantled or rusting and crumbling away. Our main problem is a fight against time. This is our first priority but there are other points to be considered. . . . But the main factor is time."[13]

This preoccupation with the temporality of buildings finds marked correspondence in the historical gesture the photographs also stage. Indeed, the second claim voiced repeatedly about the Bechers' project is that the work pays homage to the photographers of the Neue Sachlichkeit, or New Objectivity, most famously, August Sander. In his *People of the Twentieth Century*, Sander produced a systematic typology of seven strata of German citizenry before the war—artisans, laborers, technicians, aristocrats, and so on—some whose traditional livelihood was threatened by the incursions of industry and modernization. The Bechers' classificatory effort is almost always seen in this light, at least in formal terms. Far less considered in their implicit nod to this earlier photographic moment is the historical problematic such a practice raises.

When we compare the Bechers' practice to the work of other Conceptual artists, however, we recognize that theirs is not a unique strategy in its conjunction of architecture, photography, and temporality. Consider, for instance, Sol LeWitt's book project *Photogrids* (1978), which appeared somewhat later than the inaugural moment

Sol LeWitt, *Photogrids*, 1978 (under cat. no. 87)

of Conceptual Art. Given LeWitt's formative role in that movement, however—not to mention his longstanding appreciation of serial procedures of photography—we could productively submit this body of work to the same line of questioning raised by the Bechers' photographs.[14]

In *Photogrids*, one confronts double spreads of gridded snapshots, nine pictures of the same motif on each page. LeWitt's typological imperative, however, is ultimately of a more personal nature than that of the Bechers, as suggested by the title of a subsequent, if similar, photographic book project, *Autobiography* (1980). *Photogrids* grew out of the artist's extensive travels. In producing his well-known wall drawings around the world, LeWitt would repeatedly come across grids in each location, however different each city or site. "No matter where one looks in an urban setting," he observed, "there are grids to be seen."[15] That the subject of architecture occupies so much space here is hardly accidental to the form of the book. The serializing impulse of the photographic grid—the sense that it could repeat, go on and on—underscores its very expansion into the environment, as demonstrated further by the proliferation of the grid within architectural space.

As one such demonstration of this conceit, consider two pages of *Photogrids* featuring the manhole cover as their principal motif. In serializing this ubiquitous and abject architectural form—abject because associated with the world of the sewer—LeWitt attends closely and repeatedly to its visual operations. Through the process of multiplying this motif via the grid, we parse the subtle and not so subtle differences of this peculiar species of urban architecture. LeWitt's gesture is to reveal difference within repetition through a predetermined formal system. However distinctive the overall character of the covers, their internal organization is nevertheless contiguous with their photographic representation. Those covers, in other words, are gridded covers: more often than not, their surfaces are regularized by the meeting of perpendiculars and squared geometries, not unlike the layout of the page upon which they are set. Here the studied repetition of the grid articulates a critical dimension of the Austerlitz effect. The photograph, in its serial and *spatial* expansion as media, mirrors the temporalization of architectural form repeated endlessly throughout the environment.

•

Some remarks from an interview with Edward Ruscha on his photographic book *Every Building on the Sunset Strip*:

Siri Engberg: Are you still photographing Sunset Boulevard?

Edward Ruscha: Mmmm-hmmm. I do it about every, on average, two to three years.

SE: And the photographs are for your own use, your own personal chronicle?

ER: Yeah, I just put them in a lab and salt them away. I just feel like sometime in the future I'll be able to do something with them, but I don't know.

SE: An L.A. time capsule?

ER: Yeah, I have a belief in this idea of the time capsule. I like that very much. . . . Time, as a property, seems important to me. You may not see it in all my work, but it is, I guess.[16]

Ruscha is speaking retrospectively about *Every Building on the Sunset Strip* (1966), an accordion-fold publication that, true to its name, pictures every last club, hotel, liquor store, apartment, and so forth on that most famously trafficked Los Angeles thoroughfare. Appealing to the legendary debasements of the area, the publication also makes two critical moves in the photographic strategies of Conceptual Art. For one, as Buchloh has argued, its mode of distribution and presentation departed radically from any postwar tradition of either fine art or documentary photography and so likewise separated itself from straight photography's representation of buildings. As I noted earlier, Buchloh has suggested that this work's "deadpan" and "laconic" imaging of vernacular architecture invokes art's encounter with issues of the public and mass culture and does so in such a way that its thematic and formal operations are interwoven. Ruscha added his two cents to the mix when he described the production of such work through the notion of a time capsule. Like the Bechers' notion of typology, Ruscha's architectural time capsule is also an archaeological motif, something to be unearthed in his photographic archive.

At this juncture dimensions of site enter into our consideration, the specific character of postwar American architecture in particular. If the Bechers tracked the disappearing structures of modernist industry across Europe (and some parts of the United States), Ruscha attended to the acutely transient, throwaway character of the 1960s California environment, giving concrete form to the notion of "time as a property." Revisiting the Sunset Strip today, one confronts changes wrought on the environment so vast that one is hard pressed to enumerate the specific differences in site between the past and the present. That vernacular architecture is linked to the rhetoric of time in Ruscha's books, however, finds a specific metonym in the structures he chose to represent. His first book, *Twentysix Gasoline Stations* (1963), recorded with a surveyor's banality filling stations on Route 66 from Los Angeles to Oklahoma City, while his *Thirtyfour Parking Lots in Los Angeles* (1967) provides blank-faced testimony to one of the city's most coveted forms of urban property. In both of these works, as well as in *Every Building on the Sunset Strip*, Ruscha offered an Angeleno's perspective on the Austerlitz effect. While photography becomes spatial and place becomes temporal with Austerlitz and the Bechers, Ruscha's gesture is to account for that sense of passing, of transience, in the space traversed by the automobile. Like the worker absent from the Bechers' photographs, the car is, for the most part, an out-

Edward Ruscha; image from *Thirtyfour Parking Lots in Los Angeles*, 1967; photo-offset-printed book; 10¼ x 8 in. (26 x 20.3 cm); Walker Art Center

Max Company, 4190 Laurel Canyon, North Hollywood

of-camera presence, and the accelerating vista it provides is not unlike the "third window" Paul Virilio described relative to that afforded by the windshield.[17] The windshield serves as a framing device whose images incessantly change in time through the traversal of space; unlike the perspectival window of Renaissance painting, the window becomes a moving picture. The serial nature of *Every Building on the Sunset Strip* appeals to the mobility of this image as it is produced by the car. The car, in other words, both literally and metaphorically drives the temporal organization of the image. It is both a new form of architecture and a secret medium.

In turn, that urban surround is itself saturated with photographic images, each more spectacular than the next. For if there is one form of "architecture" that proliferates on the Sunset Strip—or that has maintained its privileged status on that street—it is the billboard, the monumentalization of the advertisement to architectural scale. Those gargantuan pictures of bodies and commodities and various popular events remain largely removed from Ruscha's photographic scene, but we know they're there. Their off-site if unimpeachable presence tells us something else about the ambiguous status of place at this moment: that place, we could say, is always already elsewhere.

•

We might extrapolate this fixation with architecture in the photoconceptualism of the 1960s and 1970s to a preoccupation with site more generally. In contrast to high modernism's emphasis on the autonomy of the work of art, artists of a

Conceptual orientation insisted upon the material embeddedness of a work's relationship to place, to site. No doubt this consideration of site was a function of emerging critiques of art's institutional and public status. But it would be wrong to suggest that this engagement with site— and architecture along with it—upheld these conditions as an article of faith. On the contrary, both Robert Smithson and Gordon Matta-Clark reflected critically upon the terms by which site was itself coordinated and then rendered obsolete, conditioned as those places were by the forces of industry. In their best-known site-specific projects—such as Smithson's *Spiral Jetty* (1970), his enormous coil of land on the Great Salt Lake, or Matta-Clark's *Splitting* (1974), a bland suburban home sliced in two—both artists exhibited a pronounced understanding of the way in which architecture is temporally contingent. For Smithson, place and architecture were bound to the laws of entropy and thus invariably fell into ruin; for Matta-Clark, the ideologies of progress that attended modernist building programs underwrote the alternating processes of construction and destruction in the postwar American environment.

Indeed, their photography maintains that architecture too is always elsewhere. Smithson's affectless snapshots of architectural ruin reveal that the experience of architecture or site is largely (sometimes exclusively) mediated by the pictures and geological specimens alleged to "document" them—a dialectical relationship that he called the "Site" and the "Nonsite."[18] We understand this idea implicitly in acknowledging that most of us know an

earthwork like *Spiral Jetty* only through photographs, but this notion is more than just practical or experiential. In Smithson's "Monuments of Passaic, New Jersey," published in *Artforum* in 1967, twenty-four pictures of a trip to that fabled town are parodically described through the art historical conventions of the monument. Smithson's photographic idyll is composed of various "unidentified monuments"— a parking lot, a storage tank, a manhole, a pumping derrick. Thus the work betrays an obsession with the industrial landscape informed by the status of its "monuments"—testaments to history, distant events, cultural memory. These monuments, though, are *not* built for the ages. They are to be neither glorified nor preserved, and the photographs that document this less than grand tour are equally mundane. Instead, such pictures, which strangely recall Austerlitz's own photographic souvenirs, speak to the increasingly tenuous character of place in the postwar moment.

Another such example of Smithson's entropically figured site came in the form of one of the most banal photographic activities, the slide show. A presentational format used with increasing frequency in the late 1960s, the slide projection represented the literal expansion of the photograph into architectural space.[19] With *Hotel Palenque* (1969), Smithson exploited a technique linked less to the rarefied world of the museum than to the dread rituals of middle-class domesticity or the boredom of the lecture hall. Consisting of thirty-one chromogenic slides (126 format), it reveals a crumbling, decidedly unglamorous hotel occupied by Smithson, Nancy Holt, and

Edward Ruscha, *Every Building on the Sunset Strip* (detail), 1966 (cat. no. 131)

Virginia Dwan on a trip to the Yucatan Peninsula in 1969. From a hapless pile of bricks to a degraded wall to a roofless suite of rooms to a weedy, overgrown lot, the slides picture the hotel from a variety of perspectives, each more banal than the next. As with so much of Smithson's work, however, those perspectives, dissolute and multiple as they may seem, are organized around an equally split formulation of time. As Robert Sobieszek has written of the work, "at the time the hotel itself was caught between the seemingly equal forces of slow disintegration and periodic construction."[20]

Presented in the context of a slide lecture, *Hotel Palenque* confirms both the temporal and the spatializing agendas of the Austerlitz effect. Pulling between the forces of the entropic and the constructive, Smithson's vision of architecture continuously flips between the possibility of its loss and the potential for its immanence and so underscores the repetitive temporality to which processes of building are subjected. As Smithson droned in the talk accompanying the images: "You can see that instead of just tearing it down all at once, they tear it down partially so you're not deprived of the complete wreckage situation. It's not often that you see buildings both being ripped down and built up at the same time."[21] But his "lecture" also evokes images of the simultaneously near and far, of mundane spaces and the spaces of tourism: think the comfort of the darkened living room with its projections of faraway lands, say, or the classroom and its washed-out images of masterpieces from the Louvre. The slide lecture collapses literal distance through projecting images to environmental (if virtual) scale.

Smithson's notion of site was drawn upon heavily in the work of Gordon Matta-Clark. This is as true for Matta-Clark's photographs as for his site-specific projects, whether the collaged analogues to his building cuts or in his representation of space that fell between the architectonic, as in the social and artistic collaboration known as "Anarchitecture."[22] Such pictures are treated primarily as so many transparent records of his now-destroyed site works. As I have written on Matta-Clark's "self effacing documents," however, these images share in the larger suspicion around the alleged neutrality of the photographic document within Conceptual Art. Both the formal and thematic sensibilities of Matta-Clark's photographs display a certain canniness about photography's convergence with the medium of architecture; indeed, the artist acknowledged "the need to avoid purely photographic documentation."[23]

Take, for example, any number of Matta-Clark's montaged works. Here photographic fragments are sutured together to represent the disorienting perspectives of his building cuts: site lines are rendered impossible, perspective is radicalized, traditional figure-ground relationships are overturned. On one level, these pictures seem to literalize the vertiginous experience of those phenomenal spaces. "Which way is up?" many implicitly seem to ask, providing little useful information to those who seek to rationalize such spaces.

In turn we could argue that Matta-Clark's site works literalize the *temporal* proscriptions of the photographic. The serialization and presentation of the photographic image—and the cut associated with its expansion into the medium of film—is metonymically expressed by the building cut, whose experience unfolds in time like a series of radically distinct snapshots. Matta-Clark's collaged images dramatize the endless multiplicity of perspectives that his architecture affords: both are organized around the idea that they can be equally manipulated through the notion of structural framing. "I like the idea that

Gordon Matta-Clark, *Splitting*, 1974 (cat. no. 93)

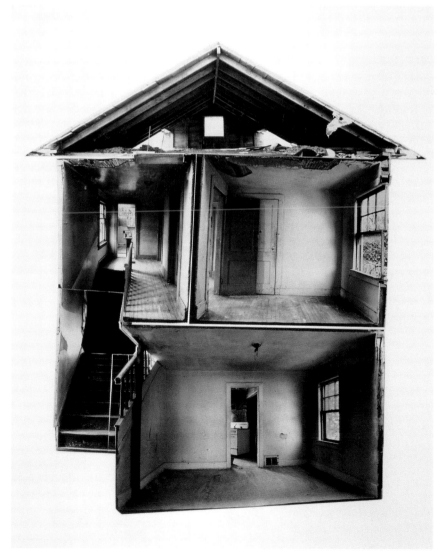

the sacred photo framing process is equally 'violatable'" he once suggested, "and I think that's partly a carryover from the way I deal with structures to the way that I deal with photography."[24]

Matta-Clark's site projects represented a provisional—indeed precarious—gesture into the timeliness and untimeliness of modernist building programs, whose effects were writ large across both the blighted landscape of New York and the suburban wastelands of New Jersey. Like Smithson's reading of architecture and entropy, his works depend upon an intractable dialectic of construction and destruction, endless novelty and unceasing outmodedness. In Matta-Clark's contribution to the "Anarchitecture" project—a casual collaboration of artists who worked together in early SoHo—architecture was sometimes *literally* on the move. A picture of an entire hotel transported—dragged by a truck in Hayward, Wisconsin—serves as a concrete reminder of the very mobility of place. In the work of both Smithson and Matta-Clark, an acute fascination with architectural dejecta, most often wrought by shifts in industry, attests to a deep awareness of the temporalization of the built environment.

•

That architecture might be on the move in these pictures prompts the question: Where to go? Where are we to locate architecture's pictorial representation now? The Austerlitz effect underscores the historical liminality of such representations—liminal because conditioned by new critical relationships to space and time. We might see the fallout of these conditions today in the imaging of global networks and their technologies, and the sense of time that results from these quickening forms of communication.

The work of Andreas Gursky, one of many well-known artists who studied with the Bechers at the Düsseldorf Art Academy, provides a case in point. Gursky's visual records of banks and commodities trading floors represent the opposite extreme of the Bechers' photographic spectrum, not only in terms of his subject matter, which takes little interest in the industrial outmoded, but in his pronounced use of digital technology. Consider his spectacular picture of Norman Foster's equally spectacular Hong Kong and Shanghai National Bank, a glinting nocturnal monument. The picture is outsize in scale, as most Gurskys are, and it imparts a vast sense of displacement from the scene it depicts. That

displacement or, more to the point, sense of alienation, may be thematic. We are stared down by a towering figure of global capital, the architecture of exchange value or "general equivalence."

Perhaps this displacement is not only thematic but also structural to the logic of the building's representation. Perhaps it is so keenly felt because Gursky's digital manipulations are so thoroughly internalized to the image—to the seamless, monolithic visage it presents—that the subject matter of general equivalence corresponds to the means of the image's production. Through the totalizing reach of the pixel, and its capacity to be equalized and erased at the same time, history and its texture have been evacuated, literally glossed over in the disturbingly pristine, airless surface of Gursky's photograph. Where once, following Austerlitz, the temporal conditions of architecture told us something about the spatiality of the photograph and vice versa, here the digital image collapses both into one pictorial register. Austerlitz's interest in the "architectural style of the capitalist era" finds its most insidious, because most seductive, extreme here. The image seems strangely unmoored from the space—and time—that it ostensibly represents.

Yet it would be wrong to stop here, too pessimistic and too shortsighted. For might there be a way in which this new visuality offers the potential for critical appropriation? And what role might architecture play in this scenario? It is telling that another contemporary response to the Austerlitz effect likewise makes use of advanced digital media. And it is telling as well that the artist who made this image was also schooled by the Bechers. In Thomas Ruff's series Night Pictures, the very question of distance and time raised by such imaging technologies points to the subject of architecture.

Ruff is best known for his vastly scaled colored portraits from the 1980s and 1990s, in which we encounter the human face as a kind of hybrid photographic genre, both anthropological type and panoramic landscape. Here every last bump, blemish, and hair is exposed to visual consumption, if through the unerringly smooth surfaces of the digitally manipulated C-print. To a lesser degree, Ruff has also taken up the subject of architecture. As with his Düsseldorf peers Gursky and Candida

Gordon Matta-Clark; *Anarchitecture: Home Moving*, 1974; gelatin silver print; 8 x 10 in. (20.3 x 25.4 cm); courtesy the Estate of Gordon Matta-Clark and David Zwirner, New York

Höfer, his engagements lie not in the industrial and suburban edifices favored by the photoconceptualist generation but in the signature aesthetic style of the newly emergent architectural celebrity. (In Ruff's case, those architects would be the Swiss studio of Herzog and de Meuron.) With the Night Pictures, however, we see Ruff presenting a different take on the Austerlitz effect than that seen in Gursky's bank image, one with far-reaching political implications.

In 1991, when the first Gulf War broke out, Ruff was struck by a new kind of picture he saw on television: the green-screen picture of military night vision beamed nightly by CNN and other global media networks. Those ghostly and disembodied images, too often described through the rhetoric of video games, concealed boundless destruction under cover of darkness. As Ruff recalled: "It was like TV to the third power. First you're looking at pictures from a region you've never been to, secondly, it's nighttime and you can still see; and thirdly, you're witnessing actions you'd never experience in everyday life." Ruff describes a recent iteration of the Austerlitz effect: the globalization of the image resulting from a very different kind of war than the one that so gravely affected Austerlitz as a child. That vast distance brought close to hand through visual representation is understood in necessarily ideological terms. "The war took place in the Gulf region," Ruff said, "but it was actually about our oil in the West—our fuel interests. The military decisions were taken here in Western Europe and the United States. That's why I declared Düsseldorf a war zone and started looking at the city with a starlight system."[25]

In the Night Pictures, Ruff made use of a spectral technology associated with both military and private surveillance. And he did so to comment on a radically new vision of place—and, by extension, architecture. Instead of training his gaze on the Persian Gulf, however, he took on the art historically charged site of Düsseldorf as his subject, in the process dramatizing how the seeming distance traversed by the new image is always a matter close to home. Not only are the consequences of such images experienced locally (one's daily habitus in Düsseldorf is ultimately inseparable from a war happening elsewhere, for example), but as his statement

suggests, the images themselves may well be the result of far more proximate considerations.

Ruff's *Nacht 5 I* (1992) presents a night scene of Düsseldorf veiled in the brackish shades of the green screen. Several windows provide acid highlights against a murky depth of field, while the building itself appears to radiate. Glowing green, the structure is nonetheless rendered strangely anonymous: it is devoid of identifying features or spatializing cues that would give context to this nocturnal image. Paradoxically, this virtual anonymity is at once historically concrete and *specific*. It is specific to the historic moment and place at which Ruff was working and specific relative to the visual datum then—and more recently—circulating in the image stream. There is a material dimension to this work that may well be lacking in Gursky's photographs. It shores up a sense of place and time, even if by attesting to the mythic disappearance of such conditions in the digital image.

What emerges from this view is a certain return to Austerlitz's preoccupations, to his haunted relationship to architecture and the photograph and his even more haunting attitudes toward history and time. Architecture, following Austerlitz, served to index a sense of historical dislocation; perhaps now it reveals to us a set of recently emerging historical conditions— a sense of displacement in geopolitical terms. The pictorial representation of architecture, from photoconceptualism to the present, bears witness to this phenomenon. In the best work it attempts to

register the mobilization of place while simultaneously grounding it. And by acknowledging photography's critical relationship to architecture, it brings home the material exigencies of place, however seemingly transient or on the way.

Notes

For Christine Mehring.

1. W. G. Sebald, *Austerlitz* (New York: Random House, 2001), 77.

2. Ibid., 33.

3. The most important account is in Benjamin H. D. Buchloh, "Conceptual Art, 1962–1969: From the Aesthetics of Administration to the Critique of Institutions," *October*, no. 55 (winter 1990): 119. For a different reading that nonetheless takes up photoconceptualism's de-skilling operations, see Jeff Wall, "'Marks of Indifference': Aspects of Photography in, or as, Conceptual Art," in *Reconsidering the Object of Art, 1965–1975*, exh. cat., ed. Ann Goldstein and Anne Rorimer (Los Angeles: Museum of Contemporary Art, 1995), 247–267.

4. Buchloh, "Conceptual Art, 1962–1969," 119.

5. See, e.g., Terry Riley, "Architecture as Subject," in *Architecture without Shadow*, ed. Gloria Moure (Barcelona: Ediciones Poligrafa, 2000), 12.

6. Among others, this is in part the subject of Claire Zimmerman's recent research on Mies van der Rohe and the Barcelona Pavilion. Populist writers on architecture are quick to speak of the inadequacy of photographs to represent the experience of architecture and so

Andreas Gursky; *Hong Kong and Shanghai Bank*, 1994; chromogenic color print; 89 x 69 5/16 in. (226 x 176 cm); courtesy Matthew Marks Gallery, New York

Thomas Ruff; *Nacht 5 I*, 1992; chromogenic color print; 50 13/16 x 53 5/16 in. (20 x 21 cm); courtesy David Zwirner, New York

shore up the same division between architecture and photography in conventional photographic accounts. See, e.g., Witold Rybczynski, *The Look of Architecture* ([New York]: New York Public Library; Oxford: Oxford University Press, 2001), 13–16.

7. This is the subject of my forthcoming book *Chronophobia: On Time in the Art of the 1960s*, to be published by MIT Press. Two previously published chapters that articulate this problematic are "Ultramoderne: How George Kubler Stole the Time in 60s Art," *Grey Room* 2 (spring 2001): 46–77, and "Bridget Riley's Eye/Body Problem," *October* 98 (fall 2001): 27–46. The latter essay in particular speaks to the ways in which the image is spatialized or rendered three-dimensional in the new media culture of the 1960s.

8. Among many other examples, the 1960s marked the beginning of the so-called computer race, which would dramatize the new cultural attitude toward time in critical respects. For instance, IBM introduced its first transistorized computer in 1959, and its development of "mainframe" systems offered the seeming potential of virtually instantaneous data processing and what would come to be known as "real time" systems networking. Likewise, we could point to the introduction of automation technologies in the workforce as threatening the time of labor production: in the 1960s the speed of machines, so it was (and is) argued, would radically offset the productivity of the worker.

9. I should note that such schemes took on an institutional or bureaucratic dimension in the 1960s; indeed, in the United States, the Department of Housing and Urban Development (HUD) was granted cabinet-level status in 1965.

10. Such documents would include, respectively, Walter Benjamin, "The Work of Art in the Age of Mechanical Reproduction," in *Illuminations*, ed. Hannah Arendt, trans. Harry Zohn (New York: Schocken Books, 1968), 217–252; and Rosalind Krauss, "The Originality of the Avant-garde," in *The Originality of the Avant-garde and Other Modernist Myths* (Cambridge: MIT Press, 1985), 151–172.

11. Dan Graham, "Homes for America," in *Rock My Religion* (Cambridge: MIT Press, 1993), 14–21. It is important to note here that *Arts Magazine* published a version of the work in 1966–1967 but, contrary to Graham's wishes, without its photographs of homes. Graham had shown these images as slide projections in 1966, predating, as we shall see, Robert Smithson's use of the carousel projector.

12. Ibid., 21.

13. Bernd and Hilla Becher, interviewed by Lynda Morris, in *Bernd and Hilla Becher* (London: Arts Council, 1973), unpaginated.

Of the countless critical texts on the Bechers, see Thierry de Duve, "Bernd et Hilla Becher ou la photographie monumentaire," *Cahiers du Musée National d'Art Moderne* 39 (spring 1992): 118–130.

14. LeWitt was the author of the canonical Conceptual documents "Sentences on Conceptual Art" (1967) and "Paragraphs on Conceptual Art" (1969), reprinted in *Sol LeWitt: Critical Writings*, ed. Adachiara Zevi (Rome: Libri di AEIUO, 1994), 78–82, 88–90.

15. Sol LeWitt, cited in *Sol LeWitt*, exh. cat., ed. Alicia Legg (New York: Museum of Modern Art, 1978), 158.

16. Siri Engberg, "The Weather of Prints: An Interview with Edward Ruscha," *Art on Paper* 4 (November–December 1999): 73.

17. Virilio makes similar arguments in, among many texts, *The Aesthetics of Disappearance* (New York: Semiotext(e), 1991), 65.

18. On Smithson's photographic practice, see Robert A. Sobieszek, *Robert Smithson: Photo Works* (Los Angeles: Los Angeles County Museum of Art; Santa Fe: University of New Mexico Press, 1993).

19. For instance, an exhibition called *Projected Art* appeared at Finch College in November 1966, including the work of Dan Graham among others.

20. Sobieszek, *Robert Smithson*, 36.

21. Ibid., 116.

22. On Matta-Clark and the temporality of the built environment, see my *Object to Be Destroyed: The Work of Gordon Matta-Clark* (Cambridge: MIT Press, 2001).

23. Ibid., 217.

24. Ibid.

25. Thomas Ruff, cited in Moure, *Architecture without Shadow*, 86.

John Baldessari

My Files of Movie Stills

Originally published in John R. Lane and John Caldwell, *Carnegie International* (Pittsburgh: Museum of Art, Carnegie Institute, 1985), 91.

Below are the current categories in my files of movie stills, which form a large part of the raw material from which I draw to do my work. I hope the categories (which are continually shifting according to my needs and interests) will provide some clues to what animates the work I do.

A
attack, animal, animal/man, above, automobiles (left), automobiles (right)

B
birds, building, below, barrier, blood, bar (man in), books, blind, brew, betray, book-ending, bound, bury, banal, bridge, boat, birth, balance, bathroom

C
cage, camouflage, chaos/order, city, cooking, chairs, curves, cheering, celebrity, consumerism, curiosity, crucifixion, crowds, climbing, color, civic

D
dwarf, death, disgrace, danger, discipline, disaster, division, door

E
escape, eat, ephemeral, exteriors

F
facial (expression), fall, fake, framing, freeway, fire, foreground, falling, forest, females, form

G
good/evil, goodbye, giant, gate, grief, guns, guns (aggression), gamble, growth, groups

H
hope, horizontal, hard/soft, hands, heel (ankle), hole (cavity), houses, hiding

I
injury (impair), interiors

J
judgment, journey (path, guide)

K
knife, kiss

L
lifeless, letter, light, looking (watching), laughing

M
money, music, males (+ 1 female), males 2 (+ 1 female), male/female, message, mutilation, movement, masks (monsters), missing (area), macho

N
naked, noose, nature, nature (water), nourish, newsphotos

O
octopus, operation, oval, obstacle

P
phallic, prison, purity, perspective, posture, paint, past, parachute, products, portrait (male), portrait (male, color), parallelograms, pairs (images)

R
roller coaster, rescue, repel, radiating (lines), race, relief, revive, rectangle (long), rectangle (wavy), reason

S
snakes, shadows, ships, smoke, sports, signal, search, secret, survive, stress, separation, safe, struggle, sad, soul, suitcase, switch, sinking, structure, seduction, sex (desire), small, shape (smear), shape (awkward), shape (black), shape (arc), shape (circle), shape (blur), shape (white)

T
technology, tables, table (settings), thinking, trapeze, time, three, trains, two, teeth, thought, triangle, triangle (truncated)

U
upside down, unconscious

V
vision, victim, vulnerable

W
walls, water, wound, watching, winning, women, women (2), women (group)

A bargain always must be struck between what is available in movie stills and the concerns I have at the moment—I don't order the stills, I must choose from the menu. Also, one will read from this a rather hopeless desire to make words and images interchangeable—yet it is that futility that engrosses me. Lastly, I think one will notice the words falling into their own categories, two being those of formal concerns and content.

Melanie Mariño

Disposable Matter: Photoconceptual Magazine Work of the 1960s

Melanie Mariño is a writer and art historian based in New York. She has published widely on contemporary art and is currently preparing a book on Conceptual photography.

It was a bound magazine, published once upon a time, in a barely remembered age.... Yes, matter has grown old and weary, and little has survived of those legendary days—a couple of machines, two or three fountains—and no one regrets the past, and even the very concept of "past" has changed.

Vladimir Nabokov, *Invitation to a Beheading*

We enter this past through a lament from the world of fashion, straight from its versatile impresario Irving Penn: "The printed page seems to have come to something of a dead end for all of us."[1] Penn made this statement in 1964, but it was precisely at that moment (around 1963) that Conceptual Art reinstated photography to the space of printed matter: books, catalogues, and magazines. There is a difference, of course, between the slick accomplishment of commercial photography exemplified by Penn's artful platinum prints and the photoconceptual adaptation of the slipshod, amateur snapshot to mass publication. It is the difference between the cultivation of an art effect and the mimesis of a non-art style. That difference bears on photography's dense and complex relation to the high-low dialectic, the knotty binarism that splices through the discourse of the medium, shuttling to one end Alfred Stieglitz's modernist icon *Paula* and, to the other, Richard Avedon's lustrous superstars.

By now, the narrative of Conceptual Art is well rehearsed. The unruly "movement" was united by its wide-ranging inquiry into the nature of art-in-general. Disputing the values of aesthetic autonomy and purity prized by high-modernist formalism,

generic art transgressed the boundaries that traditionally delimited the specificity of each medium—for instance, the irreducible flatness of painting. No longer constrained by such categorical confinements, these practices also tested institutional limitations, extending the display and distribution of art beyond the white cube of the gallery or the museum.

For more than a decade, the various recoveries of that story by academy and museum alike have opened a space to rethink the central, if unconscious, place of photography. Previously subsumed under the rubric of art that uses photography—in contradistinction to art photography—the convergence of art and photography within Conceptual Art is now condensed by the terms Conceptual photography and photoconceptualism.[2] But as those hybrid names endow the transformation of the photographic medium within Conceptual Art with a punctual identity, they also tend to obscure the very inconsistencies that render photoconceptualism impossible to contain and that mark that impossibility as a place of reading in its own right. For instance, how might we grasp the contradiction between the photographic mediation of Conceptual Art and the aim to dismantle medium-based categories of art that demarcated the shared cognitive ground of the so-called movement?

Clement Greenberg once exhorted, "Let photography be literary."[3] The implacably prescriptive modernist critic appeared to stipulate an anecdotal specificity for the photographic medium. Without stating it, Greenberg alluded to a semiotic ontology of the medium that casts the photograph as intrinsically narrative and therefore as simultaneously visual and temporal. This heterogeneous condition, he seemed to suggest, derives from its stubborn indexicality—the photographic image is a photomechanically reproduced trace of its referent or what it represents.

It is to that history of mechanical reproduction that Conceptual photography looks back. It leads from the medium's beginnings in the nineteenth century—from the invention of the calotype to the perfection of the halftone block—to its incarnation in the twentieth century, the mass-media image. For the first half of the last century, that image found its home next to print, in early illustrated periodicals such as

Illustrated American, *Paris moderne*, and *Berliner illustrierte Zeitung*; in the legendary picture magazines *Life* and *Look*; and in style and fashion monthlies such as *Vu*, *Vogue*, and *Harper's Bazaar*.

In their heyday in the 1930s and 1940s these widely circulated publications boasted some of the most influential names in photojournalism, as photographers like Margaret Bourke-White, Robert Capa, Alfred Eisenstaedt, Andreas Feininger, and W. Eugene Smith brought the news home with "Lifestyle" verve. It was then too that an international readership luxuriated in the modish fashion and celebrity spreads of Cecil Beaton, Louise Dahl-Wolfe, Man Ray, Martin Munkacsi, and Edward Steichen. Meanwhile, Brassaï, Lisette Model, and Weegee pictured a "social fantastic"[4] that cannily synthesized Surrealism and journalism.

Of course, prior to that moment, the various endorsements of the artistic legitimacy of the ascendant media image (which did not preclude critical innovation) were controverted by a collective (if often conflicted) assault on the aura of bourgeois aestheticism. Berlin Dada and its heirs displayed anarchic photomontages to advance an agenda of political protest and agitation—for instance, in *Der Knuppel*, *Die rote Fahne*, and *Arbeiter illustrierte Zeitung*. Almost simultaneously, Russian Constructivism deployed a homologous array of photographic practices—for exam-

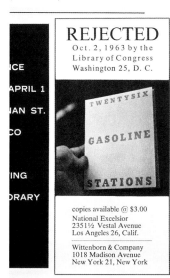

ple, in *Lef* and *Kino Front* or *Vestnik Truda* and *Molodaya Gvardia*—to shape a collective revolutionary consciousness. These interventions opened onto a critique of media culture—take, for example, Hannah Höch's complex response to the network of "New Woman" stereotypes circulated within the Weimar press or Aleksandr Rodchenko's uses of the defamiliarizing snapshot to revolutionize the Soviet press—whose utopian aspirations would be mitigated, at least implicitly, by Conceptual photography.

Conceptual photography made its way into the magazine page[5] during a time of transition for the magazine industry; *Collier's* closed shop in 1957, followed by *Look* in October 1971 and *Life* in December of the next year.[6] Photoconceptual magazine work held its brief tenure within the narrowed venue of the specialist magazine, slipping nearly imperceptibly into the pages of art magazines like *Artforum* and *Arts Magazine* or the fashion magazine *Harper's Bazaar*. Rigging out their own amateur idiolects of advertising and reportage, these subtle pieces flouted the arty conventionality of contemporary media photography, while demythifying the radical social promise attributed to such interventions by their avant-garde precursors. This double-edged critique looked neither aesthetic nor quite commercial. But even that crafty disguise could not ensure its survival.

First, a Manual

In the year following the publication of *Twentysix Gasoline Stations* (1962), Edward Ruscha placed an ad in *Artforum*. Above a photograph of the book's cover, the following notice was posted in bold print: "REJECTED / Oct. 2, 1963 by the / Library of Congress / Washington 25, D.C."[7] This wry publicity image parodied the book's obscurity. "When I first did the book on gasoline stations," Ruscha recalled, "people would look at it and say, 'Are you kidding or what? Why are you doing this?' In a sense, that's what I was after; I was after the head-scratching."[8]

Intended as a "training manual"[9] for mass distribution, *Twentysix Gasoline Stations* collated a typology of the filling stations that dotted Route 66, along the stretch that connected Los Angeles to Oklahoma City. Throughout its forty-eight pages the book interspersed blank sheets with twenty-six photographs, printed in halftone (as single square images on the upper-right-hand corner of a page or as full-page spreads) and identified by a caption that tersely listed the corresponding station's trade name and location. This mundane collection calibrated a uniform, amateur locution to its "banal-vernacular"[10] subject matter. Each image—like the squat structure it housed—looked like the next.

In effect, the book presented a "non-statement with no style"[11] that tuned the "documentary style" of Walker Evans and Robert Frank (its effacement of the author)[12] to the Duchampian readymade (its withdrawal of the auratic art object).[13] Ruscha once referred to the *Stations* as "an extension of a readymade in photographic form."[14] Here the artist asserts the secondary, intermediate status of photography while pointing to the way the *Stations*, following the readymade, tested art's conventions (by substituting for art photography a version of popular snapshot photography keyed to its mass-cultural iconography) and art's institutions (by displacing the fine art print destined for the gallery or museum wall with the book designed for mass distribution).

This exposition of the readymade's aesthetic indifference to industrial dedifferentiation owes much to Andy Warhol. Like the artist's Campbell's Soup Cans, exhibited at the Ferus Gallery in Los Angeles in the same year that Ruscha's book was published,*Twentysix Gasoline Stations* tied artistic production to the serial rhythms of production and consumption. Like Warhol's thirty-two paintings, which pictured the exact number of Campbell's soups available at the time, mounted to the wall and ranged along a thin, white shelf like cans sold in a supermarket, Ruscha's twenty-six stations present their own eccentric lineup. We consume his books and stations as so many repetitious signs, whose symbolic value is now determined by their difference from other signs—the Standard Station from the Union Station, for instance. Yet if it follows the logic of the commodity-sign, it follows the logic of obsolescence; as Warhol favored the fading icon, "the thing just on its way out,"[15] Ruscha "operated on a kind of waste-retrieval method."[16]

Ruscha's books drive the worn down and left out into our visual focus. There they return as depleted of value as they are devoid of sense. For Ruscha's shabby gas stations—like his derelict land parcels, depopulated parking lots, and empty swimming pools—are both redundant and nonsensical. Indeed, the atrophy of signification follows from the incessant drumming of repetition, which greased the gears of industrial production as it sanded down the very differences that produce meaning. These photographic images, like words turned to clichés or figures that blend into their ground, mime that lack of distinction,

Edward Ruscha, *Standard, Amarillo, Texas*, from *Twentysix Gasoline Stations*, 1962 (cat. no. 129)

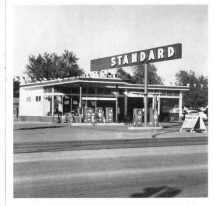

STANDARD, AMARILLO, TEXAS

that like-ness. But these hollowed-out signs also touch on a hidden economy in everyday perception, bidding us, as Ruscha put it, "to [see] the electric vibrancy in something that's so dead."[17]

Business Art

Ruscha's curious manual perplexed its readers. "Only an idiot," Jeff Wall later remarked, "would take pictures of nothing but the filling stations."[18] But stranger still than the book was the ad that followed it. For as the mass-produced *Stations* thumbed its nose at the precious *livre d'artiste*, so its branding rubbed the opulent sheen off mass advertising.

Slotted into page 55 of *Artforum's* March 1964 issue, the advertisement's montage was patently unappealing. Its dry confection of a banal black-and-white reproduction—of the softcover's red serif title, counted out into three symmetrical, evenly spaced horizontal lines—and generic typography—the faux-bureaucratic typeface of the "rejected" stamp—did nothing to woo consumer desire. Clearly this rebuff to commodity fetishism was tactical.

Ruscha, as we know, was hardly incognizant of the templates of merchandising. He worked on this very magazine's production when it still made its home in Los Angeles, appearing on its masthead from October 1965 through summer 1969 as

"Eddie Russia." This ad winks in shared knowledge of the artist's (and his art's) double status; the image could pose at once as art (object) and as design (exhibition announcement). And all of this refers us slyly to the unwieldy heterogeneity of photography's functions (aesthetic, utilitarian, commercial).

The commercial aspect is of particular significance to this magazine piece, at least insofar as commercial art relates to art. There were several names for that relation, but the most pertinent for Ruscha again comes from Warhol, who blithely pronounced, "Business art is the step that comes after Art."[19] If Ruscha's publicity "caper"[20] extends art's franchise into "business art," it does so critically, for the work's simultaneous operation of medium and mass media—now media is the medium—defies the exigencies of capital. His ad does not propel the image through the circuit of desire that is also capital's flow. It does not direct us from the promise of consumption to the consummation of purchase. Rather, it relays the latter's malfunction—no sale here, not even for free, not even to the Library of Congress—into an equivocal critique of the capitalist establishment by inverting the rhetoric of achievement into a trope for failure.

This is not to suggest that Ruscha's promotion served only to idealize the artist's thwarted success. It was the artist's con-

temporary, Bruce Nauman, who honed that strategy, unabashedly concatenating multiple personifications of doubt, of frustration, of shame and humiliation—for instance, in *Bound to Fail* (1967) or, more relevantly, the photograph of the artist's bowed head distributed by Galerie Konrad Fischer in 1969 as an exhibition announcement postcard. Ruscha's work, however, coheres less around the charismatic persona of the loser than it does around the modality of "perceptual withdrawal." The impoverishment of the image—and, we might add, its information—deflated the value of photographic reproduction within media culture, derailing, however temporarily, the ordered cycles of commerce.

Ruscha's amalgamation of culture and advertising arced into a kind of anti-ad. That conversion finds its sibling in Dan Graham's ad, *Figurative* (1965), which appeared in the March 1968 issue of *Harper's Bazaar*.[21] On page 90 of the magazine, a vertical column of numbers insinuated itself between two advertisements, one for Tampax and another for a Warner's bra. Spliced at the top and bottom to conform to the measurements of these bracketing ads, Graham's cash-register receipt in effect proffers a record of a commercial transaction. If its styptic tabulation represented anything then, it represented what has been. This signals, of course, the tense of photography, which here is diverted to supplant the subjunctive mood of advertising—"figured" by the two solicitations for the female consumer's body—with the evidence of a completed sale. The receipt quite literally eviscerates the advertisement, supplanting its fantasy of consumption with the enervated figures of expenditure.

Everyday Homes

Graham's early magazine work followed the short-lived John Daniels Gallery (founded by the artist in 1964 and closed the following year). "The art world," Graham shrewdly intuited, "was very much a part of the publicity media world," and his early forays into art tracked those connections by dodging the gallery exhibition altogether to create "conceptual pages in magazines."[22]

The most formidable instance of this circumvention remains Graham's photo essay "Homes for America," first published as

Dan Graham, "Homes for America," *Arts Magazine* 41 (December 1966–January 1967): 21–22

a double-page spread in the December 1966–January 1967 issue of *Arts Magazine*. Beginning on page 21, halfway down a column of text where the previous article ends, Graham's article pedantically explicates the system of the "large-scale housing 'developments' that constitute the new city." A double-column list of twenty-four single-family tracts, tabled alphabetically, forms an epigraph to the essay. It unfolds a litany of proper names—Belleplain, Brooklawn, Colonia, and so on. But this list does not nominate specific identities so much as aggregate one thing after another, as if to disclose their repetitive serial ordering—to insist, that is, that one is interchangeable with the next: "They are located everywhere. They are not particularly bound to existing communities; they fail to develop either regional characteristics or separate identity."[23]

In its original layout, "Homes for America" included six thirty-five-millimeter photographs—of split-level and ground-level "two home homes" (Jersey City); rear and front views of setback rows (Bayonne); and a single view of two rows of setbacks (Jersey City)—which together with the text proposed a kind of bilateral equation. If the images illustrated the text, the text amplified them in equal measure, so that Graham's pictures of redundant architectural forms—the doubled doorways, setback views, or ziggurat steps—sound a counterpoint to serial lists and columns—of models, color types, and ordinal combinations.

For the final version of the essay, the magazine's editors replaced Graham's photographs with a single image by Walker Evans, *Wooden Houses, Boston, 1930*. The Evans appears above a real estate photograph and house plan of "The Serenade," visually expounding the oppositions diagrammed by the article's subtitle, "Early Twentieth-Century Possessable House to the Quasi-Discrete Cell of '66." Although Evans' lineup of vernacular row houses seemed to shadow the repetitious domestic architecture recorded by Graham, the structures, as Graham qualified, are historically distinct; the Boston residences, "designed to last for generations,"[24] are the antithesis of the New Jersey throwaway cell. To relay this difference, Graham shunned the art of Evans' "documentary style,"[25] trading instead in the standardized currency of mass information. Hence the

unremittingly dull snapshots—automatically focused and exposed, perfunctorily framed, monotonous—which shrivel the promise of individual possession into bland ciphers of alienation.

These signs allude as much to the mass-produced architecture of the "blurbs"— to borrow Robert Smithson's portmanteau for the border zone of the suburbs—as to the "specific objects" of Minimalism. Moving almost undetectably into the margin between art and art criticism, "Homes" introduces this connection: "Both architecture and craftsmanship as values are subverted by the dependence on simplified and easily duplicated techniques of fabrication and standardized modular plans." The passage goes on to link those methods of standardized construction and assembly to the Minimalist eschewal of subjective expression: "Contingencies such as mass production technology and land use economics make the final decisions, denying the architect his former 'unique' role." Finally, it draws a parallel between Minimalism's idealist isolation—its primary structures are disconnected from their historical referents—and the deracination of the suburban environment: "There is no organic unity connecting the land site and the home. Both are without roots—separate parts in a larger, predetermined, synthetic order."[26]

As "Homes" effectively placed Minimal

art in context—where its decentering of subjective expression reads less as a "liberating" aesthetic procedure than as a naive idealization of a penitentiary, "one-dimensional" culture—it also repositioned Pop Art. "I wanted to make a 'Pop' art which was more literally disposable," Graham insisted.[27] His work redirected Pop's mass-culture iconography, returning its borrowed signs from the space of the gallery to the printed page of the magazine. There it synchronized the Minimalist emphasis on the here and now of perceptual experience to the commodity rhythms of the magazine—here today, gone tomorrow—and in this throwaway aesthetic, we discern a mirror image of the suburban home doomed to obsolescence.

This reflection of the throwaway invites comparison with "the everyday [as] platitude (what lags and falls back, the residual life with which our trash cans and cemeteries are filled: scrap and refuse)."[28] In this sense, "Homes" marshals a brand of mimesis that one might call everyday realism—akin to Jean-Luc Godard's "magazine-like" films (*Deux ou trois choses que je sais d'elle* or *Weekend*) and to Alain Robbe-Grillet's "nouveau roman" tabulations (*Snapshots*). Its referent, however, is not the manufactured homes that form the essay's ostensible subject but rather everyday life in "a bureaucratic society of controlled consumption."[29] That is, "Homes" duplicates the everyday logic of enforced

Dan Graham; *Homes for America*, 1966–1967; photo-offset reproduction of layout for *Arts Magazine*; 34½ x 25 in. (87.6 x 63.5 cm); Walker Art Center

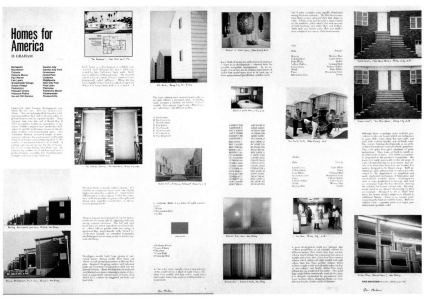

consumption that packages our "quasi-discrete cells" into morbid uniformity. This quotidian rationalization withers the very possibility of aesthetic expression. Ultimately, it is this grim dynamic of depletion that Graham's article mimes, offering up to its readers a spectacle of the deep banality of everyday experience.

Picturesque Tours

"Banality? Why should the study of the banal be itself banal? Are not the surreal, the extraordinary, the surprising, even the magical, also part of the real? Why shouldn't the concept of everydayness reveal the extraordinary in the ordinary?"[30] These are not Robert Smithson's words—they belong to Henri Lefebvre—but Smithson might well have posed the same questions to Graham. In a way, Smithson did just that in a series of magazine articles: "The Crystal Land" (*Harper's Bazaar*, May 1966), "Monuments of Passaic" (*Artforum*, December 1967), and "Incidents of Mirror Travel in the Yucatan" (*Artforum*, September 1969). Proposing their own quixotic rendition of reportage—we might call it expeditionary—these illustrated essays followed Smithson's rambles from the Garden State to the Yucatan to disclose "the extraordinary in the ordinary."

In the first of Smithson's travelogues, "The Crystal Land," he records (without photographs) a day trip to Upper Montclair Quarry and Great Notch Quarry with his wife, Nancy Holt, and Donald and Julie Judd. Smithson rattles off two lists, an alphabetic sequence of more than fifty trap-rock minerals from his Brian H. Mason booklet—actinolite, albite, allanite,

and so on—and, quickly thereafter, the names and colors of Montclair's "box-like" middle-income housing developments: Royal Garden Estates, Rolling Knolls Farm, and so on. Smithson's compulsive list making recalls Graham's "Homes"; both make the connection between Minimal art (Smithson refers to Judd's "pink-plexiglas box") and everyday suburban architecture. But Smithson's article also crystallizes the "mineral" latticework of those redundant homes, only to rip into its underside, an abandoned industrial quarry where "fragmentation, corrosion, decomposition, disintegration, rock creep, debris slides, mud flow, and avalanche were everywhere in evidence."[31]

Smithson's errant pairing of architecture and nature, of the bland regularity of one and the material degeneration of the other, inducts us into his next essay, "Monuments of Passaic." Originally titled "A Tour of the Monuments of Passaic, New Jersey," the article warps the Grand Tour—in which Rome, as the ancient capital of Western civilization, traditionally figured as a privileged destination—into a detour through the industrial detritus that borders Passaic's polluted river, leading from the bridge linking Bergen County with Passaic County, through the construction site of an unfinished highway along the river, and finally into the town center. The text trails eight images of "the rotting industrial town"; a newspaper reproduction of Samuel Morse's painting *Allegorical Landscape*; photographic views of "The Bridge Monument," "Monument with Pontoons," "The Great Pipes Monument," "The Fountain Monument," and "The Sand-Box Monument"; and a negative

photostat of a map of the site. This tour recalled to some the eighteenth-century category of the picturesque.[32] The critic Sidney Tillim, for one, wrote: "Robert Smithson virtually parodied the modern picturesque when he visited the 'monuments' of Passaic, carrying his Instamatic camera like the older connoisseur carried a sketchbook, perhaps."[33] Smithson blasted this association (or at least its pictorial implications), although he too recognized the essay's picturesque filiation when he submitted its prospectus to a magazine well known for its longstanding allegiance to the picturesque travelogue, *Harper's*, which nevertheless rejected his idea as too "elliptical."[34]

To read Smithson's narrative is to move between image and text, from site to site. Like the stroller delighting in the picturesque garden, who stops and looks to constitute and de-constitute its various prospects, we too advance by breaking between reading and looking. Over and over again, we go back and forth, meandering through a sequence of interruptions. These interruptions bring us to the heart of Smithson's picturesque, which we might therefore conceive as closer to Minimal art (in its privilege of succession) and far afield of the pictorial (in its repudiation of static opticality).

At times, this contingent, moment-by-moment account spirals out into "a typical abyss."[35] Consider the first stop, "The Monument of Dislocated Directions." Before the rotating bridge, Smithson recounts: "Noon-day sunshine cinematized the site, turning the bridge and the river into an overexposed picture. Photographing it with my Instamatic was like photographing a photograph" (49). We turn to the image, which pictures at once a reflexive image of photography's light and dark (through the partial silhouettes cast by the structural steel beams and railing) and the painterly, monocular perspective system of camera optics—the wooden slats of the walkway narrow in its recessional march toward the bleached-out horizon. To shift from the textual register to the visual is to confront a photograph of what is already a photograph, to plunge, like Smithson, through the empty space of endless referral.

Delay, too, breaches the coherence of Smithson's third travelogue, "Incidents of

Robert Smithson, "Monuments of Passaic," *Artforum* 6 (December 1967): 48–49

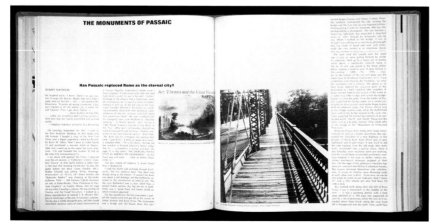

Mirror Travel in the Yucatan." Chronicling the artist's expedition through the Yucatan Peninsula in April 1969, the photo essay is organized around a series of twelve-inch-square mirrors, scattered and half-buried at nine different locations in almost parallel configurations. Each installation is enantiomorphic, which is to say, both symmetrical and asymmetrical to the next, so that the already decomposed landscape—whose photographic view is partially blocked by the mirrors, which in their turn reflect only a partial view of the sky—ever so progressively collapses in on itself: "In this line where sky meets earth, objects cease to exist."[36]

What do these indistinctions evoke if not the sublime? Is this then the other name for Smithson's picturesque? Passaic, our guide tells us, is "a self-destroying postcard world of failed immortality and oppressive grandeur" (50). Grandeur notwithstanding—we think of fugitive monuments like the drainage pipes and sandbox elevated to the status of "The Great Pipes Monument" and "The Desert"—the sublime effect of the suburb's monuments cannot be likened to the terrified awe of Kant's tourist, who enters Saint Peter's Basilica for the first time gripped by "the feeling that his imagination is inadequate for exhibiting the idea of a whole."[37] The same intuition of boundlessness, of objects "great beyond all measure," convulses Passaic's visitor, who confesses, "I had been wandering in a moving picture I couldn't quite picture" (50). But here that experience of incommensurability (between that which can be thought and that which can be represented) is brought into view through the terms of entropy.

To Smithson, the idea of entropy as "energy drain" called up "a new kind of monumentality."[38] Remodeling building as ruination,[39] these "new monuments" follow the logic of temporal dispersion so that "time becomes a place minus motion."[40] Passaic's monuments exemplified precisely that "zero panorama," replete with "holes," with "monumental vacancies that define, without trying, the memory-traces of an abandoned set of futures" (50).

It was that very emptiness that sloped the picturesque (long familiar to magazines) into the threat of "nothing further happening,"[41] the privations of the sublime. But that adjustment also entailed a problematic dedifferentiation of history. If Ruscha and Graham took as their subject the homogenization of everyday life, they remain, strategically, in the historical now. Smithson, by contrast, exalted the effacement of historical memory: "the suburbs exist without a rational past and without the 'big events' of history . . . just what passes for a future" (56). Antimonumental in its impulse, this maneuver jettisoned the present into a paradoxical prehistoric future—thus, the sand-box monument is likened to an "open grave," "the sudden dissolution of entire continents, the drying up of oceans," "a vast deposit of bones and stones pulverized into dust" (51).

In the end, however, "Monuments" was not quite so sublime. Its author was careful to draw a distinction between the "experience before the physical abyss" (the sublime) and that "before the mapped version" (the sublime picturesque).[42] "It isn't a question of form or anti-form," Smithson repeatedly insisted, "it's a limitation."[43]

His photo-essay stands as a figure for that limitation. As it overruns the confines of medium, extending art into the open landscape and onto the printed page, it generates a hybrid picture "that has broken away from the whole, while containing the lack of its own containment."[44]

Postscript

Is the magazine, like Smithson's future, "out-of-date" and "old-fashioned"? Are photoconceptualism's pages, like so much outmoded ephemera, doomed to inconsequence? After all, they looked like nothing really. But it was just that blankness that pointed to the banality of everyday life, whose elaboration in the artwork enlarged the compass of art's intervention. In this way, these magazine pieces not only disputed the autonomy of the art object—by mingling the photographic and the textual and by exploiting the suspension of the photograph and the magazine between mass culture and high art—but effectively turned that challenge to social use—by figuring, in different ways and to different degrees, the everyday conditions that impinge on the re-presentation of art in late capitalist culture.

As Conceptual Art's institutional critique—or what Smithson referred to as "the apparatus the artist is threaded through"[45]—dilated into cultural critique, it increasingly invalidated the distinction between art and non-art. Throughout the 1970s the politics of feminism reshaped this expanded model of art, which intensively pursued the question of the subject's constitution in social

Robert Smithson, *The Bridge Monument Showing Sidewalks*, from *Monuments of Passaic*, 1967 (under cat. no. 173)

Robert Smithson, "Monuments of Passaic," *Artforum* 6 (December 1967): 50–51

and psychosexual difference. And thus in various periodicals, artists such as Victor Burgin and Martha Rosler shifted the analysis of art's commodity status into a critique of class relations, on one hand (Burgin's "Think about It"), and mass-cultural representations of women, on the other (Rosler's "Body Beautiful, or Beauty Knows No Pain"). In parallel fashion, less strictly Conceptual artists such as Judy Chicago (*Artforum*, December 1970) and, notoriously, Lynda Benglis (*Artforum*, November 1974) posted self-advertisements that restyled the commodification of artistic identity into a parody of gender bias in the art world.

Propelled by the turn of feminist art to other mass-media spaces and, in larger and more troubling measure, by Conceptual Art's displacement by a "hunger for pictures,"[46] Conceptual magazine work receded in the 1980s. Today, however, the return of art and theory to the 1960s asks us to reread those early pages. For to this day their austere intercession remains inarticulate, too little understood. It hangs in the margins, like a kind of residual life, waiting to reinvent the practice of critical leveling, waiting to transform the inconsistencies of our globally enforced homogenization. Might that suspension also harbor an invitation? To heed its call is to dispel our indifference to the past. Then perhaps this work would not be disposable after all.

Notes

1. Richard Avedon/Irving Penn session, n.d., in Alexey Brodovitch workshop session notes, Design Laboratory, 1964, Library, Museum of Modern Art, New York.
2. For an early review of art that "uses" photography, see Lawrence Alloway, "Artists and Photographs," *Studio International* 179 (April 1970): 162–163. For more contemporary considerations of Conceptual photography, see Jeff Wall, "'Marks of Indifference': Aspects of Photography in, or as, Conceptual Art," in *Reconsidering the Object of Art, 1965–1975*, exh. cat., ed. Ann Goldstein and Anne Rorimer (Los Angeles: Museum of Contemporary Art, 1995), 247–267; John Roberts, "Photography, Iconophobia, and the Ruins of Conceptual Art," in *The Impossible Document: Photography and Conceptual Art in Britain, 1966–1976*, exh. cat. (London: Camerawork, 1997), 7–45.
3. Clement Greenberg, "The Camera's Glass-Eye: Review of an Exhibition by Edward Weston" (March 9, 1946), in *Clement Greenberg: The Collected Essays and Criticism*, ed. John

O'Brian, vol. 2, *Arrogant Purpose, 1945–1949* (Chicago: University of Chicago Press, 1986), 63.
4. See Pierre MacOrlan, "Elements of a Social Fantastic" (1929), in *Photography in the Modern Era: European Documents and Critical Writings, 1913–1940*, ed. Christopher Phillips (New York: Metropolitan Museum of Art, 1989), 31–33.
5. Here I do not refer to the numerous examples of purely textual magazine or even newspaper work, such as Dan Graham's *Schema* (March 1966), which was originally set for *Arts Magazine* but appeared instead in *Aspen*, no. 5–6 (1966–1967), Stephen Kaltenbach's advertisements in *Artforum* from 1968 and 1969, and Joseph Kosuth's *Second Investigation* (1968–1969), which was published in newspapers from different countries.
6. Threatened by the expansion of the suburbs, with their fragmented sales and distribution infrastructure, and by market competition from the paperback book industry and commercial television, magazines increasingly targeted more specific audiences. See John Tebbel and Mary Ellen Zuckerman, *The Magazine in America, 1741–1990* (New York and Oxford: Oxford University Press, 1991), esp. 227–247.
7. See *Artforum* 29 (March 1964): 55.
8. Trina Mitchum, "A Conversation with Ed Ruscha," *Southern California Art Magazine* (Los Angeles Institute of Contemporary Art), no. 21 (January–February 1979): 24.
9. Traveling outside California's culture industry of Hollywood and Disney, Ruscha's books allude as well to the technocratic culture that had gathered since the 1940s around the massive development of the aircraft and military defense industries and their companion think tanks in Los Angeles. See David Bourdon, "Ruscha as Publisher (or All Booked Up)," *Art News* 71 (April 1972): 33.
10. Dan Flavin, "Some Other Comments . . . : More Pages from a Spleenish Journal," *Artforum* 6 (December 1967): 27.
11. Bourdon, "Ruscha as Publisher," 68.
12. Ruscha first encountered the work of Evans and Frank while he was enrolled at Chouinard Art Institute. For Evans, the "documentary style" articulated a type of "photography without operators." See Walker Evans, "The Reappearance of Photography," reprinted in *Classic Essays on Photography*, ed. Alan Trachtenberg (New Haven, Conn.: Leete's Island Books, 1980), 186.
13. When asked about Duchamp's most important contribution, Ruscha first responded, "That he discovered common objects and showed you could make art out of them," adding, "He played with materials that were taboo to other artists at the time; defying convention was one of his greatest accomplishments." See Elizabeth

Armstrong, "Interviews with Ed Ruscha and Bruce Conner," *October* 70 (fall 1994): 56.
14. The public life of the readymades had just begun to gather momentum following the publication of the first monograph on the artist by Robert Lebel (1959) and the first retrospective exhibition of his work at the Pasadena Art Museum, *By or of Marcel Duchamp or Rrose Sélavy* (1963). See Henri Man Barendse, "Ed Ruscha: An Interview," *Afterimage* (Rochester) 8 (February 1981): 9.
15. Kirk Varnedoe and Adam Gopnik, "Comics," in *High and Low: Modern Art and Popular Culture*, exh. cat. (New York: Museum of Modern Art, 1990), 193.
16. See Bernard Brunon, "Interview with Ed Ruscha," in *Edward Ruscha*, exh. cat. (Lyon: Musée Saint-Pierre Art Contemporain, 1985), 95.
17. Ruscha, as quoted in Kerry Brougher, "Words as Landscape," in *Ed Ruscha*, exh. cat. (Washington, D.C.: Hirshhorn Museum and Sculpture Garden, 2000), 161.
18. Wall, "Marks of Indifference," 266.
19. Andy Warhol, *The Philosophy of Andy Warhol (From A to B and Back Again)* (New York: Harcourt Brace Jovanovich, 1975), 92.
20. See A. D. Coleman, "I'm Not Really a Photographer," *New York Times*, 10 September 1972.
21. Graham borrowed the photographic frame of his ad from the surrounding layout, which also inspired the work's title. Both layout and title were determined by the magazine's editors.
22. Benjamin H. D. Buchloh, "Moments of History in the Work of Dan Graham" (1977), in Jean-François Chevrier, Allan Sekula, and Benjamin H. D. Buchloh, *Walker Evans and Dan Graham*, exh. cat. (New York: Whitney Museum of American Art, 1992), 211.
23. Dan Graham, "Homes for America: Early Twentieth-Century Possessable House to the Quasi-Discrete Cell of '66," *Arts* 41 (December 1966–January 1967): 21.
24. Ibid.
25. As Evans explained, "You see, a document has use, whereas art is really useless. Therefore art is never a document, though it certainly can adopt that style. I'm sometimes called a 'documentary photographer,' but that supposes quite a subtle knowledge of the distinction I've made, which is rather new" (Leslie Katz, "Interview with Walker Evans," *Art in America* 59 [March–April 1971]: 87).
26. Graham, "Homes," 22.
27. Dan Graham, "My Works for Magazine Pages: 'A History of Conceptual Art,'" in Gary Dufour, *Dan Graham*, exh. cat. (Perth: Art Gallery of Western Australia), 12.
28. Maurice Blanchot, "Everyday Speech," in ibid., 13.

29. Henri Lefebvre, "The Everyday and Everydayness," reprinted in *Yale French Studies* 73 (1987): 9. During the 1960s Lefebvre's critique of everyday life was almost completely unknown outside France, where its call to transform the banality of the everyday environment was most actively taken up by the Situationists, but the concept of everyday life was made indirectly present through the reception of the *nouveau roman*.

30. Ibid.

31. Robert Smithson, "The Crystal Land," *Harper's Bazaar*, May 1966, 73.

32. Posed halfway between the beautiful and the sublime, the picturesque denotes "that peculiar kind of beauty [agreeable in a picture]" (William Gilpin, *An Essay upon Prints* [1768], rev. ed. [London: Cadell and Davies, 1802], 2) to be found (by its first aestheticians) in nature's rough and rugged subjects—in its ruined abbeys, moldering castles, gnarled oaks, shaggy goats, and raggedy shepherds—and to be cultivated (according to the second generation) by a gardening of "variety" and "intricacy" (Uvedale Price, Esq., *Essays on the Picturesque, as Compared with the Sublime and the Beautiful; and, on the Use of Studying Pictures for the Purpose of Improving Real Landscape*, vol. 1 [London: J. Mawman, 1810], 21). Extracted from the sphere of landscape painting, the aesthetic of the picturesque was easily absorbed by the photographic medium around the mid-nineteenth century, when it flourished in the popular illustrated travelogues of the time. Nearly another century later, when the picturesque came back into fashion, Smithson worked to supplant its static view of nature with "a process of ongoing relationships existing in a physical region" (Robert Smithson, "Frederick Law Olmsted and the Dialectical Landscape," in *The Writings of Robert Smithson*, ed. Nancy Holt [New York: New York University Press, 1979], 119).

33. Sidney Tillim, "Earthworks and the New Picturesque," *Artforum* 7 (December 1968): 43.

34. Robert Smithson to Robert Kotlowitz, microfilm reel no. 3833, frame 1092, Robert Smithson Papers, Archives of American Art, Washington, D.C.

35. Robert Smithson, "The Monuments of Passaic," *Artforum* 7 (December 1967): 51. Reference to all subsequent quotations from this article is made by page number.

36. Robert Smithson, "Incidents of Mirror-Travel in the Yucatan," *Artforum* 8 (September 1969), 28.

37. Immanuel Kant, *Critique of Judgment* (1790), trans. Werner S. Pluhar (Indianapolis: Hackett, 1987), 109.

38. Smithson, "Entropy and the New Monuments," in *Writings*, 11.

39. As the artist expanded elsewhere: "They are not built for the ages but rather against the ages. They are involved in a systematic reduction of time down to fractions of seconds, rather than representing the long spaces of history" (Smithson, "Entropy Made Visible," ibid., 191).

40. Smithson, "Entropy and the New Monuments," 10.

41. Jean-François Lyotard, "The Sublime and the Avant-garde," in *The Inhuman: Reflections on Time*, trans. Geoffrey Bennington and Rachel Bowlby (Stanford, Calif.: Stanford University Press, 1991), 99.

42. Robert Smithson, "A Sedimentation of the Mind: Earth Projects," in *Writings*, 84.

43. Robert Smithson, "Fragments of a Conversation," ibid., 170.

44. Smithson, "A Sedimentation," 90.

45. Bruce Kurtz, ed., "Conversation with Robert Smithson on April 22nd 1972," in *Writings*, 200.

46. See Wolfgang Max Faust, *Hunger nach Bildern: Deutsche Malerei der Gegenwart* (Cologne: DuMont, 1982).

Douglas Crimp

The Photographic Activity of Postmodernism (1980)

Originally published in *October*, no. 15 (winter 1980): 91–101.

> It is a fetishistic, fundamentally anti-technical notion of art with which theorists of photography have tussled for almost a century, without, of course, achieving the slightest result. For they sought nothing beyond acquiring credentials for the photographer from the judgment-seat which he had already overturned.
>
> Walter Benjamin, "A Short History of Photography"

That photography had overturned the judgment-seat of art is a fact which the discourse of modernism found it necessary to repress, and so it seems that we may accurately say of postmodernism that it constitutes precisely the return of the repressed. Postmodernism can only be understood as a specific breach with modernism, with those institutions which are the preconditions for and which shape the discourse of modernism. These institutions can be named at the outset; first, the museum; then, art history; and finally, in a more complex sense, because modernism depends both upon its presence and upon its absence, photography. Postmodernism is about art's dispersal, its plurality, by which I certainly do not mean pluralism. Pluralism is, as we know, that fantasy that art is free, free of other discourses, institutions, free, above all, of history. And this fantasy of freedom can be maintained because every work of art is held to be absolutely unique and original. Against this pluralism of originals, I want to speak of the plurality of copies.

Nearly two years ago in an essay called "Pictures," in which I first found it useful to employ the term *postmodernism*, I attempted to sketch in a background to the work of a group of younger artists who were just beginning to exhibit in New York.[1] I traced the genesis of their concerns to what had pejoratively been labeled the theatricality of minimal sculpture and the extensions of that theatrical position into the art of the seventies. I wrote at that time that the aesthetic mode that was exemplary during the seventies was performance, all those works that were constituted in a specific situation and for a specific duration; works for which it could be said literally that you had to be there; works, that is, which assumed the presence of a spectator in front of the work as the work took place, thereby privileging the spectator instead of the artist.

In my attempt to continue the logic of the development I was outlining, I came eventually to a stumbling block. What I wanted to explain was how to get from this condition of presence—the *being there* necessitated by performance—to that kind of presence that is possible only through the absence that we know to be the condition of representation. For what I was writing about was work which had taken on, after nearly a century of its repression, the question of representation. I effected that transition with a kind of fudge, an epigraph quotation suspended between two sections of the text. The quotation, taken from one of the ghost tales of Henry James, was a false tautology, which played on the double, indeed antithetical, meaning of the work *presence*: "The presence before him was a presence."

What I just said was a fudge was perhaps not really that, but rather the hint of something really crucial about the work I was describing, which I would like now to elaborate. In order to do so, I want to add a third definition to the word *presence*. To that notion of presence which is about *being there*, being in front of, and that notion of presence that Henry James uses in his ghost stories, the presence which is a ghost and therefore really an absence, the presence which is *not there*, I want to add the notion of presence as a kind of increment to being there, a ghostly aspect of presence that is its excess, its supplement. This notion of presence is what we mean when we say, for example, that Laurie Anderson is a performer with presence. We mean by such a statement not simply that she is there, in front of us, but that she is more than there, that in addition to being there, she has presence. And if we think of Laurie Anderson in this way, it may seem a bit odd, because Laurie Anderson's particular presence is effected through the use of reproductive technologies which really make her quite absent, or only there as the kind of presence that Henry James meant when he said, "The presence before him was a presence."

This is precisely the kind of presence that I attributed to the performances of Jack Goldstein, such as *Two Fencers*, and to which I would now add the performances of Robert Longo, such as *Surrender*. These performances were little else than presences, performed tableaux that were there in the spectator's space but which appeared ethereal, absent. They had that odd quality of holograms, very vivid and detailed and present and at the same time ghostly, absent. Goldstein and Longo are artists whose work, together with that of a great number of their contemporaries, approaches the question of representation through photographic modes, particularly all those aspects of photography that have to do with reproduction, with copies, and copies of copies. The extraordinary presence of their work is effected through absence, through its unbridgeable distance from the original, from even the possibility of an original. Such presence is what I attribute to the kind of photographic activity I call postmodernist.

This quality of presence would seem to be just the opposite of what Walter Benjamin had in mind when he introduced into the language of criticism the notion of the aura. For the aura has to do with the presence of the original, with authenticity, with the unique existence of the work of art in the place in which it happens to be. It is that aspect of the work that can be put to the test of chemical analysis or of connoisseurship, that aspect which the discipline of art history, at least in its guise as *Kunstwissenschaft*, is able to prove or disprove, and that aspect, therefore, which either admits the work of art into, or banishes it from, the museum. For the museum has no truck with fakes or copies or reproductions. The presence of the artist in the work must be detectable; that is how the museum knows it has something authentic.

But it is this very authenticity, Benjamin tells us, that is inevitably depreciated through mechanical reproduction, diminished through the proliferation of copies. "That which withers in the age of mechanical reproduction is the aura of the work of art," is the way Benjamin put it.[2] But, of course, the aura is not a mechanistic

concept as employed by Benjamin, but rather a historical one. It is not something a handmade work has that a mechanically-made work does not have. In Benjamin's view, certain photographs had an aura, while even a painting by Rembrandt loses its aura in the age of mechanical reproduction. The withering away of the aura, the dissociation of the work from the fabric of tradition, is an *inevitable* outcome of mechanical reproduction. This is something we have all experienced. We know, for example, the impossibility of experiencing the aura of such a picture as the *Mona Lisa* as we stand before it at the Louvre. Its aura has been utterly depleted by the thousands of times we've seen its reproduction, and no degree of concentration will restore its uniqueness for us.

It would seem, though, that if the withering away of the aura is an inevitable fact of our time, then equally inevitable are all those projects to recuperate it, to pretend that the original and the unique are still possible and desirable. And this is nowhere more apparent than in the field of photography itself, the very culprit of mechanical reproduction.

Benjamin granted a presence or aura to only a very limited number of photographs. These were photographs of the so-called primitive phase, the period prior to photography's commercialization after the 1850s. He said, for example, that people in these early photographs "had an aura about them, a medium which mingled with their manner of looking and gave them a plenitude and security."[3] This aura seemed to Benjamin to be a product of two things: the long exposure time during which the subject grew, as it were, into the images; and the unique, unmediated relationship between the photographer who was "a technician of the latest school," and his sitter, who was "a member of a class on the ascendant, replete with an aura which penetrated to the very folds of his bourgeois overcoat or bow-tie."[4] The aura in these photographs, then, is not to be found in the presence of the photographer in the photograph in the way that the aura of the painting is determined by the presence of the painter's unmistakable hand in his picture. Rather it is the presence of the subject, of what is photographed, "the tiny spark of chance, of the here and now, with which reality has, as it were, seared the character of the picture."[5] For Benjamin,

then, the connoisseurship of photography is an activity diametrically opposed to the connoisseurship of painting; it means looking not for the hand of the artist but for the uncontrolled and uncontrollable intrusion of reality, the absolutely unique and even magical quality not of the artist but of his subject. And that is perhaps why it seemed to him so misguided that photographs began, after the commercialization of the medium, to simulate the lost aura through the application of techniques imitative of those of painting. His example was the gum bichromate process used in pictorial photography.

Although it may at first seem that Benjamin lamented the loss of the aura, the contrary is in fact true. Reproduction's "social significance, particularly in its most positive form, is inconceivable," wrote Benjamin, "without its destructive cathartic aspect, its liquidation of the traditional value of the cultural heritage."[6] That was for him the greatness of Atget: "He initiated the liberation of the object from the aura, which is the most incontestable achievement of the recent school of photography."[7] "The remarkable thing about [Atget's] pictures . . . is their emptiness."[8]

This emptying operation, the depletion of the aura, the contestation of the uniqueness of the work of art, has been accelerated and intensified in the art of the past two decades. From the multiplication of silkscreened photographic images in the works of Rauschenberg and Warhol to the industrially manufactured, repetitively structured works of the minimal sculptors, everything in radical artistic practice seemed to conspire in that liquidation of traditional cultural values that Benjamin spoke of. And because the museum is that institution which was founded upon just those values, whose job it is to sustain those values, it has faced a crisis of considerable proportions. One symptom of that crisis is the way in which our museums, one after another, around 1970, abdicated their responsibility toward contemporary artistic practice and turned with nostalgia to the art that had previously been relegated to their storerooms. Revisionist art history soon began to be vindicated by "revelations" of the achievements of academic artists and minor figures of all kinds.

By the mid-1970s another, more serious symptom of the museum's crisis appeared,

the one I have already mentioned: the various attempts to recuperate the auratic. These attempts are manifest in two, contradictory phenomena: the resurgence of expressionist painting and the triumph of photography-as-art. The museum has embraced both of these phenomena with equal enthusiasm, not to say voraciousness.

Little, I think, needs to be said about the return to a painting of personal expression. We see it everywhere we turn. The marketplace is glutted with it. It comes in all guises—pattern painting, new-image painting, neoconstructivism, neoexpressionism; it is pluralist to be sure. But within its individualism, this painting is utterly conformist on one point: its hatred of photography. Writing a manifesto-like text for the catalogue of her *American Painting: The Eighties*—that oracular exhibition staged in the fall of 1979 to demonstrate the miraculous resurrection of painting— Barbara Rose told us:

> The serious painters of the eighties are an extremely heterogeneous group—some abstract, some representational. But they are united on a sufficient number of critical issues that it is possible to isolate them as a group. They are, in the first place, dedicated to the preservation of painting as a transcendental high art, and an art of universal as opposed to local or topical significance. Their aesthetic, which synthesizes tactile with optical qualities, defines itself in conscious opposition to photography and all forms of mechanical reproduction which seek to deprive the art work of its unique "aura." It is, in fact, the enhancement of this aura, through a variety of means, that painting now self-consciously intends— either by emphasizing the artist's hand, or by creating highly individual visionary images that cannot be confused either with reality itself or with one another.[9]

That this kind of painting should so clearly see mechanical reproduction as the enemy is symptomatic of the profound threat to inherited ideas (the only ideas known to this painting) posed by the photographic activity of postmodernism. But in this case it is also symptomatic of a more limited and internecine threat: the one posed to painting when photography itself suddenly acquires an aura. Now it's not only a question of ideology; now it's a real competition for the acquisition budget and wall space of the museum.

But how is it that photography has suddenly had conferred upon it an aura? How has the plenitude of copies been reduced to the scarcity of originals? And how do we know the authentic from its reproduction?[10]

Enter the connoisseur. But not the connoisseur of photography, of whom the type is Walter Benjamin, or, closer to us, Roland Barthes. Neither Benjamin's "spark of chance" nor Barthes's "third meaning" would guarantee photography's place in the museum. The connoisseur needed for this job is the old-fashioned art historian with his chemical analyses and, more importantly, his stylistic analyses. To authenticate photography requires all the machinery of art history and museology, with a few additions, and more than a few sleights of hand. To begin, there is, of course, the incontestable rarity of age, the vintage print. Certain techniques, paper types, and chemicals have passed out of use and thus the age of a print can easily be established. But this kind of certifiable rarity is not what interests me, nor its parallel in contemporary photographic practice, the limited edition. What interests me is the subjectivization of photography, the ways in which the connoisseurship of the photograph's "spark of chance" is converted into a connoisseurship of the photograph's style. For now, it seems, we can detect the photographer's hand after all, except of course that it is his eye, his unique vision. (Although it can also be his hand; one need only listen to the partisans of photographic subjectivity describe the mystical ritual performed by the photographer in his darkroom.)

I realize of course that in raising the question of subjectivity I am revising the central debate in photography's aesthetic history, that between the straight and the manipulated print, or the many variations on that theme. But I do so here in order to point out that the recuperation of the aura for photography would in fact subsume under the banner of subjectivity *all* of photography, the photography whose source is the human mind and the photography whose source is the world around us, the most thoroughly manipulated photographic fictions and the most faithful transcriptions of the real, the directorial and the documentary, the mirrors and the windows, *Camera Work*, in its infancy, *Life* in its heyday. But these are only the terms of style and mode of the agreed-upon spectrum of photography-as-art. The restoration of the aura, the consequent collecting and exhibiting, does not stop there. It is extended to the carte-de-visite, the fashion plate, the advertising shot, the anonymous snap or polaroid. At the origin of every one there is an Artist and therefore each can find its place on the spectrum of subjectivity. For it has long been a commonplace of art history that realism and expressionism are only matters of degree, matters, that is, of style.

The photographic activity of postmodernism operates, as we might expect, in complicity with these modes of photography-as-art, but it does so only in order to subvert and exceed them. And it does so precisely in relation to the aura, not, however, to recuperate it, but to displace it, to show that it too is now only an aspect of the copy, not the original. A group of young artists working with photography have addressed photography's claims to originality, showing those claims for the fiction they are, showing photography to be always a *re*presentation, always-already-seen. Their images are purloined, confiscated, appropriated, *stolen*. In their work, the original cannot be located, it always deferred; even the self which might have generated an original is shown to be itself a copy.

In a characteristic gesture, Sherrie Levine begins a statement about her work with an anecdote that is very familiar:

> Since the door was only half closed, I got a jumbled view of my mother and father on the bed, one on top of the other. Mortified, hurt, horror-struck, I had the hateful sensation of having placed myself blindly and completely in unworthy hands. Instinctively and without effort, I divided myself, so to speak, into two persons, of whom one, the real, the genuine one, continued on her own account, while the other, a successful imitation of the first, was delegated to have relations with the world. My first self remains at a distance, impassive, ironical, and watching.[11]

Not only do we recognize this as a description of something we already know—the primal scene—but our recognition might extend even further to the Moravia novel from which it has been lifted. For Levine's autobiographical statement is only a string of quotations pilfered from others; and if we might think this is a strange way of writing about one's own working methods, then perhaps we should turn to the work it describes.

At a recent exhibition, Levine showed six photographs of a nude youth. They were simply rephotographed from the famous series by Edward Weston of his young son Neil, available to Levine as a poster published by the Witkin Gallery. According to the copyright law, the images belong to Weston, or now to the Weston estate. I think, to be fair, however, we might just as well give them to Praxiteles, for if it is the *image* that can be owned, then surely these belong to classical sculpture, which would put them in the public domain. Levine has said that, when she showed her photographs to a friend, he remarked that they only made him want to see the originals. "Of course," she replied, "and the originals make you want to see that little boy, but when you see the boy, the art is gone." For the desire that is initiated by that representation does not come to closure around that little boy, is not at all satisfied by him. The desire of representation exists only insofar as it never be fulfilled, insofar as the original always be deferred. It is only in the absence of the original that representation may take place. And representation takes place because it is always already there in the world *as* representation. It was, of course, Weston himself who said that "the photograph must be visualized in full before the exposure is made." Levine has taken the master at his word and in so doing has shown him what he really meant. The a priori Weston had in mind was not really in his mind at all; it was in the world, and Weston only copied it.

This fact is perhaps even more crucial in those series by Levine where that a priori image is not so obviously confiscated from high culture—by which I intend both Weston and Praxiteles—but from the world

Cindy Sherman; *Untitled #66*, 1980; color photograph; 20 x 24 in. (50.8 x 61 cm); courtesy Metro Pictures

itself, where nature poses as the antithesis of representation. Thus the images which Levine has cut out of books of photographs by Andreas Feininger and Elliot Porter show scenes of nature that are utterly familiar. They suggest that Roland Barthes's description of the tense of photography as the "having been there" be interpreted in a new way. The presence that such photographs have for us is the presence of déjà vu, nature as already having been seen, nature as representation.

If Levine's photographs occupy a place on that spectrum of photography-as-art, it would be at the farthest reaches of straight photography, not only because the photographs she appropriates operate within that mode but because she does not manipulate her photographs in any way; she merely, and literally, *takes* photographs. At the opposite end of that spectrum is the photography which is self-consciously composed, manipulated, fictionalized, the so-called directorial mode, in which we find such *auteurs* of photography as Duane Michals and Les Krims. The strategy of this mode is to use the apparent veracity of photography against itself, creating one's fictions through the appearance of a seamless reality into which has been woven a narrative dimension. Cindy Sherman's photographs function within this mode, but only in order to expose an unwanted dimension of that fiction, for the fiction Sherman discloses is the fiction of the self. Her photographs show that the supposed autonomous and unitary self out of which those other "directors" would create their fictions is itself nothing other than a discontinuous series of representations, copies, fakes.

Sherman's photographs are all self-portraits in which she appears in disguise enacting a drama whose particulars are withheld. This ambiguity of narrative parallels the ambiguity of the self that is both actor in the narrative and creator of it. For though Sherman is literally self-created in these works, she is created in the image of already-known feminine stereotypes; her self is therefore understood as contingent upon the possibilities provided by the culture in which Sherman participates, not by some inner impulse. As such, her photographs reverse the terms of art and autobiography. They use art not to reveal the artist's true self, but to show the self as an imaginary construct. There is no real Cindy Sherman in these photographs; there are only the guises she assumes. And she does not create these guises; she simply chooses them in the way that any of us do. The post of authorship is dispensed with not only through the mechanical means or making the image, but through the effacement of any continuous, essential persona or even recognizable visage in the scenes depicted.

The aspect of our culture which is most thoroughly manipulative of the roles we play is, of course, mass advertising, whose photographic strategy is to disguise the directorial mode as a form of documentary. Richard Prince steals the most frank and banal of these images, which register, in the context of photography-as-art, as a kind of shock. But ultimately their rather brutal familiarity gives way to strangeness, as an unintended and unwanted dimension of fiction reinvades them. By isolating, enlarging, and juxtaposing fragments of commercial images, Prince points to their invasion by

these ghosts of fiction. Focusing directly on the commodity fetish, using the master tool of commodity fetishism of our time, Prince's rephotographed photographs take on a Hitchcockian dimension: the commodity becomes a clue. It has, we might say, acquired an aura, only now it is a function not of presence but of absence, severed from an origin, from an originator, from authenticity. In our time, the aura has become only a presence, which is to say, a ghost.

Notes

This paper was first presented at the colloquium "Performance and Multidisciplinarity: Postmodernism" sponsored by *Parachute* in Montreal, October 9–11, 1980.
1. Douglas Crimp, "Pictures," *October*, no. 8 (Spring 1979), 75–88.
2. Walter Benjamin, "The Work of Art in the Age of Mechanical Reproduction," in *Illuminations*, trans. Harry Zohn, New York, Schocken Books, 1969, p. 221.
3. Walter Benjamin, "A Short History of Photography," trans. Stanley Mitchell, *Screen*, vol. 13, no. 1 (Spring 1972), 18.
4. *Ibid.*, p. 19.
5. *Ibid.*, p. 7.
6. Benjamin, "Work of Art," p. 221.
7. Benjamin, "Short History," p. 20.
8. *Ibid.*, p. 21.
9. Barbara Rose, *American Painting: The Eighties*, Buffalo, Thoren-Sidney Press, 1979, n.p.
10. The urgency of these questions first became clear to me as I read the editorial prepared by Annette Michelson for *October*, no. 5, A Special Issue on Photography (Summer 1978), 3–5.
11. Sherrie Levine, unpublished statement, 1980.

Richard Prince; *Untitled (single man again)*, 1977–1978; Ektacolor photograph; 20 x 24 in. (51 x 61 cm); courtesy Barbara Gladstone Gallery, New York

Richard Prince, *Untitled (three men looking in the same direction)* (detail), 1978 (cat. no. 120)

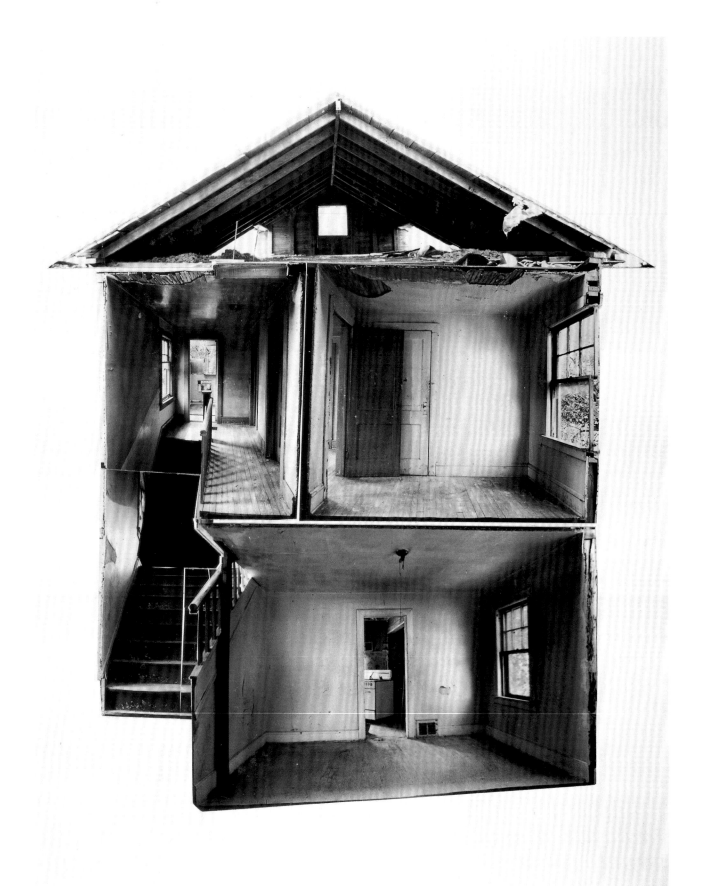

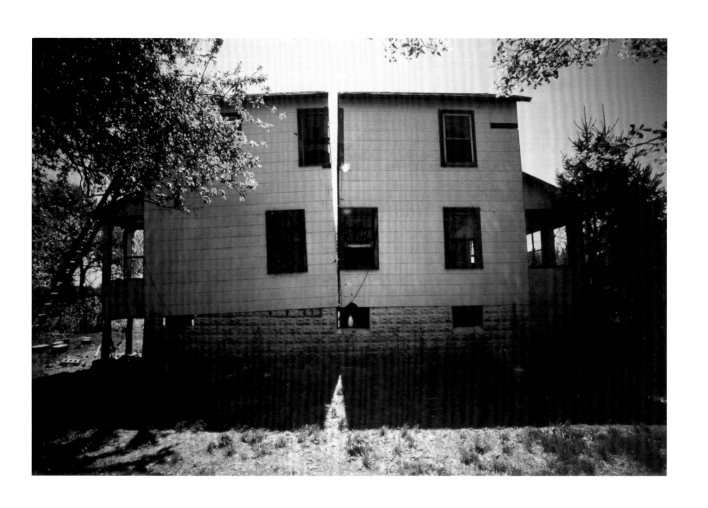

Left:
Gordon Matta-Clark, *Splitting*, 1974
(cat. no. 93)

Gordon Matta-Clark, *Splitting*, 1974
(cat. no. 92)

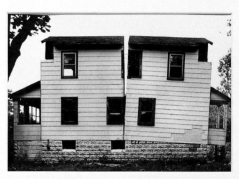

Gordon Matta-Clark, *Splitting: Exterior,*
c. 1974 (cat. no. 94)

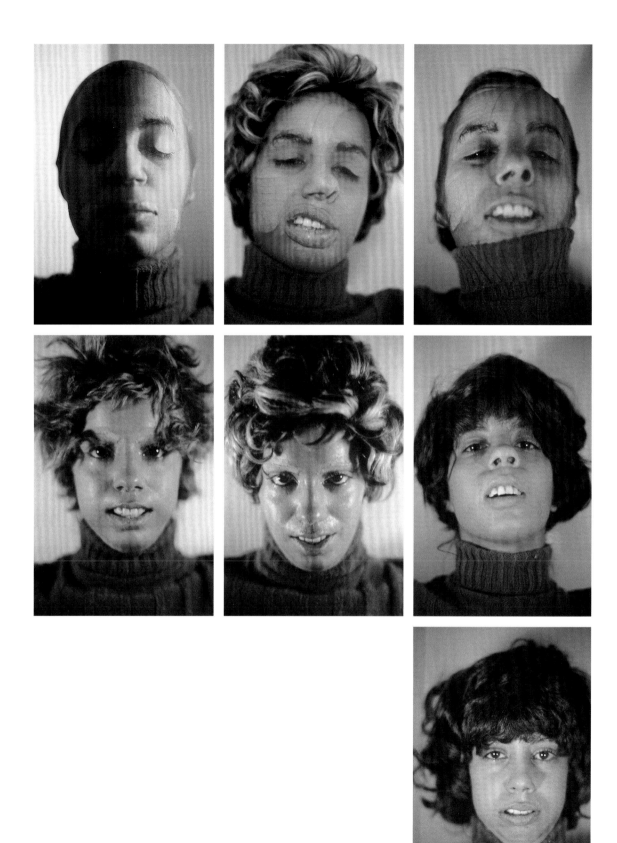

Ana Mendieta, *Untitled*
(Facial Cosmetic Variations), 1972/1997
(cat. no. 95)

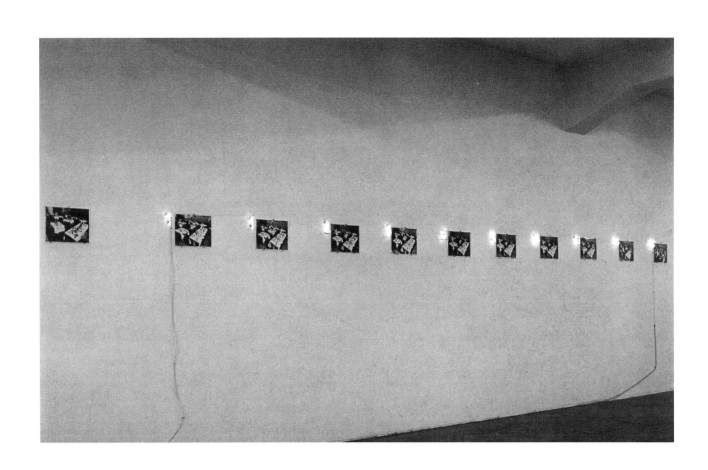

Mario Merz, *Fibonaccio 1202*, 1970
(cat. no. 96)
Right: details

Nasreen Mohamedi, Untitled, c. 1975
(cat. no. 102)

Nasreen Mohamedi, Untitled, c. 1970
(cat. no. 100)

Nasreen Mohamedi, Untitled, c. 1975
(cat. no. 104)

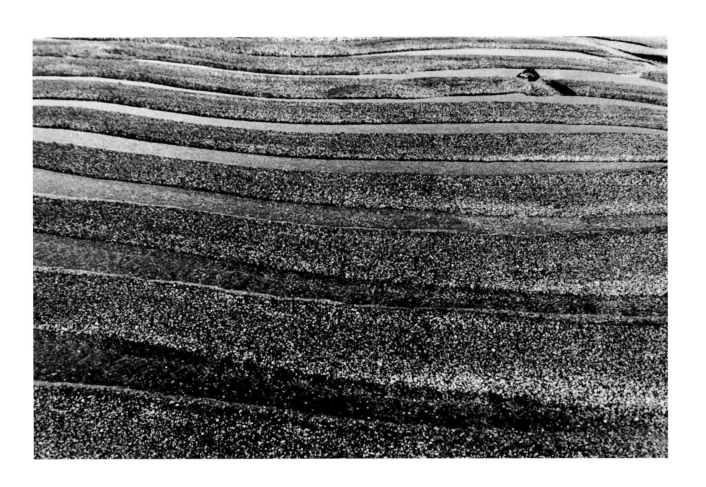

Nasreen Mohamedi, Untitled, c. 1972
(cat. no. 101)

Bruce Nauman, *Untitled (Potholder)*,
1966–1967/1970 (under cat. no. 106)

Bruce Nauman, *Waxing Hot*,
1966–1967/1970 (under cat. no. 106)

Bruce Nauman, *Eating My Words*,
1966–1967/1970 (under cat. no. 106)

Bruce Nauman,
Bound to Fail, 1966–1967/1970
(under cat. no. 106)

Bruce Nauman, *Finger Touch with Mirrors*,
1966–1967/1970 (under cat. no. 106)

Bruce Nauman, *Coffee Thrown away*
Because It Was Too Cold, 1966–1967/1970
(under cat. no. 106)

Bruce Nauman, *My Name as Though It Were Written on the Surface of the Moon: Bbbbbbbbbbrrrrrrrrrruuuuuuuuuuccccccccc ceeeeeeeeee*, 1967 (cat. no. 107)

Hélio Oiticica and Neville d'Almeida,
*03/CC 5 (Hendrix War, Cosmococa
Programa-in-Progress)*, 1973/2003
(cat. no. 108)

Hélio Oiticica and Neville d'Almeida,
*07/CC5 (Hendrix War, Cosmococa
Programa-in-Progress)*, 1973/2003
(cat. no. 110)

READING POSITION FOR SECOND DEGREE BURN
Stage I, Stage II. Book, skin, solar energy. Exposure time: 5 hours. Jones Beach. 1970

Dennis Oppenheim, *Reading Position for
Second Degree Burn*, 1970 (cat. no. 112)

GALLERY TRANSPLANT. 1969.
Floor specifications Gallery #3, Stedelijk Museum, Amsterdam, transplanted to
Jersey City, New Jersey. Surface: Snow, dirt, gravel. Duration: 4 weeks.

Dennis Oppenheim, *Gallery Transplant*,
1969 (cat. no. 111)

Giulio Paolini, *Proust*, 1968 (cat. no. 113)

Giuseppe Penone, *Svolgere la propria pelle*
(To display one's skin), 1971 (cat. no. 114)
Right: details

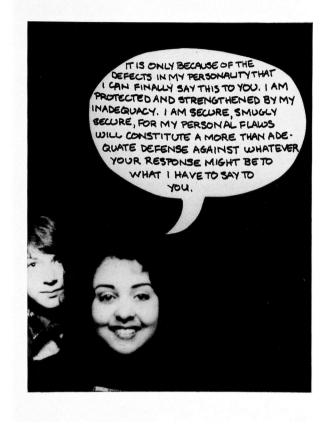

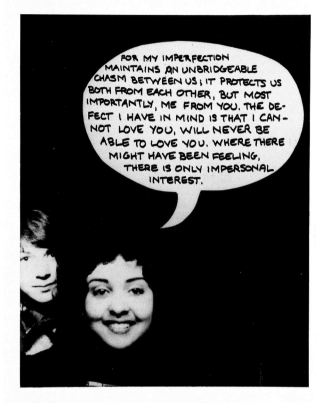

Adrian Piper, *The Mythic Being:*
I/You (Her) (details), 1974 (cat. no. 116)

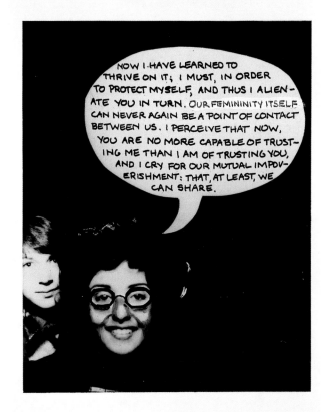

The Mythic Being: I/You (Her), 7.

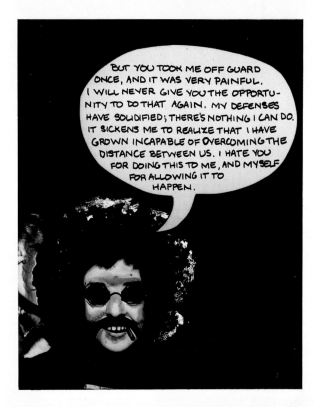

The Mythic Being: I/You (Her), 10.

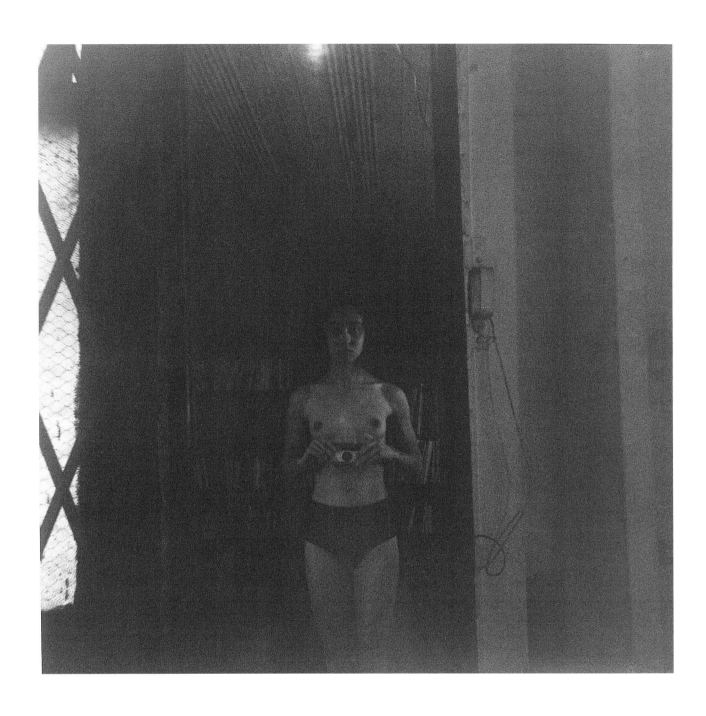

Adrian Piper, *Food for the Spirit* (details),
1971 (cat. no. 115)

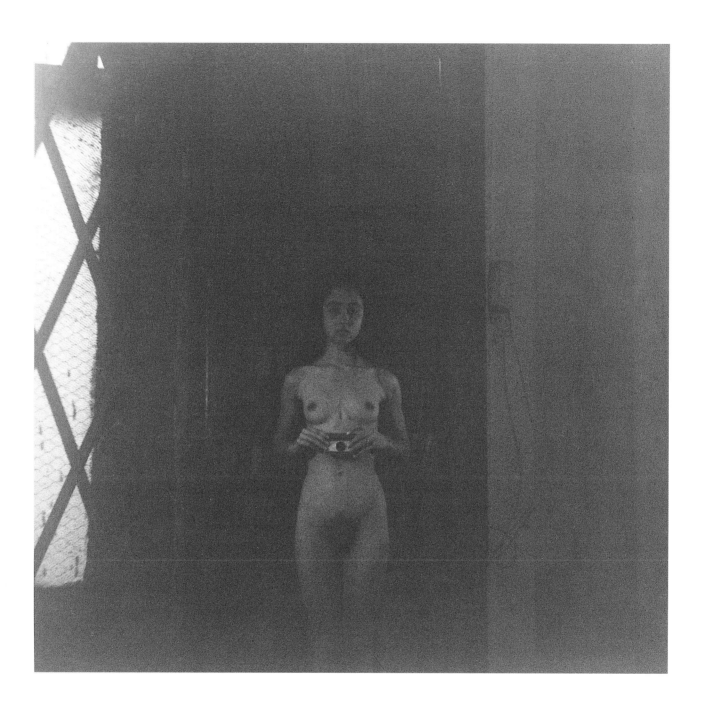

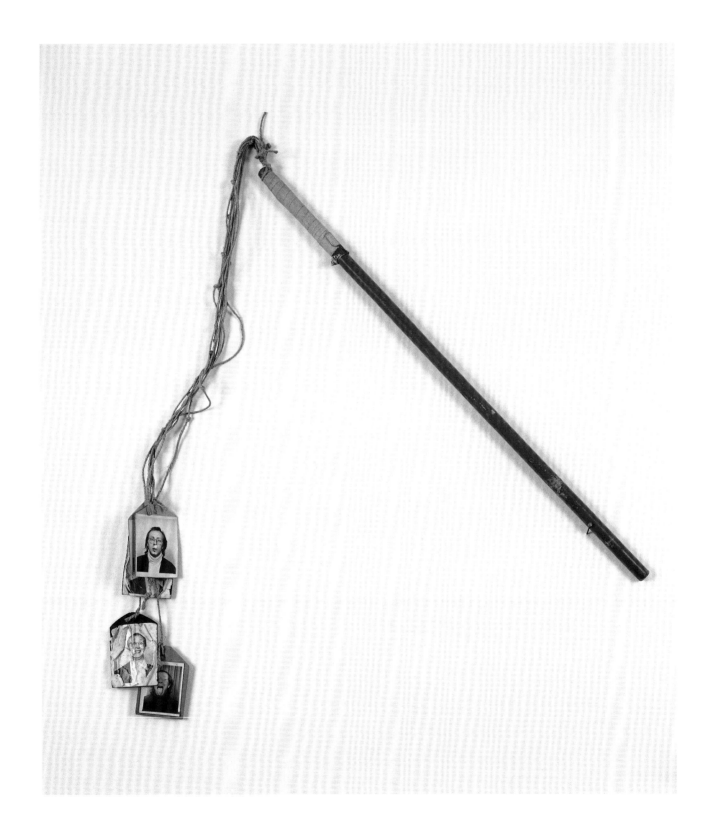

Sigmar Polke, *Polkes Peitsche*
(Polke's whip), 1968 (cat. no. 117)

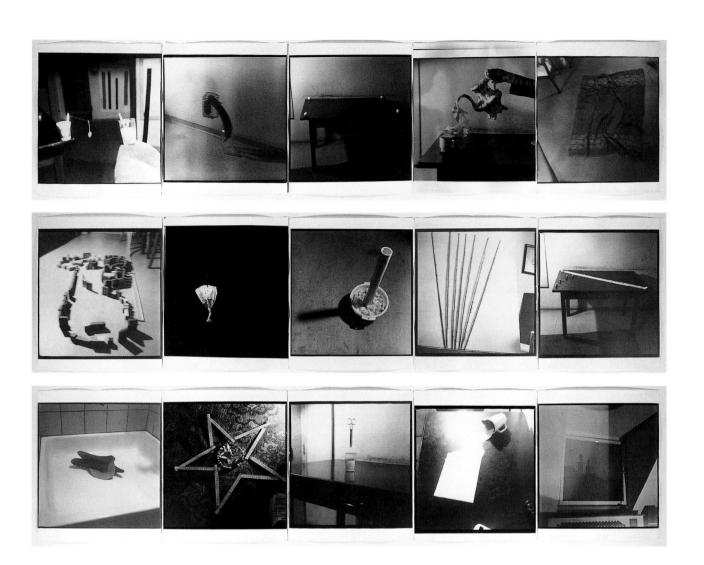

Sigmar Polke, *Bamboostange liebt
Zollstockstern* (Bamboo pole loves folding
ruler star), 1968–1969 (cat. no. 118)

Top:
Richard Prince, *Untitled (three men
looking in the same direction)*, 1978
(cat. no. 120)

Bottom:
Richard Prince, *Untitled (three women
looking in the same direction)*, 1980–1984
(cat. no. 121)

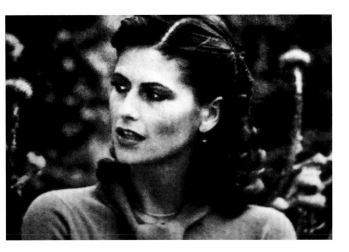

Richard Prince, *Untitled (living rooms)*, 1977 (cat. no. 119)

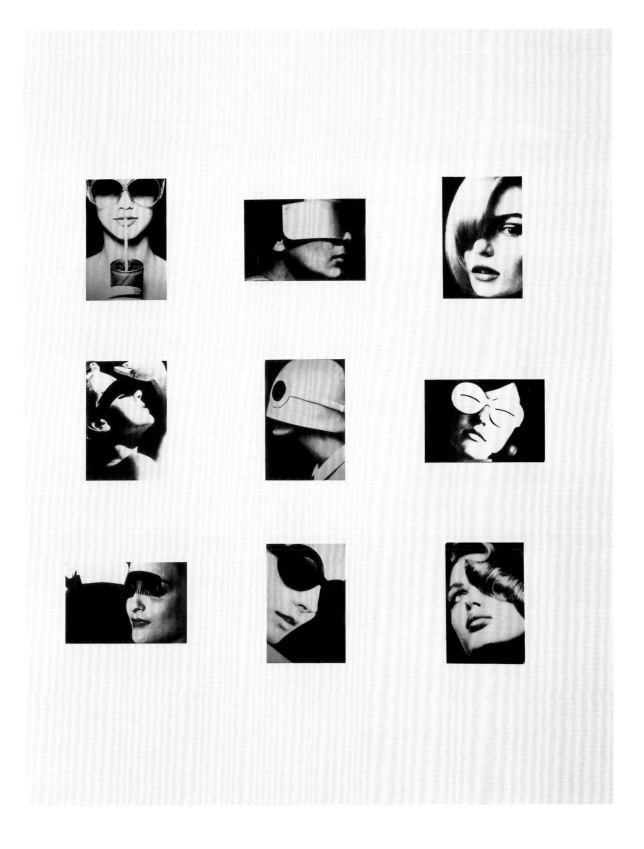

Richard Prince, *Untitled (gang)*,
1982–1984 (cat. no. 122)

Sherrie Levine

Statement (2002)

Originally published in Isabelle Grau, interview with Sherrie Levine, *Texte zur Kunst* 12, no. 46 (2002): 84–85.

When I began this work, I considered myself a still-life artist—with the bookplate as my subject. I wanted to make pictures that maintained their reference to the bookplates. And I wanted my pictures to have a material presence that was as interesting as, but quite different from, the originals.

I wanted to make pictures that contradicted themselves. I wanted to put one picture on top of another so that there were times when both pictures disappear and other times when they were both manifest. That vibration is basically what the work was about for me—that space in the middle where there's no picture, rather an emptiness, an oblivion.

You build energy by the interaction between things. One and one don't always make two, but sometimes five or eight or ten, depending on the number of interactions you can get going in a situation. Like the burlesque comedian, I am abnormally fond of that kind of precision that creates movement: A hot dog walks into a bar and asks for a drink. The bartender says, I'm sorry, Sir, we don't serve food here.

Certainly there is a contentious and oedipal aspect to my work. But I don't think it's useful to see dominant culture as monolithic or only patriarchal. I'd rather see it as polyphonic with unconscious voices, which may be at odds with one another. If I am attentive to these voices, then maybe I can collaborate with some of them to create something almost new.

Barbara Kruger

Incorrect (1982)

Originally published in *Effects*, no. 1 (summer 1983); reprinted in Barbara Kruger, *Remote Control: Power, Cultures, and the World of Appearances* (Cambridge: MIT Press, 1993), 220–221.

Photography has saturated us as spectators from its inception amidst a mingling of laboratorial pursuits and magic acts to its current status as propagator of convention, cultural commodity, and global hobby. Images are made palpable, ironed flat by technology and, in turn, dictate the seemingly real through the representative. And it is this representative, through its appearance and cultural circulation, that detonates issues and raises questions. Is it possible to construct a way of looking which welcomes the presence of pleasure and escapes the deceptions of desire? How do we, as women and as artists, navigate through the marketplace that constructs and contains us? I see my work as a series of attempts to ruin certain representations and to welcome a female spectator into the audience of men. If this work is considered "incorrect," all the better, for my attempts aim to undermine that singular pontificating male voiceover which "correctly" instructs our pleasure and histories or lack of them. I am wary of the seriousness and confidence of knowledge. I am concerned with who speaks and who is silent: with what is seen and what is not. I think about inclusions and multiplicities, not oppositions, binary indictments, and warfare. I'm not concerned with pitting morality against immorality, as "morality" can be seen as a compendium of allowances inscribed within patriarchy, within its repertoire of postures and legalities. But then, of course, there's really no "within" patriarchy because there's certainly no "without" patriarchy. I am interested in works that address these material conditions of our lives: that recognize the uses and abuses of power on both an intimate and global level. I want to speak, show, see, and hear outrageously astute questions and comments. I want to be on the sides of pleasure and laughter and to disrupt the dour certainties of pictures, property, and power.

Richard Prince

The 8-Track Photograph
(1977–1978)

Excerpts from unpublished artist's notebooks,
c. 1977–1978.

The 8-Track Photograph *(Beat this Rap Jack)*

1. original copy
2. re-photographed copy
3. angled copy
4. cropped copy
5. focused copy
6. out-of-focused copy
7. black and white copy
8. color copy

Each track (or reproduction), is a program. Each program
a code. These codes can be produced **with** commercially avail-
able materials from commercially available sources. The dis-
play of any program or combination of programs can be selected
quickly because of availability. This availability always
exists due to each programs independence from other programs.
It is never a question of addition or subtraction, since each
track is ~~always available to program~~. The primary advantage
is that the componants of the picture exist on bankable tracks.
Whatever state the picture finally exists in.... the states
that helped to make the photograph exist, continue to exist
until called for again.

*since each track is an independent component
to*

The 8-track photograph

Move, delete, menu, cursor, keypad, commanding the picture, picture-display, stored, memory, the picture can be "called-on", cropped, rotated, enlarged, enchanced, eliminated....

instead of rendered and once called can be

there is no more air-brush, paint, aritsts knieves, rubber cement

pre-plating functions such as cutting, pasting, stipping in are now preformed electronically. *with electronic scissors-*

IF A PICTURE WAS ONCE WORTH A THOUSAND WORDS, ONE SQUARE INCH OF AN IMAGE IS WORTH ~~XXXX~~ 360,000 BYTES OF COMPUTER STORAGE SPACE, *the spaces in a picture are now numbers and letters on a keypad which when depressed commands the picture*

Let's say This pr: story is picture

the Hell Chromacom turns images into numbers
you see the action on the monitor *(Teleprompter*
electoronic scissors

Right now esstentially what you have is the opportunity to actually see what your picture could look like before you committ it to paper

TYPING PICTURES

WRITING PHOTOGRAPHS *438 w 14th St nyc 1577*

The thing of it is, is that we already have one - we ~~can~~ are born with them, carry them around in our heads

you Try to get as close as possible to the object of our disgust

The arts should arouse in us, the highest possible degree of anxiety.

you must try to avoid becoming enclosed within the limitations of reason.

The honourable human being loyally accepts the worst consequences of his challenge

There's a certain point where the real & imaginary cease to be contradictions

** I want to produce what is refused by reality*

The act of destruction can be sensual

you have to come to some terms with extended adolesance - puerile instints

revolt against the real world. - escape from the common limitations of life.

Let me stand Next To your fire

Richard Prince

The Velvet Well
(1983)

Originally published as "The Velvet Well: An
Excerpt from Why I Go to the Movies Alone,"
Effects, no. 1 (summer 1983): 7.

The first time he saw her, he saw her in
a photograph. He had seen her before,
at her job, but there, she didn't come across
or measure up anywhere near as well as
she did in her picture. Behind her desk she
was too real to look at, and what she did
in daily life could never guarantee the effect
of what usually came to be received from an
objective resemblance. He had to have her
on paper, a material with a flat and seam-
less surface . . . a physical location which
could represent her resemblance all in one
place . . . a place that had the chances of
looking real, but a place that didn't have
any specific chances of being real.

His fantasies, and right now, the one of
her, needed satisfaction. And satisfaction,
at least in part, seemed to come about by
ingesting, perhaps "perceiving," the fiction
her photograph imagined.

She had to be condensed and inscribed
in a way that his expectations of what he
wanted her to be, (and what he wanted
to be too) could at least be possibly, even
remotely, realized. Overdetermination
was part of his plan and in a strange way,
the same kind of psychological after-life
was what he loved, sometimes double
loved about her picture.

It wasn't that he wanted to worship her.
And it wasn't that he wanted to be taxed
and organized by a kind of uncritical devo-
tion. But her image did seem to have a
concrete and actual form . . . an incarnate
power . . . a power that he could willingly
and easily contribute to. And what he
seemed to be able to do, either in front
or away from it, was pass time in a particu-
lar bodily state, an alternating balance
which turned him in and out and made
him see something about a life after death.

Molly Nesbit

Without Walls

Molly Nesbit is professor of art history at Vassar College and a contributing editor of *Artforum*. She was cocurator, with Hans Ulrich Obrist and Rirkrit Tiravanija, of *Utopia Station* at the 2003 Venice Biennale. She is the author of *Atget's Seven Albums* (Yale University Press, 1992) and *Their Common Sense* (Black Dog, 2000). This essay was originally published, in slightly different form, as "Bright Light, Big City: The '80s without Walls," in *Artforum* 41 (April 2003): 184–189, 245, 248.

In Buffalo, in art school, Cindy Sherman sat down in a photo booth and gave the camera a look. She came up under Lucille Ball's face so successfully that her own face subsided. Most people her age were swimming in another direction, preferring the pond of their own nonconformity. Hers was a different, though still contrary position: the negative of your negative is my Lucy. This idea had led her first toward elaborately unpredictable appearances at parties. Her boyfriend, the artist Robert Longo, suggested she combine them and her work. Was he proposing an imitation of life? They moved to New York together in the summer of 1977, the summer of the blackout and the string of murders by a man calling himself the Son of Sam.

That same year David Salle, who had come to New York from CalArts in 1975, took a job teaching drawing at the Hartford School of Art. He brought various friends there to help, among them Sherrie Levine. She herself had arrived from Madison, via Berkeley, having had her own experience of work and play. She had made a series of short Super 8 movies. One of them let six cowgirl candles burn down to a puddle, weeping, she noted later, like a country-western song, but in silence.[1] Bruce Nauman, when he saw this, felt the result was boring. She took this as reason enough to destroy the whole series.

Permanent silence seemed not to be fatal. Levine taught a course in Hartford on the work of Douglas Sirk. She and David Salle plunged themselves into the aesthetics of melodrama. They fixed on Sirk's *Imitation of Life*.[2] *Imitation of Life* had appeared in 1959, when they were children, at the end of the decade that had seen and loved six seasons of *I Love Lucy*. Sirk's film showed the danger that lay in wait for every success and star. Salle took Sirk's warning back to his studio and wrote a set of statements designed to set out the issues for his own work: "The pictures present an improvised view of life as normal. Life is shown as we think we see it but in fact never do. The pictures imitate life to find a way out."[3] There was New York.

They had all come to a city fabled for its art. They settled themselves downtown, into the new center of activity in SoHo, and took stock. Around them the entire economy had fallen into the grip of a deep and slowly grinding recession. There were no galleries coming to call, no sense that a person wanting to perform great art experiments could expect to make a living from them, much less obtain general recognition. Louise Lawler, who had come to the city earlier from Cornell, could have told them this.[4] These conditions would require inventing the space for their art. They had come to a place without walls.

Spaces were being invented, spaces for living, spaces for eating, spaces for nightlife. Inside and outside were indistinguishable. If their day jobs were necessary and various, bottom-feeding along the commercial art hierarchies or teaching nursery school or cooking in restaurants or sitting fairly dutifully at a reception desk, their own free time merged. Collective life led to collective art life. The place names were generic but memorable: Artists Space, the Kitchen, Franklin Furnace, 112 Greene Street, Printed Matter, the Performing Garage.[5] One of Louise Lawler's place-mat pictures had to be rescued from Food, the early seven-

ties restaurant-collective now best known as the brainstorm of Gordon Matta-Clark, when the police padlocked it temporarily. With the accumulation of friendship, collaboration, and exchange, none of their work was completely individual. Call it instead independent.

What to put where? Sherrie Levine would put seventy-five pairs of small shoes, sized for a child but styled for a man, on sale at the Three Mercer Street Store. That she had found them at a California job lot sale hardly mattered. Artists could work through any economy, the thrift economy too. The money economy proved more difficult. She made a series of silhouettes taken from the penny, the quarter, and the new half-dollar coin, painting the presidents so that they faced each other, flatly fluorescent on small sheets of graph paper. She called them *Sons and Lovers*. She happily parodied D. H. Lawrence. Douglas Crimp included them in the group show he did at Artists Space in the fall of 1977. He called it *Pictures*. *Pictures* also announced a twenty-six-second film loop by Jack Goldstein called *The Jump*, in which he had altered some stock footage so that one saw only a human silhouette filled with a light effect repeatedly run, jump, and dive, piking stylishly off the end of an unseen board into perfect darkness that, like a psychedelic reflex, swallowed it whole. Crimp put it first in his catalogue essay.[6] In hindsight *The Jump* looks like a pure description of a professional situation.

Cindy Sherman; Untitled, 1975; sepia-toned black-and-white photograph; 10 x 8 in. (25.4 x 20.3 cm); courtesy Metro Pictures, New York

Still from Douglas Sirk's *Imitation of Life* (1959), with Lana Turner and John Gavin

Two years later *Artforum* sent out a questionnaire asking artists to address the change in the general professional situation or, as it diplomatically put it, the change in the audience.[7] Assuming, Vito Acconci said, that the gallery could still be considered the space of operations, one had two options: either to use the gallery like language, as a sign, and for all intents and purposes turn it into a book, or to use the gallery as the space where art itself occurred while someone else watched. In the 1970s he had taken the second option, which meant that the gallery then became something else, "a community meeting-place, a place where a community could be formed, where a community could be called to order, called to a particular purpose." The community was understood to be an art community. "The art public was, in effect, a substitute for 'community,'" he noted, "but, at least, this was a way to work *in* a public rather than *in front of* a public."[8] In 1976, in the pages of *Arts Magazine*, David Salle had already paid Acconci the supreme compliment of calling him the anthropologist of his own universe.

The terrible scale of the world outside this universe, outside the galleries too, the infinity that drove its wedge into every little certainty, struck Salle early. He tried to locate the artist: "Never underestimate either the seriousness of ambivalence or the malaise of the vastness, or the attempt at vastness, of scholarship which is not really invoked to explain anything, but only used to keep going. You take ten people, get each one to tell a joke (usually not funny at all). Someone comes along, tells the joke badly—you laugh your head off. This is why Vito Acconci is an artist."[9] This was a way to begin, a way to become a figure in the vastness. Take steps, games, awkward jokes, black humor. Turn the

received idea into the devil's plaything. Play the infinity itself backwards. These were thoughtful, not adolescent moves. The scholar of this vastness, however, was someone else, whom Salle had neither met nor read. It is difficult to address art's inherited relationship to the expanse of the world without citing and turning to the scholar. In English his magnum opus is known as *The Voices of Silence*.

The Voices of Silence was written by André Malraux during a fifteen-year period that included the Second World War. Though considered a classic by the 1970s, it was circulating mostly as an echo in the work of later authors. George Kubler's *Shape of Time*, John Berger's *Ways of Seeing*, and Brian O'Doherty's series of *Artforum* articles that would become *Inside the White Cube* all showed the effects of Malraux's epic, as did Roland Barthes' *Mythologies*, written soon after *The Voices of Silence* appeared. Barthes had taken Malraux's law of metamorphosis and from it developed his concept of myth, that peculiar, bourgeois type of speech made by leeching a sign and corrupting its meaning. He had taken his examples from the Americanized mass culture then pouring into France, epitomized by myths like Greta Garbo's face.[10] The problem under consideration here, how to find forms that can address

the vastness, has a history that is and is not an art history, that is and is not American.

Malraux too was concerned with the contemporary predicament; he had, however, introduced his law of metamorphosis differently—by recounting the plight of the masterpiece, uprooted from its human time and place and left drained, bleak, alone, in the museum. He wrote of a double displacement being made by the newest act of preservation, what he termed the Museum without Walls being organized by default in a mind overstimulated by the expanding archive of the photographic reproduction. He saw a great threat. It came from the formalisms and professionalism of a modern art culture keeping art from its chief and ancient business, the confrontation with the totality of experience and fate. True arts and cultures, Malraux went on to say, put man into a relation with duration and sometimes with eternity, "and make of him something other than the most-favored denizen of a universe founded on absurdity." "No culture has ever delivered man from death," he wrote a few pages later, "but the great cultures have sometimes managed to transform his outlook on it, and almost always to justify its existence. . . . What the tragic art of modern times is trying to do away with is the gag of lies with which civilization

Cindy Sherman, *Untitled Film Still #48*, 1979 (cat. no. 152)

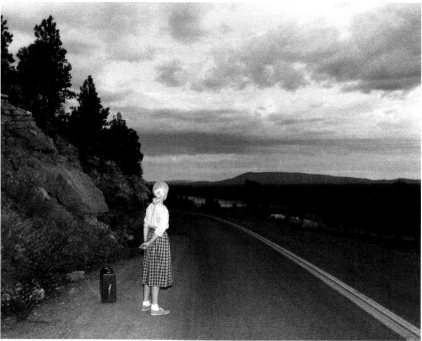

Jack Goldstein; *The Jump*, 1978; still from a color film in 16 mm; 26 seconds; courtesy 1301 PE, Los Angeles

stifles the voice of destiny." Art was meant to bear this kind of knowledge, "a limbo of negations," Malraux concluded.[11] This was the darkness, the danger, that still greeted the young artist.

At some point while revising the final chapters in 1951, Malraux watched a new storm of metamorphosis come. The ghost of Hegel had been haunting him all along, helping him chart the rhythms of metamorphosis in the vastness and see the fluctuations moving necessarily into negativity in order to make any progress, and the specter kept striking its low chords offstage. Remember Hegel? "The History of the World is not the theatre of happiness," Hegel had intoned. "Periods of happiness are blank pages in it, for they are periods of harmony—periods when the antithesis is in abeyance."[12] How not to hear Hegel in the back of Malraux's mind, lecturing on the philosophy of history?[13]

Yet Hegel had given Malraux the direction to go looking for the future. The quantum change he was witnessing, Malraux thought, as Hegel had, might be linked to the birth of an American culture, which he had described as the home of an extremely efficient publicity descended in fact from one of painting's traditions and "making for its canned goods a Museum without Walls of foodstuffs."[14] Owing to the Cold War, however, Malraux could not yet predict much. Would the changes in the twentieth century spring from the final triumph of Russian communism or even from the resurrection of Europe?[15] Malraux did not commit himself. But now we see that he was announcing the new priorities that Barthes would analyze and that would, a decade later in Fluxus and Pop, produce the massive breakdown of the hierarchies that had kept commercial art and its forms separate, at least theoretically, from the noble aesthetic pursuits. We have been schooled in the literature chronicling this collapse.[16] Let us say only that by the 1970s the irresolution of history itself was apparent in New York. The term *postmodern* was not needed to see this. Generically speaking, no walls. Institutionally speaking, few walls. Any and all media were available. Stories were shattering and rising. The youth cultures multiplying and mutating added momentum and pulse.[17] Young artists coming to the city found an unusually open theater of operations that found its physical equivalent every time the lights

went down at the movies. They would find their rhetoric of form there.

This choice came heavy with implications. The movies had inherited the old social role of the theater. Like the theater, they were central to the mediation of long-term social processes that had for more than five hundred years been pulling populations into cities. Their overwhelming importance was a given. By the end of the nineteenth century Nietzsche could lean without comment on the maskers' trope as he castigated his age, reserving the full weight of his scorn for those who fell under the spell of the banal pressure to take on a given role until it became instinct. Those intent upon success, Nietzsche remarked, had had to become skilled players, had cut their coat according to the available cloth and had adapted to every shift of circumstance and wind to such a degree that they had become the coat themselves, if it had not already become them.[18] In the twentieth century things changed slightly. One now became the coat, the same instinctual coat, with the help of a mirror.

It would not take long for the new advertising industry to claim the mirror image and produce new mechanisms for social and commercial identification. Every day Hegel's "automatic self-mirroring activity of consciousness" found practical application.[19] All kinds of thinkers and artists could readily see a reflection's central importance. In some cases, as with the psychoanalyst Jacques Lacan, a mirror alone set the development of human subjectivity into motion. When in the mid-1950s the sociologist Edgar Morin wrote of the cinema's great attraction, he tracked the parallel movement of the star's life in his or her roles and the self-consciousness of the ordinary person: "the 'I' is first of all an

Cindy Sherman; *Untitled #66*, 1980; color photograph; 20 x 24 in. (50.8 x 61 cm); courtesy Metro Pictures, New York

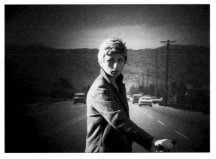

other, a double, that reveals and pinpoints the shadows, reflections, the mirrors. The double wakens when the body sleeps, it is freed and becomes 'spirit' or ghost when the body no longer wakes up. It survives the mortal. The gods will separate themselves from the common dead to become the great immortals. The double lies at the origin of the gods."[20] Modern life, he noted, had forced the double to atrophy and paste itself flat against the body's skin; it has become our "role," he said; all duality had been submerged, forced inside. The star had the power to revive the archaic force of the double and let it live elsewhere. Life being more than a hall of coats, or gloves. This was the life being set up for imitation in 1977. It was hardly superficial or conceptually thin. It was a life to uncover and discover. For the time being, walls were secondary.

After arriving in New York, Cindy Sherman and Robert Longo went one day to David Salle's loft and there saw, spread around, photos spirited out of the archive of the pulp magazine publisher where Salle had a day job. There lay cheap pictures of soft-porn starlets posing and exposing. Sherman saw them enacting picture stories, little novellas, and she took the idea back to her own work with characters. It was no longer possible for her to

Cindy Sherman, *Untitled Film Still #6*, 1977 (cat. no. 135)

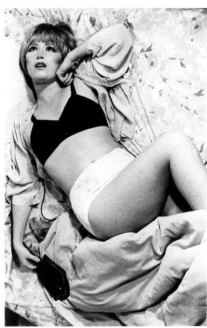

imagine personifying a star; nor did she experiment with her characters on the street. The street was already too full of people in their camouflage, New York being a city where an everyday theater of the self was viewed as both normal and necessary, a Nietzschean protection. Sherman began to make imitation film stills of herself in poses, the first six pictures showing the same blonde starlet at different points. "The role-playing was intended to make people become aware of how stupid roles are, a lot of roles," she said later, "but since it's not all that serious, perhaps that's more the moral to it, not to take anything too seriously."[21] She let her starlet go forth as a baby doll, face ready for the world but otherwise undressed, flopped on a bed, paralyzed by a thought that seemed to be crossing her mind very slowly. The light overhead shone evenly. Her hand mirror was dramatically thrown aside. Was another image coming to mind as a better alternative?

Later Sherman took her shots and her characters one by one. She arrived at them by poring over books about the movie idols of her childhood, unfocusing her memory and trying from that blurred point to embody the increasingly distant reflection. She thought of her face as a blank canvas.

Her characters kept a degree of this blankness, of a reflection that seemed incompletely bleached, its roots somehow still showing a darkness that was not a color.

She dressed herself in clothes from thrift shops. This let her pictures cut time two ways: fifties and sixties dresses could look old and new because of the contemporary aesthetic of thrift. This too was a thoughtful move. Thrift culture was being embraced in the 1970s as an antidote, the refusal of commercial fashion and its dictate to imitate; those who wore thrift were living simply, closer to the ground, using the old coat as a badge of alienation. "My 'stills' were about the fakeness of role-playing," Sherman said, "as well as contempt for the domineering 'male' audience who would mistakenly read the images as sexy."[22] She might as well have said, "Under my cloak, the king is a joke," the line Cervantes used to begin the tale of Don Quixote.[23] These were jokes to lean on and to drink to. Someone somewhere was always laughing her head off. Sherrie Levine's shoes made similar points.

Neither small shoes nor film stills offered the recipe for freedom, but they did show a woman opening a space for herself in the narrower spectrum of her choice. Might it

be possible to pry a person from her shell? Sherman kept her work at one remove from stardom, aspiring to a life rather than imitating it exactly, working loosely with the lesser lights.[24] The first results were shown at Artists Space in the fall of 1978 in a group show curated by Janelle Reiring. There she shared a space with Louise Lawler, Christopher d'Arcangelo, and Adrian Piper.[25]

That year Lawler made her own one-time character experiment disguised as Mata Hari for a book cover.[26] For Artists Space, however, she abandoned the figure completely and instead used two lights to break apart the givens of figure, picture, and theater. The scene was extreme. There was a spotlight glaring inside and a pink searchlight shining outside. On the empty wall hung a borrowed painting of a racehorse for whom all bets were off a long time ago. There was no race. The bright lights took over everything. "You are standing in your own shoes," Lawler says now. You have walked into a situation that has rearranged your own world and made you well aware of it.[27] In other words, you as an image are gone. The room was flooded, but there was neither an image nor the reflection of an image. Light moved the ground without becoming the ground. On other occasions Lawler let matters go completely dark. In Santa Monica in 1979, she arranged for a midnight screening at a local movie theater. On the marquee it was advertised as *A Movie without a Picture*, and it was just that, *The Misfits*, shown with the lights in the projector out, voices rising and falling away, but always voices without silence.

The work in the place with few walls had pushed them to concentrate on the definition of the individual figure, its silhouette, its limits, its surface and interior business. This had led them to see the vastness in

Louise Lawler; *A Movie Will Be Shown without a Picture*, 1979; Aero Theater, Santa Monica, California; courtesy the artist

Louise Lawler; untitled installation at Artists Space, New York, 1978; courtesy the artist

the figure itself, a vastness for which there would be no single pictorial equivalent, no single sign, only approximations that in their work became even more approximate as the different layers of a figure were explored. The light effects native to mass culture became the artist's scalpel; the same light effects gave these artists their material: spotlights; floodlights; fluorescent pigment; overhead, slide, and rear projectors were all put to work. These light effects did not coalesce into a code of shapes and forms, or settle into someone's definition of a medium. They overstepped their old function as modifiers. The picture of the figure was dissolving into a multiplicity, a limbo of quasi-negativity from which it would not be rescued, only bathed. It did not seem to be attached to a new meaning.

Light effects were being revealed as effects. The figure was being revealed as another effect, a social character. For their figures, these artists often relied upon images that they had found, reusing them, refilling them partly sometimes or lifting them lightly into transfers. Some called this allegory.[28] Better to say that the image too was entering into the general culture of thrift. Somewhat paradoxically, this time of thrift led to the picture of an impossibly younger, untraditional, unknowable self. Salle, Sherman, Lawler, and Levine were still making their work for themselves and their small public. This was the position: myself is ourselves, maybe.

In February 1978 Sherrie Levine reworked her presidents' heads. Each was filled with a photograph now, as if each had had a change of character. Lincoln was made into a postcard announcement, and JFK became an eight-foot-tall slide projection. The image was thrown there by light, hovered there in light, transient as a ray, utterly fragile. It was a mother-and-child photograph that had been lifted from a fashion magazine and framed as a president that hovered there, sociable but antisocial, nothing really coming together, and certainly not as a family. When Crimp published a revised version of the *Pictures* essay in *October* in 1979, the JFK projection appeared as an illustration, and Cindy Sherman's film-still project was added. As was an uncredited reference to Barthes' *Mythologies*.

There would be an effort in the essays of Crimp and Rosalind Krauss to ground this work on the figure by invoking critical categories derived from the act of making one picture imitate another form or picture—the photographic, the index, the copy, the allegory, the myth—in order to bring this work into line with the new critique of representation that was arriving from Europe.[29] In the 1970s both art criticism and art history were experiencing a change that would affect the way they posed the most basic questions of aesthetics. The crisis and expansion that ensued produced yet another set of ramifications intellectually, but for the most part the new New York art criticism was concerned not with the imitation of *life*, but only with imitation. One can see why. The imitation of life in the work of Sherman, Salle, Levine, and Lawler was difficult, and not because it was theory driven. It had become an imitation overtaken by light, the identifiable light of the movies and the stranger reflected lights observable in people on the street. A social light was leaking and flooding out of these pictures. They seemed to request nonpictorial discussion.

The title of David Salle's installation at the Kitchen in November 1979, *The Structure Is in Itself Not Reassuring*, put the matter plainly. It drew from the installations he had been doing since his solo show at Artists Space in 1976, taking shape in 1979 as a group of ink drawings on backlit rice-paper screens in front of which bare light bulbs hung down.[30] He had revised the statements he'd written over the past two years and published them in *Cover* in May. The next year he and James Welling published a conversation in which Salle put the problem in the form of an unresolvable contradiction. "An 'aesthetically motivated' . . . image is so directly of the world that it bypasses art altogether. . . . The image is held in a nexus of won'ts and can'ts, like

something always held away from you, successively distanced, and that inversion of intention makes sense if you see the aesthetic as something which is really about loss and longing rather than completion."[31] So much for words. Salle pulled the images off the screens and set them into dulled arrangements on canvas to make a series of paintings where mostly undressed women were smoking. *I Can Even Personify*, one of them claimed, as if the figure were a person. She was painted in rough red outline, thick like a lipstick; around her, like figments of someone else's imagination, gray charcoal figures floated in and out, like ash. Light here had been stubbed out. The group was shown at the new Nosei-Weber/Gagosian gallery space at the same time as the installation at the Kitchen.

The paintings and those that followed were much criticized for being misogynist, as if they were people, perhaps because they were speaking the formal language by which people recognized other people. Sherrie Levine finally felt it important to come to Salle's defense in 1981 in the summer *Flash Art*. Without saying so, she gave everyone the piece of advice ("Maybe I should see things as they really are and not as I want them to be") that had gone unheeded in *Imitation of Life*. These figures, she explained, had been given

the role of exposing the problem of the *other*, its untruth, and the untruth inherent in the cultural confusion of women with truth itself. "In this culture which publicly denies our most primary desire and dread," she concluded, "the most important function of art is to mediate between our private and public selves."[32] The self, she was intimating, was not an image. Salle had seen the other in the dullness. Was it Morin's archaic double? As for Levine herself, by the time she wrote this, she had found her own way through the labyrinths of light.

In 1980 Sherrie Levine had cut out Andreas Feininger reproductions from books and mounted them, untouched, as her own collages. Then she took photographs of the photographs reproduced in books, starting with Edward Weston's portraits of his son Neil, shown as a nude torso. She wrote a statement explaining herself:

> Instead of taking photographs of trees or nudes, I take photographs of photographs. I choose pictures that manifest the desire that nature and culture provide us with a sense of order and meaning. I appropriate these images to express my own simultaneous longing for the passion of engagement and the sublimity of aloofness. I hope that in my photographs of photographs an uneasy peace will be made between my attraction to the ideals these pictures exemplify and my desire to have no ideals or fetters whatsoever. It is my aspiration that my photographs, which contain their own contradiction, would represent the best of both worlds.[33]

The Weston estate took exception to this, seeing instead a breach of copyright. Levine was obliged to withdraw the work, but she did not abandon the approach. The next year she made a series from the work Walker Evans did for his book with James Agee, *Let Us Now Praise Famous Men*.

Levine made another statement in 1980 in which she recounted, without citation, Alberto Moravia's first sight of the primal scene, telling how when "she" witnessed "her" parents in this way, "she" divided herself into two, an imitation self who entered the world and a first self who maintained a great distance, watching.[34] She found a way to take this split and doubled (or tripled) self into the material of the photograph: she took her photographs from books and made the finished print from what is called an internegative, lifting the image into a thinner, lighter, less intensely toned second generation, less a copy than a shift. In this backstage step of transfers through a negative state, the figure emerges like a double, leaving another double behind. To put the matter more concretely, her Annie Mae Gudger print has used Evans and Agee's effort to reset the poverty of the sharecropper, as Agee said, "to recognize the stature of a portion of unimagined existence, and to contrive techniques proper to its recording, communication, analysis and defense." She revived their "independent inquiry into certain normal predicaments of human divinity."[35] But she employed the most impersonal, least theatrical techniques of thrift to bring the divinity back. The trace of her own labor was confined to the zone of internegativity, as if there she could exist, a person only of shift, not swallowed by the darkness but not visible either, something like a person without walls.

Cindy Sherman began a new series of pictures in 1980 using the cheap staging technique of rear projection. In 1979 she had gone west to visit her family, newly moved to Phoenix, and while with them had traveled, from time to time making more stills on their vacation locations. She had come with her costumes. The possibilities multiplied. Her father helped sometimes with the shutter release. He helped with "the hitchhiker." She came home with the wider repertoire. In the studio she looked into ways to extend it further. She was setting scenarios of trap and escape. She pulled into closer shots that still showed her moving in a frosty light, looking over her shoulder warily as she crossed the highway with her bike. The figure was never removed from the push of a life. Through the swell and fade of the rear projection, through the brilliance of a flashbulb forestalling sundown, a character was caught between the movies and the street outdoors. It was a limbo of another kind.

David Salle; *The Structure Is in Itself Not Reassuring*, 1979; ink on rice-paper screens with colored lights, 71 x 169 x 39 in. (180.3 x 429.3 x 99 cm), installation view, The Kitchen, New York; courtesy Mary Boone Gallery

Sherrie Levine, *After Walker Evans: 4*, 1981 (under cat. no. 85)

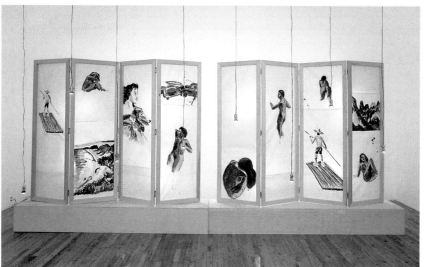

In these different ways the figure of the self being presented by this group of young artists was telescoping into zones that a pictorial figure could never contain. This self was not orbiting around the institutions art was supposed to treat as polestars. It was not drowning in the totalizations of the spectacle, but neither would it declare itself master of the social world. It was inconclusive. But this art was already setting up another idea of the stage on which art was to play, just as it was setting up a scale for itself that went beyond the usual professional questions. They were issues with which to begin a life's work, which is how Cindy Sherman and Sherrie Levine and David Salle and Louise Lawler used them.

In 1981 Sherrie Levine and Louise Lawler collaborated on a work that let them inhabit an older art collaboration begun in 1962 by Hollis Frampton and Carl Andre, then twenty-six and twenty-four, respectively, and thinking about the large questions themselves. Frampton and Andre had spent evenings typing out a dialogue of challenges to each other, Frampton at one point declaring, "A photograph is no substitute for anything."[36] Levine and Lawler, upon reading this in the book published in 1980 by Nova Scotia College of Art and Design, took the sentence into their own, not always serious pattern of internegativity and emerged with an ongoing project of their own, *A Picture Is No Substitute for Anything*. It spoke worlds *for* worlds. It also spoke up for the side of life that held *anything*.

This *anything* had come up for discussion in 1962. Its terms will be familiar. At one point, Frampton and Andre had pondered the problem of the scale of their universe. They tried to speak about how the distances had changed, and the measurements too. "Unless we have an inch in common, an *untaxed* inch, I might add," Andre declared, "our years will contradict, and our miles will wander northward without ever reaching Boston." But no one would be stepping outside the markets of their day, Frampton wrote at the end. Andre countered, adding "I would say it is important not to become a weapon in the hands of those we despise."[37]

Levine and Lawler took this up, using the warmth in the young men's coats to take up the problem of wall-lessness, of making more space for their work. Their collab-

oration set up extremely temporary, self-organized exhibition spaces. The only trace of the collaboration would come, gallery style, with an invitation card. Outside New York, the project might appear in a small gallery or on the wall of a student's studio. In New York itself, the shows were held just for an evening in the private lofts of friends. For the one held in May 1981 Lawler brought seven photograms of long-playing records, one of them the Supremes' "Where Did Our Love Go?" The next month there was an evening in Lawler's loft, where Levine showed her Eliot Porter series. And so it went, as needed, more private than public. In 1982 they did a set of pages using the title for Phil Mariani and Brian Wallis' new magazine *Wedge*.[38] *A Picture Is No Substitute for Anything*. The project marked the end of their wall-lessness, and their innocence.

For as it did so, the spaces of the art market had regrouped, and a new economy for art had emerged. Galleries now were coming to call. Mary Boone had opened; Larry Gagosian would come; in 1980 Helene Winer had left Artists Space to found Metro Pictures with Janelle Reiring. By 1981 wall-lessness was hardly the only option. The modern art museum would present itself as everyone's final destination and only point of reference. But was the museum necessarily the frame for art's future? Where did the art go?

This was the situation that prompted Cindy Sherman to speak of the fakery in role-playing. Louise Lawler would organize *A Movie Will Be Shown without a Picture* at the Bleecker Street Cinema. She chose to show *The Hustler* in the dark, along with the cartoon *What's Opera Doc?* On the poster for the event, she quoted Jack Palance's character from *Contempt* saying, "Every time I hear the word culture, I take out my checkbook." It had become a time of checkbooks.

David Salle began using an overhead projector to center his images on the canvas as he painted them, painting them into the light by immersing himself in it. In 1983 he took the picture from behind, letting the name of King Kong come up like a misunderstood rear projection over the backs of two motherly nudes walking up a beach as if they had literally walked out of the living room. The theater of the monster falling like a light over mother pushed the imitation of life over the edge. Salle began to think in the physical terms of theater, beginning here by affixing an end table to the painting, like a stage. That year he would begin to paint to the time of the dance of Karole Armitage.

Sherrie Levine grew more sanguine as she went forward. "When I started doing this work," she wrote a few years later, "I wanted to make a picture which contradicted itself. I wanted to put a picture on

Louise Lawler and Sherrie Levine; *A Picture Is No Substitute for Anything*, 1981–1982; installation view, Louise Lawler's apartment, New York, 1981; courtesy Louise Lawler

top of a picture so that there are times when both pictures disappear and other times when they're both manifest; that vibration is basically what the work's about for me—that space in the middle where there's no picture, rather an emptiness, an oblivion."[39] At the same time she also turned outward, "I like to think of my paintings as membranes permeable from both sides so there is an easy flow between the past and the future, between my history and yours."[40] My self is our self more broadly now, but the interaction being imagined remains personal, full of the trace internegativity of the old days, as if art might still be something that

passed between friends. But as she said this, she was looking backward.

Notes

1. Sherrie Levine, conversation with the author, May 8, 2002.
2. Peter Schjeldahl, *Salle* (New York: Vintage, 1987), 21, 39. See also Kate Linker, "Melodramatic Tactics," *Artforum* 21 (September 1982): 30–32.
3. Note 9 from the first version of a statement in typescript dated 1977–1978 in Salle's archives. It would be published, revised and dated 1979, in *Cover*, no. 4 (winter 1980–1981): 52–53.
4. Louise Lawler arrived in New York in 1969. The best sources for the early work of each of

these artists are as follows, and I have drawn upon all of them, as well as upon my conversations with the artists. On Sherrie Levine, see Douglas Crimp, *Pictures* (New York: Artists Space, 1977), the catalogue of an exhibition featuring the work of Troy Brauntuch, Jack Goldstein, Sherrie Levine, Robert Longo, and Philip Smith (see also the revised version in *October*, no. 8 [spring 1979]: 75–88); Craig Owens, "The Allegorical Impulse: Toward a Theory of Postmodernism," in *Beyond Recognition: Representation, Power, and Culture* (Berkeley and Los Angeles: University of California Press, 1992), 52–87, first published in *October*, nos. 12 and 13 (spring and summer 1980); Benjamin H. D. Buchloh, "Allegorical Procedures: Appropriation and Montage in Contemporary Art," *Artforum* 21 (September 1982): 45–56; Rosalind Krauss, "The Originality of the Avant-garde," *October*, no. 18 (fall 1981): 47–66; Gerald Marzorati, "Art in the (Re)Making," *Art News* 85 (May 1986): 91–99; interview with Jeanne Siegel, March 1985, published in Jeanne Siegel, *Art Talk: The Early 80s* (New York: Da Capo, 1988), 244–255; David Deitcher, *Sherrie Levine*, exh. cat. (Zurich: Kunsthalle Zürich, 1991); Howard Singerman, "Sherrie Levine's Art History," *October*, no. 101 (summer 2002): 96–121. On David Salle, see Janet Kardon, *David Salle*, exh. cat. (Philadelphia: Institute of Contemporary Art, University of Pennsylvania, 1987); his 1979 statement (see note 3 above) has been reprinted, undated, in *Blasted Allegories: An Anthology of Writings by Contemporary Artists*, ed. Brian Wallis (New York: New Museum of Contemporary Art; Cambridge: MIT Press, 1987), 325–327; interview with Peter Schjeldahl, in *Salle*; "Images That Understand Us: A Conversation with David Salle and James Welling," *LAICA Journal*, no. 27 (June–July 1980): 41–44, reprinted in the fall 1984 issue; Molly Nesbit, "Limbo," in *David Salle: Paintings and Works on Paper, 1981–1999*, exh. cat. (Monterrey, Mexico: Museo de Arte Contemporáneo de Monterrey, 2000), 27–44. On Cindy Sherman, see Gerald Marzorati, "Imitation of Life," *Art News* 82 (September 1983), 78–87; interview with Jeanne Siegel, October 1987, in Siegel, *Art Talk*, 268–282; Alan Jones, "Friday the Thirteenth: Cindy Sherman," *NY Talk*, October 1985, 44–45; Michael Shore, "Punk Rocks the Art World: How Does It Look?" *Art News* 79 (November 1980): 78–85; Vicki Goldberg, "Portrait of a Photographer as a Young Artist," *New York Times*, October 23, 1983; Peter Schjeldahl and Lisa Phillips, *Cindy Sherman*, exh. cat. (New York: Whitney Museum of American Art, 1987). On Louise Lawler, see Benjamin H. D. Buchloh, "Allegorical Procedures"; Andrea Fraser, "In and out of

David Salle; *King Kong*, 1983; oil and acrylic on canvas with mixed media, 123 x 96 x 96 in. (312.4 x 243.8 x 243.8 cm); courtesy Mary Boone Gallery, New York

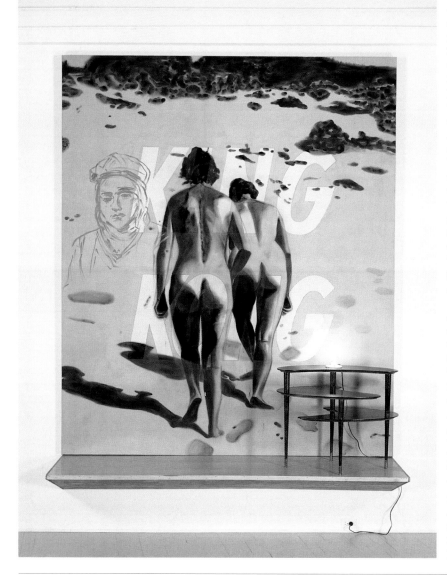

Place," *Art in America* 73 (June 1985): 122–129; Kate Linker, "Rites of Exchange," *Artforum* 25 (November 1986): 99–101; Louise Lawler, *An Arrangement of Pictures* (New York: Assouline, 2000).

5. 112 Workshop/112 Greene Street opened as a not-for-profit exhibition space in 1970; the Kitchen was founded in 1971 in the kitchen of the Mercer Art Center; Artists Space was founded in 1972, as was Printed Matter; the Wooster Group, founded in 1975, was based in the Performing Garage; Franklin Furnace was founded in 1976.

6. Crimp, *Pictures*; the revised version of the catalogue essay was included in the anthology *Art after Modernism: Rethinking Representation*, ed. Brian Wallis (New York: New Museum of Contemporary Art; Boston: D. R. Godine, 1984), 175–187, which remains the best general guide to the debates in New York during this time.

7. "Situation Esthetics: Impermanent Art and the Seventies Audience," *Artforum* 18 (January 1980): 22–28.

8. Ibid., 22.

9. David Salle, "Vito Acconci's Recent Work," *Arts* 51 (December 1976): 91. Four years later George Trow would write a book on the sinister effects of this scale, *Within the Context of No Context* (New York: Atlantic Monthly Press, 1981), first published in the *New Yorker* in 1980.

10. André Malraux, *The Voices of Silence*, trans. Stuart Gilbert (Princeton: Princeton University Press, 1978), first French edition 1953; George Kubler, *The Shape of Time: Remarks on the History of Things* (New Haven: Yale University Press, 1962); John Berger, *Ways of Seeing* (London: Penguin, 1972); Brian O'Doherty, *Inside the White Cube: The Ideology of the Gallery Space*, 2d ed. (Berkeley and Los Angeles: University of California Press, 1999); Roland Barthes, *Mythologies*, trans. Annette Lavers (New York: Hill & Wang, 1972), first French edition 1957.

11. Malraux, *Voices of Silence*, 525, 540, respectively.

12. G. W. F. Hegel, *The Philosophy of History*, trans. J. Sibree (Buffalo, N.Y.: Prometheus, 1991), 26–27. See also his *Introductory Lectures on Aesthetics*, trans. Bernard Bosanquet (London: Penguin, 1993), 51–52.

13. Hegel, *Philosophy of History*, 77: "Time is the negative element in the sensuous world. Thought is the same negativity, but it is the deepest, the infinite form of it, in which therefore all existence is dissolved; first, finite existence—determinate, limited form: but existence generally, in its objective character, is limited; it appears therefore as a mere datum—something immediate—author-ity;—and is either intrinsically finite and limited, or presents itself as a limit for the thinking sub-ject, and its infinite reflection on itself."

14. Malraux, *Voices of Silence*, 523.

15. Ibid., 543. See also Hegel, *Philosophy of History*, 86.

16. See, for example, the following texts and their arguments, marked as much by Hegel as by Marx: Guy Debord, *The Society of the Spectacle*, trans. Donald Nicholson Smith (New York: Swerve, 1994), first French edition 1967; Henri Lefebvre, *The Production of Space*, trans. Donald Nicholson-Smith (Oxford: Blackwell, 1991), first French edition 1974; Jean-François Lyotard, *The Postmodern Condition*, trans. Brian Massumi (Minneapolis: University of Minnesota Press, 1984), first French edition 1979.

17. On the role played by the mass media forms in the development of modern art, see especially Thomas Crow, "Modernism and Mass Culture in the Visual Arts," in *Modernism and Modernity: The Vancouver Conference Papers*, ed. Benjamin H. D. Buchloh, Serge Guilbaut, and David Solkin (Halifax: Press of the Nova Scotia College of Art and Design, 1983), 215–264; reprinted in short-ened form in Crow's collection *Modern Art in the Common Culture* (New Haven: Yale University Press, 1996). The discussion of the relevance of the high/low art hierarchy continued to be played out in academic and museum circles during the 1980s. Its historical importance for modern art in the years before 1968 remains undisputed, and after 1968 it continued to have its usefulness in the development of a political aesthetics. But on the street these questions were moot, and by the time of the *High and Low* exhibition at the Museum of Modern Art in 1990, it was clear that they could only sustain academic life.

18. Friedrich Nietzsche, *The Gay Science*, trans. Walter Kaufmann (New York: Random House, 1974), 316–317. The way out of such normative social construction has been famously plotted by Judith Butler in *Gender Trouble: Feminism and the Subversion of Identity* (New York: Routledge, 1990).

19. Hegel, *Philosophy of History*, 77.

20. Edgar Morin, *Les stars* (1957), 3d ed. (Paris: Seuil, 1972), 63 (translation by the author). Jacques Lacan's landmark article on the mirror phase, "The Mirror Stage as Formative of the Function of the I," was first given as a talk in 1949 and published in his *Ecrits*, trans. Alan Sheridan (New York: Norton, 1977), 1–7. For more on the mirror functions in social formation, see, for starters, Marshall McLuhan, *Understanding Media: The Extensions of Man* (New York: McGraw-Hill, 1965), and Lefebvre, *The Production of Space*.

21. Interview, in Siegel, *Art Talk*, 282.

22. Ibid., 272.

23. Miguel de Cervantes, *The Adventures of Don Quixote de la Mancha*, trans. Tobias Smollett (New York: Farrar, Straus, Giroux, 1986), 21.

24. Eventually she would frame her shots by propping a real mirror near the camera so that she could check the effect of her pose.

25. The 1978 Artists Space show, curated by Janelle Reiring, September 23–October 28, included work by Christopher d'Arcangelo, Louise Lawler, Adrian Piper, and Cindy Sherman.

26. It provided the cover for one of the small, untitled books she made in 1978.

27. Louise Lawler, conversation with the author, September 12, 2002.

28. Notably Craig Owens ("The Allegorical Impulse") and Benjamin H. D. Buchloh ("Allegorical Procedures").

29. For a good characterization of the landscape facing the art critic, see Anders Stephanson's "Interview with Craig Owens" (1987), in Owens, *Beyond Recognition*, 300: "[In the mid- to late 1970s] there was a new interest in and prolifera-tion of art writing, which deliberately did not set itself the task of coming up to the level of 'seri-ousness' set by Greenberg and Fried. What then came to be seen as the postmodern was that pro-liferation of discourses on the outside. These were not activities that were trying to theorize postmodernism or the question of postmod-ernism, but to function *as* postmodernism. Roughly at the same time, some of us began to articulate this within art practice, as one way of detaching oneself from the art that was being pushed by the galleries, the art that was being written about in the art journals. So there was a strong sense that this articulation removed one from the dominant centers of the art world and art market. Whether it was good old modernist withdrawal is another matter. . . . Initially what was informing the debate anyway was Frankfurt School stuff, and Walter Benjamin. The dis-course in the art world was identified with *the photographic*." This work on this identification was being led by Rosalind Krauss. See her inter-view with Paul Taylor, in *Art and Text*, no. 8 (sum-mer 1982): 31–37, and her essays from the period, collected in *The Originality of the Avant-garde and Other Modernist Myths* (Cambridge: MIT Press, 1985); most relevant is the title essay (see note 4 above). Equally important to the for-mation of a criticism around this work are Douglas Crimp's essay for *Pictures* (see note 4 above) and his "The Photographic Conditions of Postmodernism," *October*, no. 15 (winter 1980): 91–101, in addition to the articles on allegory by Owens and Buchloh.

30. "Ultimately," said the press release, "the viewer confronts a situation in which all associa-tions and connections—though real and opera-tive in the context of the piece—become

subsumed in 'just looking.' The disconnected connectedness of the images is related to the notion of hypnagogic thinking—that state before sleep when images pass through the mind with a sense of portent that cannot be explained rationally."

31. Salle and Welling, "Images That Understand Us," 44.

32. "David Salle," *Flash Art*, no. 103 (summer 1981): 34. Later Paul Taylor would report that Levine thought that Salle's pictures, whatever the gender of his figures, showed a man being looked at by a woman and that she thought that Cindy Sherman's pictures worked the same way, except that they showed a woman being looked at by a man: "I had the idea that they were pictures of a man looking at a woman looking at a man. And I thought that was pretty interesting, because I've always seen the self-portraits of Cindy Sherman as pictures of a woman looking at a man looking at a woman. His are pictures that posit a man's consciousness in relation to a woman's consciousness" (in Paul Taylor, "How David Salle Mixes High Art and Trash," *New York Times Magazine*, January 11, 1987, 28). Salle would agree. He spoke of internalizing the meaning of a gesture "as if she's doing it to me or I'm *her* doing it," he said in his interview with Peter Schjeldahl in *LAICA Journal*, no. 30 (September–October 1981): 20.

33. First published, dated 1980, in Buchloh, "Allegorical Procedures," 52–53.

34. First published, dated 1980, in Crimp, "Photographic Activity of Postmodernism," 98, and then reprinted with a group of statements in *Blasted Allegories*, 92.

35. James Agee and Walker Evans, *Let Us Now Praise Famous Men* (Boston: Houghton Mifflin, 1941), xiv.

36. Carl Andre and Hollis Frampton, *Twelve Dialogues, 1962–1963*, ed. Benjamin H. D. Buchloh (Halifax: Press of the Nova Scotia College of Art and Design; New York: New York University Press, 1980), 21. Later Frampton pushed into the problem of using appearances in order to sketch an aesthetics of their use. "To use an image is to make another," he declared (92). And earlier he had put it even more modestly, "Photographs and paintings are not visible substitutes for visible things, but are additions to the list of visible things" (70).

37. Ibid., 40, 92, respectively.

38. Guy Bellavance wrote about the project for *Parachute* (December 1983). The project developed in various venues as follows: (1) "His Gesture Moved Us to Tears" was printed on a small blue card pinned to the wall at James Turcotte Gallery, Santa Monica, April 6, 1981; (2) "A Picture Is No Substitute for Anything" was printed on an unsolicited matchbook cover for an evening with Julian Schnabel when he lec-

tured in the spring of 1981 at UCLA; (3) an exhibition of Lawler's photograms was shown at the loft of Harold Rivkin, 45 Lispenard Street, New York, on May 27, 1981, from 7 to 9 p.m.; (4) an exhibition of Levine's photographs after Eliot Porter was shown at Lawler's loft on Greenwich Street on June 25, 1981; (5) Ronnelle Gallery in Nova Scotia showed a Lawler arrangement photograph, on December 18 and 19, 1981; (6) at CalArts on Valentine's Day 1982, Levine and Lawler displayed a poster showing Andy Warhol poster in red in an arrangement of Lawler's done for a student's studio wall; (7) project pages for *Wedge*, no. 2 (fall 1982): 58–67; (8) a matchbook cover for friends; (9) "Can you argue with a natural?" was planned for Max's Kansas City as a glass bowl of white roses on an empty table.

39. First published (with the last phrase edited out) in the March 1985 interview in Siegel, *Art Talk*, 247.

40. *Blasted Allegories*, 93.

Sarah Charlesworth and Barbara Kruger

Glossolalia
(1983)

Originally published in *Bomb*, no. 5
(spring 1983): 60–61.

Representation, then, is not—nor can it be—neutral; it is an act—indeed the founding act—of power in our culture.
—**Craig Owens**

Thou shalt not make unto thee any graven image, or any likeness of any thing that is in the earth beneath, or that is in the water under the earth: thou shalt not bow down thyself to them; nor serve them . . .
—**God**

Deprived of narrative, representation alone, as signifying device, operates as guarantee for the mythic community: it appears as symptomatic of the pictorial work's adherence to an ideology; but it also represents the opposite side of the norm, the antinorm, the forbidden, the anomalous, the excessive, and the repressed: Hell.
—**Julia Kristeva**

The desire of representation exists only insofar as the original is always deferred. It is only in the absence of the original that representation takes place, because it is already there in the world as representation.
—**Douglas Crimp**

Every cigarette, every drink, every love affair echoes down a never-ending passageway of references—to advertisements, to television shows, to movies—to the point where we no longer know if we mimic or are mimicked.
—**Tom Lawson**

Relationship between human beings is based on the image-forming, defensive mechanism. In our relationships each of us builds an image about the other and these two images have relationship, not the human beings themselves. . . . One has an image about one's country and about oneself, and we are always strengthening these images by adding more and more to them. And it is these images which have relationship. The actual relationship between two human beings completely ends when there is a formation of images. . . . All our relationships, whether they be property, ideas, or people, are based essentially on this image-forming, and hence there is always a conflict.
—**Krishnamurti**

Where the real world changes into simple images, the simple images become real beings and effective motivations of hypnotic behavior.
—**Guy Debord**

The acquisition of my tape recorder (camera) really finished whatever emotional life I might have had, but I was glad to see it go. Nothing was ever a problem again, because a problem just meant a good tape (photo), and when a problem transforms itself into a good tape (photo) its not a problem anymore. An interesting problem was an interesting tape (photo). Everybody knew that and performed for the tape (photo). You couldn't tell which problems were real and which problems were exaggerated for the tape (photo). Better yet, the people telling you the problems couldn't decide anymore if they were really having problems or if they were just performing.
—**Andy Warhol**

The objects which the image presents to us and to which our only relation can be that of possession, necessarily represents our being, our situation in the world. The libidinal investment in the image, an investment on which the economic investment turns, is profoundly narcissistic, and avoidance of the problem of the other.
—**Colin MacCabe**

The photographs have a reality for me that the people don't. It's through the photograph that I know them. Maybe it's in the nature of being a photographer. I'm really never implicated. I don't have any real knowledge.
—**Richard Avedon**

Incapable of producing metaphors by means of signs alone, he (the phobic person) produces them in the very material of drives—and it turns out that the only rhetoric of which he is capable is that of affect, and it is projected, as often as not, by means of images.
—**Julia Kristeva**

. . . the image is treated as a stand-in or as a replacement for someone who would not otherwise appear . . .
—**Craig Owens**

All art is "image making" and all image making is the creation of substitutes.
—**E. H. Gombrich**

In a world which is topsy-turvy, the true is a moment of false.
—**Guy Debord**

Photography today seems to be in a state of flight. . . . The amateur forces his Sundays into a series of unnatural poses.
—**Dorothea Lange**

The destiny of photography has taken it far beyond the role to which it was originally thought to be limited; to give more accurate reports on reality (including works of art). Photography is the reality; the real object is often experienced as a letdown. Photographs make normative an experience of art that is mediated, second-hand, intense in a different way.
—**Susan Sontag**

To see and to show, is the mission now undertaken by LIFE. (magazine)
—**Henry Luce**

The literal photograph reduces us to the scandal of horror, not to the horror itself.
—**Roland Barthes**

People were murdered for the camera; and some photographers and a television camera crew departed without taking a picture in the hope that in the absence of cameramen acts might not be committed. Others felt that the mob was beyond appeal to mercy. They stayed and won Pulitzer Prizes. Were they right?
—**Harold Evans**

Distanciation is this: going all the way in the representation to the point where the meaning is no longer the truth of the actor but the political relation of the situation.
—**Roland Barthes**

The world is centered for us by the camera and we are at the center of a world always in focus. As long as we accept this centering we shall never be able to pose the question of "who speaks" in the image, never be able to understand the dictation of our place.
—**Colin MacCabe**

A clear boundary has been drawn between photography and its social character. In other words, the ills of photography are the ills of estheticism. Estheticism must be superceded, in its entirety, for a meaningful art, of any sort, to emerge.
—**Allan Sekula**

Our conviction that we are free to choose what we make of a photograph hides the complicity to which we are recruited in the very act of looking.
—**Victor Burgin**

For the first time in world history, mechanical reproduction emancipates the work of art from its parasitical dependence on ritual. To an even greater degree the work of art reproduced becomes the work of art designed for reproducibility.
—**Walter Benjamin**

. . . for the modern photographer the end product of his efforts is the printed page, not the photographic print.
—**Irving Penn**

Much of painting today aspires to the qualities of reproducible objects. Finally, photographs have become so much the leading visual experience that we now have works of art which are produced in order to be photographed.
—**Susan Sontag**

For a certain moment photography enters the practice of art in such a way that it contaminates the purity of modernism's separate categories, the categories of paint and sculpture. These categories are subsequently divested of their fictive autonomy, their idealism, and thus their power.
—**Douglas Crimp**

The morphology of photography would have been vastly different had photographs resisted the urge to acquire the credentials of esthetic respectability for their medium, and instead simply pursued it as a way of producing evidence of intelligent life on earth.
—**A. D. Coleman**

For every photographer who clamors to make it as an artist, there is an artist running the risk of turning into a photographer.
—**Nancy Foote**

Photography is better than art. It is a solar phenomenon in which the artist collaborates with the sun.
—**Lamartine**

The photographic artist's downfall is the romance with technique.
—**Carol Squiers**

The creative in photography is its capitulation to fashion. The world is beautiful. That is its watchword.
—**Walter Benjamin**

While the aesthetics of consumption (photographic or otherwise) requires a heroicized myth of the artist, the exemplary practice of the player-off codes requires only an operator, a producer, a scriptor, or a pasticheur.
—**Abigail Solomon Godeau**

Montage before shooting, montage during shooting and montage after shooting.
—**The Dziga Vertov Group**

A work that does not dominate reality and that does not allow the public to dominate it is not a work of art.
—**Bertolt Brecht**

A certain contempt for the material employed to express an idea is indispensable to the purist realization of this idea.
—**Man Ray**

You know exactly what I think of photography. I would like to see it make people despise painting until something else would make photography unbearable.
—**Marcel Duchamp**

. . . the very question of whether photography is or is not an art is essentially a misleading one. Although photography generates works that can be called art— it requires subjectivity, it can lie, it gives aesthetic pleasure—photography is not, to begin with, an art form at all. Like language, it is a medium in which works of art (among other things) are made.
—**Susan Sontag**

The blatantly mechanistic condition bound to photographic seeing has confounded photographic discourse. One-way thinking has stratified this moonlighting medium ever since its invention, zoning it into polemic ghettos walled off by hegemonies and hierarchies.
—**Ingrid Sischy**

It is a fetishistic and fundamentally anti-technical notion of art with which theorists of photography have tussled for almost a century, without of course achieving the slightest result! For they sought nothing beyond acquiring credentials for the photographer from the judgement-seat he had already overturned.
—**Walter Benjamin**

That photography had overturned the judgement-seat of art is a fact which the discourse of modernism found it necessary to repress, and so it seems that we may say of postmodernism that it constitutes the return of the repressed. These institutions can be named at the outset: first the museums; then Art History; and finally, in a more complex sense, because modernism depends both on its presence and upon its absence, photography.
—**Douglas Crimp**

The postmodernist critique of representation undermines the referential status of visual imagery, its claim to represent reality as it really is—either the appearance of things or some ideal order behind or beyond appearance.
—**Craig Owens**

Quotation has mediation as its essence, if not its primary concern, and any claims for objectivity or accuracy are in relation to representations of representations, not representations of truth.
—**Martha Rosler**

Perception that stops at the surface has forgotten the labyrinth of the visible.
—**Ingrid Sischy and Germano Celant**

In order for history to be truthfully represented, the mere surface offered by the photograph must somehow be disrupted.
—**Siegfried Kracauer**

The intention of the artist must therefore be to unsettle conventional thought from within, to cast doubt on the normalized perception of the "natural" by destabilizing the means used to represent it.
—**Tom Lawson**

To reframe is of course to represent that which I have seen . . . to represent the process by which vision projects and transforms itself, to engage in the struggle to discover that which is absent, obscured from our vision, through an encounter with that which is manifest, given.
—**Sarah Charlesworth**

To photograph is to confer importance. There is probably no subject that cannot be beautified; moreover, there is no way to suppress the tendency inherent in all photographs to accord value to their subjects. But the value itself can be altered . . .
—**Susan Sontag**

Kate Bush

The Latest Picture

Kate Bush is senior programmer at the Photographers' Gallery, London, where she produces a program that brings into dialogue diverse aspects of photographic practice. She has organized exhibitions of work by Amy Adler, Ed van der Elsken, Malerie Marder, Jean-Luc Mylayne, Catherine Opie, Shirana Shahbazi, Piotr Uklanski, Richard Wentworth, and Francesca Woodman, among others. She is a regular contributor to *Artforum* magazine.

With documentary-"style" photography and video currently saturating the contemporary art world, it would be easy to lose sight of the impact on present generations of the eras of photoconceptualism and photographic postmodernism. Representational, pictorial, expensive, and large, photography seems to be everywhere, apotheosized by the escalating market success of the two giants of the Düsseldorf school, Andreas Gursky and Thomas Struth. In the 1980s and 1990s poststructuralist theory, suspicious of photography's putative purchase on the "truth," encouraged a generation of artists to critique their privileged relation to the world they pictured and to qualify the photograph's inherently flexible meanings by combining it with text. The waning influence of these theories has coincided with an emphatic return to observant modes and the scaling of new heights of technical spectacle, suggesting a rupture with the immediately preceding decades and a direct return to traditions of photographic modernism exemplified by a lineage that stems from Eugène Atget through Walker Evans to Robert Adams and beyond, in which the world is the primary referent and the image is conceived with maximum clarity and minimum artifice.

The signal works in photography of the 1960s, 1970s, and early 1980s—Dan Graham's magazine articles, Edward Ruscha's seventeen photography books, the Bechers' industrial typologies, Cindy Sherman's simulated film stills, Sherrie Levine's appropriations, and Richard Prince's rephotographs among them— were radical in their approach and sometimes perhaps too finite in the terms of

their critical interrogations to generate a lengthy conversation with future generations. And yet photography now is not just omnipresent, it is also plural in its forms, and it is possible to discern mutated aspects of the Conceptual and neo-Conceptual project in the work of young artists, even though the shift from Conceptual Art's interest in the photograph as document to the current understanding of the photograph as art object has been firmly and finally established.[1]

Early Conceptual artists can be divided into those who utilized photography as a tool to document ephemeral actions or events or gestures and those who reflected more profoundly on photography's inherent "anti-artistic" nature—its widespread functional applications; its descriptive precision; its non-unique, serial nature; and its stylistic neutrality. Photography was widely recruited in a philosophical assault against the auratic, authored, and commodified artwork. As a pure instrument of reproduction, a "dumb copying device," as Douglas Huebler termed it,[2] photography could work to relieve artists from aesthetic decision-making and leave them free to concentrate on pure idea. Photography could also potentially redeem art from the reificatory space of the art gallery by sharing its

historical home in the dematerialized, democratically disseminated printed media.

The legacy of these investigations is felt in the work of a variety of artists who continue to reflect self-consciously and critically on photography's identity and value as a representational medium. First among them is the conceptual photographer Thomas Ruff, an artist whose entire oeuvre has been dedicated to exploring photography not merely as medium, but as subject (and in this he is greatly distinguished from his Düsseldorf colleagues Gursky and Struth). Where Ruff has furthered the work of 1960s Conceptualists is in accepting that, however rigorously systematized and objectified his approach, the photograph ultimately can never transcend authorship or aesthetic choice. He acknowledges: "I'm always present in my photographs as the author because I point to something, be it a face, a house, a star. I'm always there in the choice of subject and frame." Rather than photographing an original model existing in reality, Ruff makes images of images, representations of representations. "Photographs are still always depictions, it's just that for my generation the model for the photograph is probably not reality anymore, but images we have of that reality."[3] This concern

Bruno Serralongue; *Escalier Central, Expo 2000*, 2000; Ilfochrome, aluminum; 50¾ x 63⅜ in. (129 x 161 cm); courtesy Air de Paris

connects him back to Pop (and before Pop, interestingly, to Walker Evans, whose photographs of urban signage and billboards have been cited by Dan Graham as a clear influence on both Pop and Conceptual Art[4]) through to postmodernism and appropriation art. But where Sherrie Levine, for example, appropriated individual photographs by "masters" such as Edward Weston and Aleksandr Rodchenko in order to refute notions of artistic originality, Ruff mimics and manipulates different codes or types of photographic representation in order to amplify the semantic limitations of the medium itself and to assert its status not as "window to the world," but as autonomous depiction, as pure picture. From press and passport pictures to night surveillance photography to Internet pornography, he co-opts everyday, vernacular imagery and technology so as to probe the limits of what photography can do and mean.

For Ruff, ultimately, photography lacks narrative, psychological, and metaphoric meaning and reveals itself as nothing more than an apparatus for the production of images: pure surfaces, pure reproductions, pure depictions. His methodology, in being as coolly detached and systematic as possible, relates directly back to Conceptual forebears, notably his teachers Bernd and Hilla Becher. But where, for the Bechers, the subject of the photograph—and therefore its documentary value—was of primary concern (as it was arguably too for Ruscha, who said in 1981 of his first book, *Twentysix Gasoline Stations* [1962]: "The photography by itself doesn't mean anything to me: it's the gas station, that's the important thing"), one senses for Ruff that the subject of the image is increasingly, and perhaps inevitably, secondary to his modernistic reduction of the photograph to its perceptual and philosophical limits. It's significant that the recent Substratum series (2001–) pushes the blurred effects of the preceding Nudes (1999–) into a purer realm of abstraction. Here, with the subject all but evacuated, we are left with a gorgeous, radiant, pulsating surface. The photograph comes full circle to return as pure image, distinct and nearly autonomous from the world, in contrast to the representational photography of Gursky and Struth.

Conceptual artists impersonated not just the look of non-artistic or vernacular photography but also the role or persona of the journalist-photographer or reporter. In Robert Smithson's mock travelogues, Dan Graham's magazine articles, and, most thoroughly, in Douglas Huebler's self-assigned absurdist photography projects, the artists parodied "working" photography in order to release the artwork from aesthetic concerns into an order of pure information. In *Location Piece No. 13, November 1969*, Huebler took the logical step and got himself a job as special correspondent for the *Haverhill Gazette*, a local Massachusetts paper, making the front page with a story about a peace march in Washington, D.C.

The young French photographer Bruno Serralongue, in hybridizing the roles of photojournalist and conceptual artist, rekindles this strand of conceptual practice. Serralongue, like Ruff, rejects photographic "auteurism" and develops methodologies that work to reduce his authorial decisions to a minimum in order to pare the photograph down to an essential degree of meaning—or lack thereof. In the 1997 piece *Corse-Matin*, he joined the staff of a regional daily newspaper in Corsica and spent a month working on assignment. The newspaper's editor determined the subject, the selection, and the final form of Serralongue's photographs. The resultant artwork consists of a compilation of the twenty photographs that were published, with the editor's crops intact. The piece echoes Henry Bond and Liam Gillick's Documents series, made in the early 1990s—in which the artists tracked press calls and newsworthy events in black-and-white reportage shots—but Serralongue goes further in relinquishing all decisions about content and form to someone else, thus demoting himself from "artist" to pure "operator."

Serralongue works to critique not just the role of photographer as author but also, in subsequent works, the role of the photojournalist as empowered or privileged witness to world events. He has been present at a variety of historically significant occasions—the thirtieth anniversary of the death of Che Guevara in Cuba in 1997, the British return of Hong Kong to the Chinese in the same year, a mass meeting of thousands of supporters organized by the Zapatista Indians in southern Mexico in 1996—and the photographs he has made of these events are characterized by a strange tension between communicating something, and yet nothing, of the events unfolding around him.

This recognition of the photograph as repository of concrete information about the real world, and its simultaneously limited ability to articulate any definitive truth about that world, is also fundamental to the work of the young Iranian artist Shirana Shahbazi. Shahbazi, like Serralongue, while being well aware of photography's shortcomings, nevertheless claims the right to return her art to a social field. She practices an emphatically utilitarian documentary approach to the extent that individual images, whether street portraits or urban landscapes, might appear excruciatingly banal in the rigidity of their viewpoints, in the simplicity of their compositions, and in their eschewal of decisive or significant moments. Yet her images, arranged serially in magazine-style layouts on the wall of the gallery, accumulate into a shifting set of "micro-events" and observations, which collectively map her subject—the contemporary city of Tehran—without claiming to define it. Also like Serralongue, Shahbazi delegates aspects of the making of her work to others—in this case, to commercial street-poster painters in Tehran, who are commissioned to realize her understated, sometimes private photographs as billboard-scale public paintings.

Many artists of the Conceptual and neo-Conceptual generations used photography

Shirana Shahbazi; from *Goftare Nik*, 2000–2001; chromogenic print; dimensions variable; courtesy the Photographers' Gallery, London

to document putatively theatrical actions or events. Bruce Nauman's Eleven Color Photographs and Gilbert and George's Living Sculptures in the late 1960s; works for camera by Adrian Piper, Eleanor Antin, and Bas Jan Ader in the early 1970s; and Cindy Sherman's Untitled Film Stills in the late 1970s can all be linked to a trajectory involving the fictive staging of self which can be traced as far back into the early history of photography as Hippolyte Bayard's *Self-Portrait as a Drowned Man* (1840), in which the photographer famously staged his own suicide. This fusion of reportage photography with preconceived performative acts continues into the present in work as diverse as Austrian sculptor Erwin Wurm's One-Minute Sculptures and the performed self-portraits of the young Korean artist Nikki S. Lee.

But what appears particularly distinctive in art now is the emergence of what might be dubbed a hybrid form of "performative reportage," a kind of photography/video that dislodges the artist as protagonist of the performance, replacing him or her with traditional social documentary subjects. In Boris Mikhailov's Case History, for example, or in the recent work of Gillian Wearing or Santiago Sierra, there's been a dramatic return (in contravention of the prohibitions against the photographic exploitation of "others" so carefully established by politicized Conceptual photographers such as Victor Burgin and Martha

Rosler) to the stock subjects of liberal or humanist documentary: the representation of "real" people whose lives have unfolded outside societal norms—the poor, the disenfranchised, the dysfunctional—but elaborated in ways that confront the discredited morals and mores of that historical genre of photography. These artists explicitly coerce their subjects—with money, drink, or drugs—to perform more or less degrading scenarios to camera, and the resulting works are—certainly in the case of Wearing's monumental black-and-white video projection *Drunk*, more subtly in Mikhailov's Case History—frankly aestheticized and unapologetic about their status as artworks rather than "documents." As such, they've garnered a predictable amount of opprobrium.

Mikhailov's Case History is an epic, bruising account of a new underclass of homeless people in his native Kharkov, the *bomzhes*, social casualties of the Ukraine's abrupt shift from Soviet-style socialism to capitalism. He pays these people to reveal their derelict, diseased bodies and to perform intimate acts in front of his lens, which he then examines as forensically, and dispassionately, as a surgeon or a pornographer. There's no pretence to nobility in suffering here, as social documentarians insisted, and Mikhailov makes no recourse to the redemptive or transformative rhetoric of socially engaged photography: "We as spectators are the ones who are humili-

ated and degraded by the confrontation, exposed to a truth we cannot walk away from and cannot bear to share." Instead, he casts his work as a theatrical representation of social reality: "Manipulating with money is somehow a new way of legal relations in all areas of the former USSR. . . . I wanted to transmit the feeling that in that place and now, people can be openly manipulated. . . . I wanted to copy or perform the same relations which exist in society between a model and myself."[5]

Drunk, Gillian Wearing's study of a group of London street alcoholics, also emphasizes the performative nature of all social documentary photography: the fact that, however noble its intentions, it always turns other people's lives into a kind of visual theater for the entertainment of more or less privileged viewers. Wearing, like Mikhailov, short-circuits any emotional or empathic identification we might form with her subjects and, in doing so, makes us continually aware—in a way comparable to a Brechtian model of theater—that while what we are watching is, on one level, real, it is also always a drama or representation.

Young Japanese photographer Shizuka Yokomizo also marries pseudo-conceptual strategy to a documentary style in order to dramatize difference or "otherness," albeit in a much gentler emotional register. In Strangers (1999–2001), she wrote letters to people she had never met, but whom she knew to live on the ground floor of a house or apartment somewhere in the city. The letters were addressed simply "Dear stranger" and signed, equally anonymously, "From the artist." They stated that, at a particular time and date, Yokomizo would be waiting with her camera outside their window and would, if they chose to cooperate, take their portrait as they drew their curtains and looked outside toward her. They, the subjects, were promised a copy of their image at the conclusion of the exercise, but the artist requested that the contract of anonymity never be breached and that they never attempt to make contact with her again.

The stranger—whether oppressed outsider, exotic foreigner, or elusive celebrity—is the classic subject of documentary portraiture, but here the "strangeness" of the stranger is concentrated, rather than struggled to be overcome through a state of temporary intimacy

Boris Mikhailov, from the Case History series, 1998; chromogenic prints; 90½ x 50 in. (230 x 127 cm); courtesy the Photographers' Gallery, London

willed by the photographer toward the photographed. Most photographed people present themselves to the lens of the camera rather than the person behind it, and yet here it is the photographer, crouching behind her apparatus in the obscurity of the night, who is as much the undiscovered subject of the picture, as each individual peers out at the mysterious voyeur. In these portraits, both photographer and subject are looking and being looked at: both are active subjects of their own gaze and, simultaneously, passive objects of the gaze of the Other. Intimacy—and its correlative, empathy—is replaced with a more varied emotional scale—wariness, fear, curiosity, trepidation, anxiety, hesitation. Operating around a two-way dynamic of calculated estrangement, Strangers could be described as a dramatized photography of "otherness."

Where Yokomizo dramatizes separation, Nikki S. Lee's photographic projects could be said to dramatize notions of assimilation or integration. There are clear antecedents for the work of this young Korean artist in the concerns of female artists during the 1970s and 1980s, artists who enacted to camera performances of self-transformation in order to highlight the pervasive effects of ethnic and gender archetypes (works such as Eleanor Antin's 1972 *Representational Painting*, Adrian Piper's 1975 *Mythic Being: Cruising White Women*, and of course, the photographs of Cindy Sherman). Lee, over a period of weeks or months, infiltrates a particular social group (to date, those groups have included lesbians, punks, Hispanics, yuppies, skateboarders, exotic dancers, and midwesterners), adapting her dress code, her body language, and even her skin color and her weight, in order to blend, chameleon-like, into her chosen community. Her extraordinary acts of physical and behavioral mimesis are recorded in photographs that themselves mimic the code of amateur photography (and as such revive a visual trope descended from Conceptual photography). These cheap color snaps, complete with date stamp, are artless and naturalistic, and they work to register the realism of Lee's transformation to such an extent that occasionally it is difficult to distinguish her from others in the picture. Lee's work develops the thinking of the earlier generation of artists who understood the photograph's primacy in the construction of personal identity. But where

for Sherman et al. it was a question of using the camera to signify the fundamentally fragile nature of the self, forged as an imaginary construct through representational stereotypes, for Lee, identity is understood as constantly—and positively—fluctuating through a set of shifting relationships with other people. Here the self is not presupposed to consist of some unitary essence, but is defined in relation to what, and who, is around it.

Many young contemporaries could be loosely deemed "post-appropriationists." There's a thriving school of "clip and montage artists," who raid popular culture, particularly television and film, for their raw material—Pierre Bismuth, Candice Breitz, Douglas Gordon, Johan Grimonprez, and Jonathan Horowitz among them—but if one were to single out an artist who has explored most directly the legacy of Andy Warhol, Richard Prince, Louise Lawler, and Sherrie Levine, it might be Los Angeles–based Amy Adler. In appropriation art, reality is represented as always constructed in representation, rather than residing in any original referent. Appropriationists exploited photographic reproducibility in a critical questioning

of painterly uniqueness and artistic originality. As a conceptual maneuver it was interestingly flawed, for as works by Prince and Levine took their place in the pantheon of significant art, it became clear that the "aura" of an original had not been permanently dislodged but merely displaced to become an aspect of the appropriationist's copy.

Amy Adler picks up this dialogue in her complex play with photographs and drawings, copies and originals. For her, Prince's rephotographs ultimately devolved not into a critique of mass advertising, but into a representation of his own desire, constructed through the appropriation of popular imagery. Her own work has investigated the complex ways in which images can both encapsulate and catalyze desire. Here, real-life characters—including herself—and film characters converge: "I believe it is impossible to separate the two worlds, as I know that my identity has been formed in relation to characters I see in film . . . they come to represent people you know, desire, want to be." What happens when the representation, the fantasy, becomes real, as it did on January 15, 2001, when Leonardo DiCaprio came to Adler's

Shizuka Yokomizo; *Stranger*, 1999; framed chromogenic print; 42½ x 50 in. (108 x 127 cm); courtesy the Approach, London

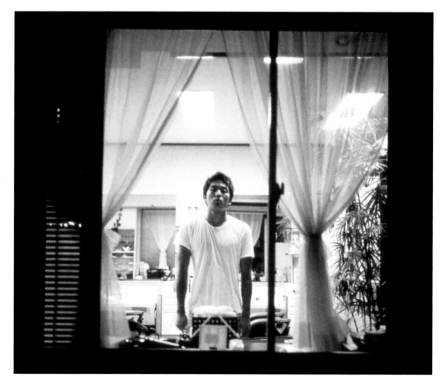

flat in a modest South London neighborhood? "There he was. My apartment turned inside out. My living room was the stage, the cup of coffee I offered him, a prop. He was tall, shaggy, ok . . . beautiful, sexy, and radiant. . . . I shot a roll of film there in my bedroom by the window. I didn't pose him or style him, he was there, that was the point."[6]

In the resulting work, *Amy Adler Photographs Leonardo DiCaprio* (2001), Adler has appropriated not just the image of a celebrity icon, but the celebrity himself. "I cast him into my work, my landscape. He's playing a part in my film."[7] The photographs she made were then subjected to her characteristic working method: she develops the original photograph, makes a pastel drawing from it, and then photographs her drawing. The drawing is then destroyed, and all that remains is a sequence of unique glossy Cibachromes, with Adler's drawings "trapped" in their surfaces. The destruction of the drawing—which, in being hand-crafted, stands for "art," as opposed to the documentary photograph—renders the photographic copy the original by default. In stressing the uniqueness of these Cibachromes, Adler reverses Levine and the notion of the photograph as pure reproduction or copy and works to demonstrate the displacement of the "aura" from drawing to photograph. But, then again,

in a final twist, each of her Cibachromes is only one in a series, and thus they could also be said to be as non-unique and interdependent as a frame in an animated film. Adler's convoluted game-play, her layering of originals—lost and substituted— and copies, her blurring of real experiences and representations, are ultimately metaphors for the convolutions of desire itself, which, like photography, tends to be predicated on a lost object or original.

For the early Conceptual artists, photography became relevant because it was, in its vernacular forms at least, a functional medium, evolved to record and describe rather than to express or aestheticize. The rigorous application of photography's purely reproductive function in, for example, the work of Ruscha or Huebler was in a sense as radical and unrepeatable an idea as Duchamp's readymades. Now, with the proliferation of "pictorial" photography—and by *pictorial* I mean both the idiom of artificially enhanced or "directed" reality bequeathed by Jeff Wall and the post-Becher school of painting-scaled composed photography practiced by Gursky—it appears that artist-photographers have forgotten Conceptualism in their bid to finally claim equal status with painting and sculpture. And yet the spirit of Conceptual Art's engagement with photography lives on in the work of many contemporary artists who continue to ask not, "Is photography art?" but "Can photography show us something that art isn't?"

Notes

1. Jeff Wall, in "'Marks of Indifference': Aspects of Photography in, or as, Conceptual Art," argues convincingly that it was precisely early Conceptualism's inscription of what was deemed to be "non-artistic" photography within avant-gardist discourses that paradoxically created the conditions for photography to be subsequently and finally accepted as an art form in its own right. "Photography could emerge socially as art only at the moment when its aesthetic presuppositions seemed to be undergoing a withering radical critique, a critique apparently aimed at foreclosing any further aetheticization or 'artification' of the medium. Photoconceptualism led the way toward the complete acceptance of photography as art—autonomous, bourgeois, collectible art—by virtue of insisting that this medium might be privileged to be the negation of that whole idea" (in *Reconsidering the Object of Art, 1965–1975*, exh. cat., ed. Ann Goldstein and Anne Rorimer [Los Angeles: Museum of Contemporary Art, 1995], 252).

2. Douglas Huebler, exhibition catalogue statement for *Prospect '69*, Städtische Kunsthalle, Düsseldorf, September–October 1969, quoted in Jack Burnham, "Alice's Head: Reflections on Conceptual Art," *Artforum* 8 (February 1970): 41.

3. Thomas Ruff, quoted in Matthias Winzen, "A Credible Invention of Reality," in *Thomas Ruff: 1979 to the Present*, exh. cat. (Cologne: Verlag der Buchhandlung Walther König, 2002), 155, 150.

4. Dan Graham, in Chris Dercon, "Dan Graham: I Enjoy That Closeness . . ." *Forum International* 2 (September–October 1991), quoted in the foreword to Jean-François Chevrier, Allan Sekula, and Benjamin H. D. Buchloh, *Walker Evans and Dan Graham*, exh. cat. (Rotterdam: Witte de With; New York: Whitney Museum of American Art, 1992), 6.

5. Boris Mikhailov, in *Boris Mikhailov: Case History* (Zurich: Scalo, 1999), 9.

6. Amy Adler, unpublished lecture, The Photographers' Gallery, London, 2001.

7. Ibid.

Amy Adler; *Amy Adler Photographs Leonardo DiCaprio*, 2001; 6 Cibachrome prints; 50 x 40 in. (127 x 101.6 cm) each, (detail 2 of 6); collection of Gary and Tracy Mezzatesta

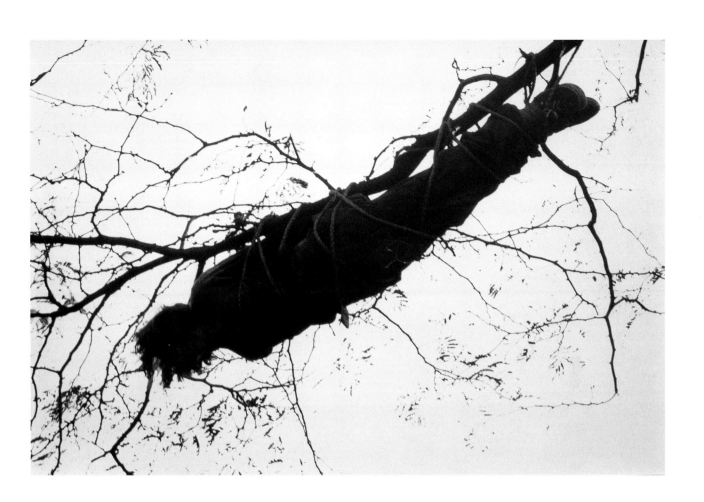

Charles Ray, Untitled, 1973
(cat. no. 125)

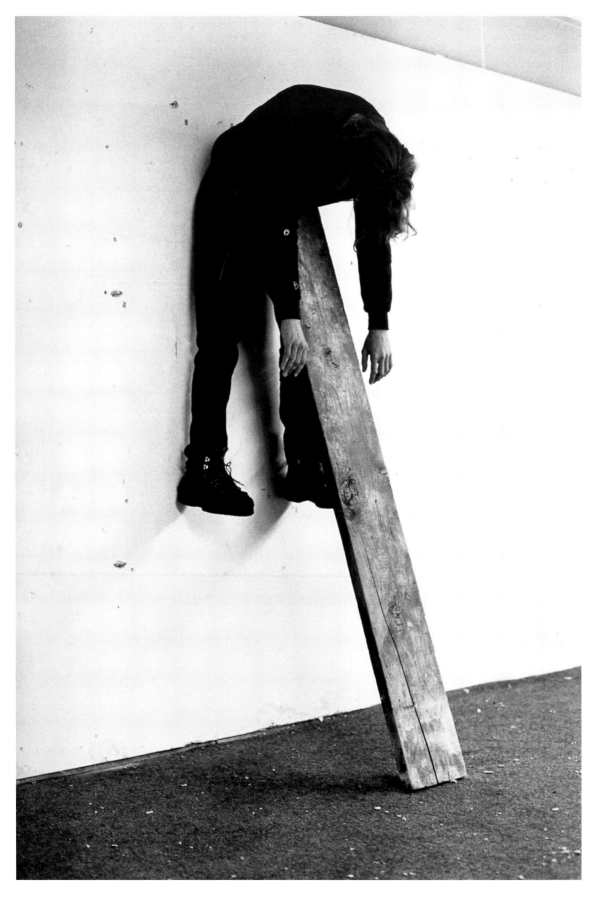

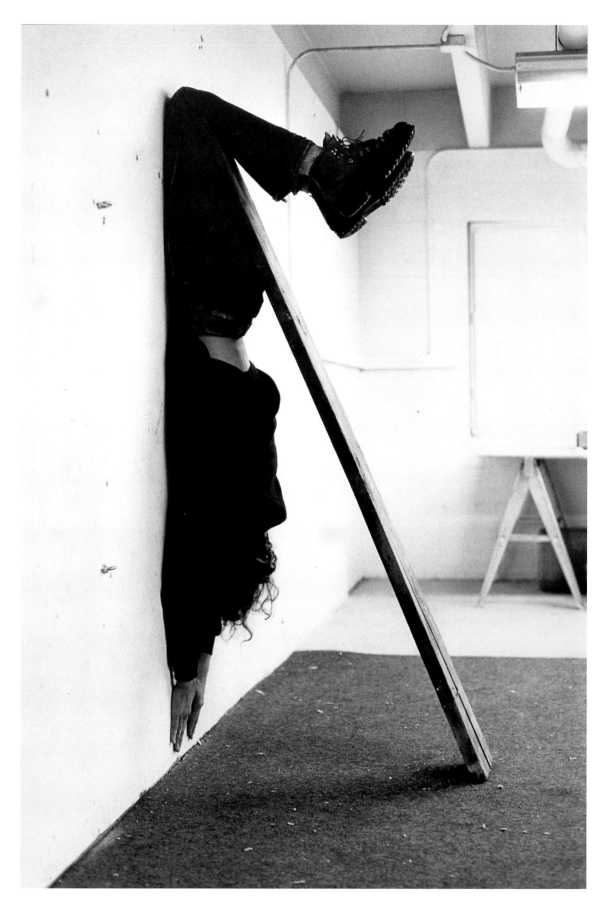

Previous spread:
Charles Ray, *Plank Piece I–II*, 1973
(cat. no. 124)

Charles Ray, *All My Clothes*, 1973
(cat. no. 123)

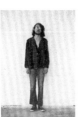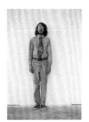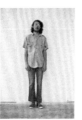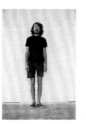

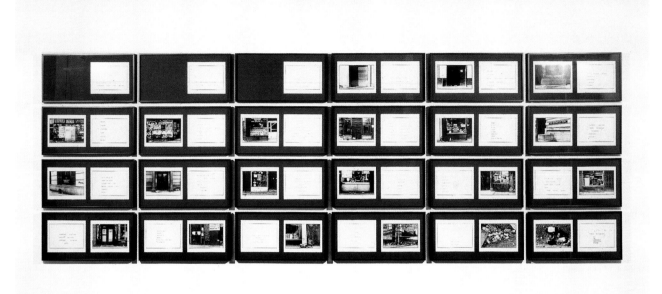

Martha Rosler, *The Bowery in Two
Inadequate Descriptive Systems*, 1974
(cat. no. 126)
Right: details

loopy groggy boozy

tight steamed up bent

folded flooey

in one's cups

under the influence

liquored up tanked up

juiced up slopped up sloppy

bloated loaded full

Allen Ruppersberg, *W. B. Yeats*, 1972
(cat. no. 128)

Allen Ruppersberg, *Seeing and Believing*,
1972 (cat. no. 127)
Right: details

TWENTYSIX

GASOLINE

STATIONS

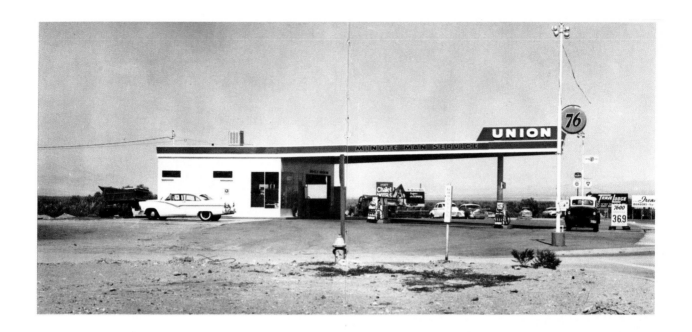

UNION, NEEDLES, CALIFORNIA

Edward Ruscha,
Twentysix Gasoline Stations (details), 1962
(cat. no. 129)

VARIOUS

SMALL

FIRES

**VARIOUS
SMALL FIRES
AND MILK**

EDWARD RUSCHA

1 9 6 4

Edward Ruscha,
Various Small Fires and Milk (details), 1964
(cat. no. 130)

EVERY BUILDING
ON THE
SUNSET
STRIP

EDWARD RUSCHA

1 9 6 6

Edward Ruscha,
Every Building on the Sunset Strip (details),
1966 (cat. no. 131)

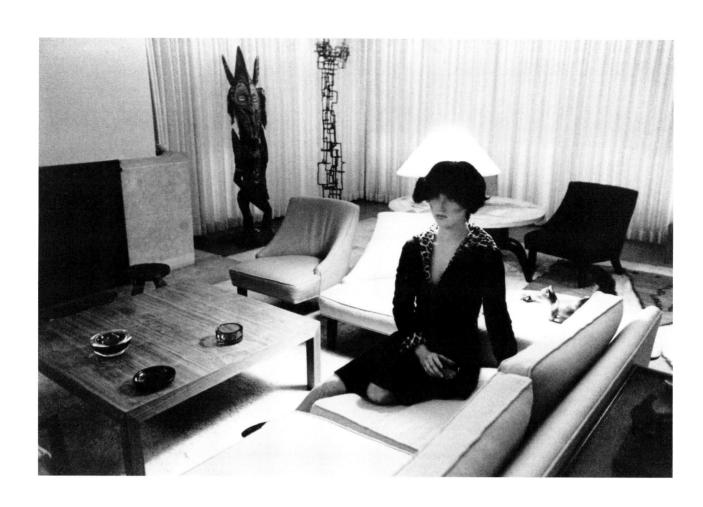

Cindy Sherman, *Untitled Film Still #50*,
1979 (cat. no. 153)

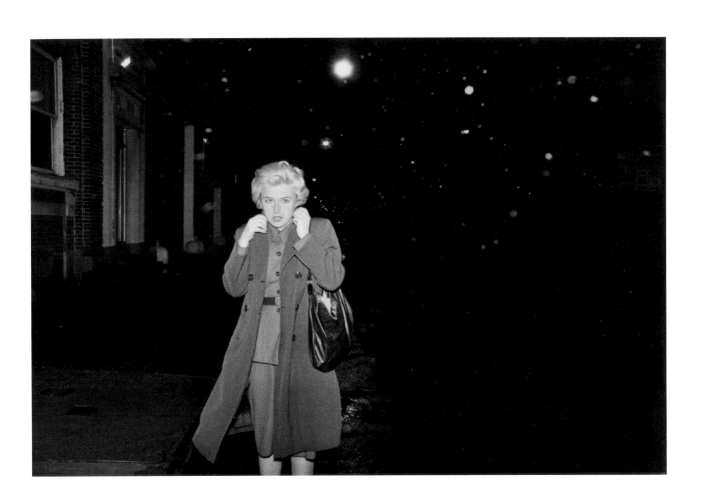

Cindy Sherman, *Untitled Film Still #54*,
1980 (cat. no. 156)

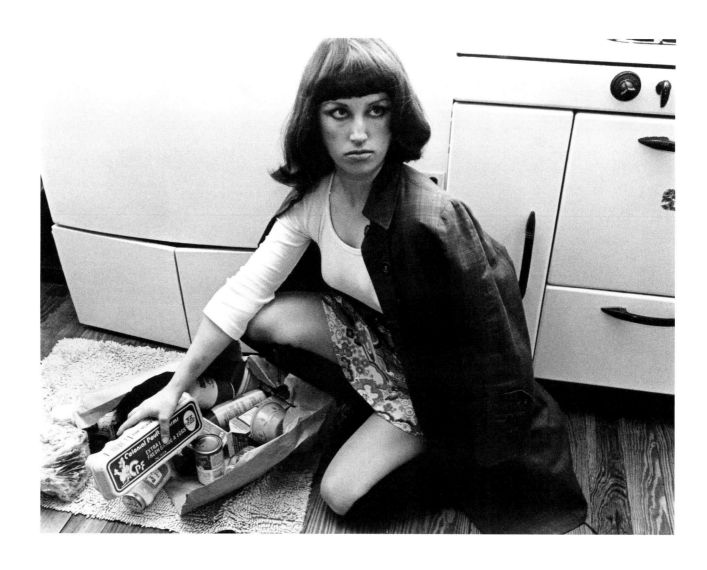

Cindy Sherman, *Untitled Film Still #10*,
1978 (cat. no. 137)

Right:
Cindy Sherman, *Untitled Film Still #34*,
1979 (cat. no. 145)

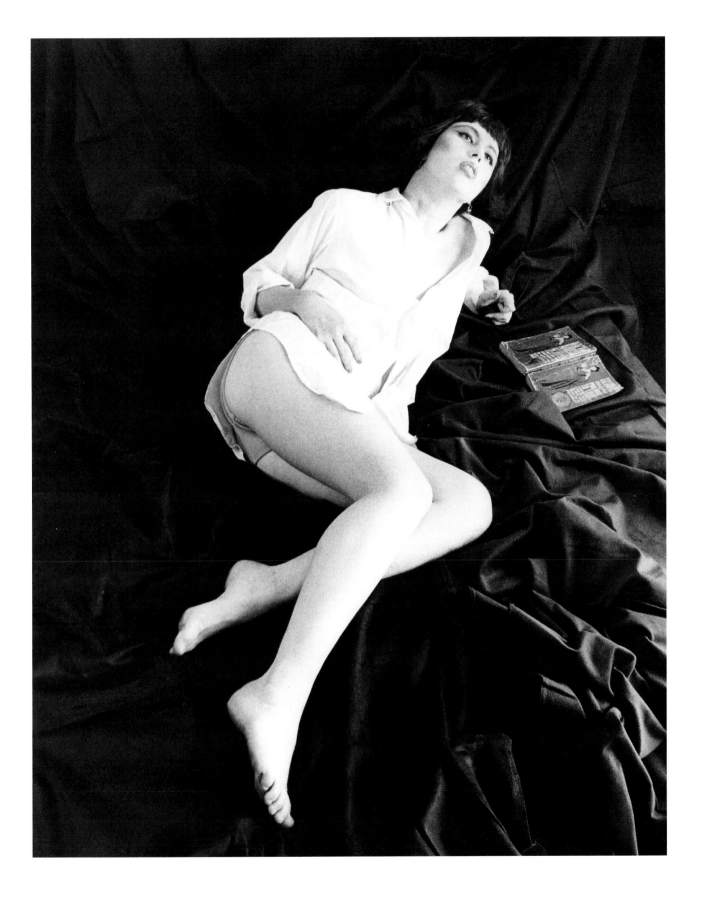

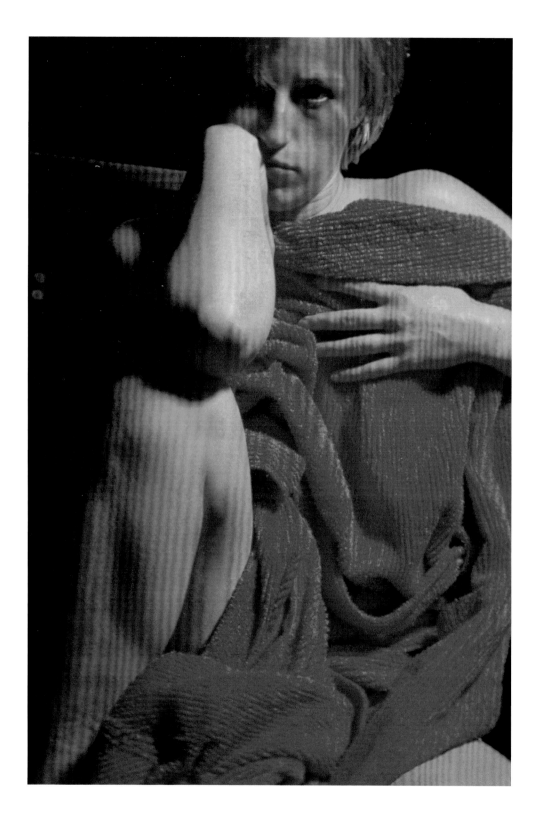

Cindy Sherman, *Untitled #97*, 1982
(cat. no. 159)

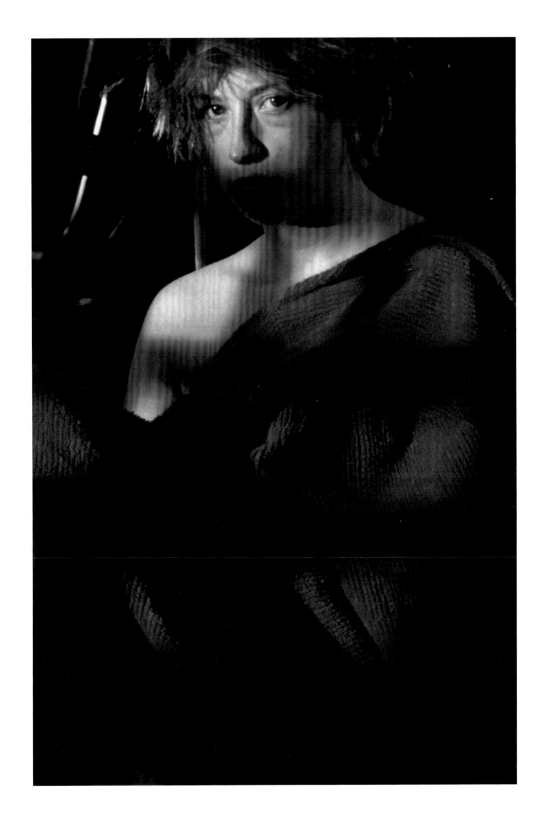

Cindy Sherman, *Untitled #98*, 1982
(cat. no. 160)

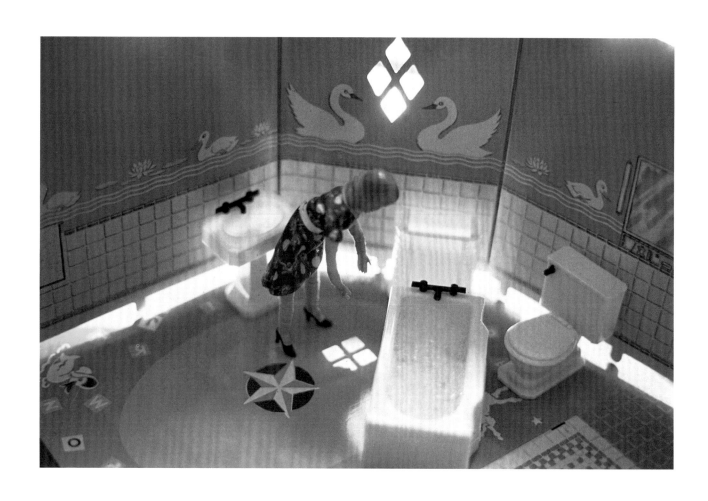

Laurie Simmons,
New Bathroom/Woman Standing, 1979
(cat. no. 170)

Laurie Simmons, *Blonde/Red Dress/Kitchen/Milk*,
1978; Cibachrome print; 3 ¹/₂ x 5 in. (8.9 x 12.7 cm);
courtesy the artist and Per Skarstedt, New York

Laurie Simmons, *Brothers/Horizon*, 1979
(cat. no. 163)

Laurie Simmons,
Woman/Green Shirt/Red Barn, 1979
(cat. no. 171)

Robert Smithson,
Monuments of Passaic (detail), 1967
(cat. no. 173)

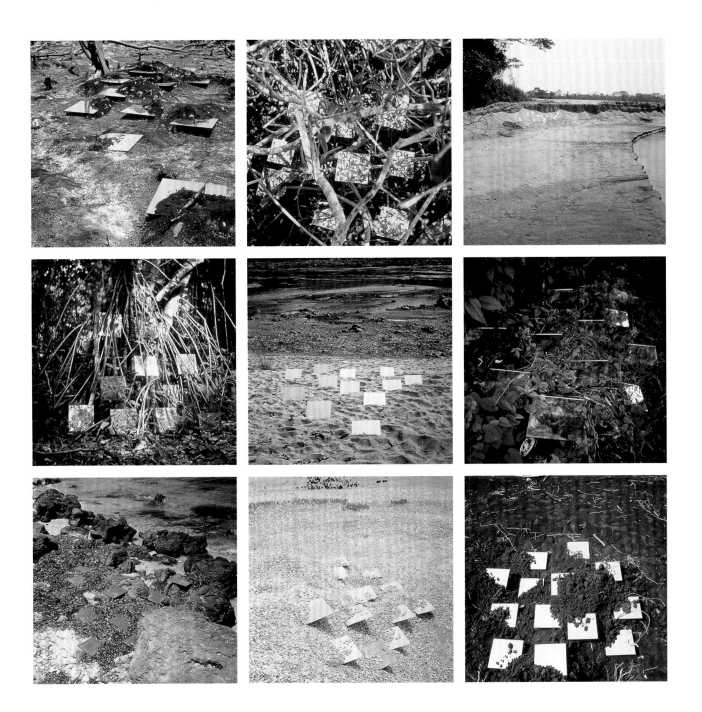

Robert Smithson,
Yucatan Mirror Displacements (1–9), 1969
(cat. no. 175)

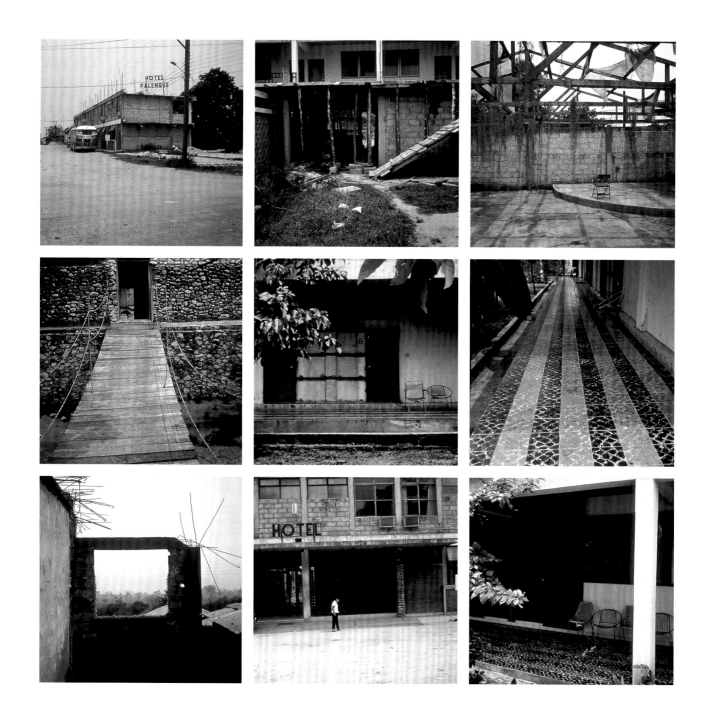

Robert Smithson,
Hotel Palenque (details), 1969
(cat. no. 174)

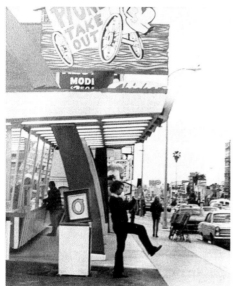

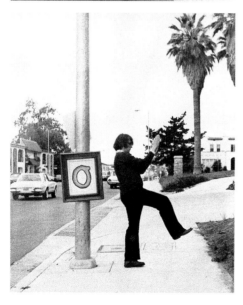

Ger Van Elk, *The Co-Founder of the Word O.K.—Hollywood*, 1971 (cat. no. 176)

Ger Van Elk, *Los Angeles Freeway Flyer*,
1973/2003 (cat. no. 178)

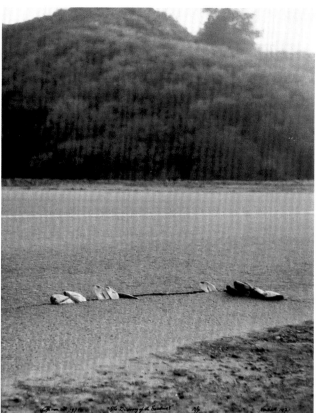

Ger Van Elk, *The Discovery of the Sardines,*
Placerita Canyon, Newhall, California, 1971
(cat. no. 177)

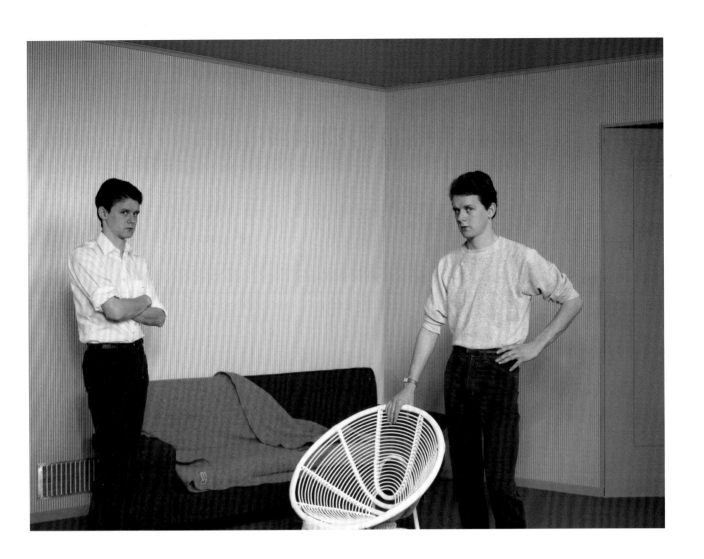

Jeff Wall, *Double Self-Portrait*, 1979
(cat. no. 179)

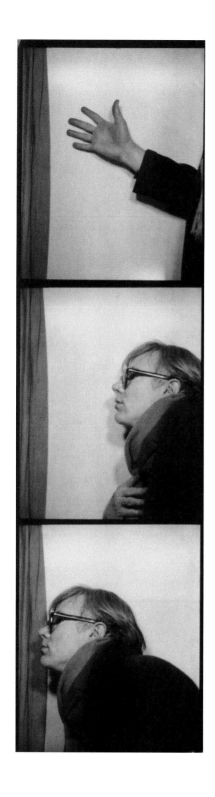

Andy Warhol, *Photobooth Pictures*
(*Andy Warhol with Sunglasses*), c. 1963
(cat. no. 181)

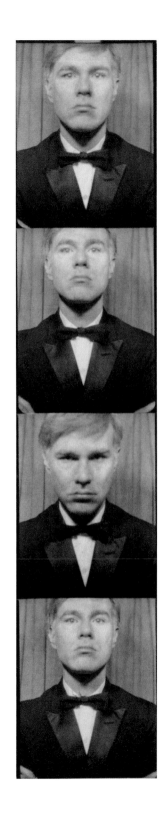

Andy Warhol, *Photobooth Pictures*
(*Andy Warhol in Tuxedo*), c. 1963
(cat. no. 180)

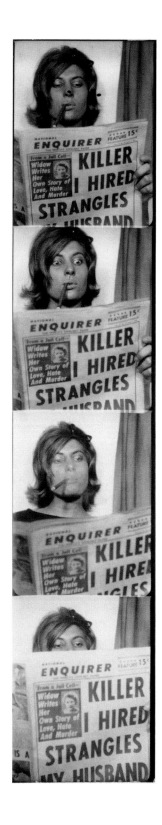

Andy Warhol, *Photobooth Pictures (Sandra Hochman for Harper's Bazaar "New Faces, New Forces, New Names in the Arts")*, June 1963 (cat. no. 183)

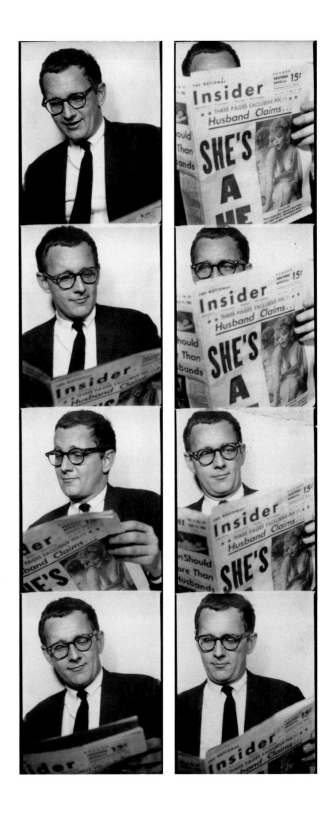

Andy Warhol, *Photobooth Pictures (Writer
Donald Barthelme for Harper's Bazaar "New
Faces, New Forces, New Names in the Arts")*,
June 1963 (cat. no. 184)

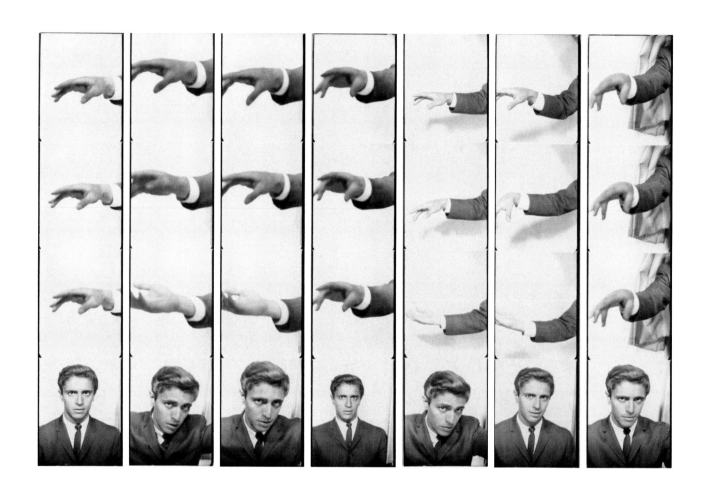

Andy Warhol, *Photobooth Pictures (Edward
Villella for Harper's Bazaar "New Faces,
New Forces, New Names in the Arts")*, June
1963 (cat. no. 182)

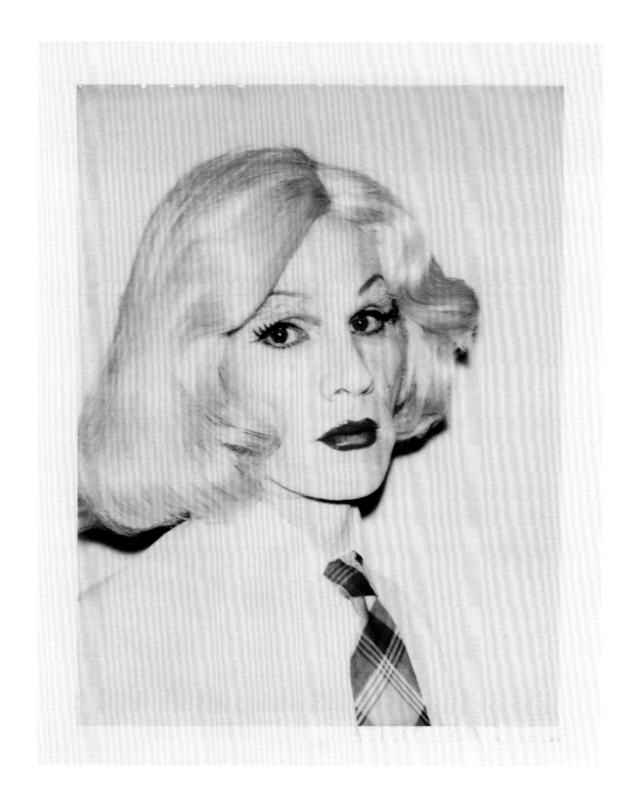

Andy Warhol, *Self-Portrait in Drag,*
c. 1981 (cat. no. 187)

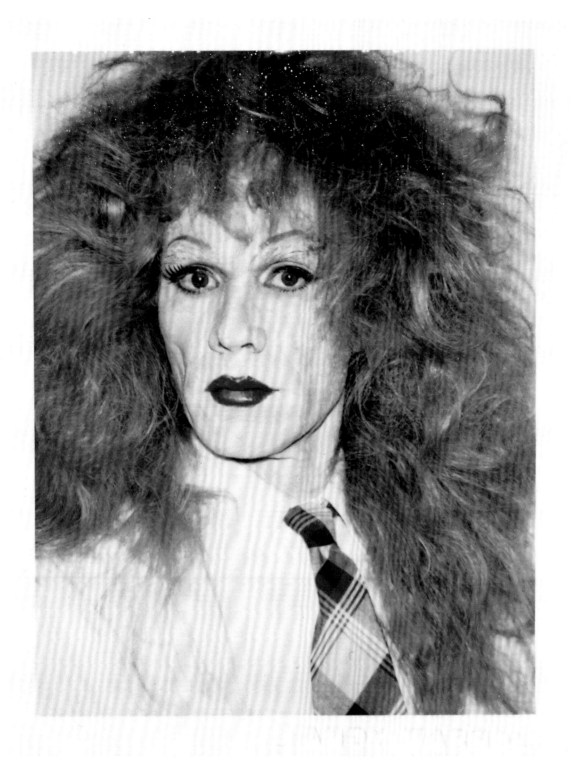

Andy Warhol, *Self-Portrait in Drag*,
c. 1981 (cat. no. 188)

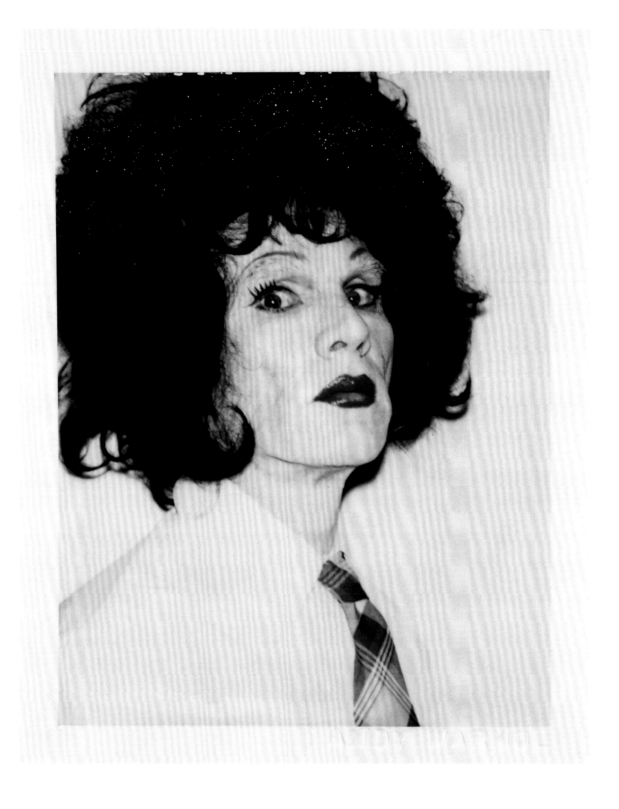

Andy Warhol, *Self-Portrait in Drag*,
c. 1981 (cat. no. 189)

Robert Watts, *TV Dinner*, 1965
(cat. no. 191)

Right:
Robert Watts, *Portrait Dress*, 1965
(cat. no. 190)

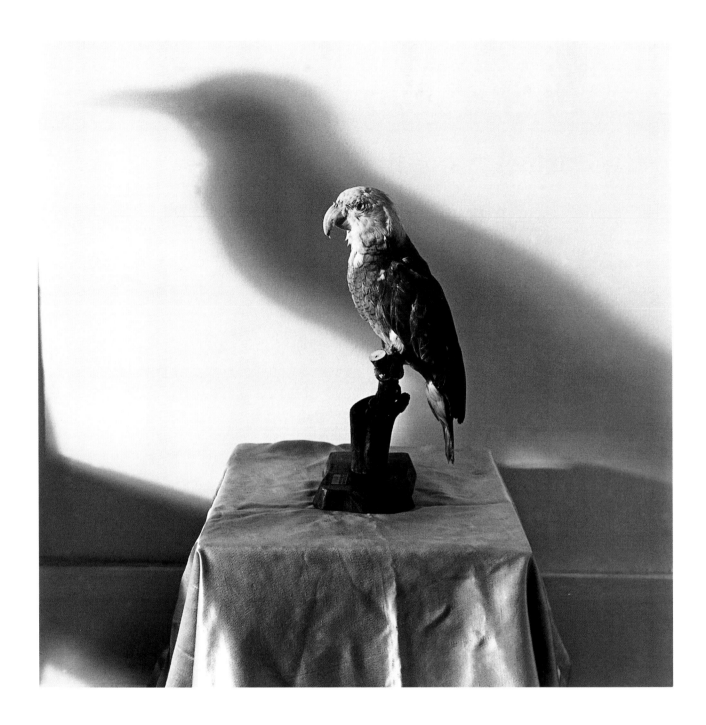

William Wegman, *Crow*, 1970
(cat. no. 193)

William Wegman, *Milk/Floor*, 1970
(cat. no. 194)

William Wegman, *Reading Two Books*, 1971
(cat. no. 196)

TO HIDE HIS DEFORMITY HE WORE SPECIAL CLOTHING

William Wegman, *To Hide His Deformity*
He Wore Special Clothing, 1971
(cat. no. 197)

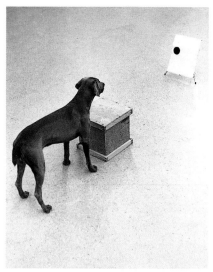 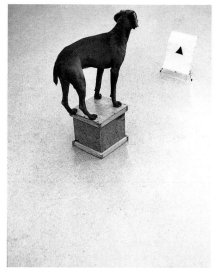 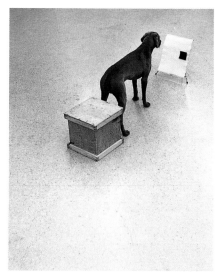

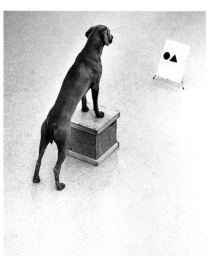 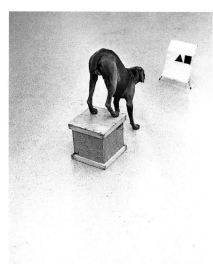 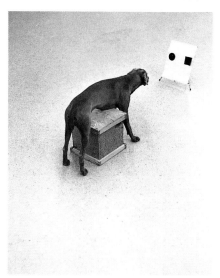

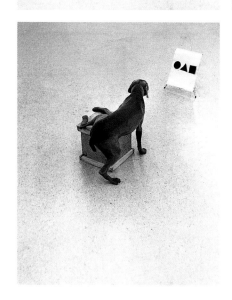

William Wegman,
Before/On/After: Permutations, 1972
(cat. no. 198)

James Welling, *The Waterfall*, 1981
(cat. no. 205)

James Welling, *In Search of …*, 1981
(cat. no. 202)

James Welling, *2-29 IV, 1980*, 1980
(cat. no. 201)

James Welling, *July 10 (a) (1980)*, 1980
(cat. no. 199)

James Welling, *March 16 (1980)*, 1980
(cat. no. 200)

James Welling, *Whitfield*, 1981
(cat. no. 206)

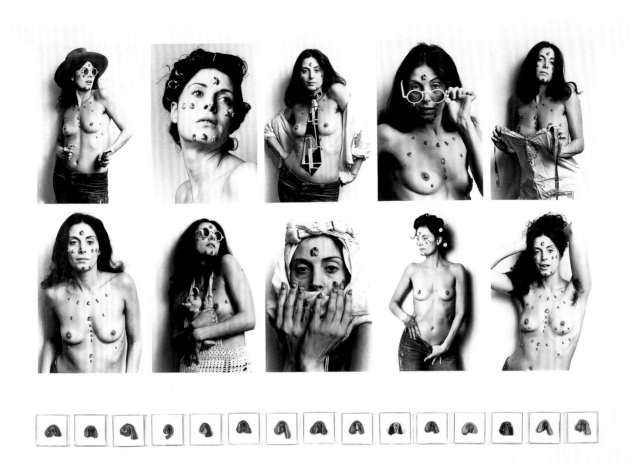

Hannah Wilke, *S.O.S.—Starification
Object Series*, 1974–1982
(cat. no. 207)

Exhibition Checklist

Vito Acconci
(born New York 1940)

1. *Jumps*, 1969
Black-and-white photographs,
foam core, chalkboard spray,
chalk, felt-tip pen ink
27 x 143 in. (68.6 x 363.2 cm)
Collection Michael Benevento,
New York

2. *Margins*, 1969
Black-and-white photographs,
foam core, chalkboard spray,
chalk, felt-tip pen ink
95 x 95 in. (241.3 x 241.3 cm)
Collection Fried, Frank, Harris,
Shriver & Jacobson, New York

Bas Jan Ader
(born Winschoten, Holland, 1942; died 1976)

3. *Broken Fall (Geometric), Westkapelle, Holland*, 1971
Color photograph
Edition 2/3
15 ½ x 11 ⅝ in. (39.4 x 29.5 cm)
Courtesy Bas Jan Ader Estate,
Patrick Painter Editions, Hong
Kong and Vancouver

4. *Pitfall on the Way to a New Neo Plasticism, Westkapelle, Holland*, 1971
Color photograph
Edition 2/3
15 ¾ x 11 ⅝ in. (40 x 29.5 cm)
Courtesy Bas Jan Ader Estate,
Patrick Painter Editions, Hong
Kong and Vancouver

5. *Untitled (Tea Party)*, 1972
Color photographs
Edition 3/3
6 photographs, 4 ¹⁵/₁₆ x 7 ⅝ in.
(12.5 x 19.4 cm) each
Courtesy Bas Jan Ader Estate,
Patrick Painter Editions, Hong
Kong and Vancouver

6. *In Search of the Miraculous (One Night in Los Angeles)*, 1973
Black-and-white photographs with
handwritten text in white ink
18 photographs, 8 x 10 in.
(20.3 x 25.4 cm) each
30 x 75 in. (76.2 x 190.5 cm)
overall installed
Collection Philip E. Aarons,
New York
(Not shown in Minneapolis)

7. *Untitled (Flower Work)*, 1974
Chromogenic prints
Edition 1/3
3 frames, 13 ⅛ x 100 ⅝ x 1 ¾ in.
(33.4 x 255.6 x 4.5 cm) each
La Colección Jumex, Mexico
(Shown only in Minneapolis)

Giovanni Anselmo
(born Borgofranco d'Ivrea, Italy, 1934)

8. *Lato destro* (Right side), 1970
Color photograph
12 ⅝ x 8 ⅞ in. (32.1 x 22.5 cm)
Courtesy Esso Gallery and Books,
New York

9. *Entrare nell'opera*
(Entering the work), 1971
Photographic emulsion on canvas
104 ⁵/₁₆ x 153 ⁹/₁₆ in.
(264.9 x 390.1 cm)
Private collection; courtesy Galleria
Tucci Russo, Torre Pellice, Italy

Eleanor Antin
(born New York 1935)

10. *Carving: A Traditional Sculpture*, 1972
Black-and-white photographs,
text panel
Edition 2/2
148 photographs, 7 x 5 in.
(17.8 x 12.7 cm) each
15 ½ x 10 ¼ in.
(39.4 x 26.1 cm) text
31 x 209 ¼ in. (78.7 x 531.5 cm)
overall installed
Collection Gary and Tracy
Mezzatesta, Los Angeles

John Baldessari
(born National City, California, 1931)

11. *The Spectator Is Compelled . . .*, 1966–1968
Acrylic and photographic emulsion
on canvas
59 x 45 in. (149.9 x 114.3 cm)
The Broad Art Foundation,
Santa Monica

12. *Choosing (A Game for Two Players): Rhubarb*, 1972
Type-R prints, typewritten sheet,
mounted on paperboard
7 prints, 14 x 11 in.
(35.6 x 27.9 cm) each
11 x 8 ½ in. (27.9 x 21.6 cm) text
Collection Angelo R. Baldassarre,
Bari, Italy

13. *A Movie: Directional Piece. Where People Are Looking (with R, V, G, Variants and Ending with Yellow)*, 1972–1973
Black-and-white and color
photographs, acrylic paint,
mounted on paperboard
28 photographs, 3 ½ x 5 in.
(9 x 13 cm) each
84 x 72 in. (213.4 x 182.9 cm)
overall installed
Collection Fundação de Serralves,
Museum of Contemporary Art,
Porto, Portugal

14. *Embed Series: Oiled Arm (Sinking Boat and Palms)*, 1974
Black-and-white photographs
mounted on paperboard
2 photographs, 16 ¾ x 23 ½ in.
(42.6 x 59.7 cm) each
23 ¼ x 54 ½ in.
(59.1 x 138.4 cm) framed
Collection Walker Art Center,
Minneapolis; T. B. Walker
Acquisition Fund, 1996

15. *Alignment Series: Things in My Studio (by Height)*, 1975
Black-and-white photographs,
ink, mounted on paperboard
11 photographs, 3 ½ x 5 in.
(8.9 x 12.7 cm) each
Private collection, New Jersey

Bernd and Hilla Becher
(Bernd Becher: born Siegen, Germany, 1931)
(Hilla Becher: born Potsdam, Germany, 1934)

16. *Gas Tanks (Spherical)*, 1963
Black-and-white photographs
9 photographs, 22 ⅛ x 18 ¼ in.
(56.2 x 46.3 cm) each
68 ¼ x 56 ¼ in. (173.4 x 142.9 cm)
overall installed
Collection Artur Walther,
New York

17. *Coal Bunkers*, 1966–1977/2000
Black-and-white photographs
9 photographs, 22 ⅛ x 18 ¼ in.
(56.2 x 46.4 cm) each
68 ¼ x 56 ¼ in. (173.4 x 142.9 cm)
overall installed
Collection Artur Walther,
New York

18. *Grain Elevators USA*, 1977/1995
Black-and-white photographs
15 photographs, 22 ⅛ x 18 ¼ in.
(56.2 x 46.3 cm) each
66 ⅜ x 91 ¼ in. (168.6 x 231.8 cm)
overall installed
Collection Artur Walther,
New York

Joseph Beuys
(born Krefeld, Germany, 1921; died 1986)

19. *Vakuum ⟷ Masse*
(Vacuum ⟷ mass), 1970
Black-and-white photograph
on photosensitive canvas
Edition 7/100
49 ¼ x 69 in. (125.1 x 175.3 cm)
Alfred and Marie Greisinger
Collection, Walker Art Center; T. B.
Walker Acquisition Fund, 1992

20. *La rivoluzione siamo noi*, 1972
Phototype on polyester, ink,
ink stamp
Edition 7/180 (+ 18 APs)
75 ½ x 39 ⅜ in. (191.8 x 100 cm)
Alfred and Marie Greisinger
Collection, Walker Art Center; T. B.
Walker Acquisition Fund, 1992

21. *Enterprise 18.11.72, 18:5:16 Uhr* (Enterprise 11/18/72, 18:5:16 hours), 1973
Zinc, black-and-white
photograph, camera, felt
Edition 7/24
16 ⅛ x 12 x 6 ⅛ in.
(40.9 x 30.5 x 15.6 cm)
Alfred and Marie Greisinger
Collection, Walker Art Center; T. B.
Walker Acquisition Fund, 1992

Mel Bochner
(born Pittsburgh 1940)

22. *Crumple*, 1967/1994
Silhouetted silver dye
bleach print (Ilfochrome)
74 x 34 in. (188 x 86.4 cm)
Courtesy Sonnabend Gallery,
New York

23. *Surface Deformation/Crumple*,
1967/2000
Gelatin silver print mounted
on Masonite
54 x 28 in. (137 x 71 cm)
Collection Suzanne Cohen,
Baltimore

24. *Surface Dis/Tension*, 1968
Silhouetted composite gelatin silver
print mounted on board
72 x 68 in. (182.9 x 172.7 cm)
Courtesy Sonnabend Gallery,
New York

Christian Boltanski
(born Paris 1944)

25. *Les habits de François C.*
(The clothes of François C.), 1972
Black-and-white photographs
in tin frames with glass
24 photographs, 8 ¾ x 12 in.
(22.2 x 30.5 cm) each
38 x 77 in. (96.5 x 195.6 cm)
overall installed
Collection Daniel Bosser, Paris

26. *Les 62 membres du Club Mickey
en 1955* (The 62 members of the
Mickey Mouse Club in 1955), 1972
Black-and-white photographs in
tin frames with glass
62 photographs, 12 x 8 ¾ in.
(30.5 x 22.3 cm) each
72 x 88 in. (182.9 x 223.5 cm)
overall installed
Courtesy Sonnabend Gallery,
New York

Marcel Broodthaers
(born Brussels 1924; died 1976)

27. *No Photographs Allowed/Défense
de photographier*, 1974
Color photographs on cardboard
16 photographs, 11 x 12 ⅜ in.
(27.9 x 31.5 cm) each
Die Photographische Sammlung/SK
Stiftung Kultur, Cologne, Germany

28. *La soupe de Daguerre* (The soup
of Daguerre), 1974, from *Artists
and Photographs* portfolio, 1975
Color photographs mounted
on paper
Edition 20/60
21 x 20 ½ in. (53.3 x 52.1 cm)
Courtesy Marian Goodman
Gallery, New York

Victor Burgin
(born Sheffield, England, 1941)

29. *Performative/Narrative*, 1971
Black-and-white photographs,
printed text
16 panels, 13 ⅜ x 26 ⅜ in.
(33.9 x 66.9 cm) each
Courtesy the artist and Christine
Burgin Gallery, New York

Sarah Charlesworth
**(born East Orange, New Jersey,
1947)**

30. *April 21, 1978*, from *Modern
History*, 1978
Black-and-white direct positive
prints
AP 1/2 (edition of 3 + 2 APs)
45 prints, 22 x 16 in.
(55.9 x 40.6 cm) each
Collection Walker Art Center,
Minneapolis; Justin Smith Purchase
Fund, 2003

Bruce Conner
(born McPherson, Kansas, 1933)

31. ANGEL, 1975
Gelatin silver print photogram
85 x 39 in. (215.9 x 99.1 cm)
Collection Walker Art Center,
Minneapolis; Butler Family
Fund, 1989

32. NIGHT ANGEL, 1975
Gelatin silver print photogram
85 x 39 in. (215.9 x 99.1 cm)
Collection Walker Art Center,
Minneapolis; Butler Family
Fund, 1989

Jan Dibbets
**(born Weert, the Netherlands,
1941)**

33. *Comet Horizon 6°–72°
Sky / Land / Sky*, 1973
12 color photographs
122 x 113 ³⁄₁₆ in. (309.9 x 287.5 cm)
overall installed
Courtesy the artist, Amsterdam

34. *Horizon 1°–10° Land*, 1973
10 color photographs
48 x variable width in. (121.9 x vari-
able width cm) overall installed
Collection Walker Art Center,
Minneapolis; Art Center
Acquisition Fund, 1978

Valie Export
(born Linz, Austria, 1940)

35. *Aufhockung I* (Squat in I), 1972
Ink on black-and-white photograph
31 x 22 in. (78.7 x 55.9 cm) framed
Marieluise Hessel Collection on
permanent loan to the Center for
Curatorial Studies, Bard College,
Annandale-on-Hudson, New York

36. *Geometrische Figuration*
(Geometrical figuration), 1972
Acrylic paint on black-and-white
photograph
2/3; edition of 3
16 ⅛ x 24 in. (41 x 61 cm)
Collection Kunstmuseum
Winterthur, Winterthur,
Switzerland

37. *Starre Identität*
(Fixed identity), 1972
Ink on black-and-white photograph
16 ⅛ x 24 in. (41 x 61 cm)
Collection Museum moderner
Kunst, Stiftung Ludwig, Vienna
(Shown only in Minneapolis)

38. *Trapez* (Trapezoid), 1972
Black-and-white photograph
16 ⅜ x 24 in. (41.6 x 60.9 cm)
Collection Cindy Sherman,
New York

39. *Wir sind Gefangene unserer
Selbst* (We are prisoners of
ourselves), 1972
Black-and-white photograph
16 ½ x 24 in. (41.9 x 60.9 cm)
Courtesy the artist, Vienna

40. *Zuhockung II* (Squat in II), 1972
Ink on black-and-white photograph
16 ½ x 24 ¼ in. (41.9 x 61.6 cm)
Collection Thea Westreich and
Ethan Wagner, New York

41. *Abrundung II*
(Round off II), 1976
Black-and-white photograph,
cut out on negative
22 x 31 in. (55.9 x 78.7 cm) framed
Marieluise Hessel Collection on
permanent loan to the Center for
Curatorial Studies, Bard College,
Annandale-on-Hudson, New York

42. *Einkreisung*
(Encirclement), 1976
Ink on black-and-white photograph
16 ½ x 24 ¼ in. (41.9 x 61.6) cm
Collection Thea Westreich and
Ethan Wagner, New York; prom-
ised gift to The Metropolitan
Museum of Art, New York

Hans-Peter Feldmann
(born Düsseldorf 1941)

43. *12 Bilder* (12 pictures), 1968
Offset lithograph, ink stamp
3 ½ x 3 ⅞ in. (8.9 x 9.8 cm)
Courtesy 303 Gallery, New York

44. *11 Bilder* (11 pictures), 1969
Offset lithograph, ink stamp
3 ⅝ x 3 ¹¹⁄₁₆ in. (9.2 x 9.4 cm)
Courtesy 303 Gallery, New York

45. *3 Bilder* (3 pictures), 1970
Offset lithograph, ink stamp
5 ¼ x 3 ¹¹⁄₁₆ in. (13.3 x 9.4 cm)
Courtesy 303 Gallery, New York

46. *1 Bild* (1 picture), 1970
Offset lithograph, ink stamp
5 ¼ x 3 ¹¹⁄₁₆ in. (13.3 x 9.4 cm)
Courtesy 303 Gallery, New York

47. *7 Bilder* (7 pictures), 1970
Offset lithograph, ink stamp
3 ⁹⁄₁₆ x 5 ¼ in. (9.1 x 13.3 cm)
Courtesy 303 Gallery, New York

48. *1 Bild* (1 picture), 1971
Offset lithograph, ink stamp
8 x 5 ¹³⁄₁₆ in. (20.3 x 14.8 cm)
Courtesy 303 Gallery, New York

49. *14 Bilder* (14 pictures), 1971
Offset lithograph, ink stamp
3 ¹³⁄₁₆ x 5 ½ in. (9.7 x 13.9 cm)
Courtesy 303 Gallery, New York

50. *9 Bilder* (9 pictures), 1971
Offset lithograph, ink stamp
3 ⅝ x 3 ¹¹⁄₁₆ in. (9.2 x 9.4 cm)
Courtesy 303 Gallery, New York

51. *8 Bilder* (8 pictures), 1972
Offset lithograph, ink stamp
2 ¾ x 3 ¹¹⁄₁₆ in. (6.9 x 9.4 cm)
Courtesy 303 Gallery, New York

52. *3 Bilder* (3 pictures), 1972
Offset lithograph, ink stamp
5 ¹⁄₁₆ x 4 ¼ in. (12.9 x 10.8 cm)
Courtesy 303 Gallery, New York

53. *3 Bilder* (3 pictures), 1972
Offset lithograph, ink stamp
5 ¼ x 4 ¼ in. (13.3 x 10.8 cm)
Courtesy 303 Gallery, New York

54. *5 Bilder* (5 pictures), 1972
Offset lithograph, ink stamp
6 ¹⁄₁₆ x 5 in. (15.4 x 12.7 cm)
Courtesy 303 Gallery, New York

55. *7 Bilder* (7 pictures), 1973
Offset lithograph, ink stamp
4 $^7/_{16}$ x 3 $^3/_4$ in. (11.3 x 9.5 cm)
Courtesy 303 Gallery, New York

56. *Sonntagsbilder*
(Sunday pictures), 1976–1977
Black-and-white offset
lithographs and screenprints
21 of various dimensions
The Heithoff Family Collection,
Minneapolis

Peter Fischli and David Weiss
(Peter Fischli: born Zurich 1952)
(David Weiss: born Zurich 1946)

57. Wurstserie
(Sausage series), 1979
Am Nordpol (At the North Pole)
Der Brand von Uster
(The fire of Uster)
Höhlenbewohner (Caveman)
Im Teppichladen
(In the carpet shop)
In den Bergen (In the mountains)
Modeschau (Fashion show)
Moonraker
Pavesi
Titanic
Der Unfall (The accident)
Color photographs
9 $^1/_2$ x 13 $^3/_4$ in. (24.2 x 34.9 cm) each
Collection Walker Art Center,
Minneapolis; Clinton and Della
Walker Acquisition Fund, 1993

Gilbert & George
(Gilbert: born Dolomites,
Italy, 1943)
(George: born Devon,
England, 1942)

58. *Photo-Piece*, 1971
25 black-and-white photographs
73 x 37 in. (185.4 x 93.9 cm)
overall installed
Collection Angelo R. Baldassarre,
Bari, Italy

59. *Raining Gin*, 1973
44 black-and-white photographs
78 x 45 in. (198.1 x 114.3 cm)
overall installed
Courtesy Sonnabend Gallery,
New York

60. *Dead Boards #5*, 1976
16 black-and-white photographs
97 x 81 in. (247 x 206 cm)
overall installed
Courtesy Sonnabend Gallery,
New York

Dan Graham
(born Urbana, Illinois, 1942)

61. *Homes for America*, 1966–1967
Slide projection
Dimensions variable
Courtesy the artist and Marian
Goodman Gallery, New York

Hans Haacke
(born Cologne, Germany, 1936)

62. *Live Airborne System,*
November 30, 1968, 1968
Black-and-white photograph
30 x 40 in. (76.2 x 101.6 cm)
Private collection, New Jersey

63. *Cast Ice: Freezing and Melting,*
January 3, 4, 5 . . . 1969, 1969
Black-and-white photograph
8 x 10 in. (20.3 x 25.4 cm)
Private collection, New Jersey

64. *Spray of Ithaca Falls: Freezing*
and Melting on Rope, February
7, 8, 9 . . . 1969, 1969
Black-and-white photograph
8 x 10 in. (20.3 x 25.4 cm)
Private collection, New Jersey

65. *Tokyo Trickle*, 1970
Black-and-white photograph
8 x 10 in. (20.3 x 25.4 cm)
Private collection, New Jersey

Douglas Huebler
(born Ann Arbor, Michigan, 1924;
died 1997)

66. *Variable Piece #99, Israel,*
July 1973, 1973
Drawings, photographs,
typed text on paperboard
31 $^5/_8$ x 31 $^7/_{16}$ in. (80.3 x 79.9 cm)
Courtesy Greengrassi, London

67. *Variable Piece #101, West*
Germany, March 1973, 1973
Black-and-white photographs
and statement
10 photographs, 6 $^1/_2$ x 4 $^1/_2$ in.
(16.5 x 11.4 cm) each
11 x 8 $^1/_2$ in. (27.9 x 21.6 cm)
statement
32 x 38 in. (81.3 x 96.5 cm)
overall installed
Collection Bruno van Lierde,
Brussels

Yves Klein
(born Nice, France, 1928;
died 1962)

68. *Dimanche*, 1960
Offset lithograph
22 x 15 in. (55.9 x 38.1 cm)
Collection Walker Art Center,
Minneapolis; T. B. Walker
Acquisition Fund, 1994

Imi Knoebel
(born Dessau, Germany, 1940)

69. *Projektion 1 (450 Fotos Innen-*
und Aussenprojektionen) (Projection
1 [450 photos interior and exterior
projection]), 1968–1971
Black-and-white photographs
120 photographs, 9 $^7/_{16}$ x 12 in.
(23.9 x 30.5 cm) each
98 x 148 $^7/_{16}$ in. (248.9 x 377 cm)
overall installed
Courtesy the artist, Düsseldorf

70. *Projektion 3 (115 Fotos kleine*
abstrakte Projektion)
(Projection 3 [115 photos small
abstract projection]), 1973
Black-and-white photographs
80 photographs, 9 $^7/_{16}$ x 12 in.
(23.9 x 30.5 cm) each
98 x 98 $^{13}/_{16}$ in. (248.9 x 250.9 cm)
overall installed
Courtesy the artist, Düsseldorf

71. *Projektion 16*
(54 Fotos Sternenhimmel)
(Projection 16 [54 photos
starry sky]), 1974
Black-and-white photographs
54 photographs, 12 x 9 $^7/_{16}$ in.
(30.5 x 23.9 cm) each
74 x 96 $^1/_{16}$ in. (187.9 x 244 cm)
overall installed
Courtesy the artist, Düsseldorf

Silvia Kolbowski
(born Buenos Aires 1953)

72. *Model Pleasure 1*, 1982
Chromogenic prints,
gelatin silver prints
10 photographs, 8 $^1/_2$ x 10 $^1/_2$ in.
(21.6 x 26.7 cm) each
Collection Walker Art Center,
Minneapolis; T. B. Walker
Acquisition Fund, 2002

Jeff Koons
(born York, Pennsylvania, 1955)

73. *The New Jeff Koons*, 1981
Duratran, lightbox
40 $^5/_8$ x 30 $^5/_8$ in. (103.2 x 77.8 cm)
Courtesy The Brant Foundation,
Greenwich, Connecticut

Barbara Kruger
(born Newark, New Jersey, 1945)

74. *Untitled (Your comfort*
is my silence), 1981
Color photograph
60 x 40 in.
(152.4 x 101.6 cm) framed
Daros Collection, Switzerland

75. *Untitled (You are not yourself)*,
1982
Black-and-white photograph
72 x 48 in. (182.9 x 121.9 cm)
Collection Per Skarstedt, New York

David Lamelas
(born Buenos Aires 1946)

76. *Rock Star (Character*
Appropriation), 1974
Black-and-white photographs
14 photographs, 4 $^1/_2$ x 6 $^1/_4$ in.
(11.5 x 15.9. cm) each
Collection Fundação Serralves,
Museum of Contemporary Art,
Porto, Portugal

77. *The Violent Tapes of 1975*, 1975
Black-and-white photographs
10 photographs, 15 $^3/_4$ x 11 $^{13}/_{16}$ in.
(40.1 x 30 cm) each
Collection Bruno van Lierde,
Brussels

Louise Lawler
(born Bronxville, New York, 1947)

78. *Why Pictures Now*, 1981
Black-and-white photograph
Edition 1/10
3 x 6 in. (7.6 x 15.2 cm)
Courtesy the artist and Metro
Pictures, New York

79. *Arranged by Barbara and*
Eugene Schwartz, 1982
Black-and-white photograph
Edition 3/5
16 x 23 $^1/_2$ in. (40.6 x 59.9 cm)
Courtesy the artist and Metro
Pictures, New York

80. *Arranged by Donald Marron, Susan Brundage, Cheryl Biship at Paine Webber, Inc.*, 1982
Black-and-white photograph
19 1/2 x 21 3/4 in. (49.5 x 55.3 cm)
Collection Per Skarstedt, New York

81. *Portrait (Parrot)*, 1982
Color photograph
28 1/4 x 28 1/4 in.
(71.8 x 71.8 cm) framed
Collection Allan McCollum, New York

Sherrie Levine (born Hazleton, Pennsylvania, 1947)

82. *Untitled (President: 2)*, 1979
Collage on paper
24 x 18 in. (60.9 x 45.7 cm)
The Museum of Contemporary Art, Los Angeles; Purchased with funds provided by Joel Wachs

83. *Untitled (President: 4)*, 1979
Collage on paper
24 x 18 in. (60.9 x 45.7 cm)
The Metropolitan Museum of Art, Mary Martin Fund, 1990

84. *Untitled (President: 5)*, 1979
Collage on paper
24 x 18 in. (60.9 x 45.7 cm)
The Museum of Contemporary Art, Los Angeles; Purchased with funds provided by Joel Wachs

85. *After Walker Evans: 1–22*, 1981
Black-and-white photographs
22 photographs, 8 x 10 in.
(20.3 x 25.4 cm) and 10 x 8 in.
(25.4 x 20.3 cm) each
Courtesy the artist, New York

Sol LeWitt
(born Hartford, Connecticut, 1928)

86. *Brick Wall*, 1977
Photo-offset-printed book
10 1/4 x 8 3/4 x 1/4 in.
(26.1 x 22.2 x .64 cm) closed
LeWitt Collection, Chester, Connecticut

87. *Photogrids*, 1978
Photo-offset-printed book
10 1/4 x 10 1/2 x 1/4 in.
(26.1 x 26.7 x .64 cm) closed
LeWitt Collection, Chester, Connecticut

88. *Autobiography*, 1980
Photo-offset-printed book
10 1/4 x 10 1/4 x 1/2 in.
(26.1 x 26.1 x 1.3 cm) closed
LeWitt Collection, Chester, Connecticut

Richard Long
(born Bristol, England, 1945)

89. *England*, 1967
Black-and-white photographic print mounted on paperboard
33 3/4 x 45 1/2 in.
(85.7 x 115.6 cm) framed
Courtesy Anthony d'Offay, London

90. *A Line Made by Walking, England*, 1967
Black-and-white photographic print mounted on paperboard
33 3/4 x 45 1/2 in.
(85.7 x 115.6 cm) framed
Courtesy Anthony d'Offay, London

91. *A Sculpture Left by the Tide, Cornwall*, 1970
Black-and-white photographic print mounted on paperboard
35 x 49 in. (88.9 x 124.5 cm) framed
Courtesy Anthony d'Offay, London

Gordon Matta-Clark
(born New York 1943; died 1978)

92. *Splitting*, 1974
Color photograph
Edition 2/2
26 1/2 x 39 in. (67.3 x 99.1 cm) unframed
35 x 47 1/4 x 1 1/2 in.
(88.9 x 120 x 3.8 cm) framed
Courtesy the Estate of Gordon Matta-Clark and David Zwirner, New York

93. *Splitting*, 1974
Black-and-white photographic collage
40 x 30 in. (101.6 x 76.2 cm)
L A C—Switzerland

94. *Splitting: Exterior*, c. 1974
Black-and-white photographs
2 photographs, 12 1/2 x 8 1/4 in.
(31.8 x 20.9 cm) each
4 photographs, 16 x 20 in.
(40.6 x 50.8 cm) each
Private collection, New York

Ana Mendieta
(born Havana 1948; died 1985)

95. *Untitled (Facial Cosmetic Variations)*, January–February 1972/1997
Color photographs
7 photographs, 20 x 16 in.
(50.8 x 40.6 cm) each
Courtesy the Estate of Ana Mendieta and Galerie Lelong, New York

Mario Merz
(born Milan 1925)

96. *Fibonaccio 1202*, 1970
Black-and-white photographs, neon tubing
19 11/16 x 196 7/8 in. (50 x 500.1 cm) overall installed
Dallas Museum of Art, fractional gift of the Rachofsky Collection, Dallas

Nasreen Mohamedi
(born New Delhi 1937; died 1990)

97. Untitled, c. 1968
Black-and-white photograph
9 3/8 x 11 7/16 in. (23.8 x 29.1 cm)
Courtesy Talwar Gallery, New York

98. Untitled, c. 1968
Black-and-white photograph
7 5/8 x 11 13/16 in. (19.4 x 30 cm)
Courtesy Talwar Gallery, New York

99. Untitled, c. 1970
Black-and-white photograph
7 11/16 x 11 3/8 in. (19.5 x 28.9 cm)
Courtesy Talwar Gallery, New York

100. Untitled, c. 1970
Black-and-white photograph
9 1/16 x 15 in. (23.1 x 38.1 cm)
Courtesy Talwar Gallery, New York

101. Untitled, c. 1972
Black-and-white photograph
7 7/16 x 11 7/16 in. (18.9 x 29.1 cm)
Courtesy Talwar Gallery, New York

102. Untitled, c. 1975
Black-and-white photograph
7 x 11 13/16 in. (17.8 x 30 cm)
Courtesy Talwar Gallery, New York

103. Untitled, c. 1975
Black-and-white photograph
9 3/8 x 11 13/16 in. (23.8 x 30 cm)
Courtesy Talwar Gallery, New York

104. Untitled, c. 1975
Black-and-white photograph
7 11/16 x 11 7/16 in. (19.5 x 29.1 cm)
Courtesy Talwar Gallery, New York

105. Untitled, c. 1982
Black-and-white photograph
9 3/8 x 11 3/4 in. (23.8 x 29.9 cm)
Courtesy Talwar Gallery, New York

Bruce Nauman
(born Fort Wayne, Indiana, 1941)

106. Eleven Color Photographs, 1966–1967/1970
Portfolio of 11 color photographs
Bound to Fail
19 3/4 x 23 1/2 in. (50.2 x 59.7 cm)
Coffee Spilled Because the Cup Was Too Hot
19 3/8 x 23 in. (49.2 x 58.4 cm)
Coffee Thrown away Because It Was Too Cold
19 7/8 x 23 5/8 in. (50.5 x 60 cm)
Drill Team
19 7/8 x 23 3/4 in. (50.5 x 60.3 cm)
Eating My Words
19 3/8 x 23 1/8 in. (49.2 x 58.7 cm)
Feet of Clay
23 3/8 x 22 3/8 in. (59.4 x 56.8 cm)
Finger Touch No. 1
19 5/8 x 23 1/2 in. (49.8 x 59.7 cm)
Finger Touch with Mirrors
19 7/8 x 23 3/4 in. (50.5 x 60.3 cm)
Self-Portrait as a Fountain
19 5/8 x 23 1/2 in. (49.8 x 59.7 cm)
Untitled (Potholder)
19 3/4 x 23 3/4 in. (50.2 x 60.3 cm)
Waxing Hot
19 7/8 x 29 3/8 in. (50.5 x 49.2 cm)
The Heithoff Family Collection, Minneapolis

107. *My Name as Though It Were Written on the Surface of the Moon: Bbbbbbbbbbbrrrrrrrrrruuuuuuuuuuuccc ccccccceeeeeeeeee*, 1967
15 black-and-white photographs mounted in a frame
13 x 138 in. (33.1 x 350.5 cm) overall
Courtesy Sonnabend Gallery, New York

**Hélio Oiticica and
Neville d'Almeida**
**(Hélio Oiticica: born Rio de
Janeiro 1937; died 1980)**
**(Neville d'Almeida: born Belo
Horizonte, Brazil, 1941)**

108. *03/CC5 (Hendrix War,
Cosmococa Programa-in-Progress)*,
1973/2003
Chromogenic print mounted
on aluminum
Edition of 12 + 3 APs
29 ¹⁵/₁₆ x 44 ⁷/₈ in. (76.1 x 113.9 cm)
Courtesy Galeria Fortes Vilaça,
São Paulo, and Projeto H.O.,
Rio de Janeiro

109. *06/CC5 (Hendrix War,
Cosmococa Programa-in-Progress)*,
1973/2003
Chromogenic print mounted
on aluminum
Edition of 12 + 3 APs
44 ⁷/₈ x 29 ¹⁵/₁₆ in. (113.9 x 76.1 cm)
Courtesy Galeria Fortes Vilaça,
São Paulo, and Projeto H.O.,
Rio de Janeiro

110. *07/CC5 (Hendrix War,
Cosmococa Programa-in-Progress*,
1973/2003
Chromogenic print mounted
on aluminum
Edition of 12 + 3 APs
44 ⁷/₈ x 29 ¹⁵/₁₆ in. (113.9 x 76.1 cm)
Courtesy Galeria Fortes Vilaça,
São Paulo, and Projeto H.O.,
Rio de Janeiro

Dennis Oppenheim
**(born Electric City, Washington,
1938)**

111. *Gallery Transplant*, 1969
Photodocumentation: color and
black-and-white photography
with marker ink, hand-stamped
topographic map, collage text
50 x 160 in. (127 x 406.4 cm)
Courtesy the artist, New York

112. *Reading Position for Second
Degree Burn*, 1970
Photodocumentation: color and
black-and-white photography
85 x 60 in. (215.9 x 152.4 cm)
Courtesy the artist, New York

Giulio Paolini
(born Genoa, Italy, 1940)

113. *Proust*, 1968
Photographic emulsion on canvases
2 photographs, 10 ¼ x 7 ½ in.
(26.1 x 19.1 cm) each
Collection Lorenzo and Marilena
Bonomo, Bari, Italy

Giuseppe Penone
(born Garessio, Cuneo, Italy, 1947)

114. *Svolgere la propria pelle*
(To display one's skin), 1971
Black-and-white photographs on
egg paper mounted on paperboard
104 photographs, 7 ⁷/₈ x 7 ⁷/₈ in.
(20 x 20 cm) each
7 paperboard panels, 28 x 43 in.
(71.1 x 109.2 cm) each
Dave Mixer Collection, East
Greenwich, Rhode Island

Adrian Piper
(born New York 1948)

115. *Food for the Spirit*, 1971
Black-and-white photographs
14 photographs, 21 x 21 in.
(53.3 x 53.3 cm) each
Collection Thomas Erben,
New York

116. *The Mythic Being:
I/You (Her)*, 1974
Black-and-white photographs,
ink on paper
10 photographs, 8 x 5 in.
(20.32 x 12.7 cm) each
Collection Walker Art Center,
Minneapolis; T. B. Walker
Acquisition Fund, 1999

Sigmar Polke
(born Olesnica, Germany, 1944)

117. *Polkes Peitsche*
(Polke's whip), 1968
Gelatin silver prints, rope,
wood, tape
27 ½ x 18 ⅛ in. (69.9 x 46.1 cm)
Collection IVAM, Instituto
Valenciano de Arte Moderno,
Generalitat Valenciana,
Valencia, Spain
(Shown only in Minneapolis)

118. *Bamboostange liebt
Zollstockstern* (Bamboo pole loves
folding ruler star), 1968–1969
Black-and-white photographs
in 3 frames
15 photographs, 23 ⁷/₈ x 19 ¹³/₁₆ in.
(60.6 x 50.3 cm) each
81 ¾ x 104 ¼ x 2 in.
(207.6 x 264.8 x 5.1 cm)
overall installed
Collection Walker Art Center,
Minneapolis; T. B. Walker
Acquisition Fund, 1999

Richard Prince
(born Panama Canal Zone 1949)

119. *Untitled (living rooms)*, 1977
Ektacolor photograph
Edition 5/10 (+ 2 APs)
4 photographs, 20 x 24 in.
(50.8 x 60.9 cm) each
Courtesy Barbara Gladstone
Gallery, New York

120. *Untitled (three men looking
in the same direction)*, 1978
Ektacolor photographs
Edition 4/10 (+ 2 APs)
3 photographs, 20 x 24 in.
(50.8 x 60.9 cm) each
Courtesy Barbara Gladstone
Gallery, New York

121. *Untitled (three women looking
in the same direction)*, 1980–1984
Ektacolor photographs
Edition 9/10 (+ APs)
3 photographs, 20 x 24 in.
(50.8 x 60.9 cm) each
The Heithoff Family Collection,
Minneapolis

122. *Untitled (gang)*, 1982–1984
Ektacolor photograph
AP (edition of 2 + 1 AP)
86 x 48 in. (218.4 x 121.9 cm)
Collection Nina and Frank Moore,
New York

Charles Ray
(born Chicago 1953)

123. *All My Clothes*, 1973
Kodachrome photographs
mounted on paperboard
16 photographs, 9 x 60 in.
(22.9 x 152.4 cm) each
Edition 2/12
Collection Ninah and Michael
Lynne, New York

124. *Plank Piece I–II*, 1973
Black-and-white photographs
mounted on rag board
AP 1/2 (edition of 7 + 2 APs)
2 photographs, 39 ½ x 27 in.
(100.3 x 68.6 cm) each
Collection Kiki Smith, New York

125. Untitled, 1973
Black-and-white photograph
mounted on rag board
Edition 1/7 (+ 2 APs)
20 ½ x 42 ½ in. (52.1 x 107.9 cm)
The Broad Art Foundation,
Santa Monica

Martha Rosler
(born Brooklyn)

126. *The Bowery in Two Inadequate
Descriptive Systems*, 1974
Black-and-white photographs and
3 black panels mounted on 24 black
mat boards
AP (edition of 5 + 1 AP)
45 photographs, 8 x 10 in.
(20.3 x 25.4 cm) each
Courtesy Gorney Bravin + Lee,
New York

Allen Ruppersberg
(born Cleveland, Ohio, 1944)

127. *Seeing and Believing*, 1972
Color photographs, typewriting
on paper, framed in 4 frames
12 photographs; 3 ½ x 3 ½ in.
(8.9 x 8.9 cm) each
2 texts, 8 ½ x 11 in.
(21.6 x 27.9 cm) each
2 frames, 11 ½ x 9 ⅛ in.
(29.2 x 23.2 cm) each
2 frames, 13 ¾ x 18 ¾ in.
(34.9 x 47.6 cm) each
Courtesy Margo Leavin Gallery,
Los Angeles

128. *W. B. Yeats*, 1972
Black-and-white photographs
5 photographs, 26 ¾ x 22 ¾ in.
(67.9 x 57.8 cm) each
Private collection, New York

Edward Ruscha
(born Omaha, Nebraska, 1937)

129. *Twentysix Gasoline Stations*,
1962
Photo-offset-printed book
7 ¹/₁₆ x 5 ½ x ³/₁₆ in.
(17.9 x 14 x .5 cm) closed
Courtesy the artist, Venice,
California

130. *Various Small Fires and Milk*, 1964
Photo-offset-printed book
7 $^1/_{16}$ x 5 $^1/_2$ x $^3/_{16}$ in.
(17.9 x 14 x .5 cm) closed
Courtesy the artist, Venice, California

131. *Every Building on the Sunset Strip*, 1966
Photo-offset-printed book
7 x 5 $^5/_8$ x $^3/_8$ in. (17.8 x 14.3 x 1 cm) closed
7 x 299 $^1/_2$ in. (17.8 x 760.7 cm) extended
Courtesy the artist, Venice, California

Cindy Sherman
(born Glen Ridge, New Jersey, 1954)

132. *Untitled Film Still #2*, 1977
Black-and-white photograph
AP 2/2 (edition of 10 + 2 APs)
10 x 8 in. (25.4 x 20.3 cm)
Courtesy the artist and Metro Pictures, New York

133. *Untitled Film Still #3*, 1977
Black-and-white photograph
Edition 6/10 (+ 2 APs)
8 x 10 in. (20.3 x 25.4 cm)
Collection Henry Art Gallery, University of Washington, Seattle, Joseph and Elaine Monsen Photography Collection, gift of Joseph and Elaine Monsen and The Boeing Company, Seattle

134. *Untitled Film Still #4*, 1977
Black-and-white photograph
AP 2/2 (edition of 10 + 2 APs)
8 x 10 in. (20.3 x 25.4 cm)
Courtesy the artist and Metro Pictures, New York

135. *Untitled Film Still #6*, 1977
Black-and-white photograph
AP 2/2 (edition of 10 + 2 APs)
10 x 8 in. (25.4 x 20.3 cm)
Courtesy the artist and Metro Pictures, New York

136. *Untitled Film Still #7*, 1978
Black-and-white photograph
AP 2/2 (edition of 10 + 2 APs)
10 x 8 in. (25.4 x 20.3 cm)
Courtesy the artist and Metro Pictures, New York

137. *Untitled Film Still #10*, 1978
Black-and-white photograph
AP 2/2 (edition of 10 + 2 APs)
8 x 10 in. (20.3 x 25.4 cm)
Collection Art Gallery of Ontario, Toronto; Gift from the Junior Committee Fund, 1988

138. *Untitled Film Still #12*, 1978
Black-and-white photograph
AP 2/2 (edition of 10 + 2 APs)
8 x 10 in. (20.3 x 25.4 cm)
Courtesy the artist and Metro Pictures, New York

139. *Untitled Film Still #13*, 1978
Black-and-white photograph
AP 2/2 (edition of 10 + 2 APs)
10 x 8 in. (25.4 x 20.3 cm)
Courtesy the artist and Metro Pictures, New York

140. *Untitled Film Still #14*, 1978
Black-and-white photograph
AP 2/2 (edition of 10 + 2 APs)
10 x 8 in. (25.4 x 20.3 cm)
Courtesy the artist and Metro Pictures, New York

141. *Untitled Film Still #15*, 1978
Black-and-white photograph
Edition 10/10 (+ 2 APs)
8 x 10 in. (20.3 x 25.4 cm)
Collection Mr. and Mrs. Charles Shenk, Columbus, Ohio

142. *Untitled Film Still #16*, 1978
Black-and-white photograph
Edition 1/10 (+ 2 APs)
8 x 10 in. (20.3 x 25.4 cm)
Collection Sybil Shainwald, New York

143. *Untitled Film Still #21*, 1978
Black-and-white photograph
AP 2/2 (edition of 10 + 2 APs)
8 x 10 in. (20.3 x 25.4 cm)
Courtesy the artist and Metro Pictures, New York

144. *Untitled Film Still #24*, 1978
Black-and-white photograph
AP 2/2 (edition of 10 + 2 APs)
8 x 10 in. (20.3 x 25.4 cm)
Courtesy the artist and Metro Pictures, New York

145. *Untitled Film Still #34*, 1979
Black-and-white photograph
AP 2/2 (edition of 10 + 2 APs)
10 x 8 in. (25.4 x 20.3 cm)
Courtesy the artist and Metro Pictures, New York

146. *Untitled Film Still #35*, 1979
Black-and-white photograph
AP 2/2 (edition of 10 + 2 APs)
10 x 8 in. (25.4 x 20.3 cm)
Courtesy the artist and Metro Pictures, New York

147. *Untitled Film Still #37*, 1979
Black-and-white photograph
AP 2/2 (edition of 10 + 2 APs)
10 x 8 in. (25.4 x 20.3 cm)
Courtesy the artist and Metro Pictures, New York

148. *Untitled Film Still #43*, 1979
Black-and-white photograph
AP 2/2 (edition of 10 + 2 APs)
8 x 10 in. (20.3 x 25.4 cm)
Courtesy the artist and Metro Pictures, New York

149. *Untitled Film Still #45*, 1979
Black-and-white photograph
AP 2/2 (edition of 10 + 2 APs)
8 x 10 in. (20.3 x 25.4 cm)
Courtesy the artist and Metro Pictures, New York

150. *Untitled Film Still #46*, 1979
Black-and-white photograph
AP 2/2 (edition of 10 + 2 APs)
8 x 10 in. (20.3 x 25.4 cm)
Courtesy the artist and Metro Pictures, New York

151. *Untitled Film Still #47*, 1979
Black-and-white photograph
AP 2/2 (edition of 10 + 2 APs)
8 x 10 in. (20.3 x 25.4 cm)
Courtesy the artist and Metro Pictures, New York

152. *Untitled Film Still #48*, 1979
Black-and-white photograph
AP 2/2 (edition of 10 + 2 APs)
8 x 10 in. (20.3 x 25.4 cm)
Courtesy the artist and Metro Pictures, New York

153. *Untitled Film Still #50*, 1979
Black-and-white photograph
Edition 9/10 (+ 2 APs)
8 x 10 in. (20.3 x 25.4 cm)
Des Moines Art Center's Permanent Collections, Des Moines, Iowa; Purchased with funds from the Edmundson Art Foundation, Inc.

154. *Untitled Film Still #52*, 1980
Black-and-white photograph
AP 2/2 (edition of 10 + 2 APs)
8 x 10 in. (20.3 x 25.4 cm)
Courtesy the artist and Metro Pictures, New York

155. *Untitled Film Still #53*, 1980
Black-and-white photograph
AP 2/2 (edition of 10 + 2 APs)
8 x 10 in. (20.3 x 25.4 cm)
Courtesy the artist and Metro Pictures, New York

156. *Untitled Film Still #54*, 1980
Black-and-white photograph
AP 2/2 (edition of 10 + 2 APs)
8 x 10 in. (20.3 x 25.4 cm)
Courtesy the artist and Metro Pictures, New York

157. *Untitled Film Still #56*, 1980
Black-and-white photograph
Edition 6/10 (+ 2 APs)
8 x 10 in. (20.3 x 25.4 cm)
Des Moines Art Center's Permanent Collections, Des Moines, Iowa; Purchased with funds from the Edmundson Art Foundation, Inc.

158. *Untitled Film Still #83*, 1980
Black-and-white photograph
AP 2/2 (edition of 10 + 2 APs)
8 x 10 in. (20.3 x 25.4 cm)
Courtesy the artist and Metro Pictures, New York

159. *Untitled #97*, 1982
Color photograph
Edition 5/10
45 x 30 in. (114.3 x 76.2 cm)
Collection Per Skarstedt, New York

160. *Untitled #98*, 1982
Color photograph
Edition 5/10
45 x 30 in. (114.3 x 76.2 cm)
Collection Per Skarstedt, New York

Laurie Simmons
(born Long Island, New York, 1949)

161. *Blonde/Red Dress/Kitchen*, 1978
Cibachrome print
AP (edition of 7 + 1 AP)
3 $^1/_2$ x 5 in. (8.9 x 12.7 cm)
Private collection, New York

162. *Woman/Red Couch/Newspaper*, 1978
Cibachrome print
AP (edition of 7 + 1 AP)
3 $^1/_2$ x 5 in. (8.9 x 12.7 cm)
Private collection, New York

163. *Brothers/Horizon*, 1979
Cibachrome print
AP (edition of 7 + 1 AP)
5 x 7 1/4 in. (12.7 x 18.4 cm)
Collection Thea Westreich and
Ethan Wagner, New York

164. *Horses/Slant*, 1979
Cibachrome print
AP (edition of 7 + 1 AP)
5 x 7 1/4 in. (12.7 x 18.4 cm)
Courtesy the artist and Per
Skarstedt, New York

165. *Man/Blue Shirt/Red Barn*, 1979
Cibachrome print
AP (edition of 7 + 1 AP)
5 x 7 1/4 in. (12.7 x 18.4 cm)
Private collection, New York

166. *Man/Puddle*, 1979
Cibachrome print
AP (edition of 7 + 1 AP)
5 x 7 1/4 in. (12.7 x 18.4 cm)
Courtesy the artist and Per
Skarstedt, New York

167. *Man/Sky/Puddle/Second View*,
1979
Cibachrome print
AP (edition of 7 + 1 AP)
5 x 7 1/4 in. (12.7 x 18.4 cm)
Collection Nina and Frank Moore,
New York

168. *New Bathroom Plan*, 1979
Cibachrome print
AP (edition of 7 + 1 AP)
3 1/2 x 5 in. (8.9 x 12.7 cm)
Courtesy the artist and Per
Skarstedt, New York

169. *New Bathroom/Woman
Kneeling/First View*, 1979
Cibachrome print
3 1/2 x 5 in. (8.9 x 12.7 cm)
AP (edition of 7 + 1 AP)
Collection Thea Westreich and
Ethan Wagner, New York

170. *New Bathroom/Woman
Standing*, 1979
Cibachrome print
AP (edition of 7 + 1 AP)
3 1/2 x 5 in. (8.9 x 12.7 cm)
Courtesy the artist and Per
Skarstedt, New York

171. *Woman/Green Shirt/Red Barn*,
1979
Cibachrome print
AP (edition of 7 + 1 AP)
5 x 7 1/4 in. (12.7 x 18.4 cm)
Courtesy the artist and Per
Skarstedt, New York

172. *Woman Opening
Refrigerator/Milk in the Middle*, 1979
Cibachrome print
AP (edition of 7 + 1 AP)
3 1/2 x 5 in. (8.9 x 12.7 cm)
Courtesy the artist and Per
Skarstedt, New York

**Robert Smithson
(born Passaic, New Jersey, 1938;
died 1973)**

173. *Monuments of Passaic*, 1967
6 black-and-white photographs,
1 cut photostat
Dimensions variable
The Museum of Contemporary
Art, Oslo

174. *Hotel Palenque*, 1969
31 chromogenic-development slides
with audio CD
Dimensions variable
Solomon R. Guggenheim Museum,
New York; Purchased with funds
contributed by the International
Director's Council and Executive
Committee Members: Edythe
Broad, Henry Buhl, Elaine Terner
Cooper, Linda Fischbach, Ronnie
Heyman, Dakis Joannou, Cindy
Johnson, Barbara Lane, Linda
Macklowe, Brian McIver, Peter
Norton, William Peppler, Denise
Rich, Rachel Rudin, David Teiger,
Ginny Williams, Elliot Wolk, 1999
Exhibition copy

175. *Yucatan Mirror Displacements
(1–9)*, 1969
Cibachrome photographs from
chromogenic 35mm slides
9 framed prints, 17 x 17 x 1 1/2 in.
(43.2 x 43.2 x 3.8 cm) each
Collection Solomon R.
Guggenheim Museum, New York;
Purchased with funds contributed
by the Photography Committee and
with funds contributed by the
International Director's Council
and Executive Committee
Members: Edythe Broad, Henry
Buhl, Elaine Terner Cooper,
Linda Fischbach, Ronnie Heyman,
Dakis Joannou, Cindy Johnson,
Barbara Lane, Linda Macklowe,
Brian McIver, Peter Norton,
William Peppler, Denise Rich,
Rachel Rudin, David Teiger,
Ginny Williams, Elliot Wolk, 1999

**Ger Van Elk
(born Amsterdam 1941)**

176. *The Co-Founder of the Word
O.K.—Hollywood*, 1971
Color photographs
3 photographs, 12 3/16 x 10 1/4 in.
(30.9 x 26.1 cm) each
Collection Eveline de Vries Robbé,
Amsterdam

177. *The Discovery of the Sardines,
Placerita Canyon, Newhall,
California*, 1971
Color photographs
2 photographs, 25 1/2 x 27 1/2 in.
(64.8 x 69.9 cm) each
Courtesy the artist, Amsterdam

178. *Los Angeles Freeway Flyer*,
1973/2003
Color contact prints wound
around 6 walking sticks
27 x 198 7/8 in. (68.6 x 505.1 cm)
Collection the artist, Amsterdam
Exhibition copy

**Jeff Wall
(born Vancouver 1946)**

179. *Double Self-Portrait*, 1979
Cibachrome transparencies
in lightbox
64 9/16 x 85 13/16 in.
(163.9 x 217.9 cm)
Collection Art Gallery of Ontario,
Toronto; Purchase, 1982

**Andy Warhol
(born Forest City, Pennsylvania,
1928; died 1987)**

180. *Photobooth Pictures (Andy
Warhol in Tuxedo)*, c. 1963
Gelatin silver print on
photographic paper
7 3/16 x 1 9/16 in. (18.3 x 3.9 cm)
Archives of The Andy Warhol
Museum; Founding Collection;
Contribution The Andy Warhol
Foundation for the Visual Arts,
Inc., Pittsburgh
Exhibition copy

181. *Photobooth Pictures (Andy
Warhol with Sunglasses)*, c. 1963
Gelatin silver print on
photographic paper
5 7/16 x 1 9/16 in. (9.1 x 3.9 cm)
Archives of The Andy Warhol
Museum; Founding Collection,
Contribution The Andy Warhol
Foundation for the Visual Arts,
Inc., Pittsburgh
Exhibition copy

182. *Photobooth Pictures (Edward
Villella for Harper's Bazaar "New
Faces, New Forces, New Names in
the Arts")*, June 1963
Gelatin silver prints on
photographic paper
7 photographs, 7 13/16 x 1 9/16 in.
(19.8 x 3.9 cm) each
Archives of The Andy Warhol
Museum; Founding Collection;
Contribution The Andy Warhol
Foundation for the Visual Arts,
Inc., Pittsburgh
Exhibition copy

183. *Photobooth Pictures (Sandra
Hochman for Harper's Bazaar "New
Faces, New Forces, New Names in
the Arts")*, June 1963
Gelatin silver print on
photographic paper
7 13/16 x 1 9/16 in. (19.8 x 3.9 cm)
Archives of The Andy Warhol
Museum; Founding Collection;
Contribution The Andy Warhol
Foundation for the Visual Arts,
Inc., Pittsburgh
Exhibition copy

184. *Photobooth Pictures (Writer
Donald Barthelme for Harper's
Bazaar "New Faces, New Forces,
New Names in the Arts")*, June 1963
Gelatin silver prints on
photographic paper
2 photographs, 7 x 1 9/16 in.
(17.7 x 3.1 cm) each
Archives of The Andy Warhol
Museum; Founding Collection;
Contribution The Andy Warhol
Foundation for the Visual Arts,
Inc., Pittsburgh
Exhibition copy

185. Maquette for *Today's
Teenagers for Time*, 1965
Composite of 28 gelatin silver
prints on photographic paper
mounted on paperboard
8 x 11 in. (20.3 x 27.9 cm)
The Andy Warhol Museum;
Founding Collection; Contribution
The Andy Warhol Foundation for
the Visual Arts, Inc., Pittsburgh
Exhibition copy

186. *Photobooth Pictures (Edie Sedgwick)*, 1965
Gelatin silver prints on photographic paper
2 photographs, 7 3/16 x 1 9/16 in. (18.3 x 3.9 cm) each
The Andy Warhol Museum; Founding Collection; Contribution The Andy Warhol Foundation for the Visual Arts, Inc., Pittsburgh
Exhibition copy

187. *Self-Portrait in Drag*, c. 1981
Polaroid print
4 1/2 x 3 5/16 in. (11.4 x 8.4 cm)
Collection Walker Art Center, Minneapolis; Butler Family Fund, 2003

188. *Self-Portrait in Drag*, c. 1981
Polaroid print
4 1/2 x 3 5/16 in. (11.4 x 8.4 cm)
Collection Walker Art Center, Minneapolis; Butler Family Fund, 2003

189. *Self-Portrait in Drag*, c. 1981
Polaroid print
4 1/2 x 3 5/16 in. (11.4 x 8.4 cm)
Collection Walker Art Center, Minneapolis; Butler Family Fund, 2003

**Robert Watts
(born Burlington, Iowa, 1923; died 1988)**

190. *Portrait Dress*, 1965
Black-and-white photographic transparencies, cloth, vinyl, zipper
39 1/2 x 19 3/4 x 2 1/2 in. (100.3 x 50.2 x 3.5 cm)
Collection Walker Art Center, Minneapolis; T. B. Walker Acquisition Fund, 2003

191. *TV Dinner*, 1965
Photograph laminated on wood, cast plastic
1 3/8 x 20 x 11 in. (3.5 x 50.8 x 27.9 cm)
Collection Walker Art Center, Minneapolis; T. B. Walker Acquisition Fund, 1993

**William Wegman
(born Holyoke, Massachusetts, 1943)**

192. *Cotto*, 1970
Gelatin silver print
10 1/2 x 10 3/4 in. (26.7 x 27.3 cm)
Collection Ed Ruscha, Los Angeles

193. *Crow*, 1970
Black-and-white photograph
10 x 10 in. (25.4 x 25.4 cm)
Collection the artist, New York

194. *Milk/Floor*, 1970
Gelatin silver prints
2 photographs, 9 1/2 x 7 1/2 in. (24.1 x 19.1 cm) each
Collection the artist, New York

195. *Big and Little*, 1971
Black-and-white photograph
8 1/2 x 8 1/4 in. (21.6 x 20.9 cm)
Collection the artist, New York

196. *Reading Two Books*, 1971
Black-and-white photograph
14 1/4 x 10 1/2 in. (36.2 x 26.7 cm)
Private collection

197. *To Hide His Deformity He Wore Special Clothing*, 1971
Black-and-white photograph
14 x 11 in. (35.6 x 27.9 cm)
Collection the artist, New York

198. *Before/On/After: Permutations*, 1972
Black-and-white photographs
7 photographs, 9 1/2 x 7 3/4 in. (24.1 x 19.9 cm) each
Collection Walker Art Center, Minneapolis; Art Center Acquisition Fund, 1983

**James Welling
(born Hartford, Connecticut, 1951)**

199. *July 10 (a) (1980)*, 1980
Gelatin silver print
4 5/8 x 3 5/8 in. (11.8 x 9.2 cm) unframed
17 x 14 in. (43.2 x 35.6 cm) framed
Collection Leslie Tonkonow and Klaus Ottmann, New York

200. *March 16 (1980)*, 1980
Gelatin silver print
4 5/8 x 3 5/8 in. (11.8 x 9.2 cm) unframed
17 x 14 in. (43.2 x 35.6 cm) framed
Collection Leslie Tonkonow and Klaus Ottmann, New York

201. *2-29 IV, 1980*, 1980
Gelatin silver print
4 5/8 x 3 5/8 in. (11.8 x 9.2 cm) unframed
17 x 14 in. (43.2 x 35.6 cm) framed
Collection Leslie Tonkonow and Klaus Ottmann, New York

202. *In Search of . . .* , 1981
Gelatin silver print
22 3/4 x 18 3/4 in. (57.8 x 47.6 cm) framed
Collection Lisa Spellman, New York

203. *June, 1981 (#77)*, 1981
Gelatin silver print
9 15/16 x 8 in. (25.4 x 20.3 cm)
Courtesy Leslie Tonkonow Artworks + Projects, New York

204. *Untitled, 1981*, 1981
Gelatin silver print
10 x 7 7/8 in. (25.4 x 20 cm)
Collection Burt Aaron, Detroit

205. *The Waterfall*, 1981
Gelatin silver print
9 1/2 x 7 5/8 in. (24.1 x 19.4 cm) unframed
22 3/4 x 18 3/4 in. (58.8 x 47.6 cm) framed
Collection Robinson and Nancy Grover, West Hartford, Connecticut

206. *Whitfield*, 1981
Gelatin silver print
4 5/8 x 3 5/8 in. (11.8 x 9.2 cm) unframed
17 x 14 in. (43.2 x 35.6 cm) framed
Collection Leslie Tonkonow and Klaus Ottmann, New York

**Hannah Wilke
(born New York 1940; died 1993)**

207. *S.O.S.—Starification Object Series*, 1974–1982
Black-and-white photographs, chewing gum
41 3/16 x 58 3/8 x 2 15/16 in. (104.6 x 148.3 x 7.5 cm)
Private collection; courtesy Ronald Feldman Fine Arts, New York

Index

Page numbers in italics refer to illustrations.

Lenders to the Exhibition

Burt. Aaron, Detroit
Andy Warhol Museum, Pittsburgh
Art Gallery of Ontario, Toronto
Angelo R. Baldassarre, Bari, Italy
Barbara Gladstone Gallery, New York
Bard Center for Curatorial Studies, Bard College, Annandale-on-Hudson, New York
Michael Benevento, New York
Lorenzo and Marilena Bonomo, Bari, Italy
Daniel Bosser, Paris
The Brant Foundation, Greenwich, Connecticut
The Broad Art Foundation, Santa Monica
Victor Burgin, New York
Christine Burgin Gallery, New York
Suzanne Cohen, Baltimore
La Colección Jumex, Mexico City
Dallas Museum of Art
Daros Collection, Switzerland
David Zwirner Gallery, New York
Des Moines Art Center, Des Moines, Iowa
Eveline de Vries Robbé, Amsterdam
Jan Dibbets, Amsterdam
Anthony d'Offay, London
Thomas Erben, New York
Esso Gallery and Books, New York
Valie Export, Vienna
Fried, Frank, Harris, Shriver & Jacobson, New York
Galeria Fortes Vilaça, São Paulo, Brazil
Galerie Lelong, New York
Gorney, Bravin + Lee, New York
Greengrassi, London
Gayle Greenhill, New York
Robinson and Nancy Grover, West Hartford, Connecticut
Karen and Kenneth Heithoff, Minneapolis
Henry Art Gallery, Seattle

IVAM, Instituto Valenciano de Arte Moderno, Generalitat Valenciana, Valencia, Spain
Imi Knoebel, Düsseldorf
Kunstmuseum Winterthur, Winterthur, Switzerland
Marion Lambert, Geneva, Switzerland
Leslie Tonkonow Artworks + Projects, New York
Sherrie Levine, New York
Sol LeWitt
Bruno van Lierde, Brussels
Ninah and Michael Lynne, New York
Margo Leavin Gallery, Los Angeles
Marian Goodman Gallery, New York
Allan McCollum, New York
Metro Pictures, New York
The Metropolitan Museum of Art, New York
Gary and Tracy Mezzatesta, Los Angeles
David P. Mixer, East Greenwich, Rhode Island
Nina and Frank Moore, New York
Museu de Serralves, Museum of Contemporary Art, Porto, Portugal
Museum Moderner Kunst, Vienna
The Museum of Contemporary Art, Los Angeles
Museum of Contemporary Art, Oslo
Dennis Oppenheim, New York
Patrick Painter Editions, Hong Kong
Rachofsky Collection, Dallas
Ronald Feldman Fine Arts, New York
Edward Ruscha, Los Angeles
Sybil Shainwald, New York
Mr. and Mrs. Charles Shenk, Columbus, Ohio
Cindy Sherman, New York
Per Skarstedt, New York
SK Stiftung Kultur, Cologne, Germany
Kiki Smith, New York
Solomon R. Guggenheim Museum, New York
Sonnabend Gallery, New York
Robert and Melissa Soros, New York
Lisa Spellman, New York

Talwar Gallery, New York
303 Gallery, New York
Leslie Tonkonow and Klaus Ottmann, New York
Ger Van Elk, Amsterdam, The Netherlands
Walker Art Center, Minneapolis
Artur Walther, New York
William Wegman, New York
Thea Westreich and Ethan Wagner, New York

Private collections

Reproduction Credits